A System of Moments

DENNIS HOPPER

A System of Moments

With essays by

Kerry Brougher
Peter Frank
Bruce Hainley
George Herms
Fred Hoffman
Dennis Hopper
Walter Hopps
Edward Ruscha
Andy Warhol
Daniela Zyman

Edited by

Peter Noever, MAK

Hatje Cantz Publishers

This catalog was published on the occasion of the exhibition
Dennis Hopper: *A System of Moments*
MAK, Vienna, May 30 – October 7, 2001

Exhibition: Dennis Hopper, Peter Noever
Curator: Daniela Zyman
Curatorial assistance: Evelyn Fertl, Ursula Klaus, Sandra Rust
Technical coordination: Philipp Krummel, Harald Trapp
Assistance to the artist: Karen Freedman, Braden Kuhlman

Special thanks to:
Dennis Hopper; Harry Blum/The Blum Group, L. A.; Kunstsponsoring British Airways;
Columbia Pictures; Karen Freedman, Braden Kuhlman/Alta Light; LouAnne Greenwald/MAK
Center, L. A.; Fred Hoffman, L. A.; Winter Hoffman; Hollywood Classics; Hotel Sacher, Vienna;
Tony Shafrazi Gallery, New York; Sony Pictures; Stedelijk Museum, Amsterdam

MAK
Stubenring 5, 1010 Vienna, Austria
Phone (+43-1) 711 36-0, Fax (+43-1) 713 10 26
E-mail: office@MAK.at, www.MAK.at

Editor: Peter Noever
Catalog editing: Daniela Zyman
Editorial assistance: Sandra Rust, Gamynne Guillotte
Copy editing: Evelyn Fertl, Nina Holland
Graphic design: Maria-Anna Friedl
Translation (English/German): Wolfgang Astelbauer (Invitation to the Void. A System of
Moments, Dennis Hopper and the 1960s Art Scene in Los Angeles, Out of the Sixties, The
Life of Goon), Dagmar Fink/Katja Wiederspahn for gender et alia (POPism, The Pop Fathers,
Thoughts on the Return and Artistic Maturation of Dennis Hopper), Thomas Gratt
(Biography), Frank-Alexander Hettig/Sandra Rust (The Seductive Sixties), Michael Strand
(Man Who Has Five Wives Has Tough Row to Hoe, Twine, On Art and Film – A Final
Note …)
Translation (German/English): Nita Tandon (Moments of a System)

© essays, photos by the authors and photographers
© 2001 MAK, Vienna, and Hatje Cantz Verlag, Ostfildern-Ruit

Published by: Hatje Cantz Verlag
Senefelderstrasse 12, 73760 Ostfildern-Ruit, Germany
Phone (+49-711) 4405-0, Fax (+49-711) 4405-220, www.hatjecantz.de

Distribution in the US: DAP/Distributed Art Publishers, Inc.
155 Avenues of the Americas, second floor, New York, NY 10013-1507, USA
Phone (+1-212) 627 1999, Fax (+1-212) 627 9484

ISBN 3-7757-1030-2

Printed in Germany

CONTENTS

Dennis Hopper in the empty MAK Exhibition Hall during his first visit, 1999 © Herbert Fidler

Peter Noever

MOMENTS OF A SYSTEM

On the subject

He is one of those heroes, masters of the world, one of those who reflect the American dream factory's imperial self-confidence. Dennis Hopper, the film and Hollywood star, skilfully fulfills all expectations associated with this rare species. He allows the media to partake not only in his moments of triumph but also of self-doubt. It seems as though everything is turned outwards. And so he stands defenceless, without reservations – even when the public execution begins as a result of the actor's unwillingness to comply with the media-created and projected image of a winner radiating heroic and undaunted optimism. Seen in this light even Hopper's often-quoted excesses seem conventional. The occurrences and the works that contributed to his (star) fame are to be seen rather as phases of modernisation than the transcendence of Hollywood.

Dennis Hopper: A System of Moments – an exhibition often cancelled and then resumed for the first time displays a completely new and surprising dimension in Hopper's work.

Hollywood is a grand "inscenario" of the American dream, this is also where the artist, the movie director and the actor meet. The artist, the filmmaker, the actor and the author – Dennis Hopper is all of them in person and the most extreme controversies cross paths in this versatility. But the various staging techniques ultimately link the apparently disjointed and the unexpected.

The gradual approach, the continually interrupted processes, the energy to focus again on this large-scale show at the MAK, make it seem like a gigantic screenplay for "The Last Exhibition." Dennis came to Vienna, saw the MAK's main exhibition halls and was perceptibly overwhelmed not only by their dimension but also

by being aware of past artistic interventions by Donald Judd, Vito Acconci, Chris Burden, Jannis Kounellis or James Turrell. He knew, and immediately expressed the fact that he was in possession of the necessary vitality, color, motion, and expansive spirit that would turn the show in this space into the ultimate art piece.

Just a few months later, at the very outset of our meeting in his studio in Venice, California, he called the show off. He as the artist would tolerate no interference whatsoever. I became instantly aware of the fact that this man who stood before me was the creator of Frank Booth, the character in *Blue Velvet*. Maybe not right away but a few moments later he switched back to Dennis Hopper, the sovereign and sensitive artist who had been working unwaveringly at our exhibition project.

Both Dennis Hopper's work and his public appearance are marked by breaks in development as well as in the practice of his various talents. First of all, he is an artist who turned to acting only in the late 1950s. After initial conflicts with the studio-system, his career in the early 1960s was defined by photography. *Easy Rider* followed and only twelve years later, after private excesses and after the box-office-flop of *Out of the Blue,* did he return to art and painting at the beginning of the 1980s. Closely associated with film idols like James Dean, on the one hand, and Andy Warhol, Roy Lichtenstein or Edward Ruscha on the other, his art oscillates between unfulfilled dreams and adventurousness as well as a fascination for the excessive.

One is led to believe that Dennis Hopper sees his artistic work as a kind of survival strategy, the real life insurance of a radically success oriented person who is driven by a desire for the really big thing. He seems to be the American hero who, while striving for fame, is always walking at the edge of a chasm.

In personal encounters, too, he conveys the impression of an US-American per se; a guy who drives his Chevrolet right into the bedroom of his house cum studio that is designed like a self-portrait. While he is also entrenched in family and neighborly relationships he would never hesitate to use a gun to ensure absolute respect for his freedom.

His house and studio complex of interconnected buildings, designed over twenty years ago by Frank O. Gehry and later extended by Brian Murphy in an uninviting area of Venice, is more a place of a rough Third World America and definitely not Beverly Hills. He lives here with his own art and that of his friends Andy Warhol, Roy Lichtenstein, Jasper Johns, Edward Ruscha, Bruce Conner, Marcel Duchamp, Edward Kienholz, George Herms, Wallace Berman, David Salle, Julian Schnabel and others. He lives and works here, exposed to and in close relationship with an unembellished reality as once his studio was in New Mexico, the former movie theater in Taos. Hopper not only screened films on Sundays for the neighborhood kids there, but also ran an art space in order to familiarize the local community with the art and the artists important to him.

A lot in this account may seem clichéd, but Dennis Hopper possesses incredible capabilities: he can personify, a talent he has proved repeatedly as an actor. Even as an artist he can play this part if he considers it necessary to blast his body, his entire existence, with the "Russian Death Chair" just to make an aesthetic statement.

Precisely this physical experience, expressed in an act that radically ignores the boundaries between person and human being, seems to establish a relationship between the lived present, personal history and the artwork of a person who is not simply a hero in the metaphorical sense.

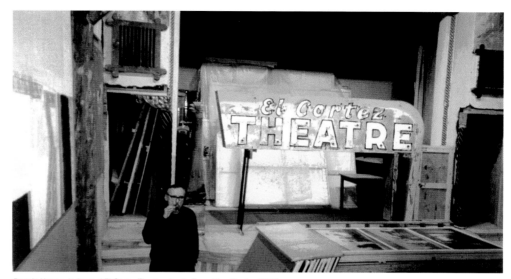

Dennis Hopper in front of El Cortez Theatre sign in Taos, New Mexico, 2000 © Peter Noever

The hero as the personified expression of an objective quality or the trend of a specific time can only penetrate social consciousness when embodied at the very cost of private life. This concept finally seemed to be a thing of the past at the very moment, when the generation of artists, to which Hopper belongs, made their entrance. They were "true Americans" who no longer looked towards Europe but rather expressed the authenticity of their own experiences in an equally authentic language. For them life itself and not just personal history seemed to be one great "scenario" devoid of every metaphysical background.

The "American Hero," neither the star of the cultural industry, nor his representation in art, are descendants of Prometheus, Oedipus, nor for that matter of Christopher Columbus. He may be "lucky" or perhaps even "unlucky," but he has no "destiny" — nor has he a "task" to fulfill. He was born free in the land of the free.

One of the strident qualities that mark Dennis Hopper as an artist is that he perceived this tendency and articulated it in his art without simply reproducing it. This was perhaps as central to his career as film star and filmmaker as for his urge to "return" to painting.

Particularly in those cultures where the inherence of a formal context in art was established — a concept that prevailed well into Modernism — the human body was the quintessential image. Its representation was therefore a transgression. Art drew its social strength from this taboo and by breaking it art became a scandal. In its traditional form art was a social strength as long as the taboo had an objective basis in the virtual impossibility of representing the body. However, with the invention of photography the taboo fell.

Hopper belongs to that generation of artists who no longer considered the absence of restriction that constituted traditional art as freedom won through struggle. For them it was a fact that they took for granted. Neither in his artwork nor in that of the contemporaries he was closely associated with did drawing, painting or the collage-like composition need to assert itself against a major theme of the modernists: representation of the body in photography. This art was no longer tormented by doubts about its necessity or even its potential, which is yet another reason why it seems so "American."

Dennis Hopper, the artist, makes pictures. He did that long before he became an actor and a film star. His artwork, however, was not unaffected by his film activity. It was as though his position as the star of an industry that, through the person of the film star, is so intensely focused on the human body had brought something into focus that called for other means of expression.

Single pictures and actions are not Dennis Hopper's only mode of expressing the tendency immanent to contemporary art, and that is also a focal point of his artistic work, as it progresses through various stages of development. His passage from young artist to actor and photographer, on to *Bomb Drop,* film director and film star and then the "self-destruction" through the "Russian Death Chair" and ultimaly finally his "return" to painting, is a picture in itself. It is perhaps one of the possibilities of a staged representation of the history of art in the second half of the twentieth century. Hopper, however, does not attain self-realization through it nor does his biography end with it. Contrary to traditional art for which the artist's entire life is his "real work," Dennis Hopper never strived to shape his own life as an artwork. Self-realization was never the aim of art for him. Art for Hopper is not an attempt to produce something private but much rather at to regain privacy. It was something that he more than all consumers of the culture industry had "sacrificed" for the sake of the right to fifteen minutes of fame that his friend Andy Warhol had proclaimed. It was the search for an authentic intimacy of place and time in a reality that seemed capable of randomly citing any place and any time at will.

Dennis Hopper's eye is turned outwards. His method is not of introspection and regression. He never looks for moments that would negate his person as a prevailing social reality. He explores incidents – as in the film *The Last Movie* or in his artworks *Man from La Salsa* and *Mobil Man* – that would make the individual and society incompatible. It is an investigation to see what would happen if a global industry, in this case the film industry, collided with another culture such as the Indios of Peru. In other words, an artistic representation of what remains of the individual after he is subsumed by industrialization. In a very personal manner, he inspects the relationship between the culture and the leisure industry and culture itself. Subjectivity finds articulation here that neither boasts of a definition of culture to criticize today's "event" oriented society with, nor does it strive to be executor for a commonplace culture industry's estate.

Dennis Hopper at the MAK Center opening of *American Pictures, 1961– 67: Photographs by Dennis Hopper,* 2000 © Joshua White

Dennis Hopper and Henry T. Hopkins at the MAK Center for Art and Architecture, 2000 © Joshua White

On first glance it is bewildering to figure out how Dennis Hopper expresses this moment other than through his staged collision of image and representation. His billboards, *Man from La Salsa,* his picture series *Colors* and *Morocco,* his films or the characters he invents all seem confusing, violent and lethal. At the same time, however, he reveals the fact that someone is around who, as eyewitness, presents the possibility of reconciling the ostensible antagonism.

Hopper's relevance as an artist lies in the fact that his work is never just an expression or a representation of the American Dream. It is much rather the tiresome process of waking up from that dream at the end of which there will be no familiar yesterday that the West had promised. Neither is a "New World" to be found here nor, for that matter, the anonymity of time or place that the American entertainment culture likes to present itself to us. What one does encounter is an ability to produce pictures that are not mere reflections of our narcissist image but instruments that liberate our gaze from the clasps of a material world.

Dennis Hopper demonstrates this in an exemplary manner in his Vienna show where he presents his entire œuvre for the first time. He commands the space by transforming the inner into outer space through an installation that thematizes the guiding principle of his work. A totally new perspective that enables us to gain insight in his position and dynamism. Even more so, the entire range of his ability converges here – starting with the filmmaker's know-how like setting, cropped image, pan shot, cuts, dissolves and his skills as author as well as all his narrative strategies, including methods of his art works and their installation. All this reveals that the quality of his work lies in its complexity as a system of interventions, as it becomes obvious in the englobing perspective of this presentation at the MAK.

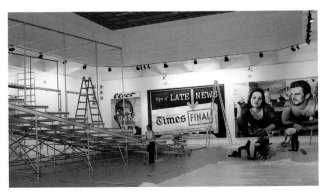

MAK Exhibition Hall during installation of *Dennis Hopper: A System of Moments,*
2001 © Manfred Trummer/MAK

Dennis Hopper: A System of Moments, exhibition banner (based on *Biker Couple,* 2000) on MAK facade, May 30 – October 7, 2001 © Gerald Zugmann

Dennis Hopper

INVITATION TO THE VOID. A SYSTEM OF MOMENTS

For this creator "the void" is an empty place between film jobs, acting, directing, writing – "a system of mo- ments" frozen like the flick of a candle caught forever licking the darkness, the splatter of wet paint caught in a dry burst coming out of a great angst and pain having been denied work in my medium of choice: mo- vies. The explosion – to fill the void between film work, a system of moments occurred, paint, photograph, manufacture, tape, plastic, lights, sets, shadow, assemblage, motion, found objects, with a rope of history binding me to Abstract Expressionism, action painting, and Marcel Duchamp (whom I met in 1963). Duchamp said the artist of the future will merely point his finger and say it's art, and it will be art. I was a part of the California School of Assemblage and New Realism with Wallace Berman, George Herms, Edward Kienholz, Llyn Foulkes, Bruce Conner, and Edward Ruscha, and one of the founders of Conceptual Art with *Proof* (1963), and *Wilhold the Mirror Up* (1961).[1]

This show is about my life in art as actor, filmmaker, writer, director, painter, photographer, and finger pointer. To enter the show, you must first encounter chain link fences and razor wire – a labyrinth of bill- boards. It's a hostile environment. It's Los Angeles. We're outside the movie studio. How do you find a way inside? A door with a guard finally lets you inside. It's a studio for movies: you see props, lights, sets, flags, cookie cutters, etc. devices to make lights and shadows in film. You are in a movie set.

This space will open into other spaces where I will display what was made in the void what the system of moments allowed to be created. At the same time shown on the monitors and projectors, are selected moments from the movies I was working on before and after these bursts of creative energy that were al- lowed to happened because film work was denied me. The void. The emotional dance around the canvases

1 The title refers to Hamlet's speech to the troupe pre- paring a dumb show which Hamlet claims "will hold the mirror up." A glue bottle (Willhold Glue) and a small head are assembled in a box mounted on a large photograph blow-up of the head, with the imprint "out- moding older concepts" (see page 141).

was possibly more valid than the human scratches that are often left on the canvases – but so is life. The necessity to make these photos and paintings came from a real place – a place of desperation and solitude – with the hope that some day these objects, paintings, and photos would be seen filling the void I was feeling. This is a story of a man/child who chose to develop his five senses and live and experience rather than just read. If you know what you hear with your ears, and see with your eyes, all the secret wonders of the world will be revealed to you. Just don't lie, and don't do what you hate, for all things are manifest before heaven.

It was the twentieth century – a machine, computer, car, airplane, radio, TV, electricity, printed word century. I took my five senses as far as I could derange them.[2]

I read only minimally, and memorize a lot of scripts which I immediately forget when I hear the director say "cut and print." If there's a hair in the gate and we have to shoot the scene one more time, I have to memorize the scene again, so complete is my disposal of the words when I hear "cut and print." So to create, empty your head, erase the old tapes, find your tension areas, relax, think of nothing, allow your smell, taste, touch, hearing and seeing to dictate the response to the stimuli, attack the canvas as in action painting or the frozen moment of a discarded corner trapped in a photo. I photographed the artists of the 1960s who brought about change; their work will be a metaphor for the art of the future. Lithos become the size of billboards. The return to reality from Abstract Expressionism, comic books, coke bottles, soup cans, movie stars, paintings off the easel onto the floor, off the wall becoming the room, discards of society becoming poetry of time lost and found frozen in the moment. Hard edge, optical, poptical, assemblage, conceptual. I was a part of what my good friend Walter Hopps called the "Dream Colony."

I was cast in plaster by Kienholz. I was one of the two Bekins' moving men in Barney's Beanery.[3] All the heads are made of clocks. I am the only one with two faces of a clock – one focuses on a society girl and the other on a black hooker. Maybe this is an appropriate metaphor for a man trying to move things along, facing the schizophrenic whole of society in a very primal gesture, in a limited space with no formal education. To work with Kienholz and Warhol before they were famous, to walk with Martin Luther King from Selma to Montgomery, to have been in over 120 films, and to be able to expose this personal and artistic expression is at once rewarding and frightening as it culminates my artistic plight. So welcome to my "invitation to the void – a system of moments."

Edward Kienholz, *The Beanery*, 1965, Mixed media
© Stedelijk Museum Amsterdam

2 Hopper refers to his 1983 self-explosion performance, Rice Media Center, Rice University, Houston, Texas which he considers a cathartic experience. He "performed" this stunt as a sort of rebirth and reintroduction to the artworld.

3 *The Beanery* (1965) by Edward Kienholz is a reconstruction of the legendary Barney's Beanery on Santa Monica Boulevard in L. A., the bar frequented by artists, beatniks, and actors. The figures are plaster casts, the clocks all being frozen at 10:10.

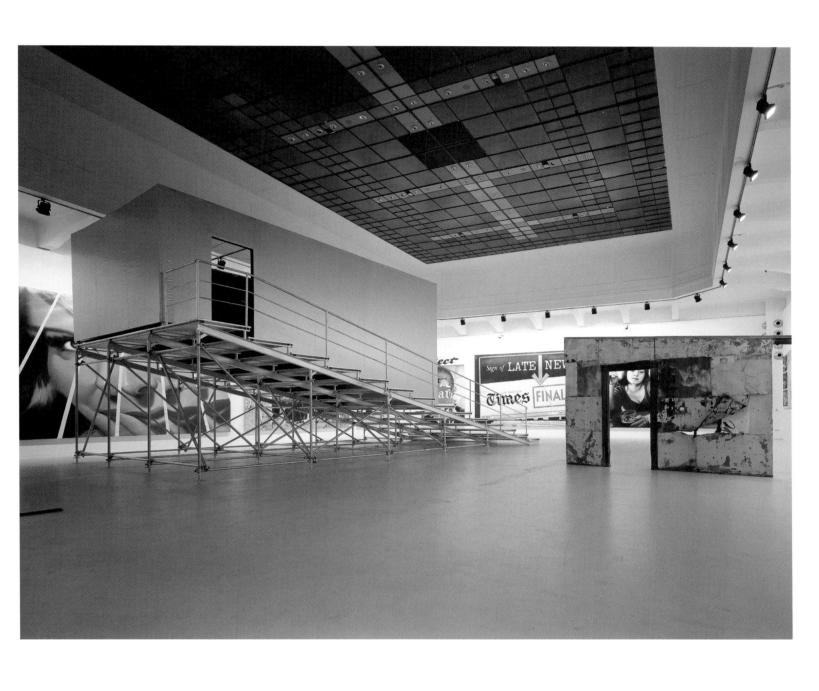

Dennis Hopper: A System of Moments, installation view, MAK Exhibition Hall with central screening room, May 30 – October 7, 2001
from left to right: Billboard Factory (Multi image of a woman's face), Torn Poster (Elect), L. A. Times Final (all billboards 2000),
Untitled # 10 (Old metal wall), 2000 © Gerald Zugmann

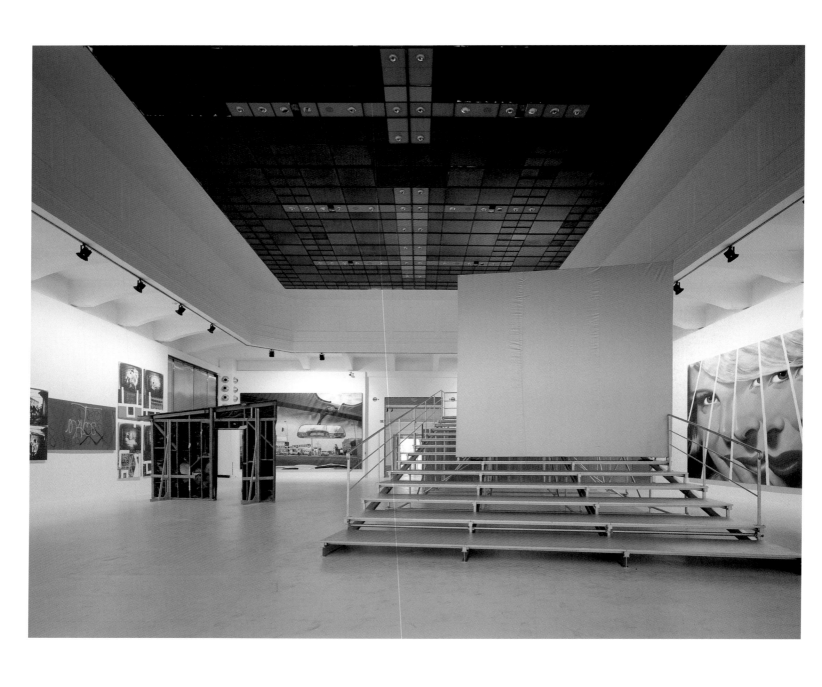

from left to right: *Heat*, 1992, *Four Joiners*, 1992, rear view of *Untitled # 10 (Old metal wall)*, *Double Standard*,

Billboard Factory (Multi image of a woman's face), all 2000 © Gerald Zugmann

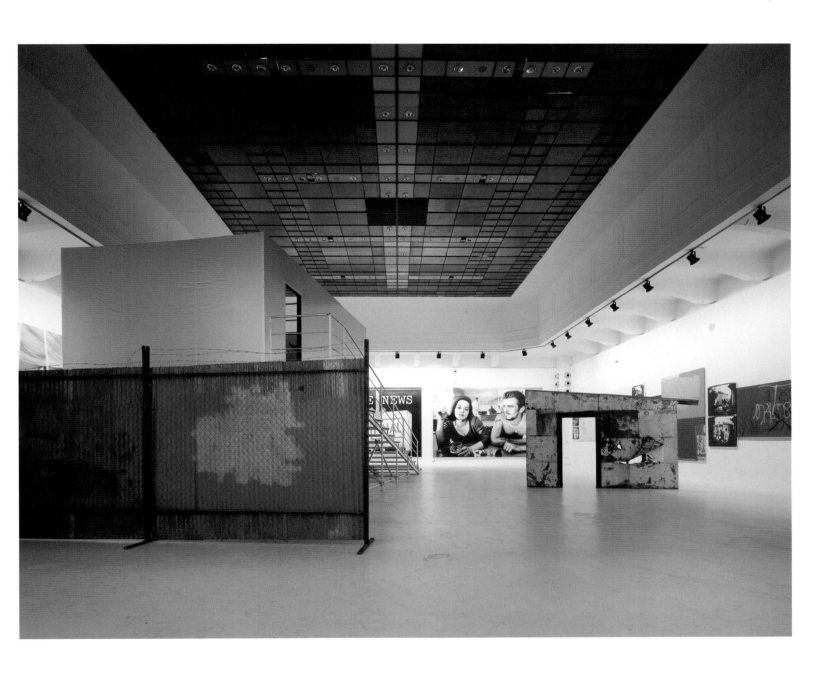

from left to right: detail of *Untitled # 4 (Corrugated fence), L. A. Times Final, Biker Couple, Untitled # 10 (Old metal wall)*, all 2000,
King Part Bust Trap, 1991–97, Heat, 1992 © Gerald Zugmann

Untitled # 11 (Representation of Man from La Salsa), 2000, installation view, MAK Terrace Plateau © Gerald Zugmann

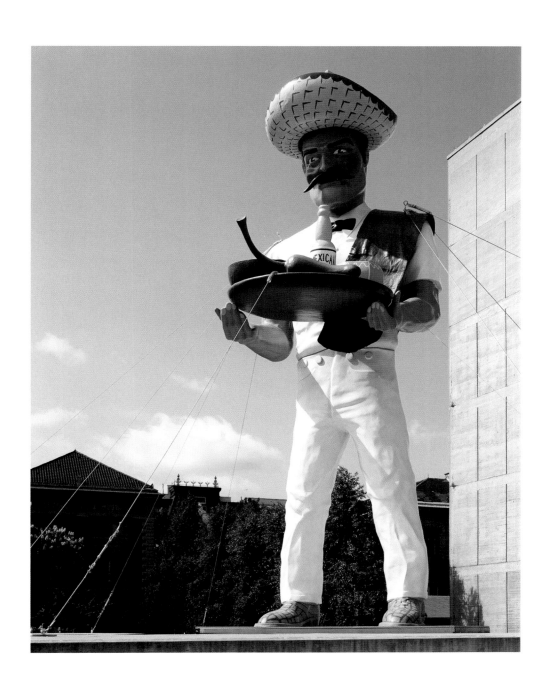

Untitled # 11 (Representation of Man from La Salsa), 2000 © Gerald Zugmann

THE SEDUCTIVE SIXTIES

MAK-Talk at the Schindler House on June 2, 2000

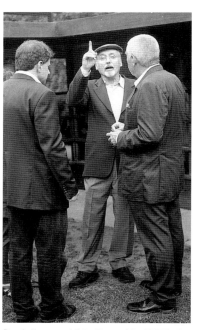

Dennis Hopper and Peter Noever at the MAK Center, L. A., 2000 © Joshua White

PETER NOEVER: Last night the MAK Center for Art and Architecture opened *American Pictures, 1961 to 1967: Photographs by Dennis Hopper.* Many of the photographs on view at the Schindler House have never been shown before. They have never even been enlarged from the negatives and are documents of a period of great artistic creativity. Dennis Hopper's 1960s photographs evoke the excitement and innovation of a decade in which rebellion and reinvention characterized both the art world and society at large. As an artist, Dennis Hopper was drawn to document the people and events affecting change at that time. Henry T. Hopkins is a professor of art at U.C.L.A. and a preeminent art world figure who has been active in Los Angeles since the 1960s as a gallerist, critic, author, curator and museum director. Together, Dennis Hopper and Henry T. Hopkins will explore their ideas about "The Seductive Sixties" in this MAK-Talk tonight.

HENRY T. HOPKINS: That was Peter Noever, who is the director of MAK Vienna and who is working on an enterprise with the Schindler House and doing wonderful things with a great opening here last night of Dennis' photographs, and it is a great treat to see them. Why me? Probably because I did the first exhibition of Hopper photographs when I was the director of the Fort Worth Museum back in what, about 1970–71?[1] Also, I had been, for a while, the custodian of all of Dennis' negatives. I don't know how many thousands there were, documenting the sixties almost completely (1961–67), not just the exhibition here, which are unseen photographs dealing with the L. A. scenes and the mixture of the New York and L. A. art circuit, with the Oldenburgs and the Rauschenbergs and the Irwins and the Bells and Bermans and the Conners and the Kienholzes and so forth. But amongst the many photographs are documentations of bike riders of that time, the love-ins, and all of the tremendous events. When I first saw the negatives, I was stunned by their number

1 *Dennis Hopper: Black and White Photographs* (1970), Fort Worth Museum of Art, Fort Worth, Texas.

and asked if it would be possible, if we printed some, to make a little exhibition. And since that time, they have been shown, different parts of them, many times. And Dennis becomes increasingly known as a photographer along with his film fame, but also, which you may not know, an artist in his own right, doing many assemblage works and objects during the 1960s. So, if it's okay with you, Dennis, I'll just go back to your very beginnings and we'll just kind of wander through your life. I know you were born in Kansas City, raised in San Diego, came up to L. A. at a given moment at an early age to hit the film world, is that correct?

DENNIS HOPPER: Well, I was born in Dodge City, Kansas. And I was in Dodge City until my father came back from the Second World War. And that's where I started out. And I was raised on a wheat farm. My grandfather was a wheat farmer. My father went away to the Second World War and when he came back, we moved to Kansas City, Missouri and I went to grade school there. Then we moved to San Diego, California and I finished grade school there and went to junior high school and then to high school in San Diego. After that, I came up here and went under contract with Warner Brothers when I was eighteen years old.

HOPKINS: Now, had you taken theater and things like that?

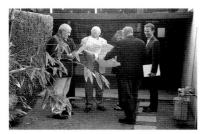

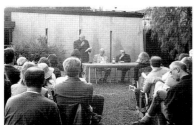

Peter Noever, Henry T. Hopkins, and Dennis Hopper
© Joshua White

HOPPER: I did the Old Globe Theater in San Diego when I was thirteen years old in Balboa Park. I did Shakespeare there. I apprenticed, actually, at La Jolla Playhouse. My boss was an interior decorator with Mary Price who was married to Vincent Price.[2] And so, when I came to Hollywood I had access to Vincent Price's kiln and did some of my first abstract work there, and William Brice, who teaches at U.C.L.A., Fanny Brice's son,[3] was a painter and was doing the tiles for Vincent's pool and I started using the kiln there.

HOPKINS: Just to fill you in a bit: Vincent Price was one of the great character actors of all time, who devoted most of his life, obviously, to horror movies later on. They kept him working well until he was seventy years old. But he was also a very avid art collector and one of the primary art collectors in L. A. during the period of the 1950s and 1960s when there were not very many. As a matter of fact, he befriended many of us and was really a wonderful guy and a great person to know, a great person to enjoy. So, you got up here, and you were under contract, right? When you came up along with Jimmy Dean and the other people of that era, what was your ambition? What was it you most wanted to work with? Who did you want to work with?

HOPPER: Well, I suppose everybody at that time wanted to work with Marlon Brando. But I wanted to work with Elia Kazan as a director. I finally did work with Brando in *Apocalypse Now,* but I never worked with Kazan. I thought Kazan was the greatest actors' director in film at that time. But to go back to Vincent, I saw my first abstract work there. I saw my first Richard Diebenkorn, my first Franz Kline, my first Jackson Pollock and Emerson Woelffer, he had a lot of Woelffer there. And that really affected me. As a matter of fact, Diebenkorn is still my favorite painter.

HOPKINS: Were you involved in art-making at all at that time?

HOPPER: I was painting and I was also working the kiln with Brice over there. I was sharing a kiln with Bill Brice.

2 Vincent Price (1911–93), actor, art collector, author, and editor of art books. Helped establish the Vincent Price Gallery, L. A. in 1951.

3 Fanny Brice (1891–1951) was an important twentieth century American entertainer. Her forty year career included work in burlesque, vaudeville, and radio.

HOPKINS: Oh, you did ceramics. I didn't know that.

HOPPER: Yeah. Then in 1961, I lost all my abstract paintings in the Bel Air fire. I had a photographic show [4] that night, and my negatives were saved. I started to paint again and do assemblages with large photographs, black and white photographs with things assembled on them.

HOPKINS: So,1960, '61 that's the era of the old Ferus Gallery over on La Cienega Boulevard. I had my little gallery, the Huysman Gallery, across the street. Those were grand days and there was a gallery right next door to Ferus, the Primus/Stuart Gallery, where Dennis showed his work. So, you're very much part of the art team by then. You weren't really photographing by then, you were still more involved with your acting, isn't that right?

HOPPER: I was trying to be involved in acting. I was having a hard time, so photography was about it for me creatively at that time. I was doing a couple of small things, but that was keeping me alive creatively, not financially.

HOPKINS: I have to go back only to remind you that the reason he's saying that photography was a factor in all of that, was simply the fact that he was almost kicked out of the Hollywood community for bad behavior, which was not unusual for stars of his age in that time. This was before *Easy Rider.* You were working on a western, if I'm right, with Howard Hawks.

HOPPER: Henry Hathaway. [5]

HOPKINS: Henry Hathaway. And then he essentially blacklisted your movie career. But you told me, that you began photography primarily because you became interested in being a director and wanted to be dealing with full-frame photography and you thought that would train your eye?

HOPPER: Yeah, I realized that you can't really crop motion pictures. So, I thought it would be better to like compose in the camera. My photos are all full-frame. So, that was something that was important to me.

HOPKINS: Do you have photo heroes at that time?

HOPPER: I didn't read a lot, but the idea of the decisive moment, catching something at a given moment, was very interesting to me. So my first photographs, which there aren't that many, are in New York of people on the streets, sort of "West Side Story" kind of photographs, of people jumping, catching balls. But then I started being drawn to the flat area, which really probably is Aaron Siskind. But I saw Siskind after. I started being drawn to the idea of shutting off perspective and trying to shoot flat on, so the picture has no depth of field, it becomes like the surface of a painting. Those were the first things that I showed and I got in this Photo Fest or Photo Vision in Australia, world competition, and I won. I sent these abstract photos in 1961, five of them, and I called them *Pieces.* I got first place.

HOPKINS: Five easy *Pieces?*

HOPPER: Yeah, five easy *Pieces.* It meant absolutely nothing, but it was important to me because I was

4 The worst fire ever to plague L. A., the Bel Air-Brentwood fire of November 6, 1961 consumed over 484 homes and caused over $20 million in property damage. Hopper's photographic negatives had been moved to Photo Lab/Gallery Barry Feinstein, L. A. in preparation for his first exhibition and thus were saved.
5 Henry Hathaway (1898–1985) was a director best known for his prolific work on action films and Westerns. He directed Hopper in several projects, including *From Hell to Texas* (1958), *The Sons of Katie Elder* (1965) and *True Grit* (1969).

being photographed all the time and it was really difficult for me. It was an intrusion to me when people photographed me. That's why, in my work later, I start masking my face out. I don't want to see it. I don't want to know about it. It becomes a silhouette. It doesn't have any relationship because the actor doesn't compute over into the other world. The actor isn't trusted. He may be acting. So, the mask of being photographed is really uncomfortable to me, and the only people that I really found comfortable being photographed, were artists. They asked me to photograph them. They were comfortable being photographed. They wanted to be photographed. And that was cool. That was okay with me. But, beyond that, I didn't really photograph other actors. I did some of Paul Newman, or Dean Stockwell, or guys that I was really close to, close friends.

HOPKINS: I remember, you did a series down in Malibu along the beach house with Jane Fonda, when they were filming *Barbarella* and things of that time. You did some movie folk, as a matter of fact. Was the thought of documenting the sixties ever on your mind or was it simply an issue of taking photographs of people that you liked?

HOPPER: I wanted to document something. I wanted to leave something that I thought would be a record of it, whether it was Martin Luther King, the hippies, or whether it was the artist. I made my selection, I made my choices and I didn't photograph everybody. I photographed these people relatively early. Also, Pop Art, all this is very easily understood now, but at the time that these things happened, this was really radical stuff I collected art. I bought the soup campaign from John Weber, Andy Warhol's first *Campbell's Soup Can,* for $75, and I bought a little Edward Kienholz called *The Quickie,* which was a little mannequin's head sitting on a roller-skate with the finger up her nose, and it said "The Quickie" on the front in tin. And I had a work called *White on the Side.* It was one of those big abstract wooden things that Kienholz made. I had a big, tall one with a wooden thing coming down in black, red, and gold. And I thought it was magnificent. It was really ugly. And my agent came in my house, and he looked at this stuff and said, "You ought to get rid of that stuff, because you're obviously spending your wife's money foolishly," and, "This is ridiculous, and it's hard enough trying to get you a job, but, I mean, if you're going to be collecting this stuff. I can't be your agent any more unless you get rid of this stuff." And I said, "I'll see you later." That was the end of that conversation.

HOPKINS: And the end of his career.

HOPPER: Yeah, probably. But it was really not understood, you know? Neither was Abstract Expressionism.

HOPKINS: So, after the bad times in the movies, and the beginnings of photography and working with that, then you kind of came back with a vengeance in *Easy Rider,* obviously, and then hit a whole generation hard on the head. You were making films like *The Last Movie,* which I know you had a lot of trouble getting distributed, but it was really an interesting film. A good friend of yours, Irving Blum, for example, was the art dealer at Ferus Gallery. When he first came to L. A., he was given a commission to be the voiceover on a film that has now become a classic nudie film called *The Immoral Mr. Teas.* The first of the nudie films to

come into the business. And he took a $500 fee instead of a percentage of the gross, and I think it's now grossed something like sixty million dollars. You can still get it at Oodle Noodles and places like that, wherever it might be. But I remember it was one of your ambitions, at that time, to do a thing that you called *Blue Movie?* Do you want to tell people about that?

HOPPER: Not necessarily. I just wanted to make the first serious pornographic film. I wanted to make a film that had drama in it and had people making love, I mean, really having sex and doing the things that people actually do. And I thought that that was just something I would like to do, because at that time I was trying to do things that people hadn't really done. And I was really into that. So, the idea of making the first important porn film, I thought, was something I wanted to do. I wrote a wonderful screenplay called, *Gracias Por Nada (Thanks for Nothing)* which took place in France. It had nothing to do with Spain, but I wanted to do that. But when I saw *Realm of the Senses*[6] in Cannes, it no longer interested me because nobody would ever do it any better. It was a great movie.

HOPKINS: So, when your film career picked up again, obviously, did you continue to photograph, have you continued to document using your photography?

HOPPER: I stopped in 1967. Also, I'm not documenting. No, now I'm drawn to the …I don't want to say walls. I always say walls. But it's not always walls. I've been drawn to the flat surface and to the … well, it gets more minimal as I go into it.

HOPKINS: Now, is it still Siskind-like or …

HOPPER: I've only seen a few Siskinds and I've only seen them recently. The first Siskinds I saw were rocks that had shapes and a brook. And that was the only thing I had seen for years. But I knew that he was doing flat surface.

HOPKINS: I think you also told me one time that Robert Capa[7] was a photographer you liked a lot in terms of the people aspect of the things, like his Korean War photographs and the other things of that time. He hung out here for a long period of time. Obviously you and Brooke Hayward[8] had very close friends. And you collected, quite avidly, works of art, and were much part of the L. A. scene. Then you took off to Taos, New Mexico and hid out there for quite a period of time. You were collecting things, but did you create things during that time?

HOPPER: Well, I stopped collecting when I went to Taos. And then the I.R.S. came and took what works of art I had. Brooke got most of the stuff. But I did have an Ad Reinhardt that I loved, a big black cross. A beautiful Ad Reinhardt. I created up there, but I didn't paint until I went down to a show in Houston with Walter Hopps[9] where I decided to blow myself up.[10] That's when I started painting again because I had talked so much about machine-made art and that the artist should not be afraid of the machine and go on and work with the machine. So, I went back to painting because I didn't really know how to do anything. I couldn't make photographs in Taos very easily, even though Gus Foster[11] makes that scene. Seems sort of absurd

6 *Realm of the Senses* (1976), Nagisa Oshima, director.
7 Robert Capa (1913–54), war photographer, who documented the Spanish Civil War, the Sino-Japanese War (1938), the European theater of World War II (1941–45), the first Arab-Israeli War (1948) and the French Indochina War (1954).
8 Hopper's second wife. He and Brooke Hayward were married from 1961 to 1969.
9 Walter Hopps, art dealer, curator, and art writer. Co-founder of the influential Ferus Gallery in 1957, along with artist, Edward Kienholz.
10 Self-explosion performance where Hopper sat in a so-called "Russian Death Chair" (1983) surrounded by twenty sticks of dynamite.
11 Gus Foster (b. 1940), photographer, set up his own photographic studio in L. A. in 1972. Has lived and worked in Taos, New Mexico since 1976.

that I said that, because he does. But I really missed it, and I wanted to go back to painting, and so I did. But I did it quietly there.

HOPKINS: Let's talk about some of the photographs and the people around them. There is one wonderful picture of Walter Hopps that shows he's got a glass eye, which I think is wonderful, and a group of things around Bruce Conner. Not only in front of the old Conner's Gym over on Santa Monica Boulevard, but with bathing beauties and so on. Tell a little story behind some of those great images and how you got them put together.

HOPPER: Bruce Conner was a very important artist in my life because he made the best experimental films – well, he made the best short films that I've still ever seen. And they include a lot of my editing thoughts and editing direction in *Easy Rider.* A lot of those ideas came out of what I saw in Bruce's work.

HOPKINS: In fact, Conner is one of the great collage-assemblage artists along with Wallace Berman and Edward Kienholz in L. A., but Conner was mostly in northern California, in San Francisco. In addition to doing his collage-assemblages, his films were that same thing, as a matter of fact, because he would go out and buy stock footage of a collapsing bridge, of car crashes, of this or that, of various things. And he would never shoot anything of his own. He was always using that stock footage and then compositing it, cutting it, editing it into a film that might be five, six, seven, eight minutes long. And they are brilliant. There's no question about that.

HOPPER: The girls in the picture are Teri Garr, Toni Basil, Fran, and Karen, I can't remember Fran and Karen's last names, but it was a while ago. They were all dancers on a dance program called *Hullabaloo,* where they all danced in cages and so on. And Bruce came down from San Francisco for this show at Brandeis University, and he got all the girls together and said, "We're going to do photographs because I need a poster." And there was a gym down on Santa Monica called Bruce Conner's Gym, Physical Services, which had nothing to do with him, which had departments for men and women. And so I took photographs and had them all posing outside. We went out and spent a day just laying around, taking photographs. There is also a photo of Bruce with the puzzle all over his face. This is in Jim Elliott's apartment over the merry-go-round in Santa Monica. Jim was one of the curators at the L. A. County Museum and we went up into that place over the merry-go-round and did the movie with Toni Basil. What was it called?

HOPKINS: *Break.*

HOPPER: Thank you, yeah. We shot *Break* up there and Stockwell held the lights and that's where I did the shot of Stockwell with an egg on his face. It was all done that day. And then Bruce decided to put the puzzle over his face.

HOPKINS: Well, in fact, the old merry-go-round building on the Santa Monica pier was very much a part of the late 1950s and the early 1960s. The merry-go-round ran every night until ten o'clock and then they would turn it off. Ringing the top of it were apartments, which you could rent for $150 a month, $200 a

month, what have you. Jim Elliott had the best one, as a matter of fact, which is the one with the big kind of gothic windows up on the corner as you walk out to the pier. And, as a curator at the county museum, he was a person who liked to entertain, and every weekend we would go down there and have split pea soup with sausages in it and beer and wine and some of the great people in the art world were there all the time. In fact, the photograph of Claes Oldenburg which Dennis took with those little white pieces of cake underneath his feet, that was Jim Elliott's wedding. And he and Claes went to the Santa Monica pier where they made these things out of plaster of Paris and had them cast. He made sixteen total cakes, sixteen different pieces.

So, wedding guests got a slice of Oldenburg's cake stamped on the bottom, "This Belongs To Oldenburg," and there's a photograph of Robert Rauschenberg in his beautiful youthfulness with his tongue hanging out, and I didn't notice until tonight, Dennis pointed out, that Claes Oldenburg stamped his tongue saying, "This is the Property of Claes Oldenburg."

HOPPER: Well, it was a great day as I remember. I think Michael McClure[12] married them?

HOPKINS: That's right.

HOPPER: Michael McClure and Bruce Conner and Billy Al Bengston and myself are all from Kansas, which is bizarre, and Stan Brakhage[13] is also from Kansas. We were all at one time called the Wichita School. I never was in Wichita and neither was Billy Al Bengston. We were both from Dodge City, Kansas.

HOPKINS: So, then there are also images of early art events here in L. A.: the Rauschenberg Dance Company, and then also the Allan Kaprow ice palace piece, the Claes Oldenburg parking lot piece … those were all among the very first Happenings, weren't they?[14]

HOPPER: It was the beginnings of Happenings. Actually, Allan coined the word, I think, Happening. He saw Jackson Pollock and said, "It's not only coming off the wall, he's painting with gravity and it's directing us into the room. We must now make the room an environment." Pasadena Museum funded what I call the ice palaces, which Allan doesn't like at all, but the ice rectangles. I think we built about five of them in various locations around town and they were magnificent looking. They stayed for maybe a day and a half and then they melted. But it was a great concept to me. And a cop came along and wanted to know if we had permits. Actually, we did have permits, and he said, "Well, it's getting dark out here. Maybe this'll help ya." And he threw a couple of flares in the middle of this ice rectangle and it suddenly glowed. And Allan said, "That's a great idea. Let's get a bunch of those and let's start lighting them." So, after we finished the rectangles, we threw flares in them and they'd glow all night. Really, really beautiful. It was wonderful. And a lot of work, man. Kaprow was always intense on everybody working hard. These Happenings were not necessarily fun but you sure were buddies by the end.

HOPKINS: There are also some wonderful photographs of Irving Blum and the artists around the Ferus Gallery. Did you know those guys well, and were they close to you?

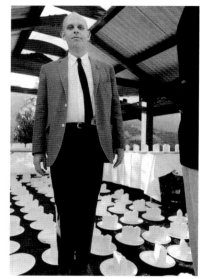

Claes Oldenburg (portrait with cake slices), 1966, gelatin silver print © Dennis Hopper

12 Michael McClure (b. 1932), poet, essayist, and playwright.
13 Stan Brakhage (b. 1933), experimental filmmaker.
14 *Pelican* (1966), Rauschenberg Dance Company; *Fluids* (1964), Allan Kaprow; and *Autobodys* (1964), Claes Oldenburg.

HOPPER: That was the gallery to be at and that was where everybody wanted to do a show. Yeah, I was both with Walter and Irving. I knew Walter, actually, before Irving came out from New York. Walter Hopps told me that he formed the Ferus Gallery with Ed Kienholz over a stale hot dog at *Pink's*.[15] And then they couldn't do any business, and then Irving came out from Knoll. He was one of the guys running Knoll Furniture in New York and he came out and Kienholz wanted out, so I think Walter bought Kienholz out and then hired Irving. I think Irving was getting $32 a month, and maybe a commission or two.

HOPKINS: Well, actually, he was doing better than that. He was actually making $300 a month. That was a lot of money for all of us, but I'm not sure he ever got paid, as a matter of fact. There are also these wonderful photographs of Andy Warhol, and one of the great true L. A. apocryphal stories has to do with the fact that Irving Blum was one of the first people to recognize Andy Warhol. He and Leo Castelli, the great New York dealer, went to Warhol's studio and Lichtenstein's studio. This was when Abstract Expressionism was still the rage. And suddenly, here are these guys doing cartoons. Now, what does that mean? Tipping the whole art world into a different arena altogether. And so it was agreed that Irving went back then after Leo had been there and talked to Andy and said, "I would like to do an exhibition of your work in L. A. at the Ferus Gallery and I'd like to work out this thing," and Andy had just painted thirty-one little *Campbell's Soup Cans,* all the different brands of Campbell's soup in existence. So Andy agreed to the exhibition and Irving agreed to buy them, the whole group of them for $1,500. You paid $75. You paid a high rate for your painting.

HOPPER: Irving sold them for $100, so I got a good deal. Because I got mine from John Weber for $75. But he sold two. He sold one to Betty Asher and one to Don Factor. And then he decided that was a bad idea and he bought them all for $25.

HOPKINS: Thirty-one varieties. And he bought the two back from the people he sold them to, so he had the full set, and now, I think, the last estimate was, what, thirty or forty million dollars, I think, for the set?

HOPPER: Well, I think he sold them for seventeen million.

HOPKINS: Pretty good profit. We don't worry about Irving too much from that point of view. Tell us a little bit about Andy and your association with Andy. He was a person who didn't spend a lot of time in L. A. Rauschenberg, Jasper Johns, all of that group found work at Gemini and did prints and things, but Andy never did do that. Were you familiar with him during his film work? Did you have any influence on him? Did he have any influence on you?

HOPPER: Well, I met Andy before the soup can show. And I was in the first movie he made, *Tarzan and Jane Revisited.* I call it *Revisited,* but I think it's *Regained.*[16] Patty Oldenburg was in it. And I was in it. We shot it down in Venice, California. Down in the canals. At that time, the canals were really ratty, too. And we climbed a lot of trees. It was totally ridiculous. I took my shirt and beat on it. I mean, I don't know. It was totally ridiculous. No, I never took any of Andy's films seriously and Andy behaved like a man who had

15 Pink's hot dog stand is a legendary landmark in L. A.
16 Andy Warhol, *Tarzan and Jane Regained … Sort of* (1963).

invented the camera, like Thomas Edison. He set it up and walked away and if something happened, great, and if it didn't, he would sit you down and that was it. And he would go away and paint or rub his finger in some paint. Most of the conversations I had with Andy, which were quite a few, he would go, "Oh. Oh. Oh. Oh? Oh."

HOPKINS: The great communicator.

HOPPER: "Oh." So, that was about all I got. But we spent a lot of time together and we really liked each other. That's all I know. I remember the first time I came into the Ferus Gallery and I was out in the back looking around and I saw the bronze light bulb of Jasper Johns. I saw the bronze paint cans with the paint brushes in it and I said, "Wow, who's this?" And I can't remember whether it was Irving or Walter, who said, "That's Jasper Johns." And I said, "Wow, that's incredible." Then everybody was talking about the return to reality. What was the return to reality going to be out of Abstract Expressionism? Because now we're second and third generation Abstract Expressionists, and everybody's saying, "Where's the return to reality?" And in the beginning that was the Bay Area figurative painters. Everybody said, "Look, that's Nathan Oliveira,[17] that's Richard Diebenkorn, David Park, Elmer Bischoff,"[18] and so on. And I looked at that and said, "This isn't a return to reality, this is the return to Chaim Soutine,[19] this is taking Abstract Expressionism and going back to its beginnings." So, when I was shown these big cartoons by, I think it was either Walter or Irving, I get them confused at this point, but maybe it was Irving, because we got on a plane the next day.

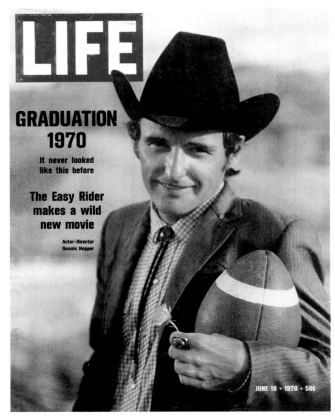

Dennis Hopper on the cover of *Life,* June 1970
© Life

HOPKINS: Probably Irving.

HOPPER: He showed me some soup can things and he showed me these big cartoons and said, "What do you think?" And I went, "My God, that's the return to reality." And he said, "Let's get on a plane." We went to New York the next day, visited Andy and went to Roy's studio and so on. Well, you saw the big paintings there in his studio, at that time, they were all his early masterpieces.

HOPKINS: That's true.

HOPPER: This is 1962, beginning of '62, maybe '61. Yeah, I think it's the beginning of '62, really.[20] And that was when I first got involved.

HOPKINS: We've been chatting here for a little while. There are things you'd like to know about Dennis, you'd like Dennis to talk to you about, so let's open it up to questions and let's get a little back and forth going here. Who wants to jump in?

AUDIENCE: I brought this copy of *Life* magazine along with me because I thought it was interesting that you were featured in it but also that there was an article on Joe Cocker.

17 Nathan Oliveira (b. 1928), painter who was instrumental in the revival of figurative painting.
18 Elmer Bischoff (1916–91), painter, who was associated with the School of Realist Expressionists other exponents of which were David Park (1911–60) and Richard Diebenkorn (1922–93).
19 Chaim Soutine (1894–1943), French expressionist painter.
20 According to Andy Warhol, they first met through Henry Geldzahler a few months before the Ferus Gallery opened *An Exhibition by Andy Warhol* (1963). See p. 117.

HOPPER: That was such a thrill for me to see the cover of that. To see I'm on the cover of *Life* magazine, holding a flower and a football, and then I open the magazine and I read the first paragraph.[21] The first paragraph sent me into the bed for three days. I mean, unbelievable. The first paragraph is unbelievable.

HOPKINS: That's in *Easy Rider* days, right?

HOPPER: This is *The Last Movie.* This is assassination time.

Can I read that? The first paragraph? This is a wonderful thing, man, to have your family see this. Is that America? There you are, right? 1970, right? Hey, I'm pretty proud. I'm just about to win the Venice Film Festival and never be distributed. How weird. This is the first paragraph: "Peru has painfully learned to live with earthquakes, avalanches, tidal waves, jaguars and poisonous snakes. But Dennis Hopper was something else. When the director of *Easy Rider* arrived in Lima several months ago, a reporter from *La Prensa* asked his opinion of marijuana (illegal in Peru) and 'homosexualism.' Taking a long reflective pull on an odd-looking cigarette, Dennis said he thought everybody should 'do his thing' and then allowed that he himself had lived with a lesbian and found it 'groovy.' No remotely comparable statement had ever appeared in a Peruvian newspaper. The clergy screamed, the ruling junta's colonels howled. Within 24 hours the government denounced the article and issued a decree repealing freedom of the press." This is the second paragraph: "Dennis Hopper was undisturbed. Furor trails him like a pet anaconda. At 34, he is known in Hollywood as a sullen renegade who talks revolution, settles arguments with karate, goes to bed with groups and has taken trips on everything you can swallow or shoot." Now, okay, this is really naïve. I had never shot drugs. And that mere word, "shoot," sent me into the biggest depression of my life, probably. It lasted three days. And I haven't been depressed since. Wow, I mean why wouldn't I sue them and so on? They said, "Hey, it's third person." Third person? Who's this third person, anyway? Anyway, it's good to see it. Haven't seen it for quite a while. It's a big article. Thank you.

AUDIENCE: What are your musical influences?

HOPPER: Well, on *Easy Rider,* when I was editing the film, which I did for a year, I got all the music in there when I was listening on the radio. It was all found music. And that was the first time found music was ever put into a film. So, *God Damn, the Pusher Man,* and *Born to Be Wild,* and all those things were coming right off the radio as I was going to work. And I was saying, "Wow, that's great." And I didn't edit to music because Orson Welles had told me once, "Editing is about picking the best shots. Picking the best shots and putting them together." And that sounded right to me. I was into the concept that light travels a lot faster than sound. And so, recording light is really more important than the sound. But then the sound becomes the reinforcement of the light. Also, I had the idea that I wanted to leave found music. I wanted to be the first person to leave a real found music score. Everything until that time, you wrote a big score for, and that was it. My influence at that time was rock and roll. But I'm really from jazz. I'm from Abstract Expressionism and jazz. That's my roots, and I'll never leave that. I like all music. I like classical music, I like opera. I like it all. I really do. Yodeling I'm trying to get used to. But, hey, I may get there. Yodeling is a little weird, you know?

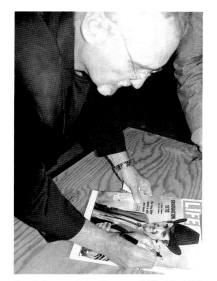

Dennis Hopper signing the cover of *Life* at the MAK Center, L. A. © Joshua White

AUDIENCE: Did you have a chance to photograph any of your musical influences?

HOPPER: Yeah, I did a few. I shot Miles Davis. Miles was a very good friend of mine. And I had the privilege of working with him just before he died, so that was cool. We made an album together.

AUDIENCE: How did the idea for *Double Standard* come about?

HOPPER: *Double Standard?* I believe that I was with Henry Geldzahler [22] that day and we were driving down the street, at the corner of Doheny and Melrose or Melrose and Santa Monica. I like the idea of the *Double Standard* and also I liked the billboard. I liked the idea that the Route 66 sign was there, and it was just something I'd put off taking for a while. I drive so much in L. A., and I'm such a visual person, I just sort of collect things that I want to do, want to make. And I may or may not do them, I may or may not execute them, but that was one of those things. This was 1961, and that was one of those things that I wanted to do for a while and I just thought it would be the right moment. And then later I'm not sure whether it was Irving or Walter Hopps that picked it. But it was Ed Ruscha's announcement for his second show, which he had *Standard Station* paintings in. I actually purchased one for $780. I had a ten foot *Standard Station* painting which now is at Dartmouth University.

AUDIENCE: How did you select the music for *Colors?*

HOPPER: Oh yeah, right, thank you. With *Colors* I had the first rap gold album. *Colors* was given to me by Sean Penn to make a film out of and it was about gangs in Chicago. There was a white guy named Cowboy who was putting cough medicine out on the street for black gangs, and there was a black cop and a white cop and it was called *Colors.* I read it and said to Sean, "This wouldn't even make a good television show. This is a bad television show. It's terrible, you know?" Sean said, "What do you think would make it good?" And I said, "We make it about L. A. Make it about gangs in L. A.," and so on. And they said, "Are there gangs in L. A.?" And I said, "There are gangs in my alley, I don't know about you. You live in Beverly Hills. I live in Venice." So, out of that, I started hearing people walking by with boxes, and I said, "What is that music coming out of those boxes?" And they said, "That's rap." And I said, "Rap. What's that?" So, I started going to concerts and seeing Salt 'n' Pepa and by collecting that and doing that film and putting the music in, I had the first rap million-album seller.

AUDIENCE: What are your thoughts on digital photography?

HOPPER: Well, I think that if you can get what I call "wet photography" that you like, you should collect it right now, because it's going to be passé. Digital photography is here. It's a great thing and it's a revolution also for the motion pictures. I guess you can't call it film any more; you have to call them movies. But, digital … it's a miracle. You don't need lights. You can shoot in natural light, so it just cuts down on your labor force tremendously. And you can really literally go out with a camera person, a sound person and do a movie. For years I've talked about the time of the easel painter becoming a reality. The easel painter being a filmmaker. I've always thought of filmmakers as being chapel builders. We build these incredible chapels.

22 Henry Geldzahler, curator at the Metropolitan Museum of Art in New York.

And we have all these lights and all these technicians. And all this will very soon be gone and antiquated. Just like there's nobody who can paint the Sistine Chapel anymore, nobody can lay the tiles, nobody can do the frescos. But at one time, you had an industry that did that. So we have an industry that does these incredible things with all of these people and all this machinery all this light and all this stuff. It's gone. Digital is here, and it's wonderful. So, the only thing with digital is, it flattens out, which I happen to prefer. You can hold depth of field, you can hold this in focus, and you can hold all that, but you have a flatness of distance. You can't really perceive distance between one thing or another. And you have a fast movement across here; you get a blur. But all that, that's a matter of time. And even if it never happens, it's a much more interesting color saturation, a much more interesting process. I can say, "I'm going to set up here, and it's there," and I can go and say, "Put the camera there," and it's there, and I don't have to have thirty people do that and wait an hour and a half for that transaction. That's a miracle. Not only that, I don't need anybody but the cameraman and myself. Or, if I want to, I can be the cameraman and the soundman. I can be it all, really. I just wouldn't be able to act in it and that would be sort of a drag for me. But it's a miracle and it's a wonderful thing and it's going to change everything. And it'll change things for the better, too. All these things that minimize labor are scary to everybody in the beginning. But digital film gives an opportunity to people. Millions and millions of dollars it costs for anybody to prove themselves as a director. Now, everybody has the possibility of going out and doing a project that they want to. They can afford to do it. And all they have to do is think of it and treat it in a realistic way, the way you would, I mean, in my world, the way I would treat a 35 mm or a big Panavision camera. You just treat it with that kind of thinking and that kind of thought. You can do whatever you want with it, and cheaply. And so it allows everybody to be able to make their movies. And that's a miracle.

AUDIENCE: What was the role of women artists in the L. A. scene?

HOPKINS: We've talked a lot about Ferus Gallery, but Dennis and I were reminiscing a little earlier. We were talking about an unusual gallery that doesn't get its proper credit, which is the Everett Ellin Gallery which was up on Sunset Boulevard and was a gallery which first showed Jasper Johns in L. A. and showed some of the Europeans. In fact, he showed Nikki de Saint Phalle and Jean Tinguely, the great Swiss artist, the great mechanical artist. Nikki de Saint Phalle did a performance here in 1963, and there are photographs documenting it. Her works were assemblages with baby rubber dolls attached to the surface of a canvas and all painted white, and then the dolls were filled with red, yellow, and blue pigment. Nikki put on a white aviatrix uniform with a hat and the goggles, and with a 22 rifle stood up on Sunset Boulevard and shot across into her pieces. And then, as she shot them, and the baby dolls were hit, this red, blue, and yellow pigment would pour out. It was one of the great Happening events in L. A.

HOPPER: And then, right after that, Jean Tinguely went to Las Vegas and he placed all this explosives in the middle of the desert and videoed it. They showed it live in Vegas blowing up all this sand.

HOPKINS: You're asking about women artists and obviously that was a big issue, because L. A. was thought of as being kind of a macho gang. But, there were really a number of artists working right along with the

guys, like Billy Al Bengston, and Kienholz. Probably the one who was toughest was Judy Chicago, at that time Judy Gerowitz, and a graduate from U.C.L.A. who began her work the very day she got out of school. She began to fight the feminist cause and put down the macho sensibility that seemed to dominate the area. And you may remember a photograph in *Artforum* magazine, at about the same period of time we're talking about, of Judy standing at the corner in her boxing trunks, her boxing gloves, in the boxing ring taking on the macho pose. It's just the continuation of that whole thing.

AUDIENCE: What are your film influences?

HOPPER: I was working in Hollywood films, but I was really appreciating European films. They were my influences. So, they were mostly in black and white because it was too expensive to shoot in color at that time. And it was cheaper to shoot in black and white. Today, it's more expensive to shoot in black and white than it is in color. It all depends upon what your market is. So, it wasn't really price, but it was about the idea that I thought that if you shot color, you wouldn't be able to have content, that you would be too easily drawn into just doing color for color's sake. And especially if I was doing what I really like, which were my abstract reality things, that you had to have content. It wasn't just about color; it was about content. I still feel that. And I do color now. But I don't do it because it's a color, I do it because I have some sense of what I think is content. That content changes, because it becomes more minimal and more minimal until it's practically invisible. And it's not a color feel to me. So, it looks like a color feel, but that's not what it's about to me. I don't know how to explain that. I mean, content is what we can't see anymore. In other words, shooting this wall, you just see a stain on it. That still has content to me. I don't know how to explain it.

AUDIENCE: Was New Wave cinema an influence on your work?

HOPPER: Well, the New Wave, I saw just the tale-end of. My favorite director was Luis Buñuel, so he was really a big influence on me. I talked about *Realm of the Senses,* but that was much later. Jean-Luc Godard was not an influence on me, but François Truffaut was. Godard was full of theories and I didn't like his films, but Truffaut was a great filmmaker. They started out together. You know, Truffaut wrote *Breathless,* which is the only film I like of Godard's, very honestly. But I just love Truffaut's movies, I think they're just incredible. I mean, the beginning of *Day For Night* is wonderful. And it's a very similar idea to *The Last Movie,* but they're totally different kind of films. When I first saw *Day For Night,* and it started out and you had the whole city looking at this street, and the woman walking with the poodle and so on, and I thought, "My God. Only in France could you shoot something like this. Look at the street. Look how great this looks, and it's snowing. Look at that. This is magnificent." And suddenly they say, "Cut!" and everything goes back to the first beginning. I went, "Wow." I saw it later that night because it was at the opening of the New York Film Festival and I had already made *The Last Movie* some years before. It was very interesting.

AUDIENCE: How do you approach photography? Would you just spontaneously snap a picture?

HOPPER: I'm a very nervous photographer. My proof sheets are a mess, man. I shoot a lot of things just because I got the camera. So I shoot a lot of crap. And then I'll focus in on something and see something

that's a picture to me, and I'll try to take it without disturbing it and changing it. Or I take somebody somewhere and carouse them into having a photograph. I take them to a place or a location because generally I find that even if it's a bad photograph of a person, the place looks interesting and the person looks better. But, that's about it. It's difficult. I'm a very shy person and so for many years the camera was a great way for me to keep people afar. I was busy taking a picture, so I didn't have to deal with them. So, it was partly that, and partly that I didn't want to disturb people, so I never forced my camera on somebody and lost a lot of pictures in my mind. Things that I really should have taken. So, when I really did cover something, I had everybody in a very relaxed kind of mood or I was just documenting it. That's about it. I'm very concerned about formal aspects of photography in my compositions. I like to keep my lines together. I like to keep it very formal and very straight. A snapshot to me is not interesting, it's not interesting on any level, really, and never will be.

AUDIENCE: Do you have American influences in film and please explain the character reversal in the last scene of *Easy Rider.*

HOPPER: I certainly do. John Ford, John Huston, Howard Hawks. I worked with a lot of greats. George Stevens, I worked with. Nick Ray, I worked with. Henry Hathaway, I worked with. John Sturges, David Lynch, and Francis Ford Coppola. I worked with a lot of great directors through the years.

My character in *Easy Rider* goes into, "What do you mean, man? Like, we're going to be rich, man. Like, you know, we're going to retire in Florida, man. Isn't that what it's all about, man?" And, "You know what freedom is, man?" And he says, "No, we blew it, man, we blew it." Okay. That was something I wrote and that I wanted to be in the movie, but Peter didn't want to do it. He didn't understand what it meant, and what it was about and so on, and it's still real obvious to me. First of all, I wanted him to say what I was saying, which he refused to do. So, I thought, okay, I've got to say all this crap, which Captain America should be saying. He should be saying, "We're fucking criminals, man, and we're losing our freedom and we don't have a fucking clue, man, how to keep it. And everything we've done is wrong, man. We're criminals and we're in a criminal society, man, and as long as we glorify our criminals, we blew it." Now, he didn't say that. So, I had to reverse that and make myself say that and then him say, "We blew it. No, man, we blew it." But that's the way creating is: creating's an accident. You have to learn to use that accident and make it work for you. And that's what creating is. Business is something else. It's not about anything else. Because you cannot have a pre-conceived idea to create anything. There's no way you can do that. If you have a pre-conceived idea, you're a first-degree murderer. And you're not a creative person. And that's the end of it. That's the bottom line, yeah.

HOPKINS: A great place to end.

Peter Frank

DENNIS HOPPER AND THE 1960s ART SCENE IN LOS ANGELES

When Dennis Hopper moved back to Los Angeles in 1961, the town he returned to was not all that much different than the one he had left. He had been based in New York for only five years, after all, and even in a city as notoriously transient as L. A., four or five years could not see that much change. Or could they? These were boom years, after all, and L. A. was undergoing its biggest transformation, in population, economy, and building construction (and design), since the war years, or even before. The most marked changes at the time, however, were being felt in the cultural life of the city.

The Los Angeles Hopper left in early 1957 was essentially a conservative southern-midwest metropolis transplanted to the Pacific shore and spiced with some residual Latin flavor and the constant influx and efflux of those involved in the movie business. The fine arts, even more than the lively ones, were just barely considered necessities, and, in the wake of the McCarthy era, were regarded more with suspicion than with

admiration. Despite the city's excellent art schools and plentiful employment in Hollywood for the visually skilled, the Los Angeles of 1957 was not especially fruitful territory for the serious fine artist.

Perhaps it was their influx and efflux that rendered movie people by and large a far less significant source of patronage than one might expect. Or perhaps it was the commercial nature of their industry, attracting as it did far fewer "cultured" individuals than did its equivalents abroad – or, for that matter, than it had in the 1930s, when European artists and intellectuals fleeing Hitler gravitated to Hollywood in search of employment. For the most part the transplants fared poorly, unable to subject their artistic visions and personalities to the lowest common denominator demands and expectations of the studio system. They provided moral and intellectual support for one another, but with the war's end, they moved back to Europe, relocated to New York, or stayed in L. A. and simply used it as a base for their own activity, publishing, performing, and lecturing elsewhere.

These were the conditions in 1957, and they were still the conditions predominant in 1961; but by then, the change – profound change – was beginning. A new generation of locally educated artists, many funded by the GI Bill, had begun to emerge from the art schools and (relatively new) university art departments. A new source of patronage, the aerospace industry, had kicked into high gear in the region. A new generation of curators and educators was starting to enliven the local discourse. And, of course, the spirit of the country as a whole had begun its transformation, from the "meat and potatoes organization man" mentality of the postwar decade to the "better things in life" outlook that began to emerge in the later 1950s. How much the end of the McCarthy era had to do with this emergence is debatable, but another political phenomenon, the election of John F. Kennedy in 1960 and the installation of a culturally sophisticated First Family in the White House, inarguably provided a moral boost to artists and their audience and encouraged others to join that audience – and even to become artists.

The seeds of the American cultural revolution sprouted in the early 1960s. They were planted in the middle 1950s, even in the "cultural wasteland" of L. A., around the time Dennis Hopper arrived. Hopper came to L. A. to work in films, but even then he thought of himself as a visual artist as much as a thespian.[1] Through stage acting in San Diego, Hopper met Mary Price, wife of Vincent Price, who was not only a prominent film actor, but also one of southern California's most active and forward-looking art collectors. Once relocated to L. A. Hopper began frequenting the Prices' house, using their kiln, viewing their collection, and meeting established artists such as William Brice and Emerson Woelffer. Hopper took particular notice of Woelffer's and Richard Diebenkorn's non-objective paintings hanging on the Prices' walls, and turned, himself, to abstraction.[2]

Hopper met more artists and art people at another, very different meeting place. The Stone Brothers printshop[3] in West Los Angeles had become an impromptu site for poetry readings and other artist-friendly events – events that constituted the beginnings of the Beat movement in L. A. Brought to Stone Brothers by fellow actor-artist Dean Stockwell, Hopper met several of the young artists whose adventurous styles and rebellious spirits would usher in the 1960s – Wallace Berman, Edward Kienholz, George Herms – and also met Walter Hopps, the young critic-curator-impresario who galvanized and championed them.

Before long the Stone Brothers circle had created a showcase for themselves, the Ferus Gallery, and

1 Hopper had taken art classes in Kansas City, at the Nelson Art Institute, while living there between the ages of nine and thirteen. He took art and drama classes in high school in La Mesa, outside San Diego – and, when he was thrown out of both classes (although not out of school altogether) in his senior year, he completed them via correspondence courses offered by the University of California, Berkeley.

2 He also appreciated the examples of New York Abstract Expressionism – Jackson Pollock, Franz Kline – in the Price collection, but the California painters were more impressively represented.

3 Stone Brothers Printing was founded by Walter Hopps, Wallace Berman, and Robert Alexander in 1956. It soon became a center for artists, poets, and writers and visitors included Dennis Hopper, James Dean, Harry Dean Stanton, and Craig Kauffman.

were causing a local stir with their exhibitions of provocative painting, sculpture, and assemblage – provocative enough to bring about at least one police raid and exhibition closing. The Huysman Gallery across La Cienega Boulevard enjoyed (if that is the right word) similar notoriety. Established by Henry T. Hopkins,[4] another young educator and champion of new art, the Huysman ultimately proved too audacious for its own good, and had to close its doors around 1961. The Ferus endured, becoming a locus for Pop Art in Los Angeles.

For the most part, Hopper was not around to witness these provocations and tribulations. He had gone through his own confrontations in the movie industry; ultimately, he was deemed more or less unemployable. Hopper took advantage of this forced freedom to move to New York in order to study at the Lee Strasberg Institute and to immerse himself in visual art. Interestingly, Hopper met no artists in New York, but he did frequent the city's museums, in particular, the Museum of Modern Art.[5]

Hopper's stay in New York may have been a self-imposed exile from Hollywood, but not from L. A.. He went back and forth, a pre-jet example of bicoastalism, and, although he may have missed some of their finer (and more dramatic) moments, he maintained his contacts with his friends in the L. A. art world. It was with them that he resumed social and intellectual contact when he came back for good.[6] He expected to paint and do collages and assemblages like his friends, but fate would prevent him and, ironically, thrust him even more centrally into the artistic milieu of 1960s L. A.

With his new wife, actress Brooke Hayward, Hopper moved into a house in the woodsy Bel Air section of West Los Angeles. He moved in his several hundred artworks and set about creating a studio for himself. He was also doing more and more photography, an art form he had taken up in New York. He was invited to exhibit his photographs at Barry Feinstein's photo studio in West Hollywood, so he brought his entire collection of negatives to the studio to make selections and print them. The night of the exhibition opening, the Hoppers' house burned to the ground in the Bel Air fire. Being at the Feinstein studio, his photographic work was spared as, for that matter, were he and Hayward. But his entire oeuvre in all other media was lost.

In the wake of this trauma Hopper did not paint again for over twenty years. But, as if taking it as a sign, Hopper fully immersed himself in photography. He subsequently created three-dimensional works, but in the L. A. art world he took on the role of chronicler. Hopper's black and white photographs captured an era of effervescent excitement, an era that delighted in experimentation and experimented with delight. While not training his lens exclusively on the art world[7] – and not L. A.'s only art-world photographer[8] – Hopper was able to get particularly close to artists and the leading members of their audience, thanks to his established and newly-minted friendships, as well as to his filmic associations. Indeed, his movie experience and his growing ambitions to be a director as well as actor informed his camerawork.[9] His subjects, in the art world and out, recognized and valued what Hopper was doing (although they gently teased him about his ever-present camera, calling him "tourist").

It is important to stress that Hopper's artist pals, and most of his cinema colleagues as well, recognized and valued what he was doing not only as a record of what they were doing, but as artistic activity equivalent to what they were doing. As a photographer, Hopper moved and worked among coevals. This allowed him

4 Hopper took one of his first art appreciation classes from Hopkins at U.C.L.A. around 1960.

5 He claims he visited MOMA "every day" (often doing his Strasbergian sense-memory exercises in the museum garden) and notes that the chronological organization of its collection – which, of course, is the signal collection of modern art in the world – provided him with his real grounding in modern art. Hopper also tells of sitting frequently across the street from the Guggenheim Museum, watching the building in construction. One day, an older gentleman came over from the museum, stated that he'd seen Hopper often sitting there, and asked him what he was doing. When Hopper replied that he was watching the building go up and that he really liked it, Frank Lloyd Wright thanked him and, without otherwise introducing himself, returned across the street.

6 1961 is given as the date of Hopper's "return," but he says that by then he was already living part-time in L. A. (at the Chateau Marmont) and part-time in New York. Newly married, with new ideas for film directing as well as acting, and with Hollywood re-employment increasingly likely, Hopper simply decided to stop paying rent in New York (where he'd lived in a different apartment each year) and settle down.

7 Hopper documented the whole social and artistic ferment of 1960s America with his camera, from civil rights marches in Alabama in 1963 to be-ins with Allen Ginsberg in 1967, from candid shots of his generation of Hollywood actors to lively group portraits of some of the era's best-known rock bands. His images of artists at work (and play) are of a piece, in form and in spirit, with these other documentations.

8 Donald Brittin, for one, also documented the 1960s L. A. art scene from the inside, with great empathy and affection.

9 It was his mentor James Dean who in the mid-1950s first urged Hopper to take up photography as a way of understanding how the movie camera framed its subjects. Dean also told Hopper that, as an actor, he should maintain and cultivate an interest in the other arts.

not only to access some of the epoch's most influential figures and momentous occurrences, but to engage crucially and integrally with these figures and in these occurrences. These are not the photographs of an eyewitness documentarian, but of a participating artist.

Elsewhere in this catalog George Herms writes, "The camera released artists from the role of 'recording secretary'." Herms also notes that "[t]he camera can interfere with the flow of life … people begin to pose … The photographs of Dennis Hopper address this problem."[10] This observation explains why, to this day, Hopper is uncomfortable with the thought of his photographs "documenting" the 1960s. Clearly, they do record the events and the people of the decade that were most responsible for making it the seminal era, the social and cultural turning point, it was. But, just as clearly, Hopper's approach to his subject matter and his medium was (and remains) informed as much by the desire to make an engaging picture as to capture a significant moment or personage. Hopper was aware of the journalistic imperative in wielding a camera; but, as a painter, an actor, and a budding filmmaker – as someone, that is, who approached the lens from many functional and conceptual angles – he was keenly aware of what else a camera could do, and of what else he wanted it to do. When Michael McClure calls Hopper's politics a "politics of doing, feeling, being, marching, striding,"[11] the poet is identifying the immediacy of the photographic experience and the experience being photographed – the collapse, or at least the telescoping, of the distance between the photographer and the photographed.

Hopper's photographs from the 1960s so often convey a "right in the middle" point of view, close up to their subjects, obliquely angled, zooming in not on a "subject" but on a moment or series of moments. Some of those moments are posed, even staged, others are fleeting and candid; some of those images are of people, others are of places, still others of situations and events, and still others of pure images found in quotidian reality and framed by the camera eye into abstraction and/or the ground-zero semiotics encouraged, even dictated, by the Pop sensibility. Many of Hopper's photographs have a "painterliness" to them that bespeaks his roots in Abstract Expressionism. More importantly, most of his works from this period display an insouciant forthrightness, a preference for clever, even witty, but uncomplicated composition and evident (if often light-hearted) drama, that reflects the urgently upbeat Pop ethos.

Hopper was living that Pop ethos, not simply as an artist straddling Hollywood and the art world, but as a creative individual able to fashion his daily life according to an overarching aesthetic. After the 1961 fire destroyed their first residence in L. A., Hopper and Hayward eventually moved into a house on North Crescent Heights Boulevard in West Hollywood – just below Laurel Canyon, on the edge of the Sunset Strip, which had emerged as the locus for Los Angeles' hip counterculture.[12] They decorated the house with the vibrant artworks they were acquiring from their friends and acquaintances on both coasts (and, eventually, Europe), and surrounded these bright canvases and bumptious sculptures with equally sprightly decor – playful artifacts, incongruous objects found in the street, decorative stained glass windows and the like. Andy Warhol recalled that the Hopper house

was furnished like an amusement park – the kind of whimsical carnival place you'd expect to find bubble-gum machines in. There were circus posters and movie props and red lacquered furniture and shellacked collages. This was before things got bright and colorful everywhere, and it was the first whole house most of us had ever been to that had this kiddie-party atmosphere.[13]

10 See p. 129.
11 Michael McClure, in *Dennis Hopper: Out of the Sixties* (Pasadena: Twelvetrees Press, 1986). McClure also notes Hopper's closeness to his subjects when he writes, "I guess this is Hollywood, not the raw gutty underside or the glitter of tinsel, but the invisible Hollywood known only to those who inhabit it or have inhabited it."
12 Hopper remembers that there were several very active jazz joints along the Strip in the 1950s (benefiting from stringent anti-drug blacklisting among New York jazz clubs); while not as numerous or forward-looking by the early 1960s, these clubs set the tone along Sunset Boulevard, so that Beat-style coffeehouses such as the Unicorn and the earliest discotheques could comfortably establish themselves there.
13 See pp. 117–118.

Warhol was, of course, made to feel all the more welcome by the presence of his own artwork amid the festive colors and spirited detritus. He could not have helped but recognize that he was included in one of the most important early collections of American Pop. By 1963 Hopper and Hayward's collection included work by New York artists and L. A. artists in equal measure, pairing paintings by Edward Ruscha and Billy Al Bengston (as well as David Hockney, not yet relocated from London) and assemblages by Herms, Kienholz, Berman, and Hopper's San Francisco-based friend Bruce Conner — as well as Hopper himself — with acrylics, drawings, and objects by Robert Rauschenberg, Jasper Johns, James Rosenquist, Roy Lichtenstein, Claes Oldenburg, and Frank Stella (whose work was understandably viewed as a kind of "Pop abstraction"), as well as Warhol. Notably, Hopper was one of the first collectors to buy one of Warhol's *Campbell's Soup Can* paintings.[14]

Hopper also worked on Warhol's first narrative movie, *Tarzan and Jane Regained … Sort of,* which, fittingly, Warhol made in L. A. "We shot it down in Venice, California," Hopper recalls, "Down in the canals. At that time, the canals were really ratty, too. And we climbed a lot of trees. It was totally ridiculous. I took my shirt and beat on it." [15]

Hopper had not met the New York artists during his Strasberg years, but was introduced to them and their art once he returned to L. A. The introductions were made by his old friend Walter Hopps and his new friend Irving Blum, who was working with Hopps at the Ferus Gallery by 1961. "I remember the first time I came into the Ferus Gallery, " Hopper recounts,

> and I was out in the back looking around and I saw the bronze light bulb of Jasper Johns. I saw the bronze paint cans with the paint brushes in it and I said, "Wow, who's this?" And I can't remember whether it was Irving or Walter, who said, "That's Jasper Johns." And I said, "Wow, that's incredible." Then everybody was talking about the return to reality. What was the return to reality going to be out of Abstract Expressionism? Because now we're second and third generation Abstract Expressionists, and everybody's saying, "Where's the return to reality?" And in the beginning that was the Bay Area figurative painters. Everybody said, "Look, that's Nathan Oliveira, that's Richard Diebenkorn, David Park, Elmer Bischoff," and so on. And I looked at that and said, "This isn't a return to reality, this is a return to Chaim Soutine …" He [Irving Blum] showed me some soup can things and he showed me these big cartoons and said, "what do you think?" And I went, "My God, that's the return to reality." And he said, "Let's get on a plane." We went to New York the next day and visited Andy and went to Roy's studio and so on. Well, you saw the big paintings there in his studio, at that time, they were all his early masterpieces … This is 1962, beginning of '62 … And that was when I first got involved.[16]

Blum was not L. A.'s only link to Pop Art, much less to New York; he was only its best, a New Yorker who came west and gave the L. A. art scene not just a shot of New York cheek, but a shot of its own more droll and casual glamor.[17] There were other gallerists in L. A. by the early 1960s who were bringing work in from New York, and even Europe-dealers such as Paul Kantor, Everett Ellin,[18] Rolf Nelson, Virginia Dwan, Herbert Palmer, and Felix Landau who identified L. A. as a potential prime site for the burgeoning American cultural explosion. These dealers were joined in their optimism and their missionary zeal by gallerists devoted to more local talents. Although many dealers of all kinds located themselves in Beverly Hills and other West Los Angeles neighborhoods,[19] a gallery scene – L. A.'s first – gradually coalesced on La Cienega Boulevard, mostly north of Melrose Avenue and south of Santa Monica Boulevard. Ferus was already here, as were the Los Angeles Art Association[20] and the Zeitlin and ver Brugge bookstore, among other cultural landmarks, and the most prominent landmark of all, the artist's hangout Barney's Beanery, was around the corner on Santa

14 All the earliest soup can purchasers were Los Angeles-based, as the series was handled by L. A. dealers, including Irving Blum and John Weber. (Although he was close to Blum, it was from Weber that Hopper acquired his soup can.)

15 See p. 29.

16 See p. 30.

17 Craig Krull notes that, "The idea of dressing up (or down), posing in sunglasses, or just clowning around for the camera was, as Peter Alexander suggests, another example of the influence of 'Hollywood and show biz … everyone secretly wanted to be glamorous.' [Donald] Brittin noted that this phenomenon was also concurrent with the arrival of Irving Blum, sometimes dubbed the 'Cary Grant' of L. A.'s art scene." (Craig Krull, "rear view," in *Photographing the L .A. Art Scene, 1955–1975* (Craig Krull Gallery, Santa Monica CA: Smart Art Press, 1996); quotations from interviews conducted in May of 1996.

18 Ellin was responsible for bringing over several of the French *nouveaux réalistes* and their Parisian Pop successors, artists such as Jean Tinguely, Nikki de Saint Phalle, and Martial Rayssse, all of whom Hopper photographed.

19 Dwan, for example, was situated in a quiet corner of Westwood Village, while Ellin was up on Sunset Boulevard, near (but not on) the Strip, and Sylvan Simone, who represented local expressionist painters such as Rico Lebrun, Harold Warshaw, and Connor Everts, sat out on Olympic Boulevard, well on the way to Santa Monica.

20 The LAAA, founded in the early 1930s by vanguard artists of the day (including Lorser Feitelson and Helen Lundeberg), had been virtually the only commercial outlet for local modernists until the late 1950s.

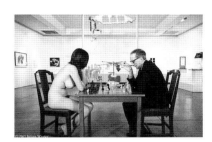

Marcel Duchamp playing chess with a nude woman at Pasadena Art Center, 1963

© 1963 Julian Wasser

Monica. Also briefly on La Cienega, right over Ferus, were the offices of *Artforum* magazine, which had started in San Francisco in 1962 and moved to L. A. the next year. As of the fall of 1966, *Artforum* had moved again, to New York – but not before using Hopper's photographs twice on its cover (once for an Abstract Expressionist-into-Pop shot of graffitied posters and once for a portrait of Warhol behind a flower).

By 1964 there were a good twenty or so galleries on or near La Cienega dealing contemporary art. They evinced various levels of quality, sophistication, and stylistic adventuresomeness, but together they constituted a true gallery scene, second in the nation only to New York's array of galleries on 57th Street and along upper Madison Avenue. The La Cienega galleries established a regular communal event, a Monday night "art walk," and spiced this evening promenade with events and festivities that helped spur local interest in contemporary art.

It was in this milieu that Dennis Hopper had his solo gallery show, a 1964 display of sculptures (fashioned from foam rubber) and assemblages at the Primus/Stuart Galleries in the middle of La Cienega's gallery row. While he had given up painting after the 1961 fire (not to return to the discipline until 1982), Hopper had continued to fabricate objects as well as take photographs. "The assemblages," recalled Walter Hopps, "combined found objects and large photo blowups which were extraordinary and ahead of their time."[21] Very few sold, however – more to the consternation of the dealers than of Hopper, but it was to be his last local gallery show for awhile.[22] In 1968, however, he exhibited his large, implicitly anti-war sculpture *Bomb Drop* at the Pasadena Art Museum.

Showing *Bomb Drop* in Pasadena was a culmination of sorts of Hopper's art career in the 1960s. If La Cienega's gallery row was one anchor of the new L. A. art scene, the Pasadena Museum was the other. Having been steered in the late 1950s onto the cutting edge of new art, the once-sleepy museum in the faux-Chinese palace at the edge of Pasadena's downtown rapidly established itself as the West's leading public venue for new art.[23] The Museum sponsored events outside as well as inside its walls, including Allan Kaprow's controversial Happening *Fluids* (in which Hopper participated, both as performer and as photographer).[24] The Pasadena Museum event that made the biggest impact on Hopper, however, was its 1963 retrospective[25] of Marcel Duchamp – the only museum survey the influential French proto-Dadaist/conceptualist would enjoy in his lifetime. Duchamp's radical declaration that art is a matter not of fabrication, but of declaration – that something is art because it is designated (rather than made) as such – had a profound effect on Hopper's thinking about art as something else besides craft. The readymade concept did not persuade Hopper that craft was useless, much less anathema; but it did place primacy on the idea rather than the thing, a primacy which substantiated his enthusiasm for Pop (ironically enough, given Pop's apparent celebration of the thing).

In the discourse of the L. A. art scene of the 1960s – perhaps even more than in New York or London or other capitals of Pop – images were currency, events were currency, and currency itself – freshness, newness, up-to-datedness – was currency. The spiritedness and nowness of things and ideas were what mattered; a photograph was of a moment, and/or for a moment. The "permanence" of artworks seemed itself vaguely embarrassing, and artists turned to photos of themselves – especially doing something, anything else besides making art and looking like artists – to enliven their exhibition announcements. Hopper's

21 See p. 44.

22 He did participate in *Los Angeles Now* at the Robert Fraser Gallery – one of London's leading outlets for Pop Art – in early 1966. Other artists in the show were Larry Bell, Wallace Berman, Llyn Foulkes, Craig Kauffman, and Edward Ruscha, as well as San Francisco artists Bruce Conner and Jess (Collins).

23 San Francisco's Museum of Modern Art was the only other claimant to this position, and its programming was not exclusively contemporary. The Los Angeles County Museum was even less dedicated to new art, although once it moved into its new complex on the edge of the La Brea Tar Pits in 1965, it had more room to show and collect contemporary work.

24 Hopper also photographed Claes Oldenburg's Happening *Autobodys* and Robert Rauschenberg's dance event *Pelican,* staged in a Santa Monica roller-skating rink, among other performances.

25 *by or of Marcel Duchamp or Rrose Selavy* (Oct. – Nov. 1963).

photographs found their way to the public eye as much this way as otherwise. His most famous single image, the 1961 *Double Standard,* first saw the light of day as the poster-announcement for Edward Ruscha's show of Standard gas station paintings at Ferus. And Hopper's most famous, and perhaps most delightful, photographic sequence from this era is of Bruce Conner cavorting with a bevy of young women. As Hopper attests,

> The girls in the pictures are Teri Garr, Toni Basil, Fran, and Karen, I can't remember Fran and Karen's last names … They were all dancers on a dance program called *Hullabaloo* where they all danced in cages and so on. And Bruce came down from San Francisco for this show at Brandeis University, and he got all the girls together and said, "We're going to do all these photographs because I need a poster." And there was a gym down on Santa Monica [Boulevard] called Bruce Conner's Gym, Physical Services, which had nothing to do with him, which had departments for men and women. And so I took photographs and had them all posing outside. We went out and spent a day just laying around, taking photographs …[26]

However much the overarching situations might be staged, these images attest to a thoroughgoing spirit of spontaneity, the "anything goes" impulse which reveled – almost proselytized for – lightheartedness and childlike joy. During the years that Hopper produced these photographs, 1961–67, the ideology of exuberance masked the darker aspects of human nature and struggled to deny the hostility of the wider world. Even his photographs of civil rights marches in Alabama concentrated on the fervency and optimism of the participants, not the hatred and revulsion that impeded their progress. But Hopper was not unaware of the weeds growing around, and even in, the garden of Flower Power; and when he put his still camera down in 1967 and got back in front of the movie cameras, it was to immerse himself in the making of a much more complex, conflicted expression of the new spirit. During the making of *Easy Rider* Hopper's participation in L. A.'s art scene dwindled almost to nothing, his marriage came to an end, his life became saturated with substances which overwhelmed him, and he left town altogether, not to return for over a decade. For Hopper the 1960s ended as they had began, in conflagration. Happily, he rose from those ashes as he had from the remains of the Bel Air fire: cleansed and rededicated to the making of art and, thereby, to the living of life.

26 See p. 27.

OUT OF THE SIXTIES

Walter Hopps, founder of the legendary Ferus Gallery in Los Angeles, speaks about Dennis Hopper's photographs, art collecting, and directing films in the sixties.[1]

To get at what I believe to be something special about Dennis Hopper's black and white photographs of the sixties, I need to mention a few things about Dennis Hopper as a worker/artist. He has been a film actor since the early 1950s and from the beginning his clear view, candor, and passion about what was going on around him got him pegged as a rebel, as was the case with a number of strong actors during the early 1950s. Coming from I don't know where, Hopper's close to the obstreperous, deadly serious underground of vanguard art hanging on in the middle 1950s in Los Angeles.

We met at Stone Brother Printing at a poetry reading, a scene *Life* would later call "beatnik." This was a milieu that included poets Stewart Perkoff and Bob (Baza) Alexander; artists Wallace Berman, Edward Kienholz, and George Herms; performers Rachel Rosenthal and the extraordinary Mr. Chang. For Hopper this milieu expanded over the years to include Californians Michael McClure and Bruce Conner, New York artists Claes Oldenburg, Robert Rauschenberg, and Andy Warhol, David Hockney in England, the attendant folks of the art world, rock musicians and film people in explosive numbers tumbling about in the 1960s. When Hopper had money he collected art and he had an eye with some of the best of his time. There had not been such a Hollywood collector since Vincent Price or Charles Laughton, in a tradition that began with George Gershwin before Hopper was born.

At the same time as Hopper acted in films and collected art he was fired to direct films, to make them. This desire has been both crushingly messed with and fulfilled. It is hard to imagine now how young, vanguard Hollywood suffered and chafed in the years of the 1950s and early 1960s as compared to the Italian and French New Waves. But one day Hopper came to direct parts of *The Glory Stompers*. It proved to anyone concerned with the Industry that he could direct. He then developed the concepts and scripts for three extraordinary films which he felt compelled to make: *The Last Movie,* finally made almost a decade after it should have been in an aftermath of tumult and high drama; *Ying-Yang,* a comedy never made; and

1 First published in *Dennis Hopper: Out of the Sixties* (Pasadena: Twelvetrees Press, 1986).

The Merode Altarpiece, a contemporary drama of art world intrigue, dope culture and family betrayal, also never made.

At the same time as Hopper made most of the photographs in this book, he was also making paintings and assemblages. The assemblages combined found objects and large photo blowups which where extraordinary and ahead of their time. They would look right at home in a good East Village gallery today. It can't be emphasized enough that all this art work, collecting, acting for TV and films, and photography was in the face of Hopper really wanting to make Industry films of his own. In a curious way what seems special about Hopper's photographs now is that they seem to resemble still shots from movies. Not so much frames from films but still photographs made on the set and locations of imagined films in progress … wonderful ones.

Out of the sixties came *Easy Rider.* This was not the film Dennis was looking to make after what one would call his technical debut with the low-rent biker epic *The Glory Stompers,* but *Easy Rider* came and was made. It became part of the history of our society at a moment of wrenching change, changing everything for Hopper in all the crazy and disruptive ways possible. I can think of no concise way to speak about events and changes since *Easy Rider,* suffice to say Hopper's making of photographs and art slowed down and was set aside until recent years. But from the time of *Easy Rider* until now Hopper has maintained a fearsome and tenacious hold on making and working in films, come hell or high water.

As more than a footnote I would like to mention two sets of deaths in the course of Hopper's life and work. In 1956, or close to, James Dean, Charlie Parker, Jackson Pollock, and Dylan Thomas were all suddenly dead. They were emblems in a variety of ways for those trying to make and deal with art somewhere in the underground of that contradictory, affluent, and stifling society we faced. By the end of the sixties another set of deaths on a far vaster stage bracketed the era: John F. Kennedy, Robert Kennedy, Dr. Martin Luther King, and Malcolm X.

Whose dreams were they? Whose dreams are we?

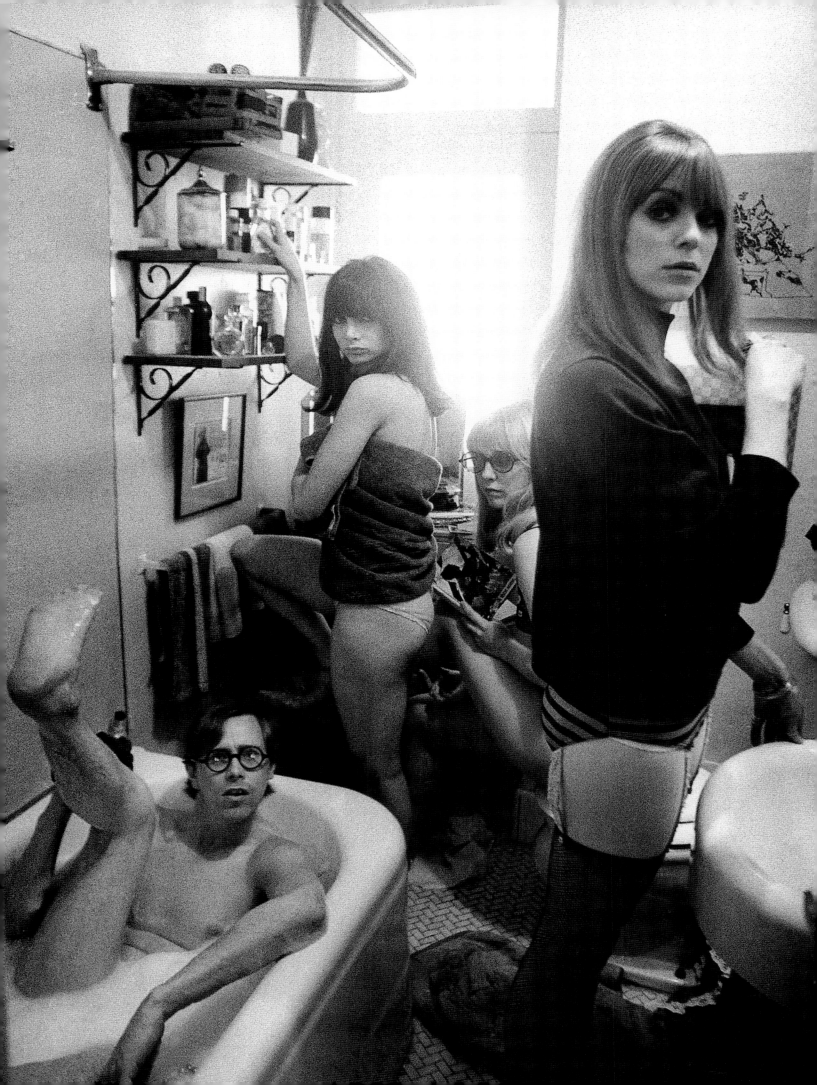

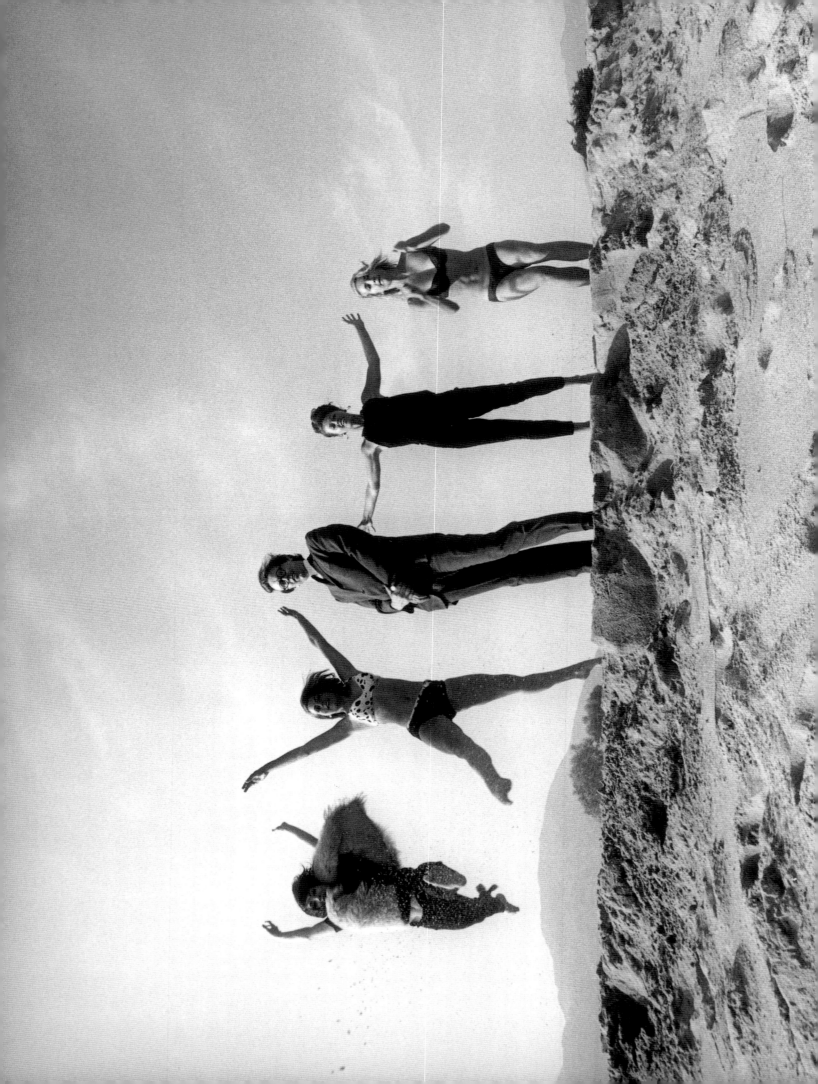

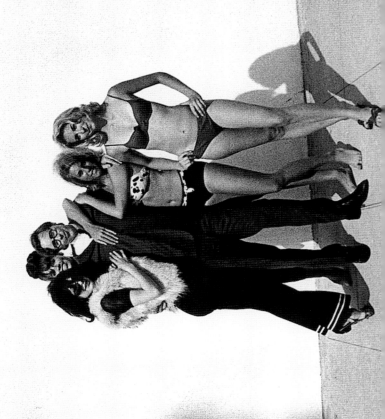

Bruce Conner's
PHYSICAL SERVICES
DEPTS FOR MEN & WOMEN
474·0022

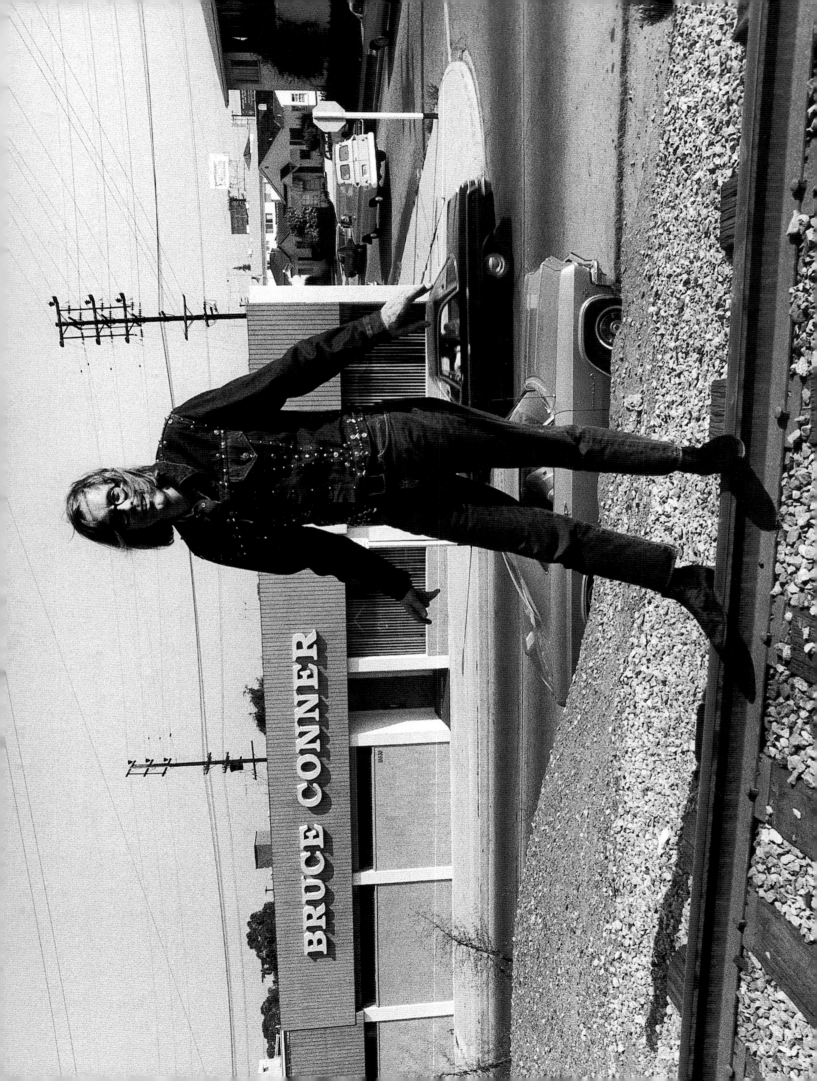

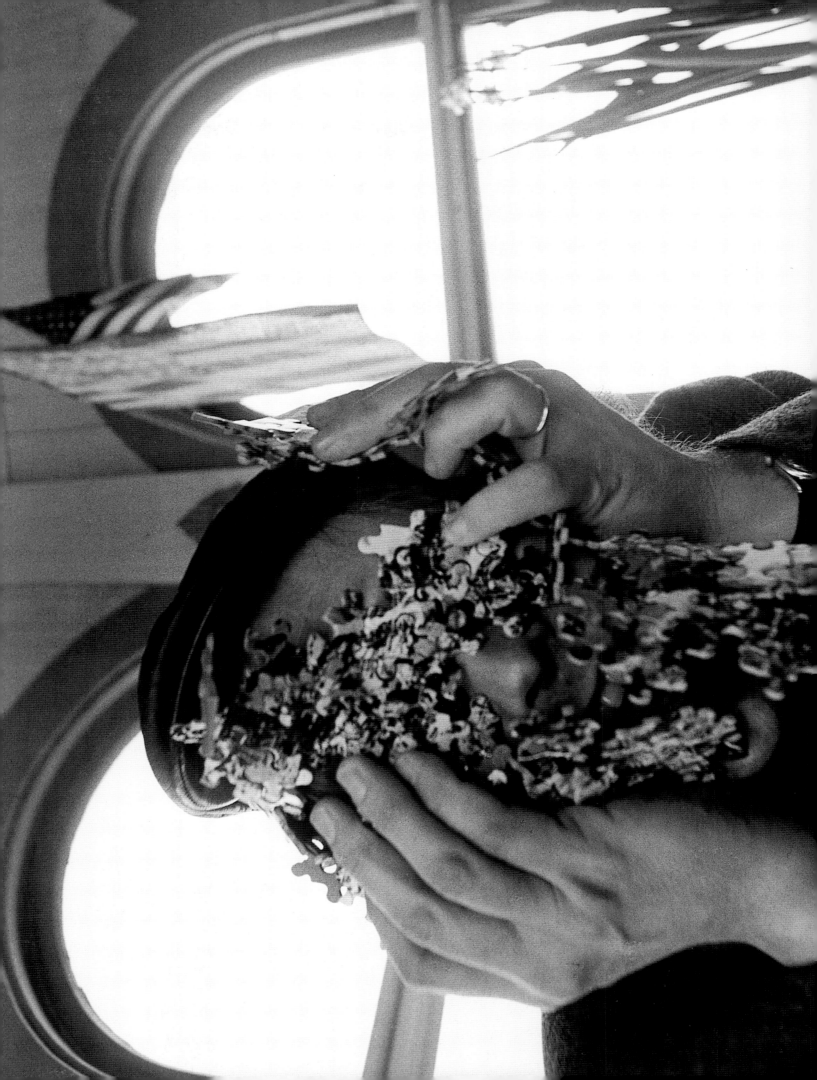

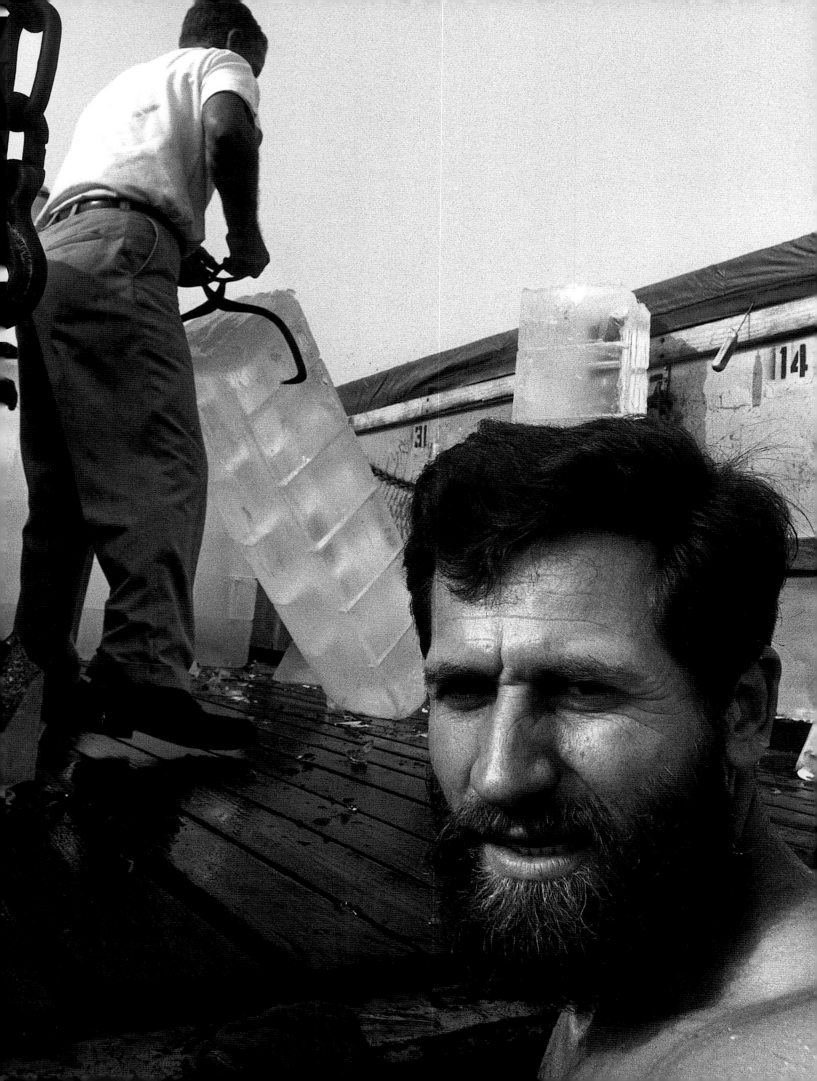

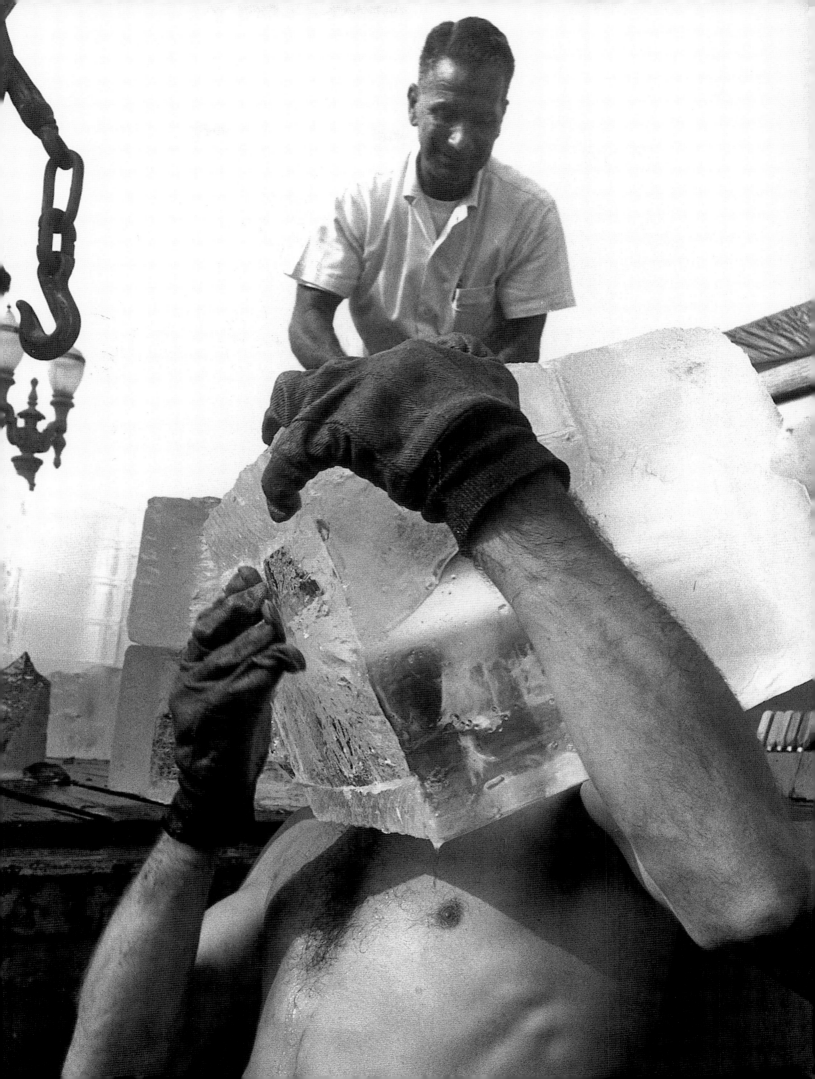

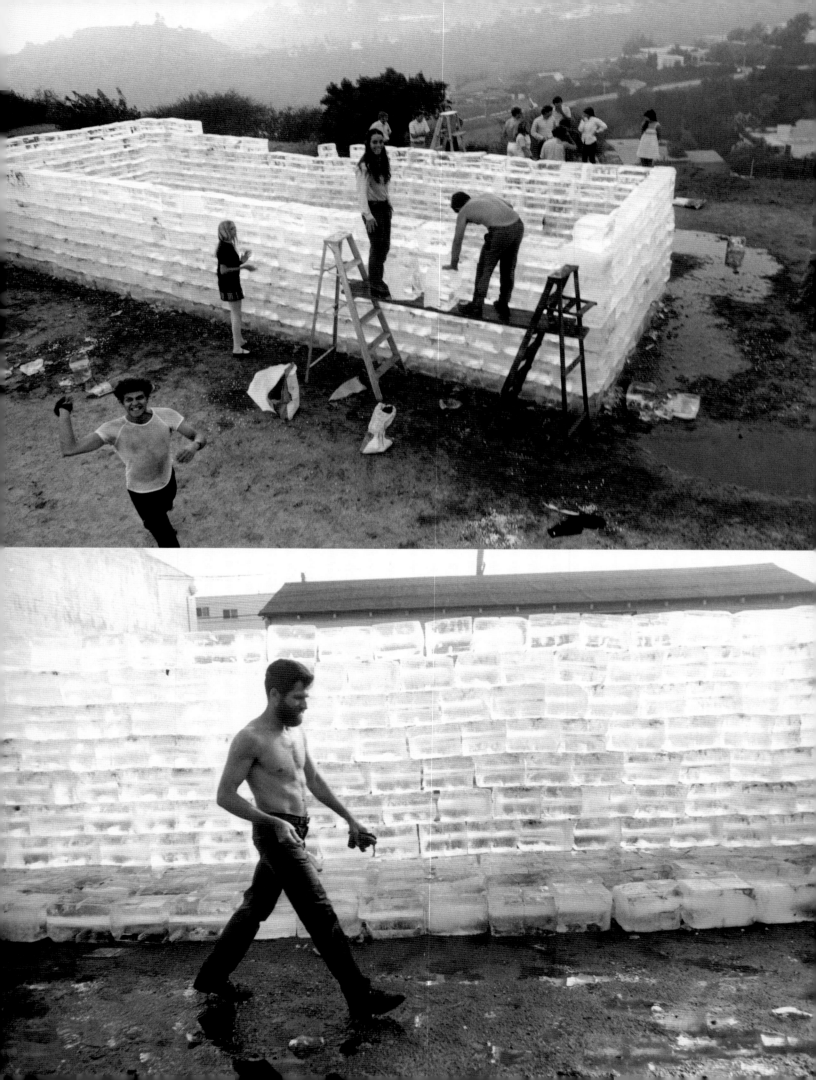

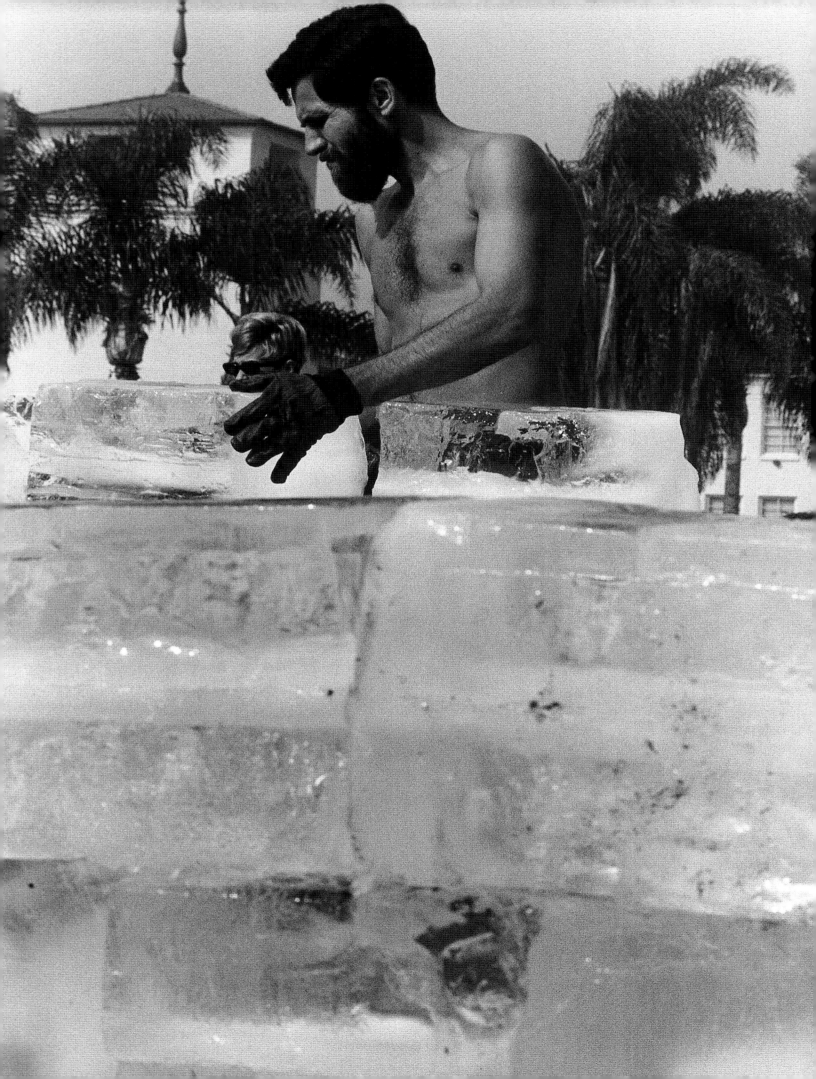

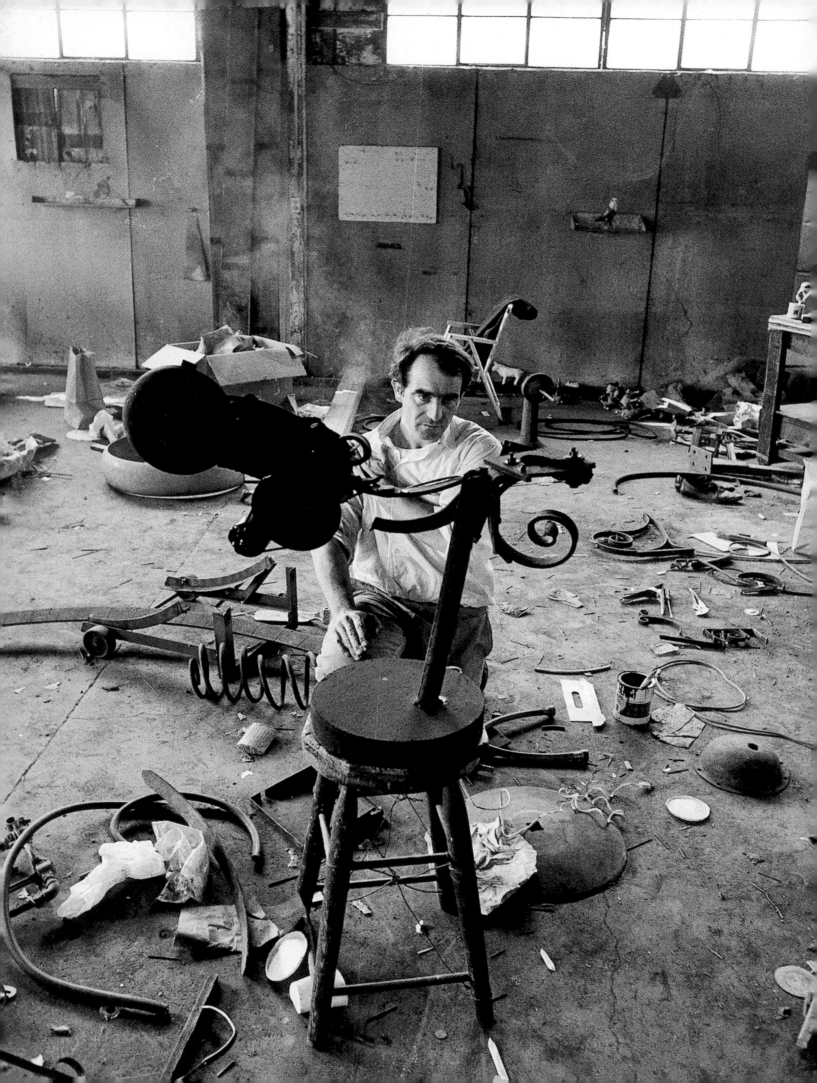

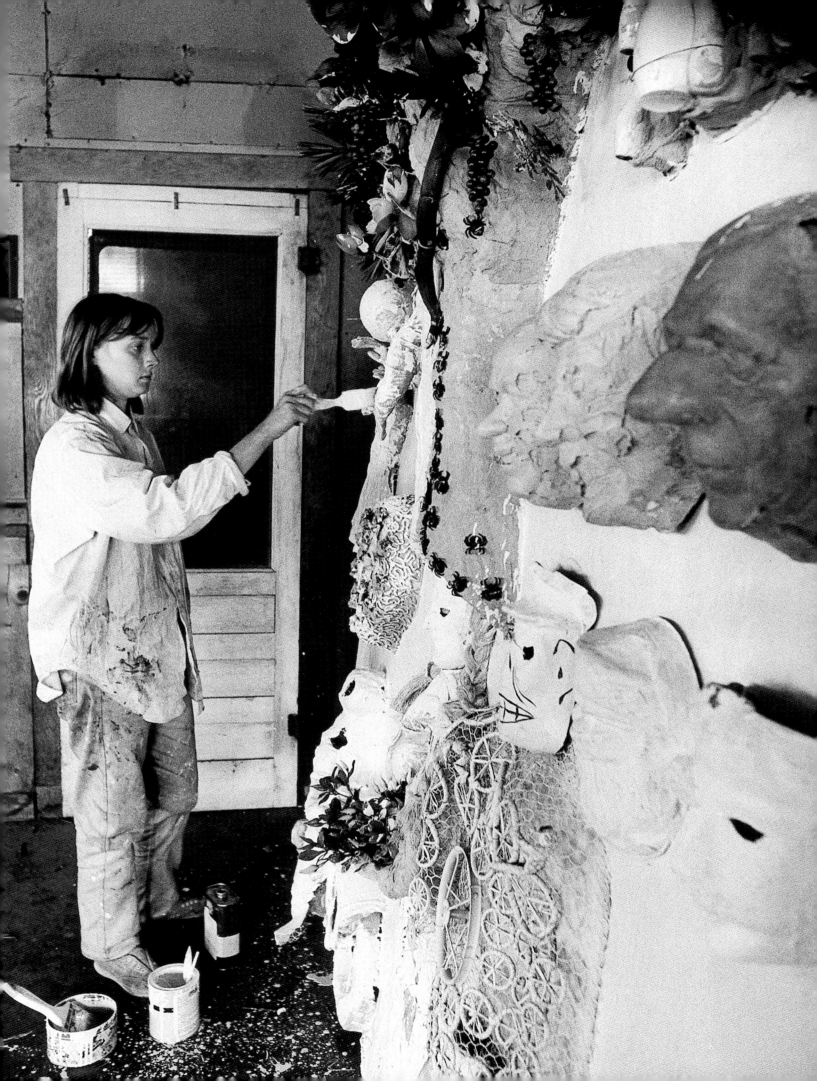

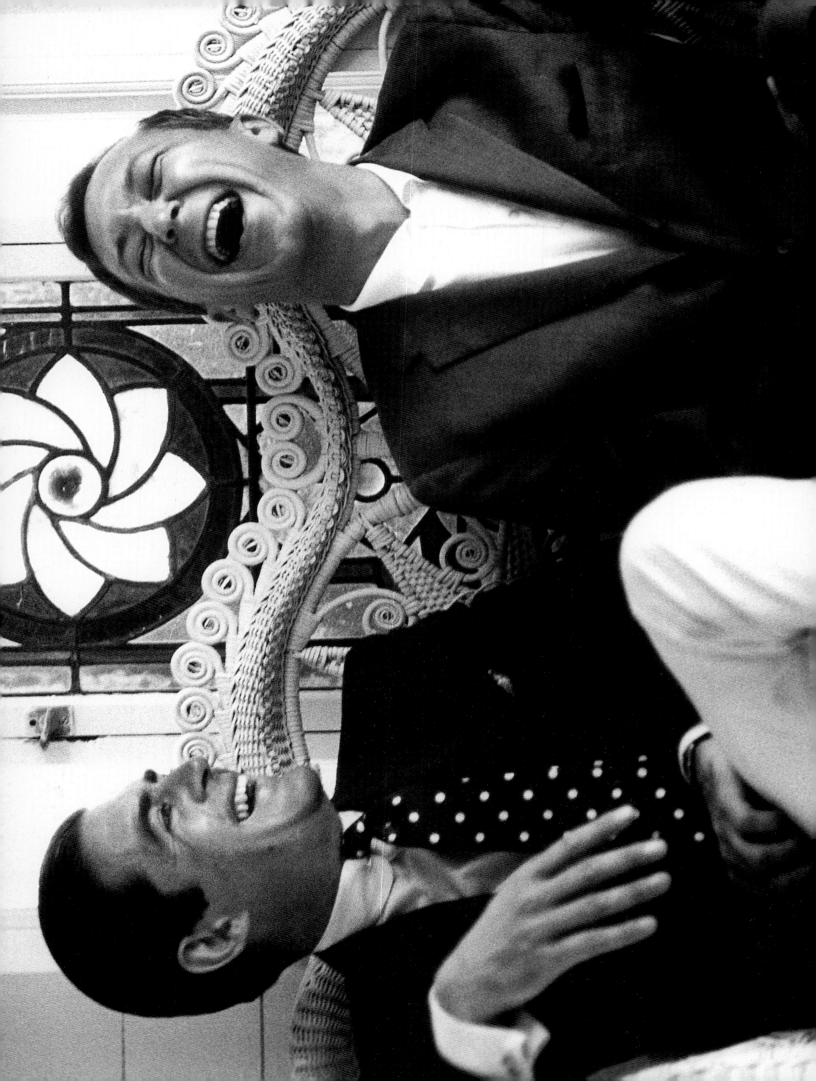

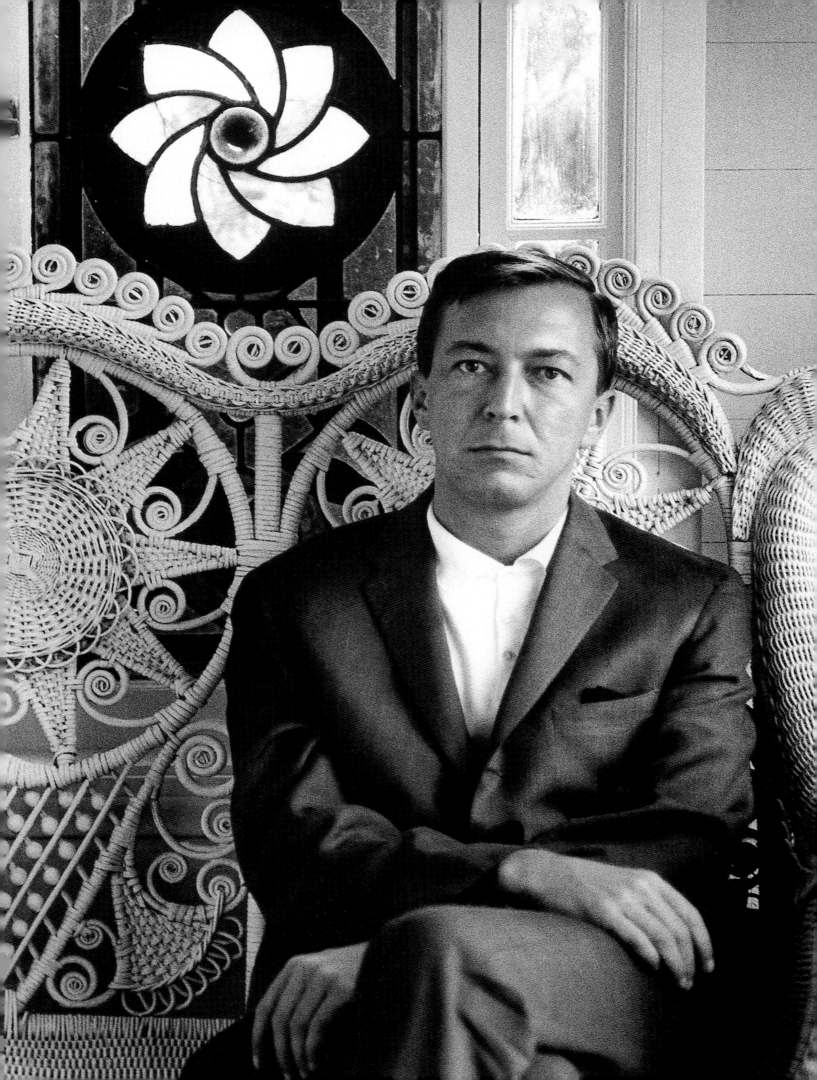

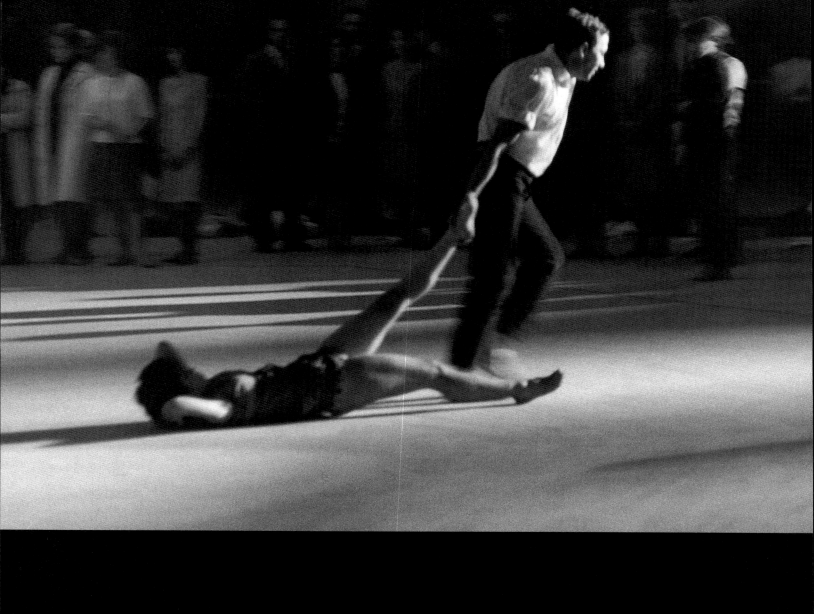
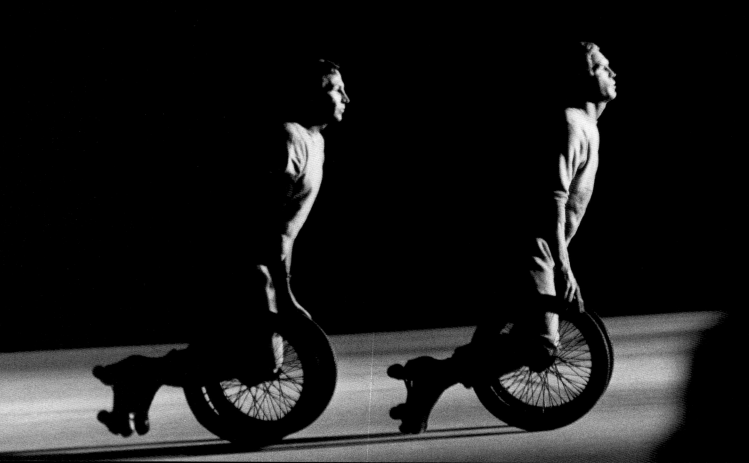

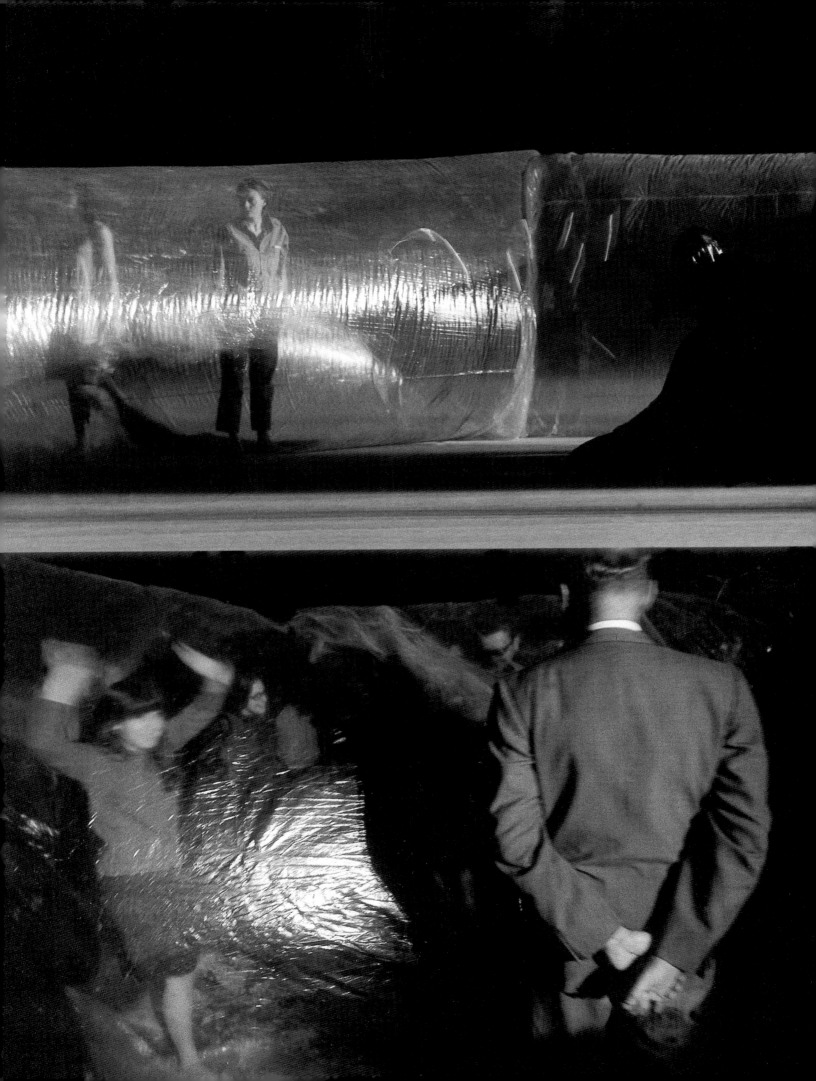

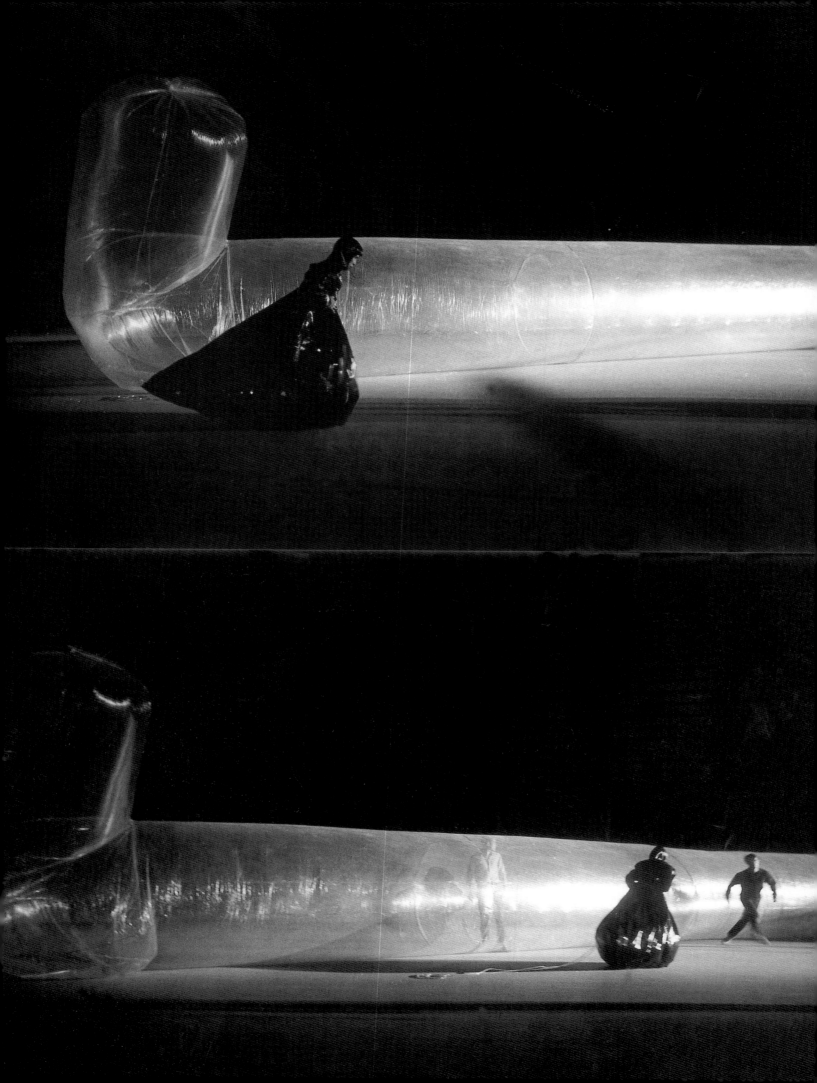

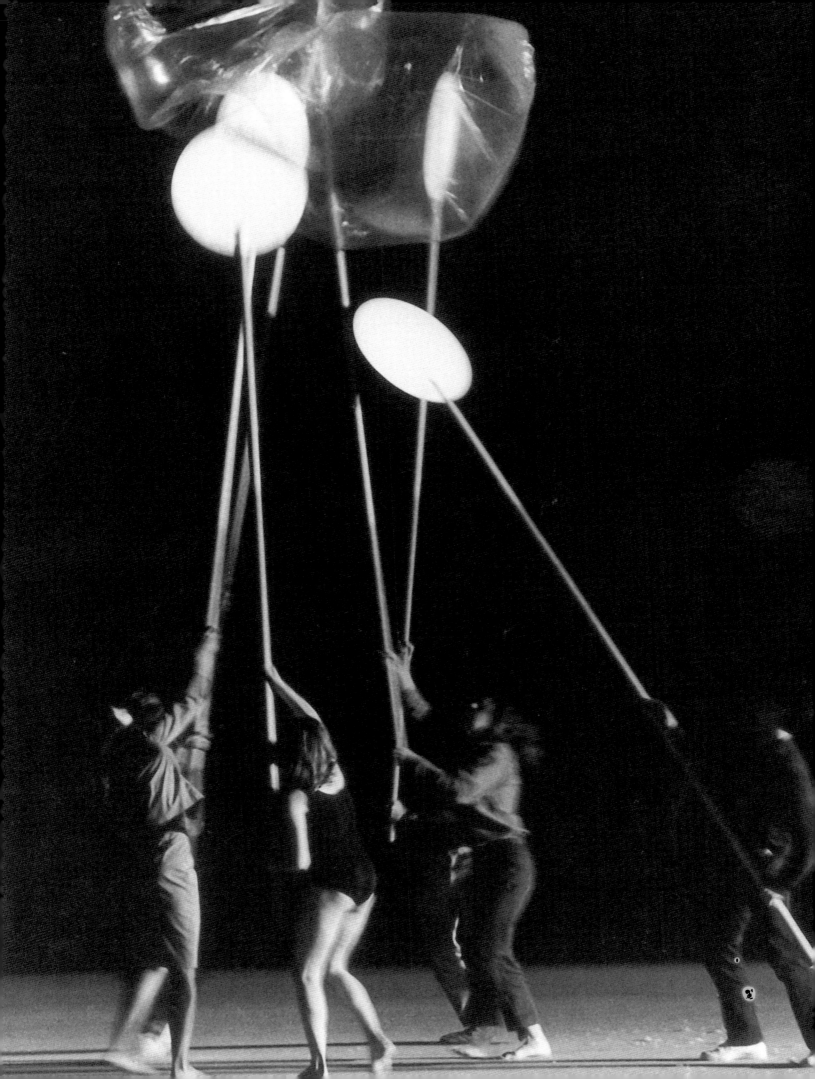

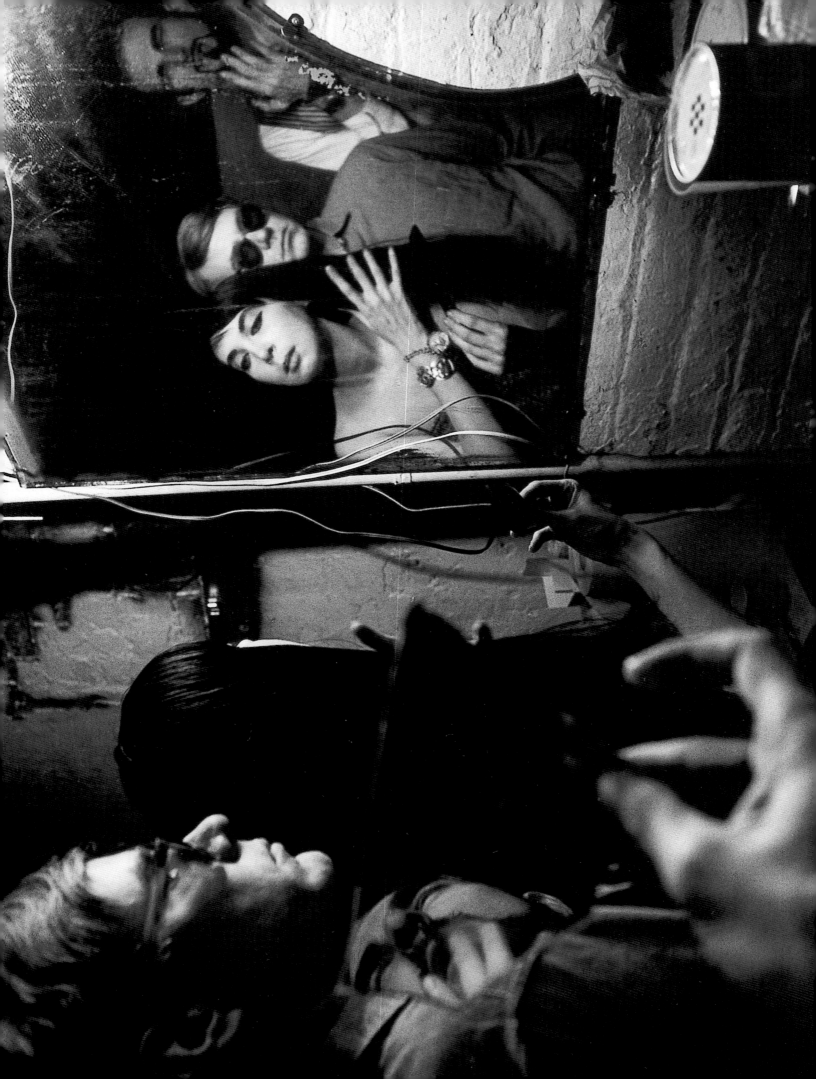

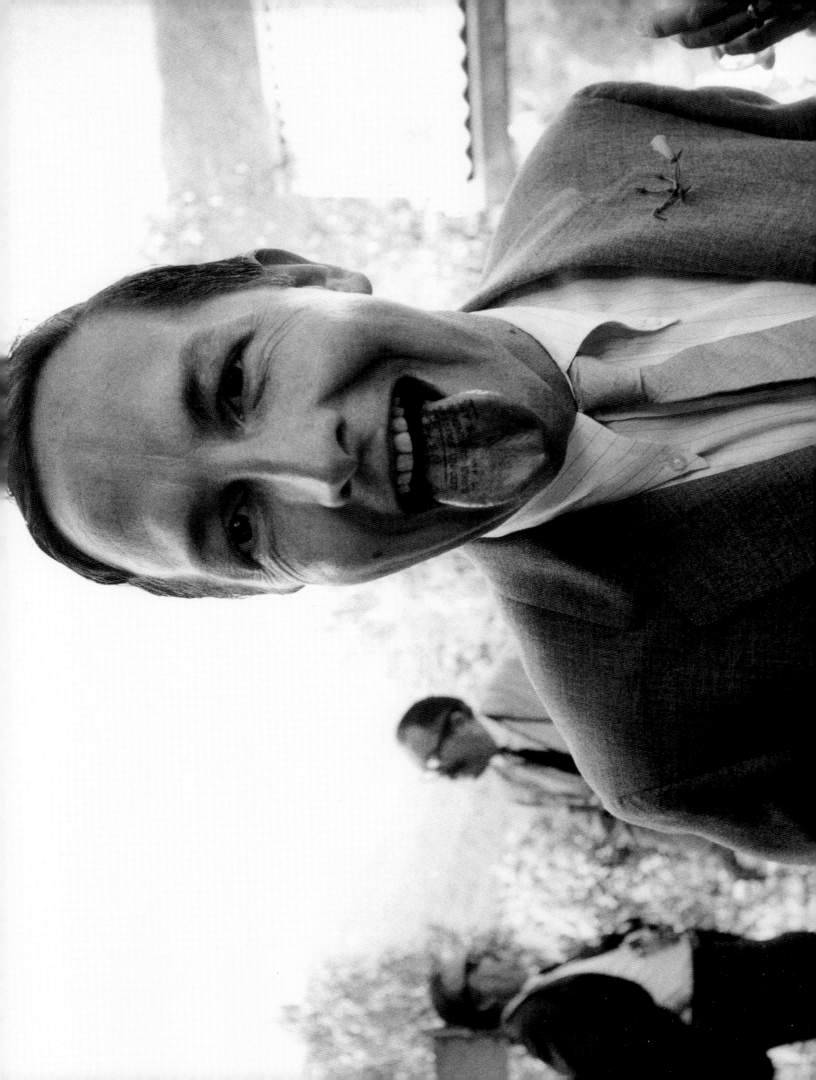

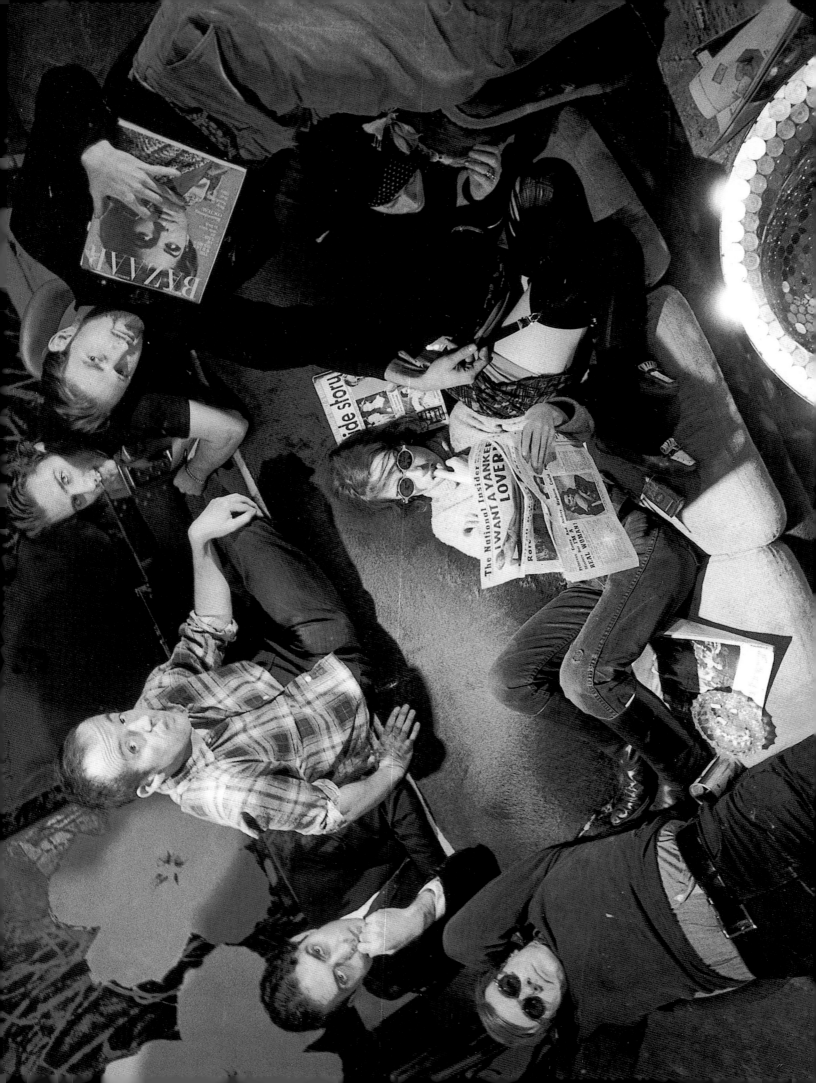

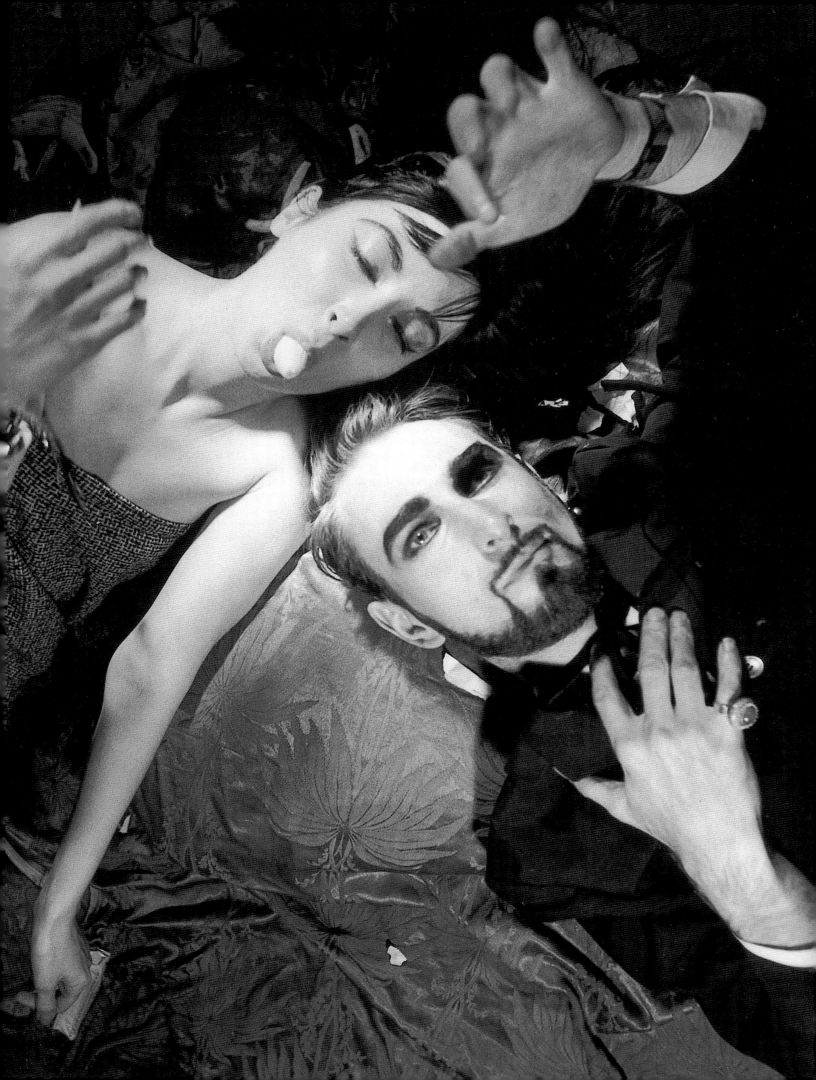

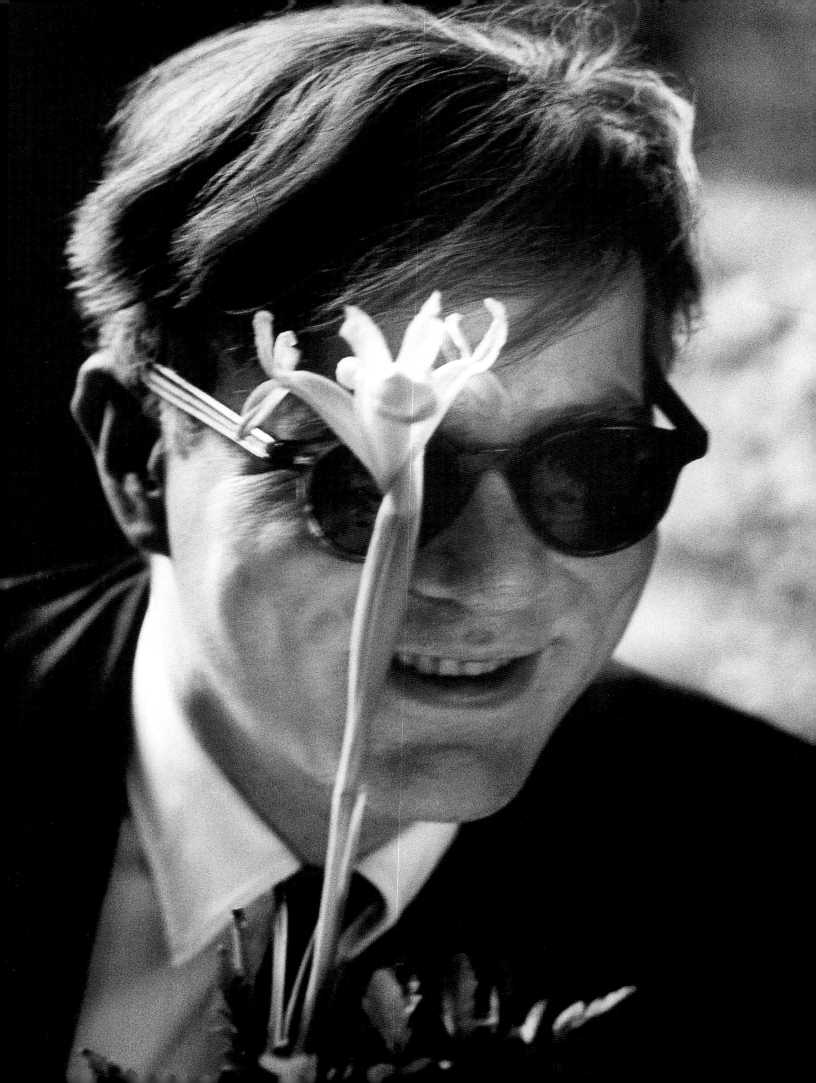

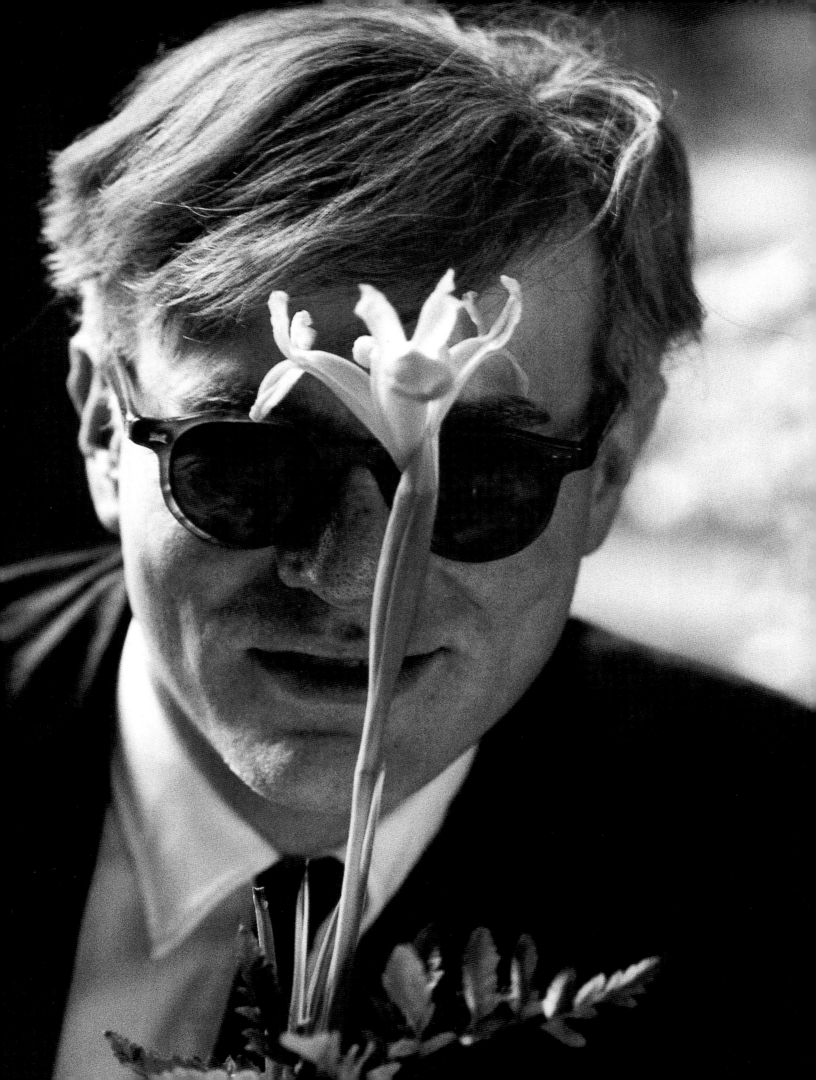

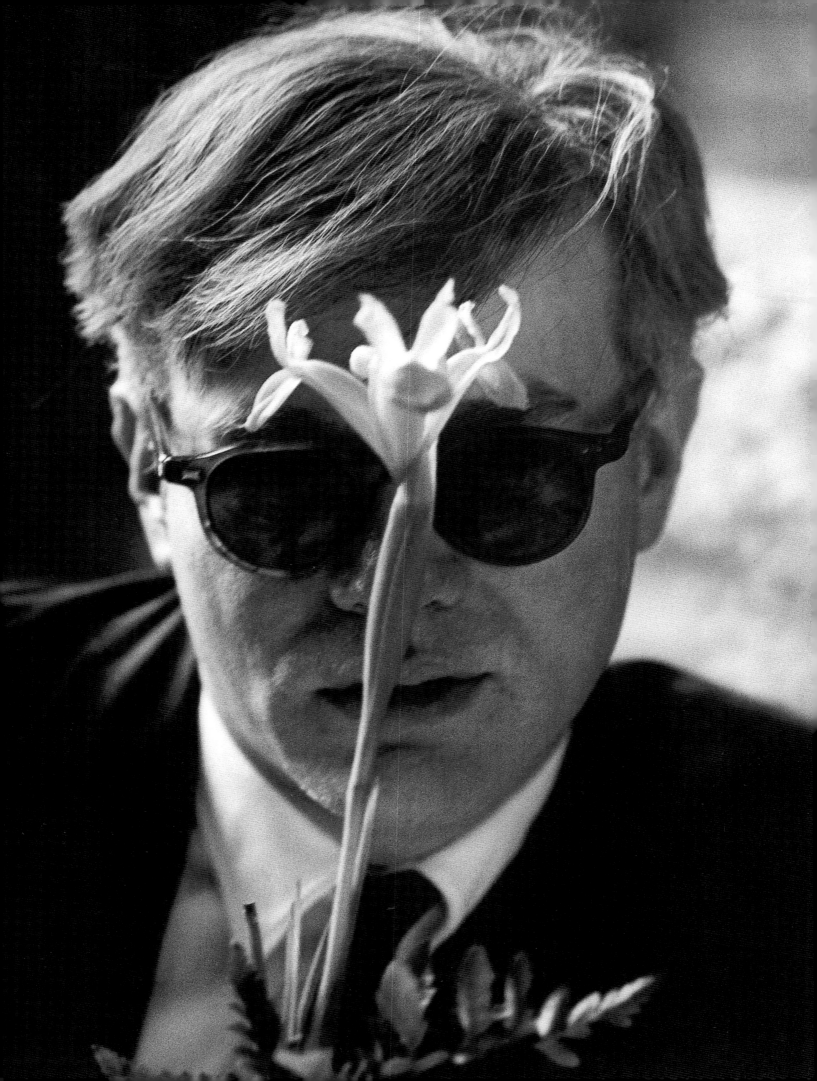

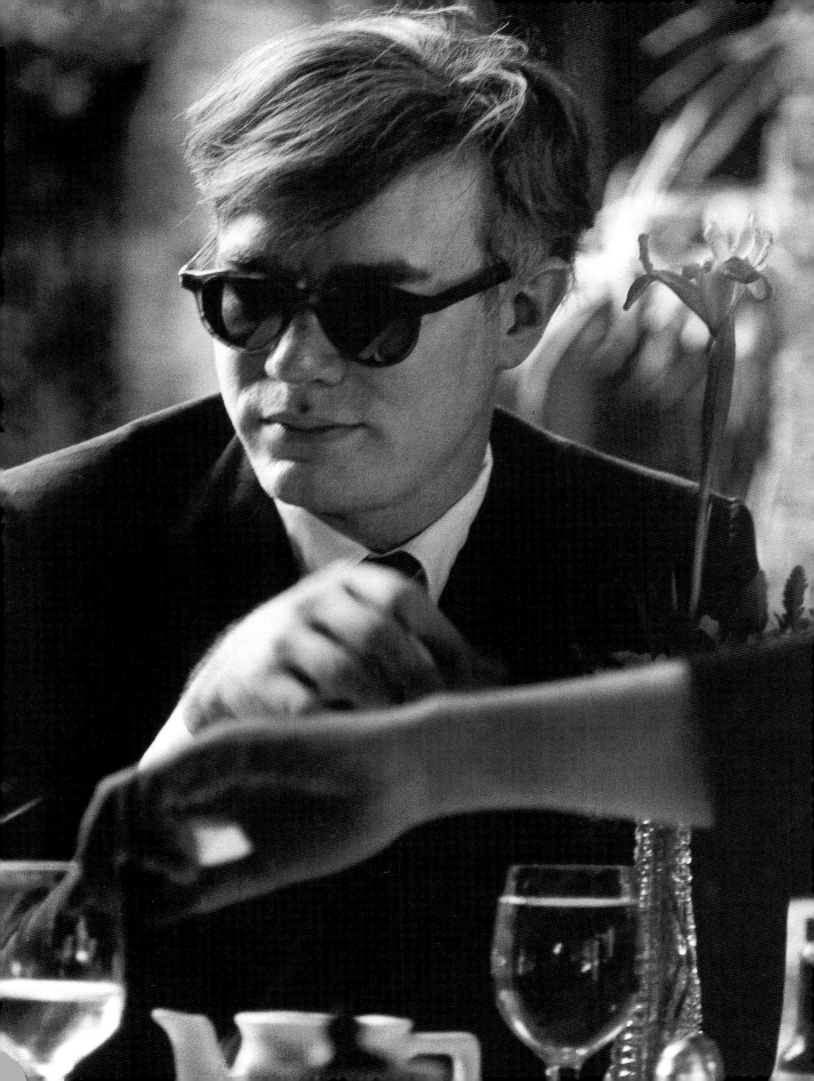

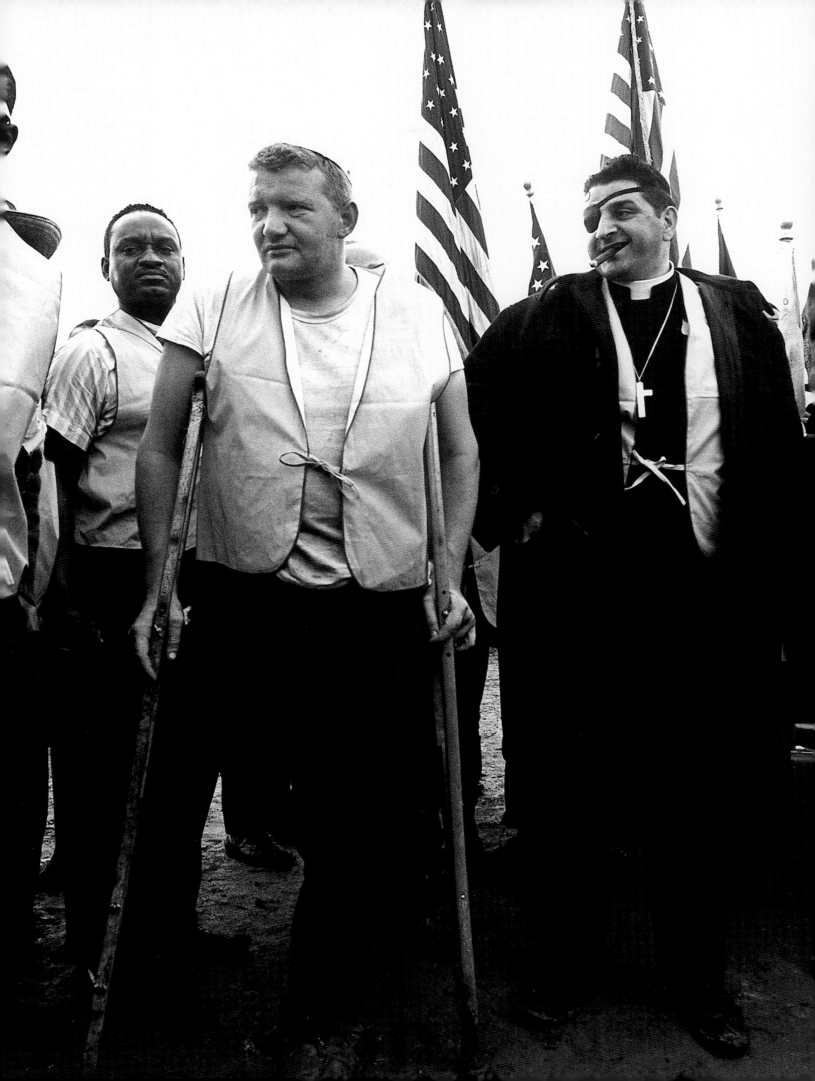

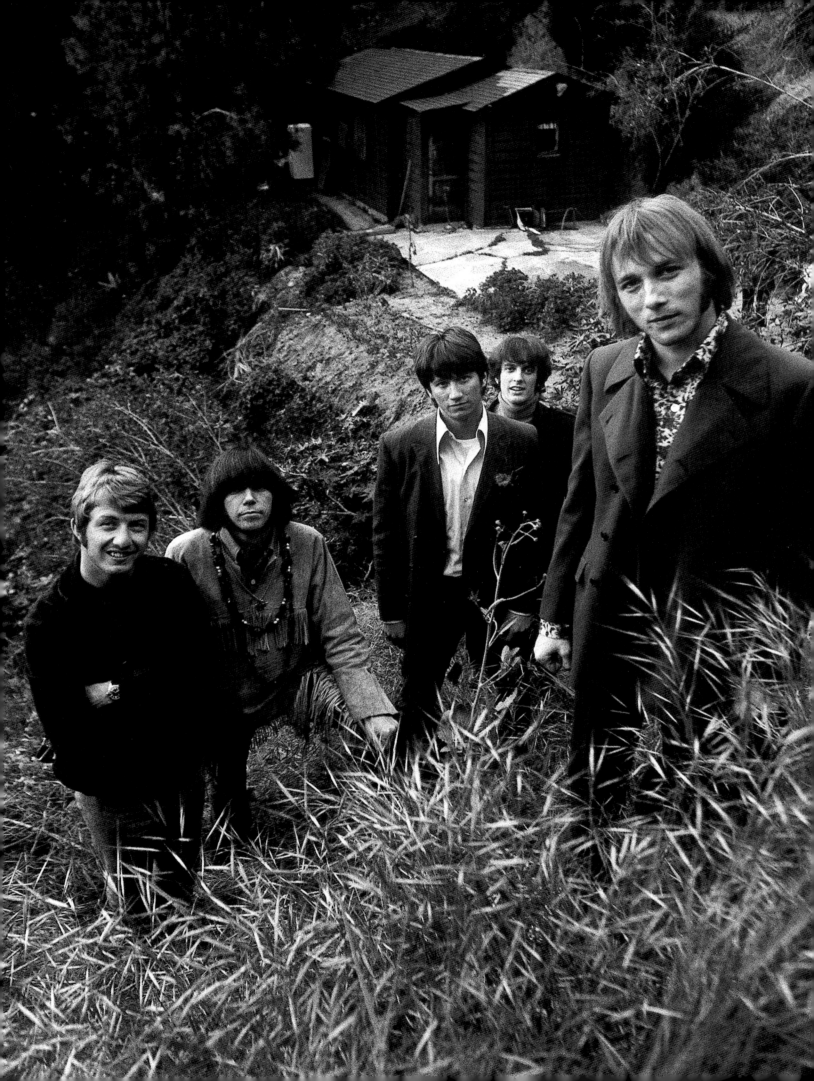

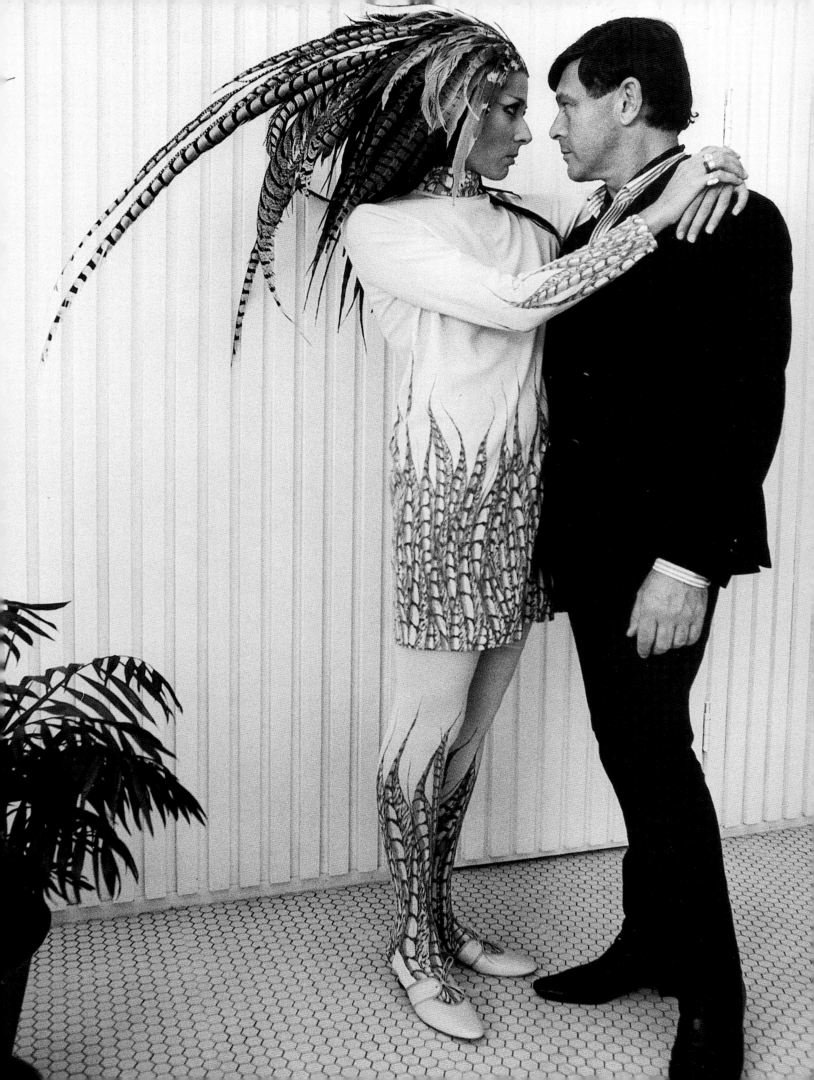

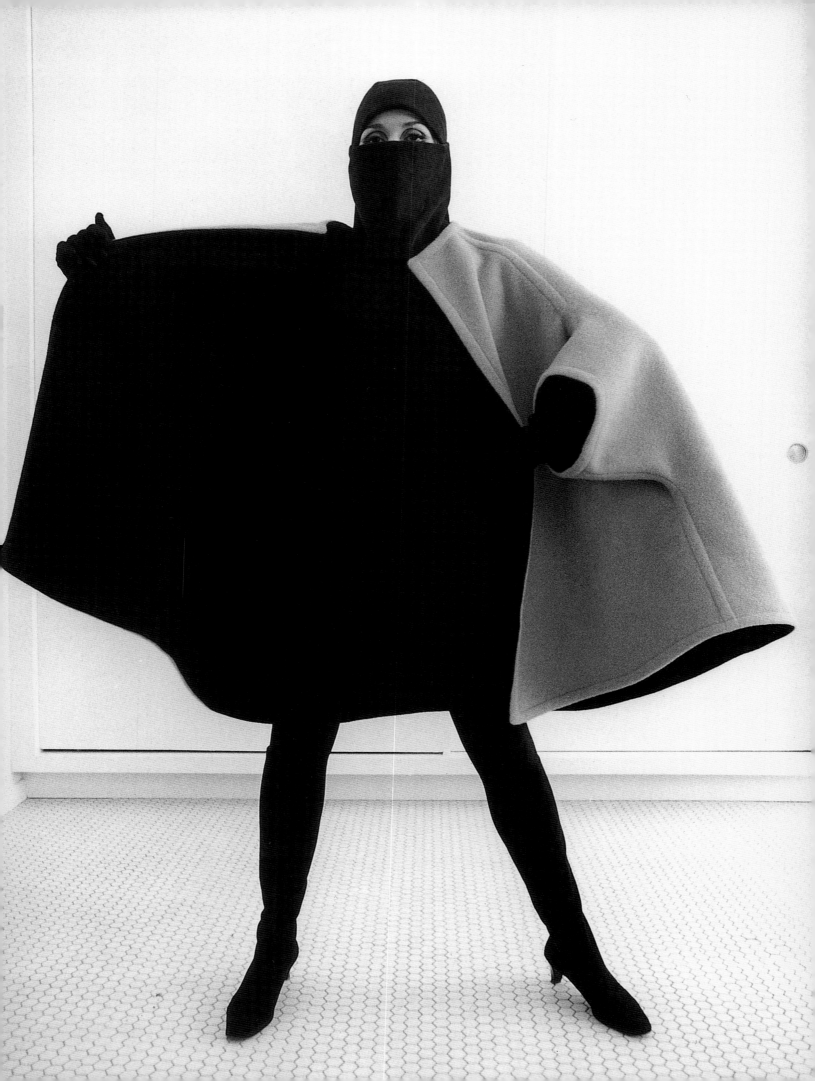

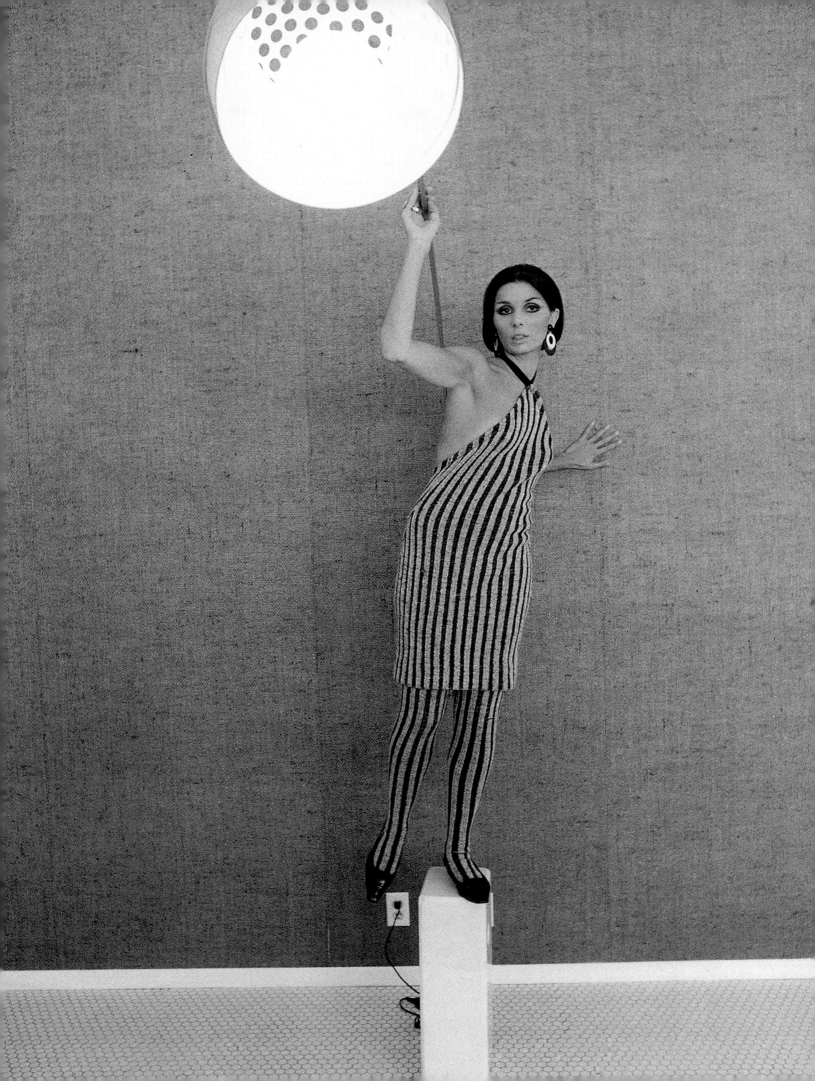

These are my photos. I started at eighteen taking pictures. I stopped at thirty-one. These represent the years from twenty-five to thirty-one, 1961–67. I didn't crop my photos. They are full frame natural light TriX. I went under contract to Warner Brothers at eighteen. I directed Easy Rider at thirty-one. I married Brooke at twenty-five and got a good camera and could afford to take pictures and print them. I never made a cent from these photos. They cost me money, but it kept me alive. They were the only creative outlet I had for these years until Easy Rider. *(Dennis Hopper)*

All: Gelatin silver print, 20 x 24 inches
Collection Dennis Hopper

BRUCE CONNER WITH TONI BASIL, TERI GARR AND ANN MARSHALL, 1964

BRUCE CONNER WITH DANCERS, TONI BASIL, TERI GARR, KAREN AND FRAN, 1964

Dennis Hopper photographed Bruce Conner in Los Angeles with his friends, dancers from the program, *Hullabaloo.* Conner was putting together a one-artist show at Brandeis University and needed images for the exhibition poster. Hopper obliged him with this series of photographs, shot over the course of a day.

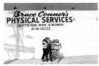

BRUCE CONNER'S PHYSICAL SERVICES, 1964

BRUCE CONNER, 1964

Bruce Conner first received attention for his innovative contributions to the growing found art movement. His large-scale, erotically charged constructions exemplify the growth of assemblage on the West Coast. Throughout his career, Conner has explored painting, drawing, collage, photography, sculpture, and printmaking. He has also made significant contributions to avant-garde film. Conner was able to expertly translate the collage and assemblage techniques of the plastic arts into fast-paced montages of found film stock. Conner's kinetic short films were to have a profound effect on American filmmaking in the 1960s and on Dennis Hopper's early films. Hopper found Bruce Conner's Gym on Santa Monica Boulevard and took advantage of the interesting coincidence in this series of photographs.

ALLAN KAPROW, Fluids, Los Angeles, 1964

In 1959, Allan Kaprow initiated the first Happenings at the Reuben Gallery in New York, seeking to challenge the viewer's/participant's relationship with art and its environments. Kaprow also worked extensively with assemblage and environments during the 1950s and 1960s. The archetypal, elemental quality that is characteristic of his work can be seen in *Fluids*. Kaprow, with the help of his friends, built about twenty rectangular enclosures of ice blocks, roughly measuring 30 feet long by 10 feet wide, by 8 feet high, in various locations around Los Angeles. The walls of each were continuous and unbroken. According to Dennis Hopper, a night patrolman offered to light their work area with an emergency flare. Kaprow liked the effect and decided to place the flares in each completed enclosure. The glowing structures held their form for approximately one and a half days.

GEORGE HERMS, 1962

George Herms' body of work is considered a precursor to much of the found art/assemblage that was to flourish on the West Coast. One of the Ferus Gallery circle of artists, Herms expressed a strong belief in the inherent vitality of the found object and, often in collaboration with Wallace Berman, assembled "things of the spirit" from outcast objects and found photography. In addition to his work in the plastic arts, Herms was also a poet, writer, filmmaker, printer, and one of the pioneers of the Happening. Dennis Hopper gave both Herms and Wallace Berman cameos in *Easy Rider,* playing commune members sowing seeds.

WALLACE BERMAN, 1964

Los Angeles in the late 1950s and early 1960s was alive to the progress of artists, writers, and performers to whom no "scene" or "ism" had yet been attributed. Wallace Berman stood at the center of the West Coast art world and acted as mentor and catalyst to many of the artists around him. In 1955, he began to publish *Semina,* a literary and arts journal that employed surrealist collage techniques to reinvent the function of the periodical. A prolific collage artist, Berman's work combined references from the Cabbalah and occultism with those of media and popular culture in a dense and textured layering of language and image. In 1964, Berman developed his first Verifax collages, using this early photochemical copier process to create some of his most important images.

VIRGINIA DWAN, 1964

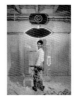

MARTIAL RAYSSE, 1966

Martial Raysse was part of the French assemblage school of Nouveau Réalisme, which included Nikki de Saint Phalle, and Jean Tinguely. Raysse worked in large-scale photo-assemblage.

EDWARD RUSCHA, 1964
Edward Ruscha and Dennis Hopper met in 1962 at the opening of *New Painting of Common Objects* at the Pasadena Art Museum. Ruscha had come to Los Angeles from Oklahoma and spent much time driving between the two states, via Route 66. The artist's fascination with the West Coast culture of mobility, privileged the driver's view as the primary compositional element in both his photography and drawing. To this, Ruscha coupled an interest in the visual language of books, evidenced in projects like, *Twentysix Gasoline Stations* and *Some Los Angeles Apartments*. This language extended to his paintings, which often utilized the same typefaces and spatial relationships that were employed in his books. Dennis Hopper's photograph *Double Standard* was used on the cover of the announcement for Ruscha's 1964 exhibition at the Ferus Gallery, showing the artist's *Standard Station* series of paintings.

JOHN ALTOON, 1964
John Altoon was an influential figure in the development of the Ferus Gallery nexus. A native of Los Angeles, Altoon explored the theories of Abstract Expressionism in Spain, during the mid-1950s. Returning to L. A., he coupled this primary influence with an exploration of new materials and began to move toward flat compositions, featuring floating biomorphic forms; the most notable of these being the *Ocean Park Series* of 1962. A prolific draftsperson, Altoon is also noted for his satirical drawings both lampooning and engaging such issues as the role of advertising in American culture and contemporary views of religion and sex.

DENNIS HOPPER, 1967

EDWARD KIENHOLZ, 1963
Co-founder of the Ferus Gallery, Edward Kienholz was best known for his large scale found art assemblage. Composed

of commonplace objects and mannequin/doll parts, his work raises disturbing and provocative questions about desire, form, and repulsion. During the 1960s, he and Dennis Hopper developed a creative friendship, often assisting each other on projects. Hopper credits Kienholz with his development as an assemblage artist, as exemplified by his 1963 works *Chiaroscuro, Proof,* and *Jarred Connection.*

JEAN TINGUELY, 1964
Jean Tinguely, a seminal figure in the post-War European art scene, developed his first *Metamachanicals* in the mid-1950s. These kinetic sculptures were characterized by their non-static qualities and their engagement of the viewer. In the late 1950s he created *Machines à Peindre,* automatic, abstract painting machines; exhibiting them in the 1959 Paris Biennial. A member of the Nouveau Réalisme movement, along with the critic Pierre Restany and Nikki de Saint Phalle. Tinguely examined the ways in which automation and production were transforming industrial society.

NIKKI DE SAINT PHALLE, 1963
Nikki de Saint Phalle received international media attention with the realization of twelve "shootings" between 1960 and 1961 – performative paintings in which paint-filled balloons were shot with a rifle, their contents exploding onto a canvas. Her work attracted Virginia Dwan, owner of Dwan Gallery, who invited the artist to enact a "shooting" at her Malibu home. The Malibu event resulted in a performance in the parking lot of the Renaissance Club on Sunset Boulevard. This photograph documents the creation of the paint-filled assemblage that was later used in the Sunset Boulevard performance.

CLAES OLDENBURG, Autobodys, 1964
In February of 1963, Claes Oldenburg began his transcontinental trilogy of Happenings with the Chicago enactment of *Gayety.* This was followed by the creation of *Stars* for the Washington Gallery of Modern Art in April. The trilogy culminated with the Los Angeles performance of *Autobodys* on December 9 and 10, 1963. Enacted at night, in the parking lot behind the American Institute of Aeronautics and Astronautics, the performance employed seven vehicles of various descriptions, and sixteen participants. The work was an examination of L. A. car culture and the interface of individual and machine. The images of the Kennedy assassination and funeral, televised a bare two weeks before, consciously informed the more violent aspects of the program.

CLAES OLDENBURG (portrait with cake slices), 1966
One of the only Pop artists to work in three-dimensional forms, Claes Oldenburg is best known for his "soft" sculptures. By manipulating the mass, scale, and form of familiar articles (telephone, ice cream, lipstick tube), he created objects at once engaging and penetrating. In addition to his sculptures, Oldenburg worked extensively with constructions, environments, and Happenings. This image was taken at Los Angeles County Museum of Art curator, Jim Elliott's wedding. Oldenburg sculpted slices of cake and had them cast in plaster of Paris. Each guest at the reception received a plaster slice of "cake." The bottom of each sculpture was stamped with the words "This Belongs to Oldenburg."

ROY LICHTENSTEIN, 1964
A seminal Pop Art figure, Roy Lichtenstein made his solo

debut at Leo Castelli Gallery in 1962. Art dealer Irving Blum took an interest in his work and became instrumental in his ascent in the art world. Lichtenstein utilized the visual language of the comic strip to subversively address the significant social changes taking place in the 1960s. He extended this popular media reference to his methodology, using the constraints of the mass printing process to achieve a precision of form.

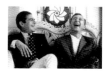

IRVING BLUM AND JASPER JOHNS, 1964

Jasper Johns was first shown in Los Angeles at the Everett Ellin Gallery, along with many of the important Europeans. Johns' work employed a neutral language of symbol to extend the questions posed by the Abstract Expressionists. By using the familiar images of flags, targets, and numbers, he was able to negate their content and return the focus to technique, color, and form. His concerns about New York School painting and his interest in the icon dovetailed with the areas of consideration for many of the Los Angeles-based artists. A year after this image was taken, Johns was to have his first retrospective at the Pasadena Art Museum, organized by Walter Hopps.

A colleague of Leo Castelli in New York, and partner to Walter Hopps, in Los Angeles, Irving Blum was intimately involved in the changes taking place in American art throughout the 1950s to 1960s. Returning to New York to partner the Blum Helman Gallery, Blum left behind him a legacy of innovation and risk in the West Coast art scene.

This series of photographs was taken on the porch of the artist's home.

JASPER JOHNS, 1964

JASPER JOHNS AND IRVING BLUM, 1964

JASPER JOHNS, 1964

CRAIG KAUFFMAN, 1964

JAMES ROSENQUIST

Foster & Klein billboard factory, Los Angeles, 1964

James Rosenquist was a prominent figure in the Pop investigation of commercial art and its objects. Rosenquist worked predominantly in collage, assembling images of the American environment in the 1960s. His work utilizes the visual language of advertising, focusing on a style-conscious presentation of consumable goods and their underlying psychological imagery. Dennis Hopper and Rosenquist had a shared interest in the aesthetic language of billboards.

ROBERT RAUSCHENBERG

Pelican, Culver City skating rink, 1966

Performed by Robert Rauschenberg, Viola Farber, and Steve Paxton

This second performance of *Pelican* was enacted at a local Culver City skating rink. The first of ten performances that Rauschenberg was to choreograph during the 1960s, *Pelican* was an expressive meditation on the technology of human flight. A tremendous presence in the art world, Rauschenberg was extensively involved in performance, producing both solo and collaborative works. In 1954 he and Merce Cunningham made their first collaborative performance,

Minutiae. A ten-year collaboration followed with the Merce Cunningham Dance Company, during which time Rauschenberg worked as a stage and costume designer.

ANDY WARHOL, The Factory (Andy in mirror), 1964

ROBERT RAUSCHENBERG, 1966

One of the most significant and influential artists of his generation, Robert Rauschenberg's explorations into industrial artifacts and popular culture, have created a body of work that has had a profound and direct impact on the nature of American art. A truly eclectic artist, he has explored every major artistic development of recent decades, including Minimalism, collage, assemblage, performance, lithography, and silkscreen. This wonderfully exuberant portrait of the young artist was taken at the wedding reception of Los Angeles County Museum of Art curator, Jim Elliott. Before posing for the photograph, Rauschenberg stamped his tongue with the stamp that Claes Oldenburg used on the bottom of his cake sculptures, bearing the words "This belongs to Oldenburg."

ANDY WARHOL and members of The Factory, 1964

ANDY WARHOL, The Factory (woman with banana), 1964

ANDY WARHOL, 1963

Arguably one of the most influential, and infamous, Pop artists, Andy Warhol explored the line between art and commerce, making reference to the visual language of advertising. Warhol's 47th Street Factory served as a laboratory for a new aesthetic, in a state of perpetual Happening, involving all media. Irving Blum was one of the first to recognize Warhol's work and offered him a solo exhibition at the Ferus Gallery. This initial Los Angeles exhibition was the beginning of a lasting relationship between himself and Dennis Hopper. The Factory's subversive spirit, clearly evident in Warhol's films, greatly influenced later independent cinema. In 1963 Hopper performed in the film *Tarzan and Jane Regained ... Sort of* directed by Warhol.

CIVIL RIGHTS MARCH, SELMA TO MONTGOMERY
U.S. historians, left to right: John Hope Franklin, John Higman, Arthur Mann, William E. Luchtenburg, 1965

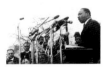

CIVIL RIGHTS MARCH, SELMA TO MONTGOMERY
Martin Luther King, Jr., 1965

CIVIL RIGHTS MARCH, SELMA TO MONTGOMERY
Full employment, 1965

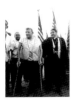

CIVIL RIGHTS MARCH, SELMA TO MONTGOMERY
Veterans, 1965

ROBERT WALKER, JR., 1964

PETER FONDA (with Edward G.), 1964

PAUL NEWMAN, 1964

PHIL SPECTOR AND TINA TURNER, 1965

PHIL SPECTOR, 1965

THE BYRDS, 1965

TINA TURNER, IKE TURNER, AND PHIL SPECTOR, 1965

BUFFALO SPRINGFIELD, 1967

RUDI GERNREICH MODEL, 1966

RUDI GERNREICH MODEL, 1967

RUDI GERNREICH with Model, 1966

Born in Vienna, Rudi Gernreich immigrated to California and founded his company G.R. Design, Inc. in Los Angeles in 1960. Without any doubt his most sensational design was the *Topless Swimsuit* 1964, which made him known worldwide. For some of the designs shown above Gernreich won a Coty Award. They demonstrate his *Total Look:* coats, suits, dresses, tights, underpants and bras – everything harmonizes perfectly. With many of his remarkable designs, as for example the first see-through clothes, the first knitted tube dresses, the tanga, the first designer jeans or the unisex-look of the 1970s he definitely changed the vocabulary of fashion for the twentieth century.

RUDI GERNREICH MODEL, 1970

RUDI GERNREICH MODEL, 1964

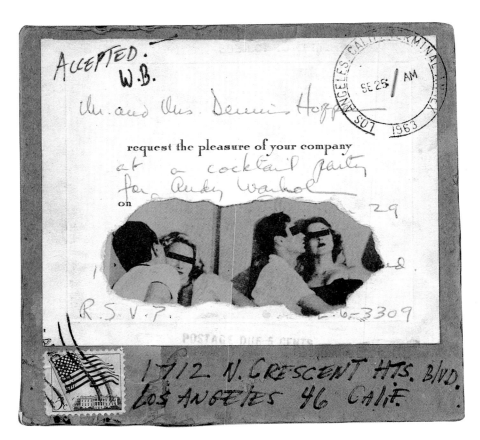

Brooke and Dennis Hopper's invitation to a cocktail party they hosted for Andy Warhol, 1963

Andy Warhol

POPism

Andy Warhol describes his encounter with Dennis Hopper in 1963.[1]

For my second show at the Ferus Gallery[2] in Los Angeles – the Liz-Elvis show – I rode cross-country from New York in a station wagon with Wynn [Chamberlain], Taylor Mead, and Gerard [Malanga]. It was a beautiful time to be driving across America. I think everyone thought I was afraid to fly, but I wasn't – I'd flown around the world once in the fifties – it was just that I wanted to see the United States; I'd never been west of Pennsylvania on the ground. [...]

I knew the whole thing would be fun, especially since Dennis Hopper had promised us a "Movie Star Party" when we got there. I'd met Dennis a couple of months earlier through Henry [Geldzahler], on the same day that I'd introduced Henry to the young English painter David Hockney. Dennis bought one of my *Mona Lisa* paintings on the spot and then he and Henry and David and I went up to the sound stage on West 125th Street where Dennis was doing an episode on the TV show *The Defenders*. [...] The farther west we drove, the more Pop everything looked on the highways. Suddenly we all felt like insiders because even though Pop was everywhere – that was the thing about it, most people still took it for granted, whereas we were dazzled by it – to us, it was the new Art. Once you "got" Pop, you could never see a sign the same way again. And once you thought Pop, you could never see America the same way again. The moment you label something, you take a step – I mean, you can never go back again to seeing it unlabeled. We were seeing the future and we knew it for sure. We saw people walking around in it without knowing it, because they were still thinking in the past, in the references of the past. But all you had to do was *know* you were in the future, and that's what put you there. [...]

We made it in to Los Angeles in three days. When we arrived, we discovered there was a World Series going on and all the hotels were filled. (Baseball had been big news in New York all summer, too – but only because the Mets lost over a hundred games in their second season.) We called Dennis Hopper and his wife, Brooke, right up and she called up her father, the producer Leland Hayward, in New York and got him to give us his suite at the Beverly Hills Hotel. (Her mother was the beautiful actress Margaret Sullavan, who'd killed herself the year before.)

Dennis assured us the Movie Star Party was on for that very night. The famous Bel-Air fire in 1961 had burned the Hoppers' house to the ground. Their new house out in Topanga Canyon[3] was furnished like an amusement park – the kind of whimsical carnival place you'd expect to find bubble-gum machines in. There

1 Excerpts from Andy Warhol, Pat Hackett, *POPism, The Warhol Sixties* (San Diego/New York/London: Harcourt Brace & Company, First Harvest edition, 1990): 35–45.

2 *An Exhibition by Andy Warhol* (Sept. – Okt. 1963).

3 Hopper's house was on North Crescent Heights Boulevard, West Hollywood, and not in Topanga Canyon.

were circus posters and movie props and red lacquered furniture and shellacked collages. This was before things got bright and colorful everywhere, and it was the first whole house most of us had ever been to that had this kiddie-party atmosphere.

Brooke and Dennis had met in *Mandingo,* a play that closed on Broadway after just a few performances. Dennis wasn't getting much film work at this point; he was doing photography then, and also, he was one of the few people out in California who collected Pop – he had my *Mona Lisa* painting up, and one of Roy's paintings, too. I'd first seen him playing Billy the Kid on one of those Warner Brothers television westerns in the fifties – *Cheyenne* or *Bronco* or *Maverick* or *Sugarfoot* – and I remember thinking how terrific he was, so crazy in the eyes. Billy the Maniac.

The Hoppers were wonderful to us. Peter Fonda was at the party that night – in those days he looked like a preppy mathematician. (He'd been on Broadway a couple of seasons earlier in a play at the same time that his sister, Jane, was doing her first Broadway run, too.) Dean Stockwell, John Saxon, Robert Walker, Jr., Russ Tamblyn, Sal Mineo, Troy Donahue, and Suzanne Pleshette – everybody in Hollywood I'd wanted to meet was there. Joints were going around and everyone was dancing to the songs we'd been hearing on the car radio all the way across the country.

This party was the most exciting thing that had ever happened to me. I only wished I'd brought my Bolex along. I'd left it back at the hotel. The party seemed the most natural thing to take pictures of – after all, I was in Hollywood, accompanied by an underground film star, Taylor. But I felt embarrassed about letting people see me with a camera. I was self-conscious shooting even people I knew – like the ones out at Wynn's country place. The only time I hadn't been shy about filming was with *Sleep* because there the star was asleep and nobody else was around. After a dazzling party like that, my art opening was bound to seem tame, and anyway, movies were pure fun, art was work. But still, it was thrilling to see the Ferus Gallery with the Elvises in the front room and the Lizes in the back.

Very few people on the Coast knew or cared about contemporary art, and the press for my show wasn't too good. I always have to laugh, though, when I think of how Hollywood called Pop Art a put-on! *Hollywood??* I mean, when you look at the kind of movies they were making then – those were supposed to be real?? [. . .] By this time I'd confessed to having my Bolex with me, and we decided to shoot a silent Tarzan movie around the bathtub in our suite at the Beverly Hills Hotel – with Taylor as Tarzan and Naomi [Levine] as Jane.[4]

Wynn knew a tall, red-headed kid from Harvard namend Denis Deegan out there who knew John Houseman, so then we did some filming at John's house, where we met Jack Larson, who'd been Jimmy Olsen on television's *Superman* and who at this point was writing operas. We all went down to the pool and Naomi took her clothes right off and jumped in the water. Taylor was supposed to climb a tree but he couldn't, so he yelled for a stunt man. Dennis [Hopper] appeared and climbed the tree to get a coconut for him. When Taylor saw the rushes back in New York, he said, "You know, I've always liked Dennis's acting, but it's usually so rigid. This is the most relaxed on camera I've ever seen him." In '69 when *Easy Rider* came out, Taylor reminded me of that day again. "I think that afternoon by the pool was a turning point for Dennis," he said. "It opened up new possibilities for him." Maybe so, I thought. You never know where people will pick things up and where they won't.

4 Andy Warhol, *Tarzan and Jane Regained . . . Sort of* (1963).

THE LOVED HOUSE
OF THE DENNIS HOPPERS

BY TERRY SOUTHERN

The Den Hoppers are tops in their field. Precisely what their field is, is by no means certain—except that she is a Great Beauty, and he a kind of Mad Person.

I remember several years back my first meeting with Hopper—at the outlandish East Fifth Street pad of Allen Ginsberg and Peter Orlovsky—during what must have been one of the first "happenings" ever to occur in New York City. Orlovsky was playing on some sort of strange Eastern timpani, and chanting *sotto voce:* "Blood in the milk, blood in the milk, blood in the milk . . ." while Allen, dipping a rolled copy of *The New York Times Book Review* into a large can of honey, inscribed hauntingly cryptic word-images across the far wall. In one corner a movie projector was rattling away, showing Buñuel's *L'Age d'Or*, in reverse, but was focused through an open door, so that nothing could be seen except when someone happened to pass through the stream of shuttering light. In the centre of the room an electric fan was lying on its back, blades up, whirling violently—and crouched beside it was a marvellous stark naked Negro girl of about twenty, holding a huge paper sack from which she took handfuls of what was apparently a mixture of rose petals and dog hair and dropped them into the fan, so that the room was like a kind of silent snow storm, all slow motion, the people moving about as in the softest dream. It was pretty weird, now that I think about it. And Hopper—who even then was probably one of the most talented actors alive—became quite excited by the spectacle and eager to take a part, gliding around in a Marcel Marceau manner, grimacing oddly and, at the same time, attempting to take photographs with a 135 mm. Nikon.

"No point to photo," shouted Orlovsky, "unless there is treacle on (Continued on page 142)

Up in the Hollywood Hills, above the Sunset Strip, Mr. and Mrs. Dennis Hopper (portraits, *above left*) have a house of such gaiety and wit that it seems the result of some marvellous scavenger hunt, full of improvised treasures, the bizarre and the beautiful and the banal in wild juxtaposition, everything the *most* of its kind. *Left*, Mrs. Hopper, who is the actress Brooke Hayward, poses in a red leather chair for Robert Walker, junior. The pillow reads "Long May It Wave." *Opposite*, Mrs. Hopper's two sons, Willie and Jeffrey, with the Hoppers' three-year-old daughter, Marin, at Watts Towers, the romantic and extravagant constructions which—encrusted with and broken bottles and old dishes, fantastic and enchanting—suggest very well the Hoppers' approach to their own house. *Opposite, above*, through the house, colour, verve, things in happy, anomalous coexistence. Here, a Frank Stella painting an art nouveau stained glass panel, a Roy Lichtenstein painting

DENNIS HOPPER

THE HOPPER HOUSE

To visit the Hopper house is to be, at every turn, surprised, freshly beguiled by a kaleidoscopically shifting assemblage of found objects, loved objects, *objets d'art*. *Above left*, startlingly supine on the living room ceiling, a larger-than-life papier-mâché clown, spotted by the Hoppers in a travelling exhibition of Mexican folk art. On the wall, a Lichtenstein "mad scientist" canvas. *Above right*, a French pitcher, Mexican paper flowers spilling from metal bowls, an art nouveau panel. *Below*, the view from the kitchen window of a 750-pound fibre glass sedan, part of a billboard retrieved from a junkyard, the effect reminiscent of a line from Terry Southern's *The Magic Christian*— "There's power to spare under this baby's forty-foot hood." *Near right, above*, in the entrance hall, a three-dimensional carousel horse, spangled with brilliants, apparently ridden by the two-dimensional girl on the circus poster with its two-dimensional horse. Overhead, a revolving mirrored ball, the kind everyone used to dance beneath in places with names like the Aragon Ballroom. *Near right, below*, on the kitchen cupboards, collages of old fruit-can wrappers. *Opposite page, above*, in the Hoppers' bedroom, an Italian brass bed with sailcloth curtains, a cut velvet spread. Dennis Hopper, who designed the woollen rug, had it woven in Mexico, for eight dollars, when he was on location acting in *The Sons of Katie Elder*. On the wall, left to right: a Helleu drawing above a Lichtenstein painting; an oil tapestry of water lilies, bought at auction; an Icart woman on a bear rug; a John Steuart Curry scene of Paris. On the table, photographs of Mrs. Hopper's father and mother, Leland Hayward and the late Margaret Sullavan. The throne chair in the corner was a studio prop. *Opposite page, below*, on the dining room walls, a 1907 Budweiser girl and a Chéret poster. In the hall, one of several streetlights in the house. On the living room wall: a Marcel Duchamp found object; above it, the Mona Lisa in duplicate by Andy Warhol.

THE POP FATHERS

Dennis Hopper has known the Californian artist Edward Ruscha for almost forty years. On the eve of Ruscha's exhibition in the Anthony D'Offay Gallery in London (May – June 2000) they talk about art, Los Angeles and Pop.[1]

EDWARD RUSCHA: I remember back when you lived on [North] Crescent Heights [Boulevard]. And I think one of the first things I saw you had done was that work *Draw Me and Win an Art Scholarship* which you had in your garage right there. And I think you also had *The Bomb?*

DENNIS HOPPER: *Bomb Drop.*[2] I made that for Betty Freeman. And I was out junking and I found this WW2 bomb drop thing and I thought that would be a great thing to make into a light machine. And she looked at it and was horrified at the whole concept. She never accepted it. I think she gave me $1,100. As soon as *Easy Rider* hit she asked me if she could have the $1,100 back!
But when did you have your first show? I remember seeing your first painting out at Pasadena in 1962.

RUSCHA: *New Painting of Common Objects.* That was supposedly the first Pop Art show. Except that they called it *Painting of Common Objects.*[3]

HOPPER: I have been asked about how your art affected me. And, you know, once you started isolating the words in your work — my whole way of looking at things changed. And suddenly, everywhere I look when I see a word or something, I relate back to you. Because I think most of the time in art terms. So when I'm in the street I constantly see things. I see a lot of words that I used to say, "I wonder why Ed never did that word?" And now I say, wow, he was so hip not to do that word! But it certainly has opened up a whole way of looking.

RUSCHA: And then in 1963 and '64 I showed the gas stations and the word paintings like *Electric* and *Smash* and *Flash.*[4]

1 Excerpts from an article first published in, *The Independent* (April 30, 2000).
2 See p. 147.
3 *New Painting of Common Objects* (Sept. – Oct. 1962), exhibition organized by Walter Hopps at the Pasadena Art Museum, L. A. which included works by Roy Lichtenstein, Edward Ruscha, and Andy Warhol.
4 Edward Ruscha had his first one-person show at the Ferus Gallery, L. A. from May – June, 1963. In Oct. 1964 Ruscha opened an exhibition at the Ferus Gallery showing his *Standard Station* series of painting.

HOPPER: That was a sensational show.

RUSCHA: We were lucky enough to have all these people around us, all these cerebral artists like Kenny Price, Joe Goode, Ed Moses and then you had the cut-ups like Billy Al Bengston and Ed Kienholz and the religious ones like, I would put Wallace Berman and George Herms in there, they're almost religious in their approach. We had all these various people, who were in California but then we always could reflect on the people from New York, too.

HOPPER: The second that I saw your words, I saw Andy Warhol's soup can, I saw James Rosenquist's billboards, I saw Roy Lichtenstein's cartoons, man, I said, this is a return to reality. This is really it, whether people accept it or not. And this is really where we are, what we are. But then you did something that I call real surreal, like the fly on the paper.

RUSCHA: I always felt like I was so closely related to abstract art that maybe the fly is just like a splatter of paint or a drop of something. It didn't even have to be a fly, it could have been a marble or it could have been a rock or it could have been anything. But how do you think that this city [L. A.], this particular city, affected you with your art and your acting?

HOPPER: Well, first of all, this city is not very visual to me. So your shots of Sunset Strip and also the apartment buildings are really important to be able to find some sort of aesthetic value here. Because I have a hard time with that in L. A. I don't find it particularly attractive. But you've helped enhance it. David Hockney's helped to enhance it too in a way with his swimming pools. But for me L. A. is a very unvisual place. And so when I drive every day and see the graffiti, all I see mostly is this relationship between the gangs in the city and these Rothko-kind of images that become these colors on colors on colors. And also the chain link. And I suppose the steel siding and stuff that are actually materials that I live in, which come out of Frank O. Gehry and out of Brian Murphy and out of this whole aesthetic. That and the razor wire, in my thinking, are very much part of my concept of what I consider landscapes of L. A. It's the graffiti which now I'm making set kind of pieces from — the wall assemblages.

RUSCHA: In some ways the galvanized metal and the chain link suggests anxiety, there's something about it that's fitting. To be in a city like this. Symbolically, though it's kind of neurotic in a way, isn't it. It's got that edge to it. But at the same time it's beautiful. But then corrugated metal is supposed to be industrial. And chain link fence means: keep out! So the value of it comes through when you live here in the city.

HOPPER: It's amazing that when I look at L. A. I see Ed Ruscha. It makes a lot of something which was never aesthetically OK with me. By your taking the apartment buildings and those various places, that gave me a whole new appreciation of that look. Because it's only here in L. A. really that you see that kind of thing.

RUSCHA: You know they say that art is supposed to be beauty, and so art must be beautiful, and beauty is art and all that. And yet, these things that I take pictures of, I can't even say that I think they're beautiful. So I'm not taking pictures of them, or I'm not illustrating them because I think they're beautiful necessarily. But

that they've got some kind of primal answer there. And so for that reason when I drive down the street, I kind of love this place and I hate it, too. You know, it's ugly and it's beautiful. So these words are almost interchangeable.

Is there anything that you've done in the world of acting that you felt has been as close to something you might do with your art. Like in your photography or sculpture?

HOPPER: Well, my life has been sort of strange because I never really did any work here after a certain point that wasn't manufactured. When I lost all my paintings in 1961 in a fire, I tried to paint again. I couldn't really paint any more. And I started assembling objects with photographs. It was things I could manipulate and manufacture. But, when I started to paint again, which was much, much later I was in Taos, New Mexico and I was isolated up there and I wasn't able to work in film any more, and I needed a creative outlet of some kind because I was going nuts. And so I started painting again. The thing I really dug was being an Abstract Expressionist, so I could just attack a canvas like an actor would attack a role. I allowed me to just behave like an action painter. But it was so sporadic, it was like creating art in a void when I couldn't do anything else. So I'd go and release myself that way. But it's so uneven because I would only paint in Taos. When I was back here I'd be doing other things. But the joy was just being able to release myself. And to try to emulate various things. Then when I started doing *Colors* and relating to the gang graffiti and stuff it allowed me an opportunity to be able to draw with the spray and then be able to cover it up and to be able to really play in a way that was really fun for me to do. And I had a reason to be an action painter. But at the same time I'm still working on Polaroids, so it was becoming something else. I was attacking like an action painter but I was also using other things, references, and I was thinking of them as landscapes and not so much as abstract painting. When you talked about putting down a fly or a drop of water, and talking about it, thinking about it in Abstract Expressionist terms, explain that a little more to me.

RUSCHA: I never know what's needed to make a work of art. It's just a bunch of hormones that come together and I can't explain it. It's a non-verbal medium to me. Making art. And yet, what am I doing putting words in things if it's a non-verbal medium? But everything that I put into my work goes back to some sort of notion that might be centred in abstract art. So that the fly that's out there at the edge of the picture, could easily be a smudge, a fingerprint, a drop of water, you know, it could be anything really.

HOPPER: Do you think of yourself as a Pop artist?

RUSCHA: I guess I am, I mean, pop is popular. The Abstract Expressionists: those people were Pop artists too. They respected automobiles, speed, fast American life, they lived mostly in big cities like New York, and New York was crass and commercial. And these guys were living life to the fullest, and painting pictures at the same time. So they're as much Pop artists as we are. The imagery is a different story. These people are making art, and really appreciating all the same things. The modern, the paranoia of modern life, and objects that were never considered beautiful that are now considered possiblities for art. So popular objects, popular art: Pop Art. But popular was also coming out of the commerical area. And using things that had never been used before, like the side of a billboard, or a tomato soup can or a Coca-Cola bottle, or a word.

A word of selling. To sell something in our society was also part of this commercial idea. That became an icon of its own in popular culture. And also the techniques. I mean, the silk screen had never been used before by fine artists. And making large things the size of billboards. Or the comic book. Which also again used words. All these artists came out as a reaction to this more cerebral painting of Abstract Expressionism which was supposedly more religious in its content. And here you have a bunch of guys that come along and they pick ugly subjects, unacceptable subjects and then you've got a rebellion. So there's the rebellious aspect of it too. And that's really nothing new, when you look at art history, it just goes in these cycles.

HOPPER: And this was a return to reality, almost. And a return to reality was the word, was the images, the hard sell?

RUSCHA: Was the soup can.

HOPPER: Was the soup can, and the hard sell of America. And our education, our comic books and or bill-boards everywhere.

RUSCHA: So when I went to New York and I went to Leo Castelli he said, "They come on back and let me show you something." And he showed me this painting of Roy Lichtenstein's of a pair of sneakers. And then at the same time I met Warhol and went over to his place and saw these things that he was doing and he'd play the same song 24 hours a day which was *I Will Follow Him* sung by Little Peggy Marsh. And I thought to myself "God, man, we're kindred spirits." I see that we're kind of doing the same thing. But the pheno-menon of Pop Art really happened in New York, and so anything that wasn't there, was not, at that time, considered Pop Art.

HOPPER: Right, but you were there, showing with Leo Castelli, you were there exhibiting in the same venues, when Lawrence Alloway adopted the name "Pop Art."

RUSCHA: Didn't that come from an Eduardo Paolozzi collage?

HOPPER: No, it was Richard Hamilton, the picture where he had the muscle man with the lollipop.[5]

RUSCHA: You know that was supposedly the first Pop Art piece and it took an Englishman to see it, I guess, which Alloway was.

RUSCHA: And Robert Fraser was there, he knew more about American music that anybody ever knew. We had that show in 1966, I guess it was. Robert Fraser's gallery on Duke Street.[6]

HOPPER: Well, I've got a catalog of it somewhere. But, yeah, it was vital man, wasn't it. Absolutely vital. People were going berserk and yet it was under control somehow. England was the most explosive creative place.

5 Richard Hamilton, *Just what is it that makes our today's homes so different, so appealing?* (1956).

6 The Robert Fraser Gallery opened in 1962. Fraser represented many of the British Pop artists such as Eduardo Paolozzi, Richard Hamilton, Derek Boshier, but also gave shows to American Pop artists such as Claes Oldenburg and Jim Dine. He also staged the memorable California exhibition, *Los Angeles Now* (Jan. – Feb. 1966), that featured Edward Ruscha, Wallace Berman, Bruce Conner, Llyn Foulkes, and Dennis Hopper among others.

Man Who Has Five Wives Has Tough Row to Hoe

Confucius (551–479 BC)

This a joke on my part, Confucius never said such a thing, but doesn't this have the language of a piece of graffiti on a wall? In truth, the five wives are meant to be the subjects of painting, photography, film, acting, and surviving, and not in that particular order. Think of these wives as little gears in a mechanism that rotates within Dennis Hopper's soul. These are the areas in which he has placed himself.

In 1964 I went to see him at this house in the hills on North Crescent Heights Boulevard. His father was visiting from Kansas and as we stood on the street Dennis opened his garage door to reveal a tightly packed collection of his own art. Among these works was *Draw Me and Win an Art Scholarship* (1964), a Plexiglas piece resembling a store display. However this work came to be, his commitment to an offbeat issue was deliberate and direct. He was addressing popular culture in a head-on manner. His photographs also confronted aspects of both the glamour and struggle of daily life. My memory also takes me back to *Bomb Drop* (1967–68), a good-sized sculpture with giant levers. Compare it to the pantheon of conceptual sculpture of the last four decades and it's laughable how original it is.

Then comes the bearing of one's soul in front of and behind a motion picture camera, and there is no doubt that this man is able to express a very lean kind of neurotic anxiety. In this respect, I've been baffled as to why more actors and entertainment people have no interest or kinship with the plastic arts of painting or sculpture when, all the while, they are very much a part of the expression business. Dennis is really the obvious exception to this fact.

Living here in an accelerated culture and hearing police sirens and running feet the other day, I thought of Dennis Hopper. I could see him checking the back of his hand for the right ASA reading then I could hear the whirring-ka-chunk of a Nikon. He's been doing all this for several decades, hasn't he?

Ed Ruscha

George Herms

TWINE

The story of two artists who began in the 1950s and are at the top of their game in 2001.

To understand the ideas and ideals of Dennis Hopper, I have unfolded the origami bird of our mutual artistic endeavors … The use of the word "we." Enjoy the difference.

We didn't come out of the art school tradition.
We were audience.
We were omnivorous.
We were emulating
Or began to emulate
The living masters.
The actors from childhood
All of life raw material
For the work.
We made masterworks
Before we could paint or draw.

We wept
In the face of great art
Came up off the canvas
And came out swinging.

Inspire by the improvisational
Skills of jazz musicians.

STONE BROTHERS

Our first art was performance art. How to be an audience is an art form. We both mastered it in darkened rooms. Like "Plato's Cave" we experienced the truth. In poet's reading … We receive the gift … And went

forth each to make art.

We took different paths. They many times crossed and became entwined.

Could the existentialists in the middle of the twentieth century have conceived of *l'homme engagé* in our

2001 world of media overload, marketing, celebrity bartering and cyber-heroics?

Would that "engaging" of *this* world, not be personified by Dennis Hopper?

We both engaged, from foreplay to climax.

We wanted each day

to make love

make art

make money.

All artists have had to wrestle with certain crossroads.

CROSSROADS I: The Camera

The camera released artists from the role of "recording secretary."

Painters could begin the journey of abstraction and the portrayal of dreams.

By the time Dennis Hopper and George Herms emerge in the mid-twentieth century the camera has become

part of an artist's palette.

The camera can interfere with the flow of life … people begin to pose …

The photographs of Dennis Hopper address this problem.

CROSSROADS II: Moving Pictures – The Movies

How life changed as the movies began to *capture* the public's imagination.

What began as documentation turned into influence. Movies, and then television,

began to "WAG THE DOG."

The moral questions began to be answered by actions of actors.

How does one behave? What is cool? What is desirable?

DIRECTOR AND SOLITAIRE

The artist in the studio alone, working with inanimate objects. Playing solitaire … freedom and loneli-

ness …

The director controlling many in the production of a movie.

The most communal of creative activities, always a challenge to the hermit …

The individual psychological pendulum swings … The isolation and prayer of the mountain top meets the

evangelist in the massive tent show.

Two paths … Intertwine.

Baroque art with the invention of the microscope and the telescope began the journey to new landscapes. With the introduction of sex and violence to Renaissance ideals, art came closer to a real humanism. Two approaches – mine: denial and alchemical sublimation. Hollywood's approach is to use sex and violence to sell movies.

In 1962, Dennis Hopper and a friend took me to the Conejo Ranch north of Los Angeles. There a ghost town, used in making Westerns, was abandoned. Sun bleached, weathered wood and rust made the movie set look like perfect raw material for my junk sculptures. This way of working with found objects had recently been dubbed assemblage. As we wandered around the facades, so real from the front, and yet just lumber struts in the back, we talked of the possibilities for works of art.
I proposed building a junk cathedral on the Conejo Ranch using the material from the ghost town and the ranch garbage dump. None of this came to fruition at the time. But years later the idea of a movie set as reality surfaces in *The Last Movie.*
In this retrospective, Hopper has taken the found object technique to unique heights with his freestanding sculptures. Literally found in his path as a moviemaker … Just as Kurt Schwitters found a cigarette butt in his path as a "collagist."

THE BALLADE OF THE GROOVE GROVE

In the middle of 100 acres in a canyon in the mountains of Malibu, I lived in splendid isolation with my wife, baby daughter, dogs and cats, puppies and kittens. The wooden cabin had no electricity or plumbing, but excellent spring water. We lived completely surrounded by nature, in the middle of Beaudelaire's Triangle: (Poetry, Art and Music).
We had turned our backs on urban civilization …The beginning of a return to our roots in pre-Columbian North America.
The old Packard had died and as I stripped it I found enough collage material for an entire exhibition.[1]
A twenty foot tall pyre was prepared for a film by Dean Stockwell called *Moonstone.*
This was the GROOVE GROVE. Into this happy idyllic scene Dennis Hopper came in late 1962 or early 1963 and shot the photograph that appears in this exhibition.
This photograph (wherein I am carrying my baby daughter, Nalota and tossing a ball in the air) is one of the rare portraits of an artist in nature among the many artist portraits shot by Dennis at this time.

THE DIRECTOR TO THE SET DRESSER
"I want it to look lived in."
EASY RIDER [2]

The commune scene centered around a "kiva" built from an American Indian design. Dennis Hopper asked me to fill the inside of the kiva with my artwork.
From the nearby community of Topanga we brought paintings, prints, collages, assemblages, sculptures

1 Aura Gallery, Pasadena (1962).
2 George Herms along with Wallace Berman was given a cameo in *Easy Rider*, both playing commune members sowing seeds.

… One was a doll with a wind up heart that when wound up, ticked (Billy and Captain America paused, in the film, to listen to the heart).

Along with the art work my wife and children came to be part of the commune family. The days spent shooting high in the glorious southern California mountains with friends and family were truly beatific.

When Dennis ran down the story of *Easy Rider* to me, the ending seemed so dismal, I suggested an ending variation, based on Richard Strauss' *Tyl Eulenspiegel,* a work, where the impish troublemaker Tyl is finally caught and put to death. At the end of the tone poem, one hears Tyl's theme, still full of mischief, on high, in the clouds.

I have always felt Dennis naturally did this with the camera, at the end of *Easy Rider* … as we pan back, up and away.

IN THE RIGHT PLACE, AT THE RIGHT TIME

Under Mexico City, the excavation for a subway was halted when they came across remnants of an ancient civilization. Work was stopped and archaeologists then unearthed the find of the century. Evidence of a matriarchy in the form of a huge stone sculptured calendar.

The President of Mexico was summoned to come underground to see this unbelievable find. Before the President arrived, Dennis Hopper was there and had already photographed the ancient work of art!

He later sold the photos to *Newsweek* magazine.

Where did Dennis come from? How many times was he on the scene … on the spot … in the world of art, Hollywood, the civil rights movement?

This gift of being almost prescient is rare.

WE ARE TWO ARTISTS

with faith in the plastic arts and their ability to show the essence of life experiences … to document the inner articulations of the heart, and the outward manifestations of our culture.

When Dennis saw my 1979 retrospective, he said: "Your works are the best record of the sixties – better than all the writings. They truly capture the spirit of those times."

SCALE AND COMPLEXITY

In the parking lot outside the L. A. Sports Arena a huge truck sits. Multiple cameras inside are documenting a Neil Young concert. When I saw the ten monitors feeding ten points of view to this command post, I turned to Dennis and said: "If I had the money I would buy one of these trucks and give it to you for your birthday!"

As a director Dennis thrives on such complexity. He told me that as a young actor between shots he studied all the details of movie making. Amassing an education that would pay off years later when be becomes a director.

Along with the capacity to organize the complex (now called multi-tasking), Dennis has a feeling for scale. The issue of scale is crucial to an understanding of this exhibition and Dennis' contribution.

Scale could be considered CROSSROADS III. Our psychological reactions to a work of art vary when it is: 1. Smaller than life-size, 2. Life-size, 3. Larger than life. Our reactions are also quite different if we see a film in a theater on a huge screen or view it on a television monitor.

If smaller we feel god-like, capable of looking down on – perhaps even able to manipulate … If life-size, there is a feeling of equality – looking straight into the eyes of the work. If larger than life, we have to look up – in awe or worship or fear.

When Dennis takes a photograph (*Double Standard,* for example) that one is used to seeing at about the size of a television screen and blows it up to the size of a billboard, the effect is almost shocking.

The scale becomes equivalent to opening a book and walking into center stage of the action.

Not all works can be made monumental. Not every postage stamp makes it as a billboard. The weakening caused by diffusion has to be addressed. Dennis' work in film is related here. The close-up, the zooming in or the zooming away … as in the pulling back at the end of *Easy Rider.*

One also has to come to grips with museum scale of the present day. The museum audience likes to stand in awe of scale. Some work, like my own at times, proceeds from the intimacy of a Joseph Cornell box. Is this "larger is better" concept American in origin? For better or worse, Dennis and I do arise from the American landscape.

CODA

The intertwining of our quite different paths and our decisions at major crossroads all lead to a woven tapestry of the late twentieth century and the early twenty-first century.

As we gaze at the serpentine future our twin visions merge in perspective. All hail the great unknown vanishing point.

134 UNTITLED, 1955 Oil on canvas

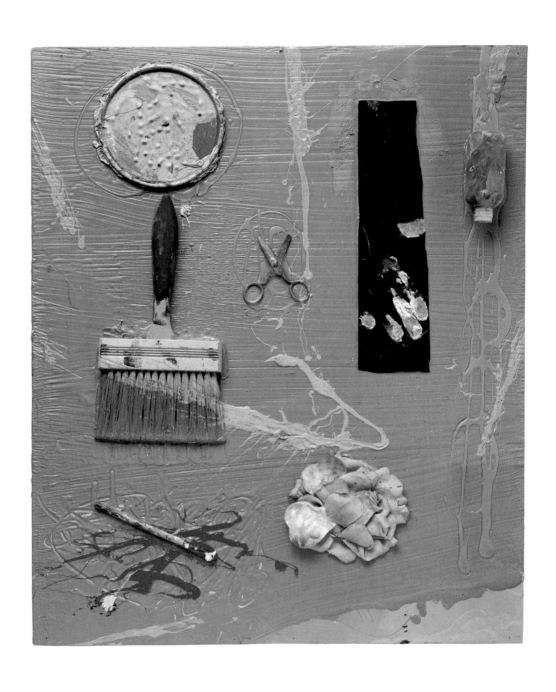

UNTITLED (With paint brush), 1961 Oil on canvas

PROOF, 1963 Woodblock, photograph, and paint on board

CHIAROSCURO, 1963/2000 Gelatin silver print on aluminium mount and wood mannequin heads (restored version)

PRESTO, 1961—64 Photograph with object

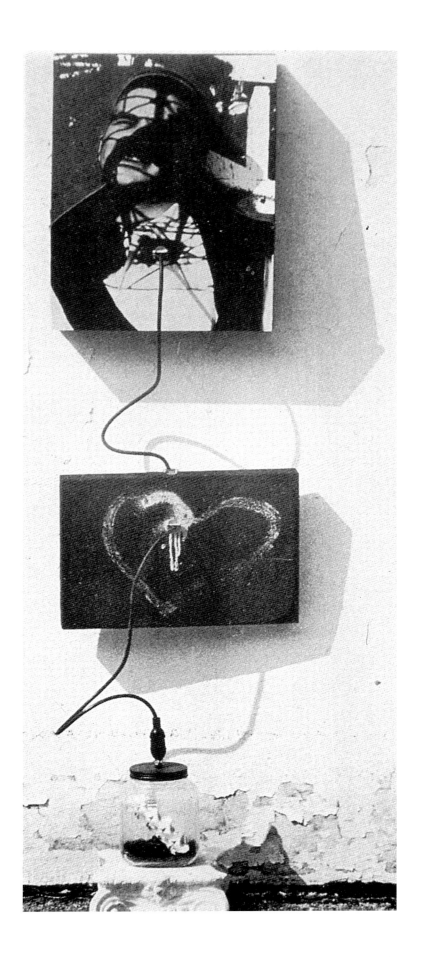

JARRED CONNECTION, 1962/2000
Glass jar, cement pedestal, black electrical wire, metal clamp connectors, electrical plugs

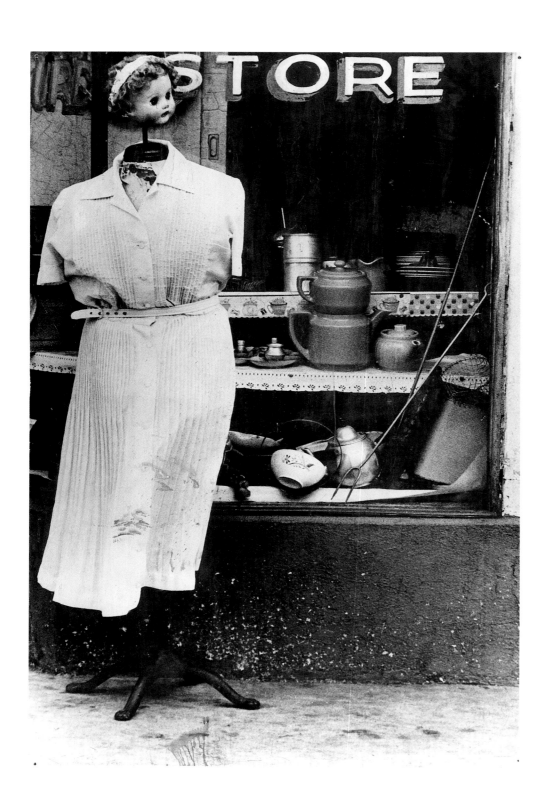

UNTITLED (Store), 1961—64 Photograph with objects

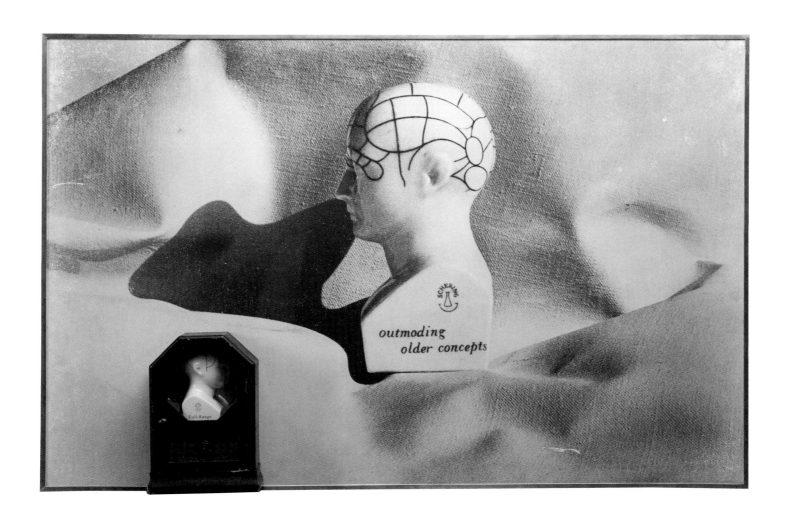

WILHOLD THE MIRROR UP, 1961 Photograph and assemblage in plexi-box

142 DRAW ME AND WIN AN ART SCHOLARSHIP, 1964/2000 Plexiglas, two views

AFTER THE FALL, 1961—64 Photograph with object

Marcel Duchamp/Dennis Hopper
HOTEL GREEN (ENTRANCE), 1963
Oil paint on wood panel

UNTITLED SCULPTURE (The Chevy Piece, 1956), 1956/2000 Urethan foam, fiberglass, and automotive paint

COCA COLA SIGN (Found object), 1962
Tin sign with glass thermometers

BOTTLE RACK (Found object), 1960 Metal

146 THIS IS ART (Marcel's dilemma), 1997 Neon sign

BOMB DROP, 1967–68/2000 Plexiglas, stainless steel, and neon

148 ROPE, 1961 Gelatin silver print

GRAFFITI HEART, 1961 Gelatin silver print

NEWSPAPER AND STREAMERS, 1961 Gelatin silver print

STEP-SONS WILLIE AND JEFFREY THOMAS, 1964 Gelatin silver print

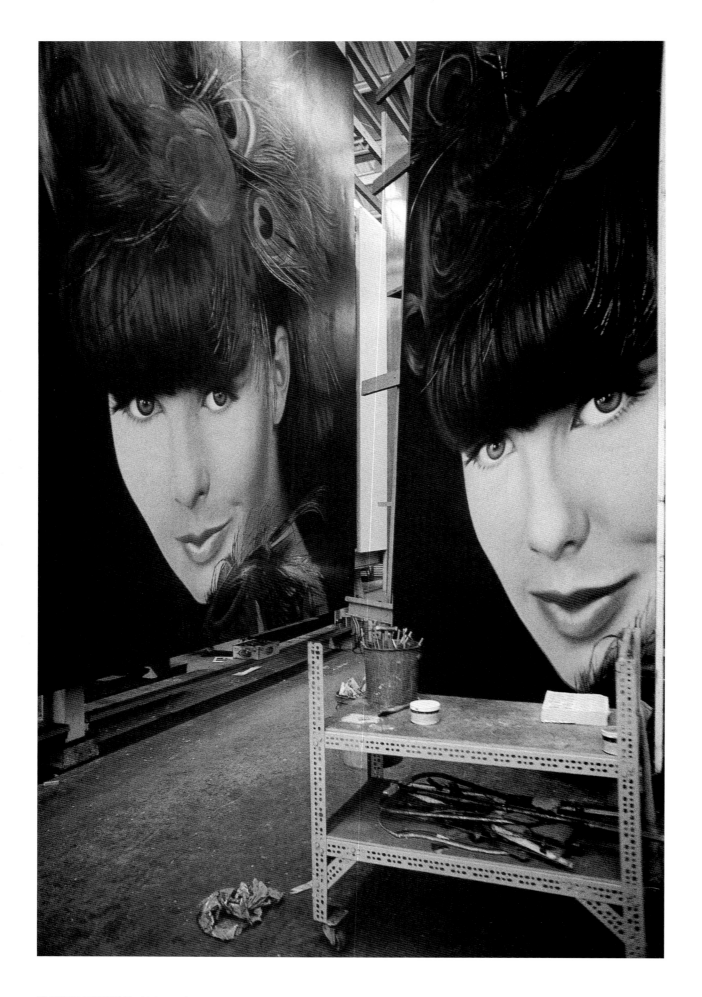

152 BILLBOARD FACTORY (Double brunette), 1961–67 Gelatin silver print

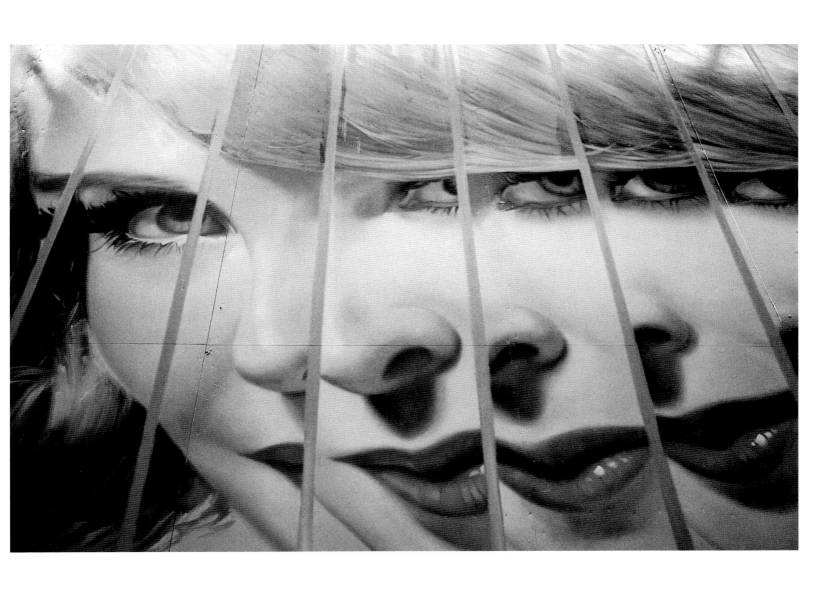

BILLBOARD FACTORY (Multi image of a woman's face), 1964
Gelatin silver print

page 154/155
BILLBOARD FACTORY (Multi image of a woman's face), 2000
Billboard, water based primer, oil paint, matte varnish on vinyl

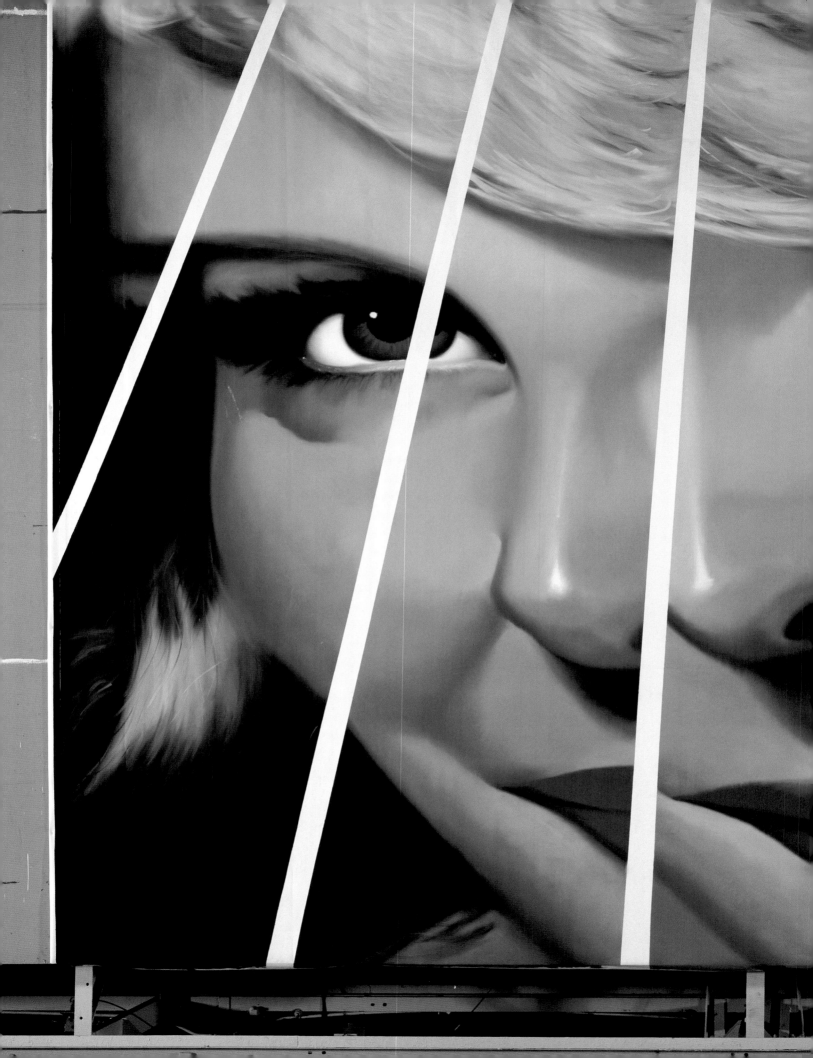

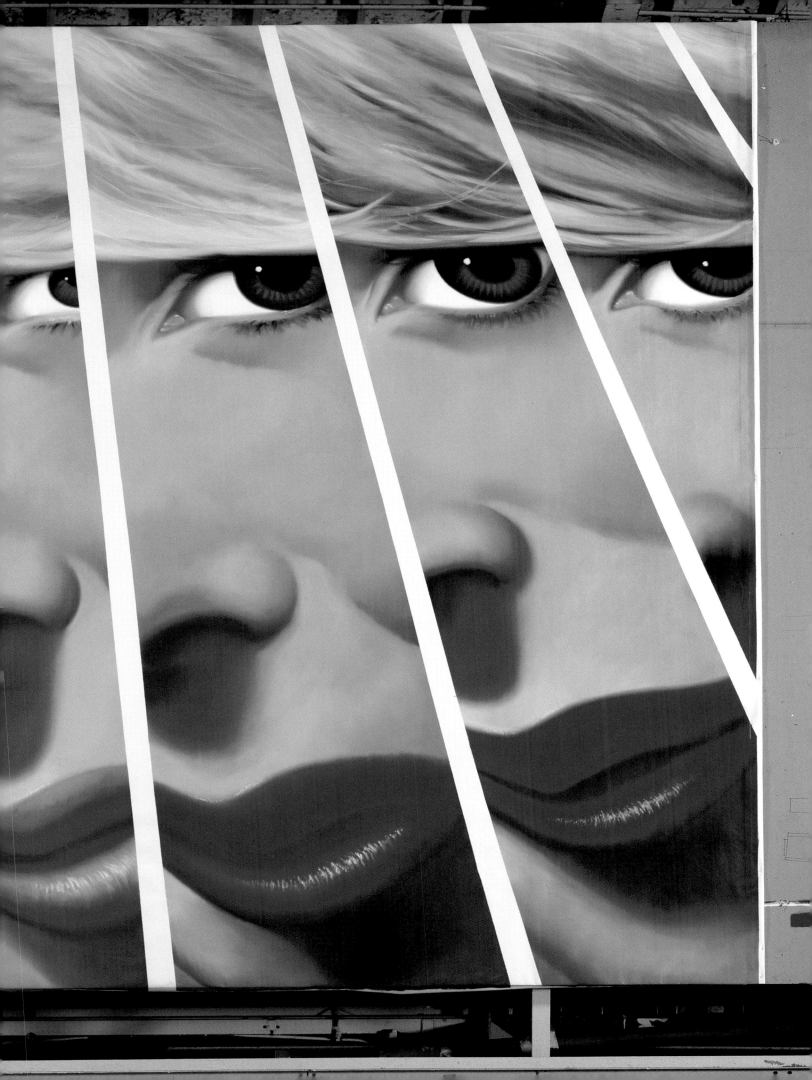

TORN POSTER (Elect), 1965 Gelatin silver print

TORN POSTER (Girl), 1964 Gelatin silver print

LOS ANGELES (Eye on fence), 1995 Color photograph

UNTITLED #7 (Old plywood wall with graffiti), 2000 Wall assemblage, mixed media

page 168/169

UNTITLED, 1991 Polaroids

UNTITLED #4 (Corrugated fence), 2000 Wall assemblage, mixed media

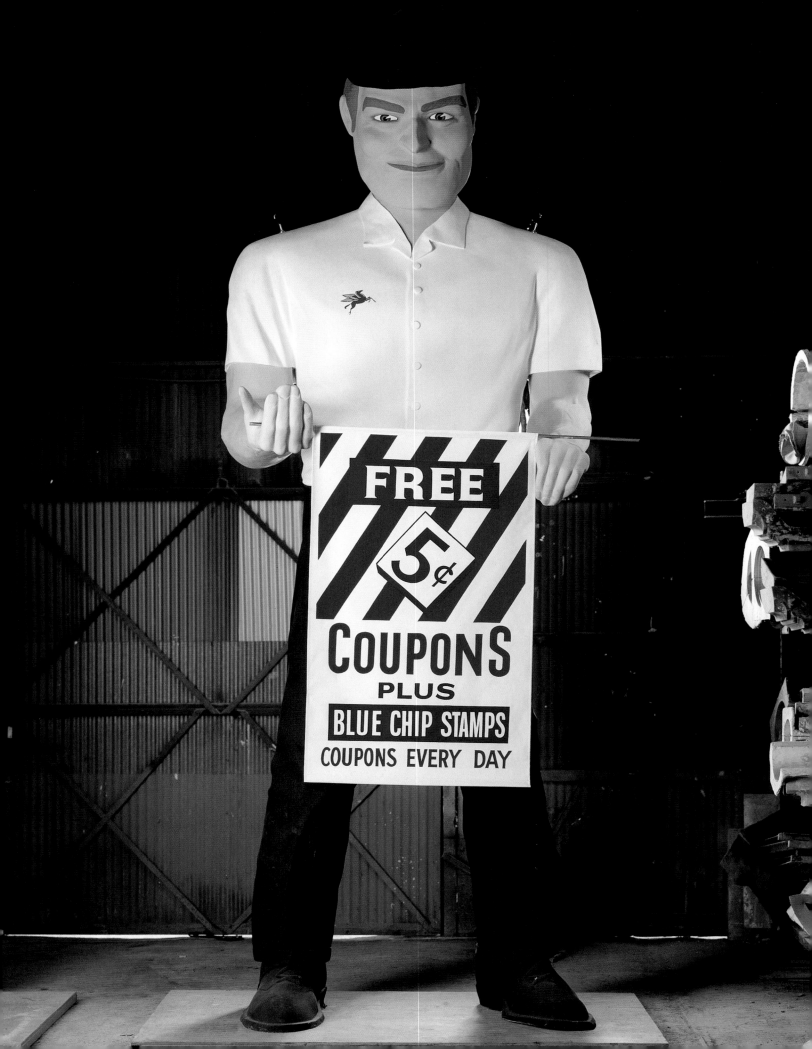

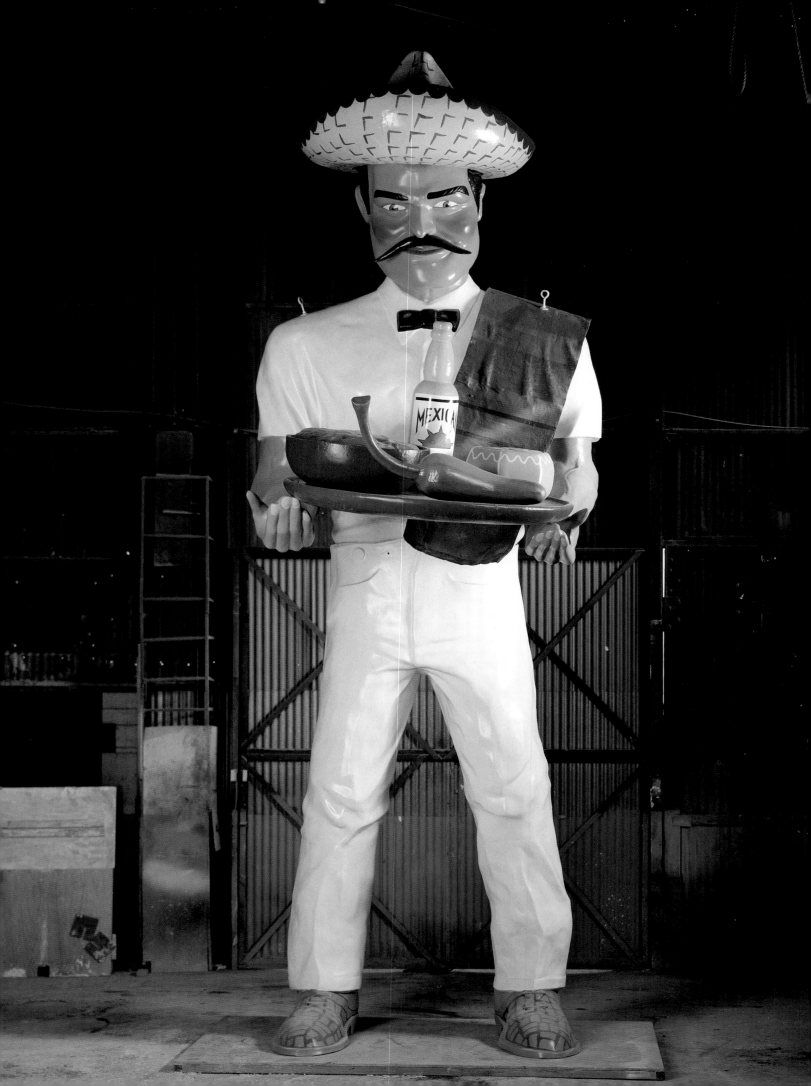

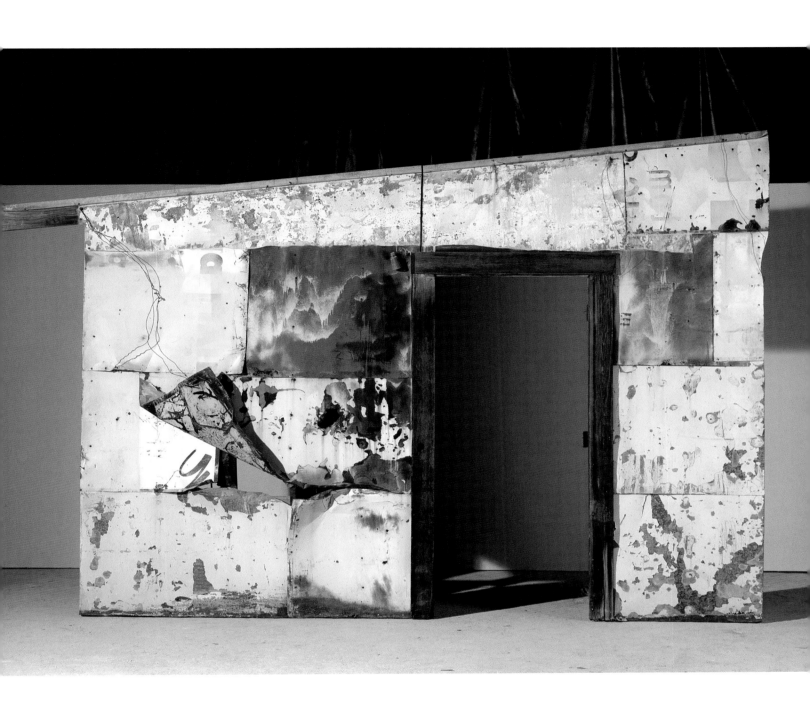

UNTITLED #10 (Old metal wall), 2000 Wall assemblage, mixed media

page 170
UNTITLED (Representation of Mobil Man), 2000 Fiberglass with steel frame and paint

page 171
MOBIL MAN, 1961—67 Gelatin silver print

page 172
UNTITLED #11 (Representation of Man from La Salsa), 2000 Fiberglass with steel frame and paint

Fred Hoffman

THOUGHTS ON THE RETURN AND ARTISTIC MATURATION OF DENNIS HOPPER

Fred Hoffman, gallerist in Los Angeles, speaks about Dennis Hopper's art work in the 1980s and 1990s.

The latest phase in the artistic career of Dennis Hopper began sometime in the first half of the 1980s with his return to Los Angeles and serious re-engagement in the contemporary art world. After having become a central figure of the Pop era, and as is brilliantly documented by the photography corpus, *Out of the Sixties,* Hopper was virtually absent from Los Angeles for the entirety of the 1970s. In making his way back to L. A., he was making his way back to a great many things, foremost of which was his desire to create and participate in the then re-vitalized contemporary art world.

One of my earliest personal encounters with Hopper was at this critical moment around 1984. At this time he would frequently visit my first art gallery. What was unique about these visits, and what still today has separated my experience and impression of Hopper from so many other figures in the contemporary art world, was his intense, seemingly methodical approach to the viewing of a work of art. Hopper would literally view and re-view a show for hours, pondering over each work from countless directions. He would study and re-study; so much so that I would often wonder if there wasn't another agenda to this viewing process besides the mere enjoyment of another artist's pictorial offerings.

Over time I saw Hopper employ a similar viewing process to the works of a great many artists, many of whom he eventually collected, some in great depth. In all cases, the viewing and eventual collecting was hardly the objective.

This unyielding and uncompromising drive to understand the essence of an artwork became Hopper's means to develop and refine his own creative offerings. Now more than fifteen years after my first in-depth engagement of Dennis Hopper, I understand that the process of scrutiny and evaluation was critical for his own artistic maturation. Not only did this process serve as a rite of passage back into the art world, but most importantly, this critical process became Hopper's means to hone his vision, focus, re-discover and develop the tools he would subsequently use as he moved down the path as a pictorial creator. Probably because of his extensive training and experience as an actor and filmmaker, Hopper knew what would be required if he was to professionally engage the radically changed art world of the 1980s. While vision and taste have always been the arbiters of what is critically acclaimed, the exponential increase in the number of artists seeking recognition as well as the heightened critical dialogue would require an even greater refinement of the decision making processes which underlie the creation and belief in one's creative acts. Hopper clearly recognized this as he re-settled into Venice in the 1980s.

So where and when did Hopper's re-engagement of art making, and especially his return to painting begin? I have never really sat down with Hopper and systematically gone through the events of his life in the late 1970s and early 1980s. I suspect one could do this, but I am not really sure it gets you to where you want to get, which is a clearer understanding of how Hopper managed to pull himself back together and resume the brilliant career of the late 1950s through 1960s. I do know that one of the key components of this re-entry was the isolation in his Taos studio in 1981–1983. During this time he had the courage to undertake a select group of acrylic paintings and mixed media collage paintings in which he clearly attempted to re-align his creative vision with many of the artists with whom he was identified in the late 1960s. I am particularly thinking of the seminal artistic presence of John Altoon, and to a lesser Jasper Johns and Richard Diebenkorn. What is particularly interesting about these works such as *Untitled (Triptych)* or *Killer Pussy*[1] (both 1982–83) is how Hopper is able to combine expressive markings and strokes, with their clear debt to gestural abstraction and cryptic personal references such as a handprint, a cartoon of a semi-naked woman, or a piece of fabric used as a string "holding the painting together." It is this concern for the modernist identification of the pictorial stroke with content and meaning, along with the equally important modernist belief in the mystery of the found or re-contextualized, which gives these paintings their relevance for Hopper's return to art making. It would be this duality which underlies a great deal of this artist's concern

1 See pp. 200–203.

going forward: the search for his own identity in the marks and gestures he makes, countered by the truth and honesty of the stuff which is always right out in front of us. The stuff that simply makes up our world. The objects, images which we so often overlook or take for granted, but nonetheless are there to be reckoned with. Having made virtually no art for over ten years, it is highly instructive what Hopper chose to do. What are the meanings of these actions at this critical juncture? Hopper refocused on the two main lines of the modernist pathway: the modernist pictorial tradition and the act of bestowing meaning on the common and readymade. These were the two main takeaways from his initial exposure to art making in the early 1960s; and again as Hopper announced his return to art making he took up the formidable task of dealing with the same forces which had driven most painters to look for some kind of meaning and essence of their actions.

Hopper must have had some idea that he was on his way back, for in association with his first exhibition of paintings in well over ten years in 1983, he undertook what amounted to a purging of much of the personal angst and anxiety which had possessed his life throughout the 1970s. Sounds pretty dramatic. Well, in fact it was. For what Hopper did was accompany a painting show with a very strange performance in which he entered a circle made of lighted sticks of dynamite placed end to end and sat crouched in the circle while it exploded. Yes, and obviously, Hopper survives; and yes there is an historical precedent to this act. In the days of the Russian Czar the very same act was called the "Russian Death Chair;"[2] and the act served the purpose of demonstrating the benevolence of the Czar's power and authority. Hopper, having had the infrastructure of the movie industry, and specifically, access to a highly trained stuntmen with whom he had collaborated over a great many years, knew the "do's and don'ts" of this act. Nonetheless, as there is always risk in such a seemingly insane act, we should not belittle the courage and determination of Hopper to undertake this feat. While his survival was clearly key, I would propose that the performance served three purposes. First, the performance was the artist's declarative act of separation from his recent past. Second, it was the artist's means of declaring his return to the theater of art making. Third, and most importantly, the radicality of the act was Hopper's public declaration of his commitment to his life as an artist. Having survived, Hopper was ready to move on.

Back in L. A., and settled into an intriguing work and living space designed by Frank O. Gehry and Brian Murphy in Venice, Hopper re-immersed himself in the art community he was so much a part of in the late 1960s. He equally began an extensive engagement with many of the new rising talents in New York City who would become so identified with the return to painting and the 1980s art boom. It was in this milieu that Hopper resumed his own pictorial activities. And consistent with his artistic undertakings in the late 1960s, he re-engaged both the media of painting and photography.

For the moment, I want to focus on Hopper's photographic activity in this period. In contrast to the tremendous body of photographic artworks concerned with the representation of people (individuals and groups) from the 1960s, the photographic work of these later years is specifically focused on using information found in our world as the means of dealing with many of the fundamental issues which have concerned modernist painting. I am here referring to the many photographic images of outdoor walls, billboards and poster details which Hopper observed, studied, and subsequently documented through the photographic

2 Hopper turned this 1983 performance into a discrete artwork called *Life After on Canvas* which consisted of a film loop of the performance projected onto a blank canvas alongside a photo silkscreen image on canvas of Hopper crouched amidst the exploding dynamite. This work was made for his 1997 exhibition *The Sixties, Eighties, and Now* at Fred Hoffman Fine Art, Santa Monica, California. See p. 286.

lens. In using as the source material that which already exists, the artist continues down the path he first embarked over twenty years earlier at which time he became fascinated with the found debris and refuse of the everyday world. Now, instead of selecting and including an object, a fragment in a composition (an assemblage), the artist roams, studies, selects, and records. That which he records he does not crop or edit, but simply has printed at an appropriate size. Whatever is selected becomes the final image. Needless to say, this method of operation puts tremendous emphasis (and I would contend pressure) on the artist's eye and his ability to chose, to judge, to know the pictorial cohesiveness of any given piece of reality which he encounters. The pressure comes from the knowledge that the chosen image must have the same degree of conviction and correctness as a pictorial composition achieved by any modernist painter attempting to achieve pictorial resolution.

So what, one might ask, is to be gained by using the camera if the goal is to achieve the end results sought after by a painter. This is where it gets interesting. I would propose that a few important issues are at hand. I would contend that these motivating factors are the impetus for Hopper to explore the possibility of making pictures from his investigative efforts with the camera. The first, and perhaps most abstract of these forces motivating Hopper was an instinctive realization of how important it was to find the means of making visual images which would have the same vitality as the art of those immediately preceding painters whom he so admired. This was especially the case as it was becoming increasingly clear that relevancy in this post modernist era, when past forms and models felt used up, was pressuring artists to abandon painting and find new media as the solution to the dilemma of the post modern era. But Hopper simply loves to reveal beauty and has never wavered from this pursuit. Add to this the artist's maturity (Hopper is fifty-eight years old when he begins this series of artworks), and we have a reasonable explanation for the drive, courage, and confidence to pursue this new form of picture making in an era which had more or less given up on it. The camera provided the solution. For it enabled the artist to present visual information which was pictorially consistent with those abstract painters he so admired (including Willem de Kooning, Jasper Johns, and Richard Diebenkorn); and at the same time eliminated the hand of the artist. By blatantly declaring that the act of doing was one with the act of selecting, these images feel more a part of our world and less tied up with the baggage and association of previous pictorial representation. The photographic process gives these images a sense of immediacy. They feel right out in front of you. We do not feel them to be part of a fictive world. These images may depict visual information which we take to be a description of elements of our world. But they are not about the conveyance of information or description. They become part of an abstract reality unto themselves.

The second motivation for relying on the camera to convey the content of an abstract painting is the knowledge that good things occur when there is an element of risk. Because of his experience, particularly as a filmmaker, Hopper has been keenly aware of the magic that can potentially result from allowing something unknown or out of one's control to enter into the creative mix. For Hopper the act of roaming, looking for pictorial solutions in the remains of past cultures and their artifacts, was a liberating process. The act declared that he was free to discover. At the same time the act declared that there was an element of risk. Risk in the sense that he was aligning his sense of creative identity with stuff that already existed. He was

willing to say that he had the confidence to know that the world would not let him down as long as he never failed to apply his keen sense of critical judgment to the process.

I would propose that a specific lesson from art history significantly enabled Hopper to trust the power of choosing as such a critical factor in the art making process. By this I refer to Marcel Duchamp's insistence that the creative act can take place without evidence of a doer, a maker (whether it be the signification of the expressive brushstroke or the implied organizational decisions of a non-objective composition). I think Hopper's discovery of Duchamp, first through the assemblage and neo-Pop artists of the late 1950s, and subsequently through his direct contact with Duchamp at the time of his 1963 retrospective exhibition at the Pasadena Art Museum, altered his approach to art-making once and forever. Duchamp became sort of a liberating force. For behind his simple act of aligning art making to the act of selection, and the subsequent declaration that the obviously emotive was no longer a guarantor of creative power, comes the implied message that order and structure are no longer guarantors of critical acclaim. For Hopper, and as most recently and prominently conveyed in his large photographic works, comes the strong and unequivocal message that meaningful, insightful, and even beautiful images are only achievable when they are the result of processes that stay in touch with the here and now of our world.

OSAKA (Black graffiti), 1997 Color photograph

VENICE (Man Ray), 1997 Color photograph

VENICE (Black circle with drip), 1997 Color photograph

LONDON (Street with red spray), 1995 Color photograph

LONDON (Grey with white square), 1995 Color photograph

PRAGUE (Blue/grey graffiti), 1995 Color photograph

FLORENCE (Muse), 1996 Color photograph

VENICE (Harpist's foot), 1995 Color photograph

PRAGUE (Red horses), 1995 Color photograph

FLORENCE (Grey wheel), 1996 Color photograph

BERLIN (Grey fluff), 1995 Color photograph

page 192/193

VENICE (The face), 1996 Color photograph

UNTITLED (Large color photograph diptych), 1998

UNTITLED, 1982 Acrylic and spray paint on canvas

196 UNTITLED (Cardboard, tin Indian), 1982

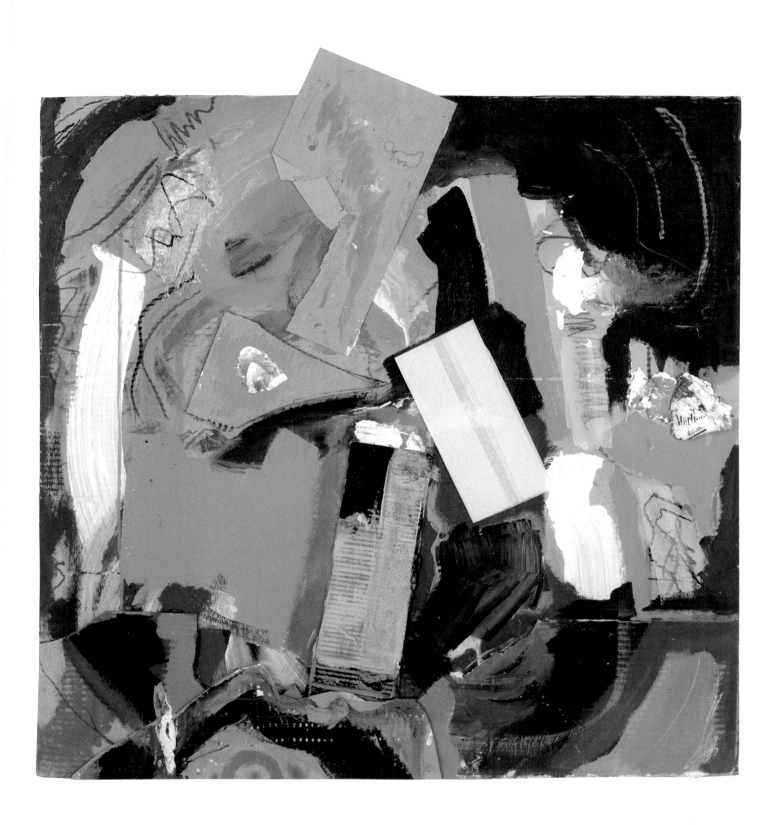

UNTITLED (Indian collage), 1982 Mixed media

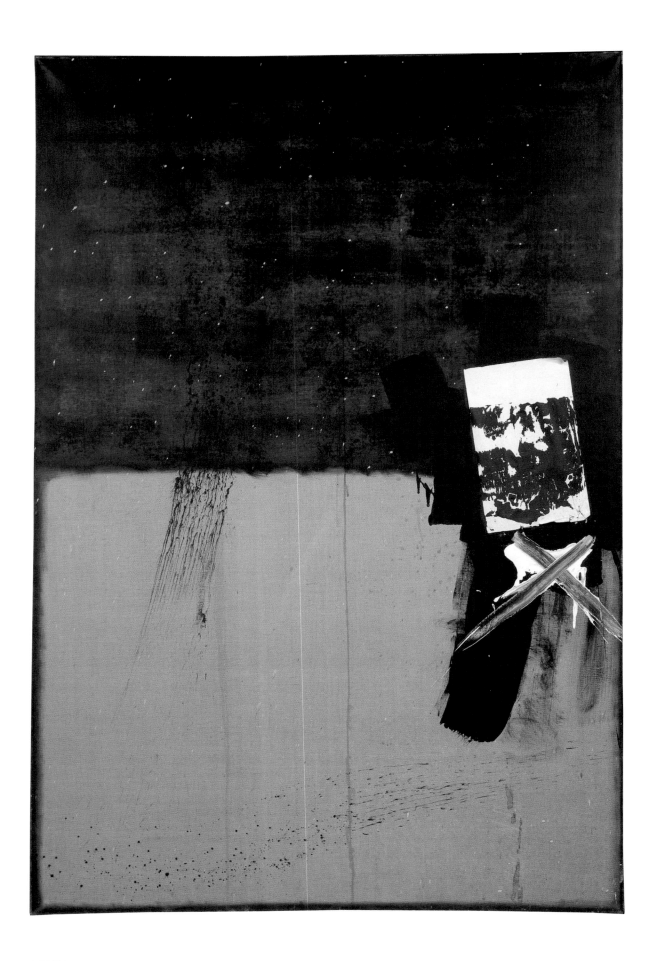

X-XEROX, 1982 Acrylic on canvas with verifax

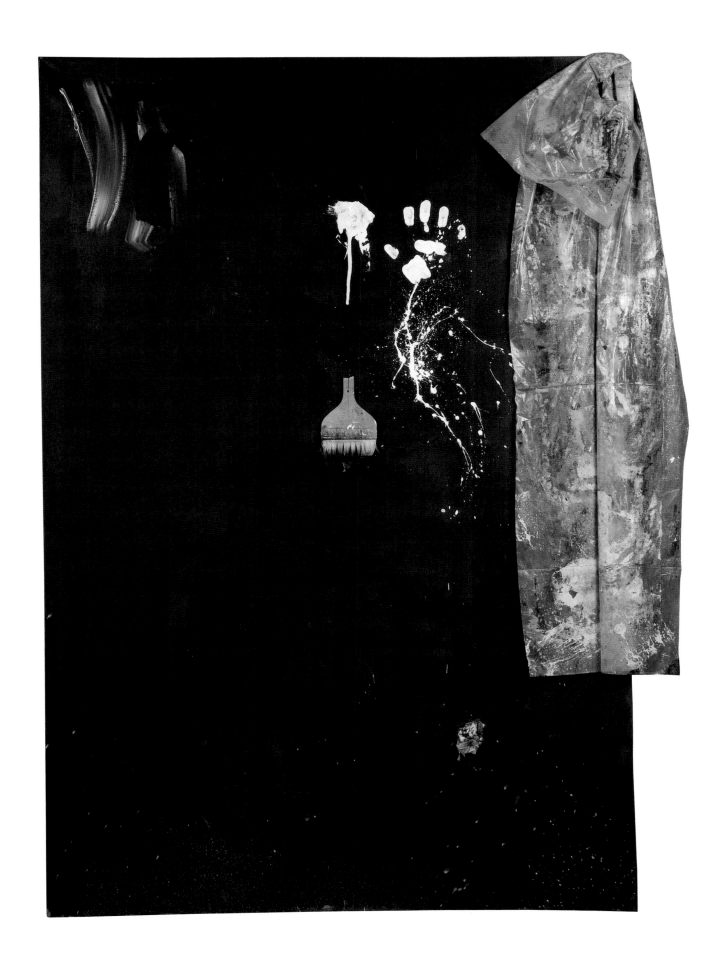

UNTITLED (Paint brush), 1982 Acrylic on canvas with paintbrush

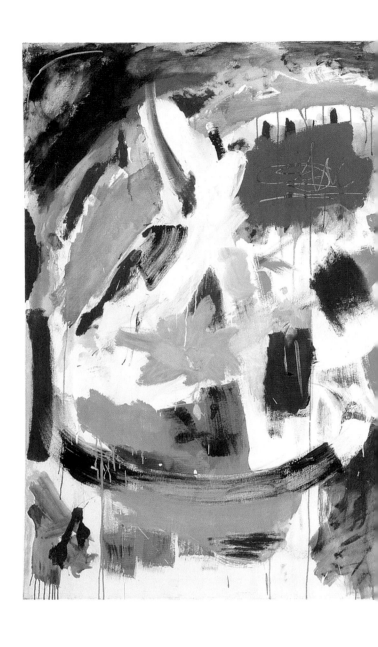

200 UNTITLED (Triptych), 1982–83 Acrylic on canvas

KILLER PUSSY (Triptych), 1982—83 Acrylic on canvas 203

204 MOROCCO (Brown grid), 1994 Acrylic on canvas

MOROCCO (Brown grid II), 1994 Acrylic on canvas

MOROCCO (Diptych), 1994 Acrylic on canvas

208 MOROCCO I, 1994 Acrylic on canvas

MOROCCO II, 1994 Acrylic on canvas

MOROCCO (Grid), 1994 Acrylic on canvas

MOROCCO (Grid II), 1994 Acrylic on canvas

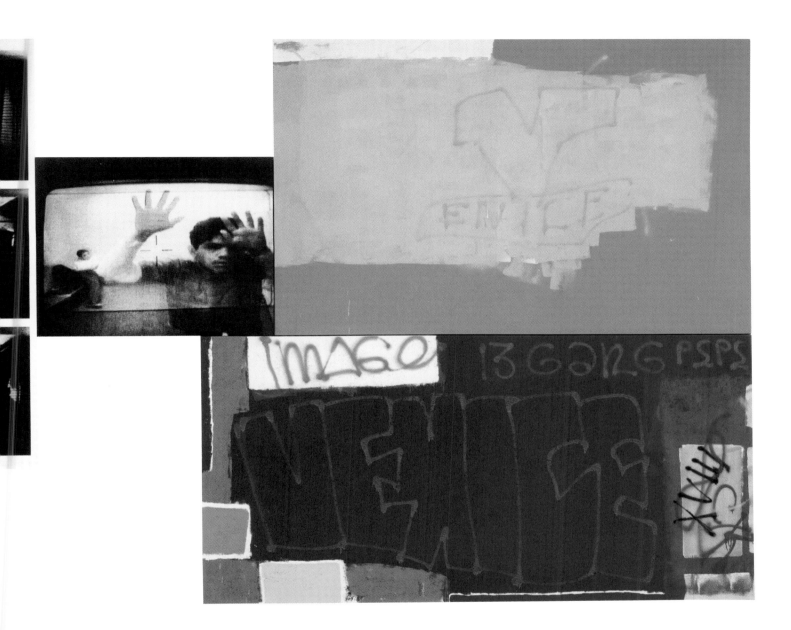

KING PART BUST TRAP, 1991–97 Photo emulsion, acrylic, rolotex, and spray paint on canvas 213

214 UNTITLED (Morocco colors), 1994 Acrylic on canvas

UNTITLED (Morocco blue), 1994 Acrylic on canvas

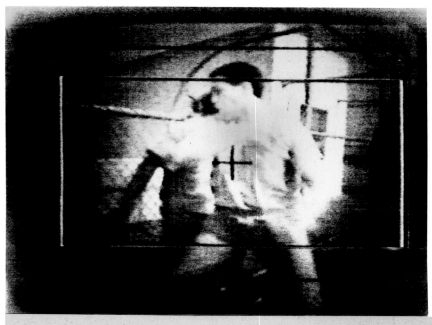

VIA, 1992 Photo emulsion, acrylic, rolotex, and spray paint

OFF, 1992 Photo emulsion, acrylic, rolotex, and spray paint

ONE OF FOUR JOINERS, 1992 Photo emulsion, rolotex, spray paint on canvas

ONE OF FOUR JOINERS, 1992 Photo emulsion, rolotex, spray paint on canvas

ONE OF FOUR JOINERS, 1992 Photo emulsion, rolotex, spray paint on canvas

TORERO (One of four joiners), 1992 Photo emulsion, rolotex, spray paint on canvas

COP, 1992 Photo emulsion, acrylic, rolotex, and spray paint on canvas

CITY, 1992 Photo emulsion, acrylic, rolotex, and spray paint

CUFF, 1992 Photo emulsion, acrylic, rolotex, and spray paint on canvas 225

BEAT, 1991 Photo emulsion, acrylic, rolotex, and spray paint on canvas 227

CEMETERY, 1997 Triptych of digitized video stills on canvas from *Easy Rider,* 1969

Bruce Hainley

THE LIFE OF GOON

I was going to write *The Autobiography of Dennis Hopper as Told to Harmony Korine*[1] because, well, in terms of starting out in the bizness at a youthful age and in terms of being seen as difficult and "experimental" and *doing it all* (taking acting roles, sitting in the director's chair, having shows in galleries, not being afraid to get or appear wasted) and in terms of a salubrious, overall out-there-ness, Harmony Korine seemed to be a kind of latter day Dennis Hopper, and no one seems to have noticed. *The Autobiography* would have allowed scenes like this:

Scene 1.
HARMONY KORINE: What was it like to have Hollywood gossip columnist Hedda Hopper as a mother? Did she take you to opening nights or give you the skinny on who was doing what in Hollywood before she printed it in her column? That must have been helpful for a young actor, to have a mother who knew the dirt.

DENNIS HOPPER *(laughs):* Well, mom dedicated her second book to me and the dedication says it all, really: "To my son, Dennis, who never took any sass from his mother and never gave her any."

HK: Did she ever spank you? Did you ever get back at her by leaking one of her scoops to archrival Louella Parsons?

DH: Uh, kid, Hedda Hopper wasn't my mother.

HK: Are you sure? Maybe your brain's fried. My notes say she was.

DH gets up from chair and slaps HK.

Scene 2.
Dogme orders HK to write an apology note to DH.

1 Harmony Korine (b. 1976), artist, screenwriter, and director of *Gummo* (1997) [editorial note].

Scene 3.

Close-up of HK writing a note to himself, waiting for DH's arrival for second interview. The note reads: *Don't begin interview by asking DH if he ever freebased with Phyllis Diller.*

Scene 4.

HK: One of Hollywood's notorious bad boys, did you or someone else coin the term "hopped-up"?

DH: If I remember correctly, James Dean was the first one to say that he was "hopped-up" on something after we worked together on *Rebel [Without a Cause]*. It was just a joke but it really caught on. During the shoot of *Giant,* Rock [Hudson] and Elizabeth [Taylor] used to arrive on the set hopped-up, mornings in a row. Jimmy would elbow me and laugh. Elizabeth was extremely fond of Jimmy, she gave him a Siamese cat, which he treasured. She was hospitalized for five days before she could finish *Giant* – absolutely distraught and hysterical over Jimmy's crash. [George] Stevens had forced her to show up the morning after she'd heard the news of Jimmy's death, and show up she did – but she lost it as soon as the first mark was called. I would visit her in the hospital and tell her stories. We both missed him a great deal.

HK: Was James Dean gay?

DH: Well, yes and no.

And then I thought, naahhh …

Instead I watched some Hopper-directed and Hopper-starring movies and looked at his photographs. Looking at them I thought:

"What are we going to do with him?"

This is the first line Dennis Hopper speaks as Goon, a street tuff, in *Rebel Without a Cause*. Basically, I think it can be said that it's Hopper's first line in any movie whatsoever. Rebel isn't really his first film, although even he usually credits it as his first. An early Warner Bros. Studio bio – dated December 5, 1956 – shows Hopper's career to begin, not with Goon in *Rebel,* but with a small role in something just as uncannily resonant:

> After a small part in Warner Bros. "I Died a Thousand Times," Hopper was given a featured role in "Rebel Without a Cause," a modern youth drama starring James Dean and Natalie Wood. He next appeared as Jordan Benedict, III in George Stevens' "Giant" for Warner Bros. Following several starring portrayals in Warner television dramas, Hopper was assigned the starring role of Napoleon in "The Story of Mankind," Irwin Allen's Cambridge production for Warner Bros.
> Vital Statistics
> Born: May 17, 1936 Where: Dodge City, Kansas
> Height: 5' 9 1/2" Weight: 160 lbs.
> Hair: Blond Eyes: Blue

I Died a Thousand Times could be the title of Hopper's autobiography, *The Story of Mankind* his goal in what he has tried and tried in his work to convey. But it's Goon and Goon's first line which encapsulates the *gesamkunstwerk* expressed in Hopper's interrelating careers.

"What are we going to do with him?"

Goon's asking the tuffs' leader about James Dean's character, Jim Stark, how the gang's gonna handle him, the new kid. The line concerns Jim Stark, but in the weird way in which signification skids, it refers as deeply to James Dean and the new energies – velveteen dissolutions – he unleashed. The line's every bit as much about Sal Mineo's Plato – his mismatched socks, one as red as Dean's iconic jacket; Plato's (and Mineo's) nascent homosexuality, what's going to be done with him if Dean were really to be his "daddy."

"What are we going to do with him?": It's about the teenager – the unraveling of the concept of "youth" into something haywire and raw: *teenager.* It's about teenager as a new American mode of being (despite Rimbaud, it took America to forge what the teenager really was); a new state of mind; an American-type thing, the way the 1950s also produced American-type painting; the teenager's being at odds not just with the status quo but with the way things are. Even more than Goon is a character, goon is /goon/-teenager, Dean and Mineo. Hopper embodied Goon, gave him breath, and made him speak.

Hopper's never not been Goon – Feck in the amazing *River's Edge;* Frank Booth in *Blue Velvet;* Don Barnes in *Out of the Blue;* the aptly named Howard Payne in *Speed.*

"What are we going to do with him?"

It's a question Hopper's always been asked about himself, his work, his blue "out-there" quality. One of his first agents quit because of his "ridiculous" art acquisitions (a Warhol soup can; [Edward] Kienholz's *The Quickie,* a weird little mannequin's head sitting on a roller skate with a finger up her nose). Hopper always knew that few people knew what to do with him, as he told a *New Yorker* correspondent in 1971:

> "When I wasn't able to get work in Hollywood, I felt really desperate. I thought I knew I was very talented, but there didn't seem to be any way I could act, let alone make movies. I didn't crop my photographs; I was learning to work within the frame of movies. Photographers always thought of me as an actor, painters thought of me as a photographer, and actors" – he grinned – "well, Paul Newman would say to me, 'You should *really* concentrate on your painting.' It was a very rough time. It wasn't really as rough as it may be *this* time, though. I stopped painting in 1961. I was an Abstract Expressionist without knowing what that was; then I found out that there was such a thing, and that other people were doing it better."

A young artist I talked to about Hopper said to me that if Goon had said much more than "what are we going to do with him" no one would have known what to do with him or the movie since it would have been clear that *Rebel Without a Cause* was really about a youth punk disaffection which wouldn't really flourish until the 1970s, which is why Hopper could remake *Rebel Without a Cause* in 1980 and call it *Out of the Blue.*

Subverting Normality

"Kill all hippies." "Pretty vacant." "There's nothing behind it – it's a punk gesture." "When Sid Vicious left he took his loved ones with him." Linda Manz delivers all these lines in Hopper's *Out of the Blue.* Manz as Ce Be collapses the easy delineation between who she was and who she portrayed. She told the *Los Angeles Times* in 1982 that the movie was "nearly about [her] life." Her then manager, Barbara Claman, said that Manz "isn't really acting": "Linda doesn't believe in the necessity of language." Consider how Dean used silence. Consider that by appearing in many scenes of *Rebel* but saying very little, Hopper learned how to use such silence and let it bleed.

Out of the Blue was made at almost exactly the same time and is, in part, a response to America's infatuation with the "realness" of *Ordinary People* and *Kramer vs. Kramer.* With a movie – fiction – Hopper was able to subvert normality of the family film by showing things rough and roughly as they are more likely to be – *out of the blue,* unexpectedly, with punk viscerality. In no small part, he succeeded because of Manz's and Hopper's ability to collapse and confuse person, persona, and character – "art" and "life."

The *Los Angeles Times* related that Linda Manz imagined herself as the reincarnation of James Dean:

> The story has been growing in Linda Manz's head for months. It's about a street kid who discovers that she's the reincarnation of James Dean. Her friends don't believe her, right up until she dies in a car accident – just like Dean. "I got the first scene finished," she says in a gritty New York accent, pulling a worn sheet of paper from her back pocket. "Everyone tells me I look just like him. He had the exact same split in the eyebrow that I do, and the same hairline too."

Hopper subverted normality just by showing that *Rebel Without a Cause* and *Out of the Blue* are both about a crisis in American masculinity, a father problem; Ce Be as Jim Stark's dark baby-dyke twin; Hopper as the dark side, the id, of Jim Backus' portrayal of Frank Stark (Jim's emasculated, apron-wearing father). In *Gummo,* Harmony Korine cast Manz as a mother of a young boy trying to sort out similar existential dilemmas in rural West Virginia. He kills cats. He huffs glue. His father's nowhere to be found.

"Kill all hippies" skips the 1960s entirely, annihilates it. Hopper's photos may *document* the 1960s, but the best part of his aesthetic skips the 1960s and ushers in the darker dissolutions of the 1970s. Hopper's film still threatens, the way Ce Be threatens another girl: "I'm gonna take you out of the blue and put you into the black."

Hopper is like Warhol in terms of his dissonance with the 1960s. The Factory's aesthetic – black leather, silver foil, speed and whips – occurred in the 1960s but predicts the 1970s. The dissonance – the "underground" quality – came into sharp focus when Warhol and the Velvet Underground made their first tour in the late 1960s to still bead-wearing hippie-dominated L. A. No one knew what to do with them, not even at the Whiskey.

Out of the Blue. Never past tense "blew," but "blow" – as in cocaine. Not "we blew it" but, blow, as in *blow it up.* Ce Be's devasting final conflagration.

Freedombasing

No one should sublimate the centrality of Hopper's investigation into, experimentation with, and abuse of drugs – in "life," in "art," on "film." Hopper smoked marijuana and peyote with Dean: "Man, Jimmy and I were into peyote and grass when it was still, like, something you couldn't even mention to your closest buddies." *(New Yorker)* He used LSD, among other drugs, while living with Brooke Hayward. He's boasted that he introduced cocaine to the United States: "The cocaine problem in the United States is really because of me. There was no cocaine before *Easy Rider* on the street. After *Easy Rider*, it was everywhere." (Biskind) During his stint in Peru for the shoot of The Last Movie, his drug du jour wasn't so much cocaine but a white power "said to be 'organic' mescaline, a psychedelic which was snorted much like cocaine but which produced effects much less linear, more on the order of awe and wonder at the Mystery of Being." *(Vanity*

Fair) Circa 1983, before sobering up, he was living in Taos: "I was drinking a half gallon of rum a day, plus another fifth of rum, and going through a half-ounce of cocaine every few days." *(Vanity Fair)*

Before, during, and after his own drug use, Hopper has become famous for playing character's intimate with the pharmacopoeia. Consider Frank Booth's use of amyl nitrate. Inhale deeply and open the mind to the possibility that Hopper's career, perhaps more than any other, proves the fact of drugs – not just culture's dependence upon drugs but culture itself as a drug. As Avital Ronell has argued so eloquently: "More so than any other 'substance,' whether real or imagined, drugs thematize the dissociation of autonomy and responsibility that has marked our epoch since Kant. Despite the indeterminacy and heterogeneity that characterizes these phenomena, drugs are crucially related to the question of freedom." Bluntly, there is no culture without drug culture.

Understand that Hopper's presence in any context signifies the culturally destabilizing effect of drugs and their connection both to ecstasy/transcendence and annihilation. He trafficks in the culture of drugs, the drug of culture, not just when he is actually high, drunk, or stoned or portraying someone who is, but just as much when he is playing sober art-pusher Bruno Bischofberger in *Basquiat.* Hopper's a *jouissance*-pusher: his career – in every aspect – thematizes and problematizes the decision-making drugs demand. Ronell has written: "Freedom decides for decision and decidability. But true freedom involves the freedom to choose what is good and what is bad; and decision, if it is within decision that freedom emerges, has to decide for good or evil. No one gets to make only good choices – that's not freedom. The decision to go into the black – or not – has been what Hopper has portrayed, enacted, embodied and much of what his work explores.

Japan (Shop window with geishas), 1991, gelatin silver print © Dennis Hopper

Stalking Walker Evans

Some might argue at this point that I'm ignoring art historical concerns, formal matters. But "drugs" is a crucial, representational matter for aesthetics. Again, Ronell: "'Drugs,' in any case, make us face the gaping chasms of *Beyond the Pleasure Principle,* where death drive and desire round up their victims." The possibility of *jouissance* – a high – which both art and drugs promise is thematized by Hopper in even the most seemingly *innocuous,* documentary work.

In a suite of photos shot in Kyoto and Tokyo in 1991 and 1994, published as *Dennis Hopper: A Tourist,* there is a shot of a photo hanging in a shop window. The photograph is a picture of a group of photographs of geishas in traditional attire, a representation of a representation, a rephotograph. Instead of a shot of an advertisement for a photography studio of a grid of people who have purchased the service of the photographer, Hopper shoots a picture of people (geishas) who themselves can be purchased. He subverts the normality of who/what is bought in a way which recalls how Evans subverted the normality of the "good photo," "art."

John Wayne and Dean Martin. Hopper shot it while he was making *The Sons of Katie Elder,* which starred Wayne and Martin. It documents their appearance in the film. But the documents puts into the black the simple belief in fathers, in cowboys. There is the fact of the fathers, cowboys – but this isn't really what the photo displays. With the camera's tripod front and center, it italicizes the *setup,* the fakery of these concepts. Fake cowboys, fake western frontiers, fake fathers: Hopper's photo accomplishes with a documentary shot what Richard Prince found rephotographing the Marlboro man cowboy twenty years later.

The Sons of Katie Elder, 1962, John Wayne and Dean Martin, gelatin silver print © Dennis Hopper

The continuity of Hopper's career can be seen as a mourning process; his "art" a way of figuring out how to go on.

In a press release for *The Last Movie* – dated August 6, 1971 – Murray Weissman, executive in charge of the press department at Universal Studios, wrote about Hopper's complicated mourning for Dean. I quote it at length as an homage to "Hollywood Press Release Prose": its style and hyperbole and sincerity, its mixture of fact and sheer mythic romanticism, echoes much of Hopper's own procedural methods.

His first important acting assignment in "Rebel Without a Cause" brought him within the orbit of another young actor who was to influence him profoundly and to remain an almost mystic force in his life. James Dean, who shortly before had reached film stardom in Elia Kazan's production of "East of Eden," was impressed by Dennis' approach to acting and by his quick mind. He made a point of watching the younger actor before the cameras and would talk to him afterwards about his scenes. The friendship was later cemented when Dennis was cast in "Giant," the film version of Edna Ferber's best-seller, starring Dean, Elizabeth Taylor and Rock Hudson.

On location in Texas the two young men talked excitedly of new cinematic forms, new acting truths, new possibilities for the motion picture medium. Each sparked the other. New concepts developed as they explored whole areas of subject matter and style untouched by filmmakers. As the weeks went by they ceased to be merely young men with visions, but two earnest actors with concrete plans for films of their own.

Dean's untimely death in an automobile accident following completion of his role in "Giant" left Dennis in a state of shock. Further shaken by the public display of morbid curiosity, the probing into the life of the friend whom he had apotheosized as a guerrilla artist, and the continuing press sensationalism surrounding Dean's death, he obtained a release from his studio contract and moved to New York. In the months that followed he became a member of the Actors Studio, began to work seriously at his photography, painting and sculpture, and managed to put into action a few of the theories he and Dean had formulated.

In 1957, still haunted by a profound sense of loss, he began work in "From Hell To Texas." The young firebrand and veteran director Henry Hathaway collided artistically almost from the first day.

... There is an element of the uncanny in the circumstance that Dennis Hopper, the actor who was influenced to the depths of his being by James Dean, is the first personality to come along since the late star to command the same febrile adulation from young people. It is almost as if, by some curious alchemy little understood by man, Dean lives on in that spare, muscular frame and that quicksilver mind.

When sets were being constructed in Chinchero, Peru, for "The Last Movie," Hopper ordered one storefront to be lettered "Jimmy's Place." Inscribed beneath was: "Jimmy's place reminds you of your destiny."

During the filming of the picture he was never without a Mexican bronze-and-silver ring bearing the face of an Aztec idol, which once belonged to Dean. There were those who have noted that Dennis Hopper, choosing his creative options, will often rub the ring as if it were a symbol of human confluence or a talisman of strange power, opening doors beyond the comprehension of those who do not believe that creative thought is a deathless energy.

The gorgeous hyperboles, Hopper was born into a generation which was raised to believe in the promise of "alchemies little understood by man." His own work, a fact-finding mission, has shown him the difficulty of such hyperbole and alternatives to it: the tonic of *now* and its trials by fire. Hopper's art-making began after Dean's death, but it doesn't redeem the death but finds in it a reason to continue.

Hopper did some of his first abstract artwork at Vincent Price's home. It was at Price's house that he saw his first work by Franz Kline, Jackson Pollock, Emerson Woelffer, and Richard Diebenkorn. (Much of Price's and Hopper's importance as collectors was to collect work by artist's who were their peers [Price Ab Ex, Hopper Pop]: art as a testament to contemporaneity rather than mere investment.)

The other night I dreamed about that Aztec idol ring, talisman of strange powers, its opening, like peyote, Huxleyesque doors of perception. It became a central device in my dream movie. Vincent Price stars as a practioner of the occult arts, the ring his most powerful magic. A wicked gang, the Dulls, are trying to steal the ring from the dying Price. Hopper plays Price's loyal student. He tries to protect Price, the ring, which his teacher keeps in a strongbox. In a climactic scene, Price is killed and Hopper must witness the leader of the Dulls crack the strongbox and put on the ring.

And then I woke up. Hopper would have learned, I guess, something which he's already always known: the ring's great power is nothing other than a reminder – *rub the ring* – to focus attention on what is going on all around one. Which is why its power is always out of reach of the dull, why his mentor – Price – never needed to wear the ring, and why Hopper vanquishes the gang just by believing in what he knows, the strange sacred magic of now.

But the ring's just a symbol of the actual lesson, dream-free and clear, Hopper learned long ago. He put it this way in 1987 in *Vanity Fair:*

> So during the "Chickie-run" scene I literally picked [Jimmy] up, threw him into the car, and said, "What are you doing?" You know, "How can I do it? Do I have to go to Strasberg? Do I have to go to New York?"
> He said, "No, no take it easy. Just listen to me and I'll help you along." He said, "Do things, don't show them. Stop the gestures. In the beginning everything will be very difficult because you're used to *acting*. But pretty soon it will be natural to you and you'll start going, and the emotions will come to you if you leave yourself open to the moment-to-moment reality."

Which is all he's been trying to keep doing and what's to be done with him and his work.

Author's list of sources

Warner Bros. 1956 bio comes from the Hopper files at the Academy of Motion Picture Art and Sciences Library. All further Warner Bros. bios come from these files.
The *New Yorker* quotations are all from: James Stevenson, "Our Local Correspondents: Afternoons with Hopper," *New Yorker* (November 13, 1971): 116.
The Linda Manz quotations are all from: Michael London, "Linda Manz: Dean Reincarnation?" *Los Angeles Times,* Part VI (December 28, 1982): 1, 4.
Peter Biskind, *Easy Riders, Raging Bulls* (New York: Simon & Schuster, 1998): back cover.
The *Vanity Fair* quotations are all from: "Riding High: Dennis Hopper Bikes Back," *Vanity Fair* (April 1987): 135, 78.
Avital Ronell, *Crack Wars: Literature Addiction Mania* (Lincoln: University of Nebraska, 1992): 59, 45–46.

Daniela Zyman

ON ART
AND FILM.
A FINAL
NOTE ...

Observations on the work of Dennis Hopper focusing on the conjunctions of art, acting, and film.

A System of Moments

So this is the problem: that it has been very difficult to be an actor and to be taken seriously at anything beyond acting. We haven't really been allowed out of the stables and barns – until we got making movies where we had money. The actors always ate with the servants and slept in the stables and barns because they were like gypsies, and they performed, and they were not considered educated and cultured people. But to be taken seriously as a fine artist is almost impossible, I mean it's been a hindrance to me rather than help. (Dennis Hopper)

With a few notable exceptions,[1] the study of cinema takes place in an autonomous world, separated from the discourses of aesthetics, art, media, and communications. A survey of film criticism and theory quickly reveals cinema's unprecedented challenge and disruption of classical aesthetics as defined over the past centuries. Embedded in a commercial industry and realized through a system of collective production, this relatively new medium (just over one hundred years) with its predominantly narrative purpose operates within a wide spectrum of sensory modes. Its system of codes, signs, and images engages the viewer in a manner that no art form has ever before attempted. And yet, art and film are discussed in exclusive terms – one as a language for mass consumption and the other, for a limited few. Moreover, as Peter Wollen

1 *Hall of Mirrors: Art and Film Since 1945* (1997), exhibition organized by Kerry Brougher, Museum of Contemporary Art (MOCA), L. A.

rightly states, "the main stumbling block for film aesthetics … has been Hollywood." Even today, Hollywood stands for the banal, "a threat to civilised values and sensibilities," a monolith of commercial interests financed for the sole purpose of capturing audiences on the lowest possible denominator. While avant-garde film — especially in Europe under the influence of the auteurist writings of André Bazin in the *Cahiers du Cinéma* — has achieved a certain equal, yet separate, status with the fine arts, Hollywood has at best been able to produce cineaste qualities. While video art and underground film have been integrated into the discourses and analytical methods of art, narrative filmmaking has been broadly denied identification as an artistic practice. And yet, not only is there a fourth type of cinema, as Kerry Brougher points out in his readings of *Easy Rider* and *The Last Movie*,[2] but with the break down of the old medium-specific hierarchies, commercial forms of creativity — be it design, fashion, advertisement, entertainment, popular culture — have been fully integrated into contemporary artistic production and discourse. Media today are regarded as constituents of a delivery system, a range of platforms (including affordable digital formats) available to artists.

As we enter the twenty-first century, a re-examination of the artistic potential of film needs to be undertaken systematically, especially in the discussion of work that continuously fuses genre, media, and industry paradigms to attempt radical cross-breedings of ideas, techniques, and forms. In an unprecedented manner, artists today — including Matthew Barney, Julian Schnabel, and Doug Aitken, among others — are destroying the conceptual and intellectual distinctions between art and film and between avant-garde and mainstream. And yet, we fail to meet the most basic prerequisites for demonstrating, first, how film has been responsive to developments in art, media, and the larger realm of ideas and, second, how critical theory can or cannot be applied across disciplinary classifications. Where does one draw the line — and which line — between an original, authentic expression and a work produced in the service of entertainment? How do the techniques, developed and refined within a particular medium, translate into other disciplinary practices and media, and what happens in the process of transposition? How can the performative, filmic work — based on a medium-specific time and movement — be represented within the limited two-dimensional and three-dimensional space of an exhibition? Can stills, excerpts, and even full retrospective presentations of filmic work create the necessary affinities between media that allow us to uncover thematic tendencies and similarities, that enable us to dismantle, deconstruct, and re-present cultural imagery? And finally, is it possible to discuss the body of work of a creator, ignoring media divides and proceeding somewhat recklessly from painting to acting, from filmmaking and directing to sculpture, script writing, photography, and assemblage? What would be the appropriate terminology for such a discussion? Is it valid to consider, for example, the ways film and photography resolve issues considered intrinsic to painting, or, conversely, how film has reenergized the visual aura of painting and high art?

To consider these issues is one of the unresolved challenges of the exhibition *Dennis Hopper: A System of Moments.* The discussion of these questions will necessarily take us back to a moment in time when, on the one hand, a generation of young filmmakers, directors, and auteurs attempt to abolish the anti-artistic precepts of old Hollywood while, on the other hand, a new generation of artists begins to use filmic

2 See pp. 273–275.

techniques in an experimental context as forms of expression withheld for nearly half a century. These two spheres of activity begin to erode the distinction and hierarchy of high forms and commercial endeavours. *A System of Moments,* thus, is the lyrical definition of the *matera prima* of art and film – of time-based elements assembled in movement for the purpose of telling a story and of the inherent flexibility of the telling with its potential for sequencing, repetition, temporal elasticity, and narrative and formal reversals. "'[T]he void' is an empty place between film jobs, acting, directing, writing – 'a system of moments' frozen like the flick of a candle caught forever licking the darkness, the splatter of wet paint caught in a dry burst coming out of a great angst and pain of having been denied work in my medium of choice: movies. To fill the void between film work, a system of moments occurred – paint, photograph, manufacture, tape, plastic, lights, sets, shadow, assemblage, motion, found objects, with a rope of history binding me to Abstract Expressionism, action painting, and Marcel Duchamp."[3] (Dennis Hopper)

The Sixties Photographs

When Hopper resettles in Los Angeles in 1961, an artistic and cultural revolution is about to take place. On the surface, the city appears as he left it a few years earlier when he had been expelled from Hollywood, and, yet, an emerging L. A. artists' community is a clear sign that the city is about to become a new center of contemporary production. Hopper's early painting draws from his initial interest in and exposure to Abstract Expressionism, especially the works of Richard Diebenkorn, Emerson Woelffer, Franz Kline, and Jackson Pollock, but is also reminiscent of the heavy earthy materialism of Jean Fautrier in Europe. The Californian approach to abstract painting and sculpture – with its strains of minimalism, its interest in light, its reliance on local phenomena such as weather, topography, and industry for subject matter as well as its central concern with the qualities of making and the experiential integrity of the results – are influences that can be ascertained, in varying degrees from overt to latent, in Hopper's art throughout his career. He refers to himself as an Abstract Expressionist by nature, an influence that he continuously reworks and revisits, especially in the works created in the 1990s.

In the early 1960s, however, it becomes evident that an aesthetic rupture has occurred that requires a new means of expression, a practice closer to Hopper's filmic interests and the manifest activities and expressions around him. Photography becomes his medium of choice. During the fifties, encouraged by his friend and mentor James Dean, photography had been an *ersatz* for directing film, his primary if yet unattainable interest. Dean had advised him to take up photography in order to train his eye and learn composition: "I know you're going to direct some day, so learn to take photographs and don't crop them. Use the still full-frame ..." This becomes a compositional guideline for Hopper's black and white photographs and an impetus for his developing ideas and interests in directing film. Photography serves as an artistic endeavor as well as mental and visual training. Hopper's cinematographic use of the camera and his talent for composition are evidenced by hundreds of photographs taken over a period of six years.

Contrary to most evaluations, Hopper's photographs are not mere documentation, that is, a "transparent" record of his surroundings, but represent a double participation or intervention, first through his artistic

3 See p. 15.

presence and then through the eye of the camera, producing an appropriately stylistic and genuinely equivalent artistic form. It is his understanding of and participation in the history that is about to unfold that give the photographs their significance. Participation requires a level of engagement beyond journalistic or "objective" documentation. As Peter Frank states: "[Photography] allowed him not only to access some of the epoch's most influential figures and momentous occurrences, but to engage crucially and integrally with these figures and in these occurrences. These are not the photographs of an eyewitness documentarian, but of a participating artist."[4]

Hopper directs his photographs as he would direct a scene in a film — composing the scene in the camera, sometimes just "being there," and sometimes creating a *mise en scène:* "I shoot a lot of things just because I got the camera. So I shoot a lot of crap, and then I'll focus in on something and see something that's a picture to me. And I'll try to take it without disturbing it and changing it. Or I take somebody somewhere and carouse them into having a photograph. I take them to a place or a location because generally I find that even if it's a bad photograph of a person, the place looks interesting and the person looks better." Here, very evidently, the formal qualities are in the foreground: "I'm very concerned about formal aspects of photography. In my compositions, I like to keep my lines together, I like to keep it very formal and very straight. A snapshot to me is not interesting, it's not interesting on any level, really, and never will be."[5]

As Rudi Fuchs points out, some of the photographs are taken from a close perspective and set in a shallow, confined space. The background is so filled as to allow no space, airiness, or atmosphere. They are dark and have a dense weight reminiscent of assemblage.

Hopper's full filmic repertoire and camera work utilize the codes of underground and documentary filmmaking, an issue that becomes significant in *Easy Rider.* Each of the photographs has its own distinct qualities, and each creates different visual and compositional resolutions. On many occasions, photographs have been taken in series (see Andy Warhol and Roy Lichtenstein) in which the rapid succession of shots creates a mini-narrative. As Hopper revisits his archives — something he has begun to do in recent years — these new serial photographs contribute to a more complete perception.

The relationship of photography to film has been well analyzed through the tools of semiotics and in Bazin's 1940s writings developing an aesthetics of cinema. Bazin's cinematic realism, which would become the dominant language of post-war European film, derives from his view of the photograph as an "exact representation" of objects, like a death-mask, a relic, an imprint that expresses the being-presence of an object. His realism attempts to minimize the deforming intervention of human agency, striving for a beauty akin to "a phenomenon of nature" that affects us directly rather than through a symbolic transformation. Similarly, film is believed to be made from "fragments of raw reality, multiple and equivocal in themselves, whose meaning can only emerge a posteriori thanks to other facts, between which the mind is able to see relations," and not according to some a priori plan or method. Such a fiction should, according to Bazin, be reduced to a minimum — acting, location, incident should be presented as naturally as possible. No actors, no *mise en scène,* no plot: the perfect representation of reality. With this in mind, it is no surprise that George Herms describes Hopper's photographs as contending with the ways "[t]he camera can interfere with the flow of life ... people begin to pose," or that, according to Peter Frank, "most of his works from this

4 See p. 38–39.
5 See p. 35.

period display an insouciant forthrightness, a preference for clever, even witty, but uncomplicated composition and evident (if often light-hearted) drama, that reflects the urgently upbeat Pop ethos."[6]

The sixties photographs represent a complete and polyvalent body of work that has yet to be fully discovered and evaluated. Only a small fraction of the thousands of existing negatives has been printed and new material continues to emerge from the archives. Widely acknowledged for their aesthetic refinement, the photographs also chronicle a new epoch of art making, including Pop, assemblage, Happening, performance, Nouveau Réalisme, jazz, fashion, and film. They disclose the insider's view of "frozen moments" during the emergence of some of the most diverse productions and manifestations of artistic expression. They are iconic images of their time.

The Photo-Assemblages

A complex "derivative" of the photographic works are Hopper's photo-assemblages, produced between 1961 and 1964, a period during which Hopper renounces any handmade form of art. "I was denouncing painting, saying painting was for cavemen, and that the machine was there, and that we should use the machine just like a paintbrush and blah blah blah …" The idea of "montage," or photo-montage, originates with Aleksandr Rodchenko, George Grosz, Kurt Schwitters, and John Heartfield — with Russian Constructivism and Berlin Dada. Even these early precursors confirm the mechanical intent of this technical tool. "We called this process photo-montage because it embodied our refusal to play the part of the artist. We regarded ourselves as engineers and our work as construction: we assembled our work." But montage is clearly a filmic technique. It refers to a carefully outlined chain of effects capable of producing a maximum intensification, concentration, and heightening of expression. It is a counter-current to the realism of the photograph. Sergei Eisenstein writes that "the science of shocks and their 'montage' in relation to [particular] concepts should suggest their form. Content, as I see it, is a series of connecting shocks arranged in a certain sequence and directed at the audience . All this material must be arranged and organized in relation to principles which would lead to the desired reaction in correct proportion."

Converging in Hopper's photo-assemblages are his interests in photography as a process of mechanical reproduction, as a momentary capturing of time and movement, and as a complex form of montage capable of questioning the relationships between "reality," "illusion," and "representation." Evidently, the concepts of assemblage and mechanical (re)production were well established territories within the L. A. art scene, especially with the work of Edward Kienholz, the Verifax of Wallace Berman, and the presence of the French Nouveaux Réalistes. Kienholz would become an occasional collaborator and artistic mentor to Hopper. Yet, Hopper's transformation of the technical repertoire into a proto-filmic vocabulary proves to be a remarkable development. "I was recording objects (in a photograph), and using the object the way it functioned, and then affixing the object itself to the record of the object, and using light and recreating the light of the real object, recreating the light in the gallery and having the record of it, the way it looked using natural light and raw canvas." It is no surprise that *The Last Movie* would return to these issues within a filmic arena.

6 See p. 39, 129.

The conceptual nature of these early photo-assemblages is evidenced by works such as *Chiaroscuro*[7] in which Hopper takes mannequin heads used for displaying wigs and hats, places them on a white canvas, and photographs the arrangement in natural light. He then enlarges the photograph of the heads and their shadows and affixes the actual objects to it. When mounted on the wall, a light is focused on the work to cast exactly the same shadow as in the photograph. *Proof*[8] consists of a photograph of a scrap of linoleum printing block onto which Hopper imprints the inked form of the block and then attaches the block itself.

An analysis of Hopper's photographic and related work points consistently to film as the dominant medium. He is able to use the photographic image to experiment with visual composition, the directing of people and models, the arrangement of circumstances and locations, the documentation of narratives and performances; but he is also able to expand the medium – through collage, assemblage, and montage – to capture the double nature of filmmaking both as pictorial recording and as a method of rendering form through editing, sequencing, and re-framing. Hopper's later emphasis on precise control over the final cut of his films is a recognition of editing as the filmmaker's ultimate method of control over his work and sometimes the greatest challenge, as he experiences with his editing of *The Last Movie.*

Pop, Neo-Dada, Happening

Hopper was one of the first to recognize the emergence of Pop Art; although, his own Pop project would not emerge for some time and then on radically different platforms. Drawn to Pop as the art of the streets, as a genuinely American expression, and through its sense of the "real," Hopper purchased for his collection a *Campbell's Soup Can* and *Mona Lisa* by 1963. "… and so when I saw the first soup can painting of Warhol, and the comic books, and the billboards of Rauschenberg's, the bronzed light bulb of Jasper Johns, and the paintbrushes and the bronze, I said this: the return to reality … people may not want to know they're a Coca-Cola bottle and a soup can and a comic book, but man, that's what we are, and that's what we're about, and this big public image, you know – Pop Art and commercial images and using silk screens and being able to do the work that commercial artists use – this is our signature, this is what we are about – and the movie stars and so on – and this is the return to reality that everybody's been screaming about." (Dennis Hopper)

Pop as an aesthetic category and as a system of labeling has suddenly becomes omnipresent. In the words of Andy Warhol, driving to L. A. in 1963, "the farther west we drove, the more Pop everything looked on the highways. Suddenly we all felt like insiders because even though Pop was everywhere – that was the thing about it, most people still took it for granted, whereas we were dazzled by it – to us, it was the new Art. Once you 'got' Pop, you could never see a sign the same way again. And once you thought Pop, you could never see America the same way again."[9]

Pop, of course, was more than a style; it was an ethos, a philosophy, a *weltanschauung* (world view) – the return to reality that Hopper and an entire generation had championed. Although Hopper did not adhere artistically to the object fetishism of Pop, its acceptance of the everyday phenomena of life certainly captured him. In line with the early Pop artists themselves, Hopper's affinity for Pop Art was strongly related to the

7 See p. 137.
8 See p. 136.
9 See p. 117.

Duchampian ready-made, conceptualism, and the idea of art as a process of transcription. In an almost surrealist fashion, Hopper's photo-assemblages play on the familiar, the sensual, and, perhaps, the shocking and uncanny as well. In his essay on the uncanny, Sigmund Freud suggests that objects can hold strange and disturbing meanings, having their own language and history. In this sense, the Duchampian "crisis of the object" – referring to a full, unaltered familiarity that enacts, at the same time, a sense of extreme unfamiliarity, displacement, and disturbance – is to be found in Hopper's earliest approach to art. The explosive potential of the mundane and its many facets is thematized increasingly in European art of the 1950s – for example, through the influential book of the French philosopher Henri Lefèbvre, *Critique of Everyday Life,* and with Christian Dotrement's demonstration of how even potatoes can become revolutionary.[10] By 1960 a group of French artists has made its appearance working with urban junk and torn-up posters, enacting the "passionate adventure of the real." The neo-Dadaist approach of these Nouveaux Réalistes, Arman, Daniel Spoerri, and Yves Klein, has been associated with the early work of Robert Rauschenberg and Jasper Johns, as well as the Happenings of Allan Kaprow and Fluxus. They all search for new ways of returning to a world that is being created around them in defiance of the immanence of the old genres, in particular, painting. As Duchamp notes, however, neo-Dada does not introduce objects from the real world as a challenge to art (as was his intention), but makes them into art. It operates by utilizing reality as yet another material, but without the critical spirit of the original Dada movement. Ultimately, the Nouveaux Réalistes, Fluxus, and the ensuing Pop movement accepted material culture as it was. "We did not think, as the Dadaists did in 1916, that the world had gone crazy and there was no redemption in sight – its current of cynicism. Rather we felt that there was freedom to put the real world together in weird ways. It was a discovery, a heady appetite for debris, for cheap throwaways, for a new kind of involvement in everyday life without judgments about it, either social or political." (Allan Kaprow)

In New York Claes Oldenburg and Rauschenberg target the gap between art and life, creating funky and fantastic assemblages of junk elements from the street. The 1961 parody of consumerism and the commercial art market, *The Store,* consists of over one hundred larger-than-life plaster objects including doughnuts, cakes, corsets, and trousers. Although handmade, they are conceptually more irritating than the neo-Dada aesthetic redistributions of used objects. It is apparent that Hopper's 1961–64 photo-assemblage *Untitled (Store)*[11] refers to this lineage. The conceptualism, which Hopper will come to cherish in his artistic practice, has two significant influences. First, the clinical investigations of Duchamp presented in a major exhibition at the Pasadena Museum of Art and, second, the work of Warhol, Kienholz, and Edward Ruscha. *The Brillo Boxes,* the *Twentysix Gasoline Stations,* and the *concept tableaux* all pose, from different points of view, the question of what constitutes art – concept versus object. In a publication of twenty-six photographs, Ruscha presents gasoline stations, photographed by himself or others in an abstractly neutral fashion, recording the factual details of a collection of "ready-mades."

The influence of these artists becomes evident in Hopper's photographs and assemblages as well as with the objects he designates, collects, or manufactures. Rather than recording the elements of popular culture in painting, Hopper goes out and steals signs, photographs billboards, and manufactures sculptural ready-mades. *Draw Me and Win an Art Scholarship*[12] is a Plexiglas head of a woman, modeled after an

10 In an 1949 Brussels exhibition, *The Object through the Ages,* Dotrement exhibited potatoes in a glass case.
11 See p. 140.
12 See p. 142.

image advertising an art scholarship on the cover of a matchbox. *Bomb Drop*[13] is a huge, kinetically-activated, plastic sculpture that emits light. "I started working in plastic, a big plastic *Bomb Drop*. And I found it out junking with Kienholz, this WWII bomb-drop, and it had these big knobs on it, and it had this thing that went from arm to safe. So I made it in a big plastic thing with lights inside and went through the primary colors – blue, yellow, red – and it would go to white and freeze there, and this big phallus with these big balls would go from arm to safe, arm to safe. And that was the last piece I did before I went, and I showed that at the Pasadena Museum." (Dennis Hopper)

But the most significant transcription of these ideas may appear in Hopper's film work, the large scale photographs of walls and other flat surfaces from the 1990s, and the wall assemblages and advertising images of 2000. For Hopper, these late works represent displaced commercial objects – "records in a non-functional way" – but they also thematize the tension between banality and aestheticism. Their familiarity and their flat, often over-sized presence are fused through a process of distancing and concentration that seems to reverse the object-subject relationship, in a similar way that an advertisment image *is there*. They seem to manifest a presence or performative quality of their own that evades the observer's ability to simply view them as objects. They play on the return of an object-based interest that is combined with Hopper's re-writing of an abstract urban iconography based on graffiti, marks, and color patches. Fred Hoffman states that "it is this concern for the modernist identification of the pictorial stroke with content and meaning, along with the equally important modernist belief in the mystery of the found or re-contextualized, which gives these paintings their relevance for Dennis Hopper's return to art making."[14]

And yet, the works seem to combine the ready-made, an interest in junk, the urban detritus of neo-Dada, the abstract painterly tradition, and a cinematographic reading of the city as an eclectic combination with its own narrative and intrinsic life. Hopper's latest works are to be read as a translation of old photos into billboards, the revisiting of early sculptures through reconstruction and the recreation of the physical and mental landscapes that formed their settings. "And so when I drive every day and see the graffiti, all I see mostly is this relationship between the gangs in the city and these Rothko kind of images that become these colors on colors on colors."[15]

The Films

The industrial medium, according to François Lyotard, has supremacy over non-reproducible forms of creation because of its ability to stabilize the referent, that is, the repetition of syntax and lexis that allows the recipient a rapid deciphering of images and sequences. As such, film has a direct impact on perception through its realization of a cinematic code; however, in the process, the medium is at risk of fulfilling its reproducibility, becoming mere genre, and annihilating any possibility of the unexpected, the non-codable. Hopper's filmmaking operates through a dual strategy, at once making use of the potentiality of Hollywood-style mass communication while also setting into play a series of abrasive elements that destabilize and disrupt the conventional codes.

13 See p. 147.
14 See p. 175.
15 See p. 124.

By the mid-1960s, audiences have abandoned Hollywood. The industry is completely ill-equipped to understand the paradigmatic changes that have captured the arts and society at large. Within a few years, the old studio system collapses, and a new generation of directors begins to transform the motion picture industry. A series of landmark movies – *Bonnie and Clyde* (Arthur Penn, 1967), *The Graduate* (Mike Nichols, 1967), *2001: A Space Odyssey* (Stanley Kubrick, 1968), *Rosemary's Baby* (Roman Polanski, 1968), *Midnight Cowboy* (John Schlesinger, 1969), *Easy Rider* (Dennis Hopper, 1969), *MASH* (Robert Altman, 1970), and *The Last Picture Show* (Peter Bogdanovich,1970) – close the decade of the sixties, sending tremors through the industry.

The result is an opening-up of the studios to new, young directors who regard film as an authorial work rather than as a process of execution without personal or stylistic integrity. Beyond the studios, film culture permeates American society and identity: "It was at this specific moment in the 100-year history of cinema that going to the movies became a passion among young people," writes Susan Sontag. *Easy Rider* not only ushered in a new Hollywood, but reconciled, for a moment, the ambitions and goals of independent filmmaking when, just a few years earlier, its thematic precursors – most notably Kenneth Anger's *Scorpio Rising* – had been shut down during the infamous *Cinémateque* screenings organized by Jonas Mekas. From the "unauthorized" independent films of the early-1960s, *Easy Rider* forges a transition that brings sex, violence, drugs, and anti-establishment sentiment into the big picture of mainstream cinema and society.

Hopper's role in the redefinition of American cinema during the collapse of the old studio system is well documented. Over a period of thirteen years he produces three films that can be regarded as a trilogy of a rebellious counter-culture. Hopper later expresses this idea in a film triptych in which three movie excerpts represent the cemetery scene from *Easy Rider,* the execution scenes from *The Last Movie,* and the final blow-up from *Out of the Blue.* The "trilogy" begins with a biker couple that sets out in search of freedom, love, and a new life in Florida, disturbing the ways of redneck America as they go. It is in the cemetery scene in *Easy Rider* that Hopper most clearly develops his visual language, departing from the iconic, from the depiction of reality as seen as well as from a narrative linearity to enter the realm of the symbolic. As Bruce Hainley discusses, the open use of drugs and hallucinatory experience allows for an artistic interpretation of cinematic language, a practice developed by the surrealists and later pursued by the Beat authors. Through the acid trip of the cemetery scene, Hopper develops a specific idiolect, recognizably rooted in the domain of the auteur, which is even more fully expressed in *The Last Movie.* Here the narration, technique, and symbolism reach a cataclysmic culmination – a stuntman who triggers his own quasi-religious execution – as an early expression of the ultimate dissolution and self-questioning that will be manifested in the performance, actionism, and body art of the 1970s. Eleven years later, *Out of the Blue* addresses this moment from a more distant position: the outcast returns to his psychodrama but no longer needs drugs as the primary vehicle of psychic and artistic realization. Set in the punk era, in the aftermath of the failed experiments of the late 1960s and 1970s, the film portrays a lost generation with no means of escape from a society that is regaining control over its youth. This tripartite meta-narrative reappears in a less individualized form in *Colors,* a film about the newest emerging group within American sub-culture, the Los Angeles street gang.

European filmmaking indirectly affects Hopper's films: My favorite director was Luis Buñuel, so he was really a big influence on me. I talked about *Realm of the Senses,* but that was much later. Jean-Luc Godard was not an influence on me, but François Truffaut was. Godard was full of theories and I didn't like his films, but Truffaut was a great filmmaker. They started out together. You know, Truffaut wrote *Breathless,* which is the only film I like of Godard's, very honestly. But I just love Truffaut's movies, I think they're just incredible. I mean, the beginning of *Day for Night* is wonderful. And it's a very similar idea to *The Last Movie,* but they're totally different kinds of films. When I first saw *Day For Night,* and it started out and you had the whole city looking at this street, and the woman walking with the poodle and so on, and I thought, "My God. Only in France could you shoot something like this. Look at the street. Look how great this looks, and it's snowing. Look at that. This is magnificent." And suddenly they say, "Cut!" and everything goes back to the first beginning. I went, "Wow." I saw it later that night because it was at the opening of the New York Film Festival and I had already made *The Last Movie* some years before. It was very interesting.[16]

The avoidance by European directors of traditional optical effects like dissolves and fades gives their films a documentary quality and an accelerated pacing. They use the traditional Hollywood genres, but break away from the traditional cinematic syntax. Michelangelo Antonioni's statement that "the visual aspect of film is, for me, strictly linked to its thematic aspect. It is in this sense that, almost always, an idea comes to me through images," seems to be applicable to Hopper's films as well. Hopper refuses to discard technical imperfections like lens flare, which occurs when the axis of the lens comes too close to the sun, causing the light to bounce around the lens. Hopper's interest in found material would proscribe eliminating what would normally end up on the cutting room floor. Because he aims for real film about real people, he captures every authenticity that he can produce, even at the risk of an amateurish, imperfect look. He has an intimate knowledge of the experimental film of the sixties, such as the work of Bruce Conner or Andy Warhol, which leads him to challenge unhesitatingly all the disciplinary principles. Although Hopper's editing approach for *Easy Rider* is influenced by a wide range of experimental filmmakers, including Stan Brakhage, it was Bruce Conner who exerted the most direct inspiration, even acting as an informal consultant. The influence can be seen in Hopper's employment of various experimental techniques such as flashback and flashforward, quick-cutting, and ironic juxtapositions of visuals and sound. But he also employs such means as running the credit sequence upside down and using extremely long shots without losing any frames. Contrary to its precursors, *Easy Rider* attempted not only a formal deconstruction of the filmic material, but also re-invented the conventional genre, establishing a clear distaste for authority and a cynical mistrust of the system. It is a reinterpretation of American iconography and Hollywood-infected American culture, and, as such, the film is arguably informed by Hopper's exposure to Pop, less stylistically than symbolically. Pop enacts a cultural shift that takes hold of society and its production of new images and products, creating a schism in the perception of reality and illusion.

The Last Movie was shot in Peru, at the time, the cocaine capital of the world. Thematically, the film is much more ambitious and apocalyptic, stylistically more structuralist. An subversive expression of counter-culture, it is a statement about the death of the West, of national expansionism, and of spiritual expansive-ness and, therefore, of the American Dream. Hopper goes a step beyond *Easy Rider,* moving noticeably

16 See p. 34.

closer to experimental film. Several narratives operate concurrently. The first involves a filming of a Hollywood western within a small Peruvian village, where local villagers recuperate the production's abandoned film sets for the celebration of a quasi-religious enactment, a Christian passion play of sorts, and finally, the story of an American stuntman that stays behind to search for gold and sex. The film describes a displaced, bourgeois American colony with its lust for love, riches, fur, and sacrifice through spiritualist ritual. The narratives are interlaced with "lyrical non-narrative bits of footage reminiscent of Hopper's own *Easy Rider,* and Brechtian devices such as the interpolation of inter-titles and clapboards, the repetition of identical or near identical shots, and the appearance of Hopper and other actors as themselves."

Hopper deals with a multitude of themes, techniques, and pictorial effects that constitute an on-going dialogue between cinema and the visual arts. His pictorial composition and montage are in constant tension with the rendering of narrative and his distinctive cinematic realism. Almost contrary to *Easy Rider,* film here becomes a self-reflexive medium. It is a film about film, speaking at once to the genre (deconstruction of the western), the film stock, the illusion of representation versus the celluloid material itself, the animation of the film apparatus, and the doubling effects of a film within a film. On several occasions, Hopper cuts through the frames to present the words "Scene Missing," abruptly suspending belief in the integrity of illusion represented by film. What we see is only film, and the indexical relation of the film to the represented object is severed. Film is simply film, as painting is paint and canvas. Or, in a doubly referential system, according to Baudrillard, what is achieved is a hyper-reality. As Brougher describes, this is a method introduced into Hollywood by Orson Welles' *Citizen Kane* (1941), in which the bright light of a film projector projects THE END, relocating us within a fictive room inside the film. Hopper reverses Welles' method, using it in a more deconstructive and less aestheticized manner, just as Jasper Johns would play on the confusion of representation and reality by painting the American flag to the edge of the canvas, leaving no fictive space, as Brougher remarks, in which the flag might exist. Citizen Kane also reverses end and beginning in a self-referential manner. In *The Last Movie,* the film apparatus reappears in a primitive reconstruction undertaken by the village people. Since they have learned what it takes to make a film, inspired and confused by the American film-team, the Peruvians set out to recreate and rightly "finish" the film. The film apparatus is reconstructed with rods and wooden elements and so ensues an archaic, atavistic feast under the direction of a fake film director — cigar and script in hand — who recreates his own identity as a paraphrase of the Hollywood director figure. But where the equipment is fake, the action is real, and, therefore, the self-proclaimed director demands real action, violence, and death. According to Herms, "with the introduction of sex and violence to Renaissance ideals, art came closer to a real humanism."[15] That's where the lynching starts and the religious folk does no longer use the 'real' stone church to celebrate but the reconstructed film set. Only the priests knows to negotiate the difference between reality and abstraction, since he is in office to celebrate allegory and simulacrum. He recognizes that his followers believe in fake gods.

The Last Movie is "the culmination of Hollywood's self examination process," in which Hopper engages all aspects of film making and cinema — film language, apparatus, celluloid, editing, genre, and film production. It is the point at which Hollywood cinema has been pushed over the edge of narrative, acting, and linearity to become intermingled with composition, rhythm, color, and material. It is "the last movie."

15 See p. 130.

And perhaps this self-reflexivity could only be realized by a man who also considers himself an artist and who has been closely involved with the artistic experiments of his time.

Author's list of sources

André Bazin, *What Is Cinema?* vol 1 (Los Angeles: University of California Press, 1989).
André Bazin, *What Is Cinema?* vol 2 (Los Angeles: University of California Press, 1971).
Peter Biskind, *Easy Riders, Raging Bulls* (New York: Simon & Schuster, 1998).
Sergei Eisenstein, *Film Form* (Fort Washington: Harvest Books, 1969).
Rudi Fuchs, "Back and Forth," in Rudi Fuchs/Jan Hein Sassen (eds.), *Dennis Hopper (A Keen Eye), Artist, Photographer, Filmmaker* (Stedelijk Museum Amsterdam: NAi Publishers Rotterdam, 2001): 14–15.
Susan Sontag, "The Decay of Cinema," *NY Times Magazine* (February 25, 1996): 61.
Peter Wollen, *Signs and Meaning in the Cinema* (Bloomington: Indiana University Press, 1972).

WITHIN A MAN OF LIGHT, THERE IS ONLY LIGHT; WITHIN A MAN OF DARKNESS, THERE IS ONLY DARKNESS (Self Portrait), 1997

Digital ink jet print transparency and lightbox

DENNIS HOPPER
Biography

by TAKESHI TANIKAWA (film)
and DANIELA ZYMAN (art)

A selection of photographs by Takeshi Tanikawa
from the archives of Dennis Hopper

I was born in Dodge City, Kansas on a farm in 1936. I followed the light changing on the horizon. I watched the hard rain in puddles. I collected bugs in the mornings by picking up leaves and putting them in a fruit jar with nail holes in the top. I lay in the ditch and watched the combines come along the dirt road. They were from Oklahoma. I wondered where the trains went. I shot a BB gun at the black crows. I fought the cows with a wooden sword. I hung ropes in the trees and played Tarzan. I listened to Joe Louis fight on the radio. I fed the chickens, pigs, cows. I swam in the swimming pool my mother waged in Dodge. I got a telescope and looked at the sun and went blind for five days. I caught lightning bugs, lightning shows, sunsets and followed animal tracks in the snow. I had a kite. I used the telescope to burn holes in newspapers. The sun was brighter than I was. God was everywhere and I was desperate. I sniffed gasoline and saw clowns and goblins in the clouds. I was Errol Flynn and Abbott and Costello. I ODed on the gasoline and attacked my grandfather's truck with a baseball bat breaking the windshield and the headlights. I ate raw onion sandwiches in the Victory Garden. My father went to war. I drove a combine and one wayed. On my broom horse I announced the beginning of the war to the crows. I was William Tell and Paul Revere. I dug fox holes in the field and played war. I racked balls in the pool hall, smoked cigarettes, drank beer, and ate more onions. My grandfather and my grandmother Davis were my best friends. I walked on the rails on the train tracks. I shot marbles with an agate shooter. I caught catfish and carp in the river. I wondered what mountains looked like and skyscrapers. I imagined them on the Kansas horizon. At thirteen I saw my first ones. They were smaller than I had imagined. So was the ocean. It was just like the horizon line on my wheat field. I was disappointed. I had a newspaper route. I delivered the news-paper from my bicycle. I collected paper to sell. I sold empty Coke bottles for money. (Dennis Hopper)

1936

Dennis Hopper, the first son of Jay and Marjorie Hopper, was born in Dodge City, Kansas on May 17, 1936. His mother managed the local swimming pool and his father, who worked for the Railway Mail Service, was often away from home for days at a time on mail runs from Kansas City to Denver. When Jay enlisted in the Armed Forced during World War II, Hopper was sent to live on the farm of his grandparents, a few miles from Dodge City. His happiest moments throughout these years occurred during weekly trips to town, where he would sell eggs with his grandmother and then spend hours in darkened movie theaters watching Roy Rogers, Gene Autry, Wild Bill Elliott, and Randolph Scott. When his father returned from the war, the family moved to Kansas City, Missouri, where, at the age of nine or ten, Hopper enrolled in an art class at the Nelson Art Gallery and began to paint. The gallery also offered a drama class, which provided Hopper with his first opportunity to observe and sketch live actors.

1949

In 1949 the family relocated to San Diego, California because of his younger brother David's asthma. Following his passion and talent for acting, Hopper auditioned for a production of Charles Dickens' *A Christmas Carol.* Winning the role of an urchin, he made his stage debut at Old Globe Theater in San Diego. Hopper worked there throughout highschool acting in small roles and learning every facet of backstage work. During one summer vacation when Hopper was fifteen years old, he ran away from home to go to the Pasadena Playhouse where he starred in the play *Doomsday.* When he returned home, he continued to work at the Old Globe Theater. During his highschool years, Hopper also won three dramatic oration contests in California state-wide competitions.

While still in high school, Hopper joined La Jolla Playhouse, which was founded and managed by John Swope, an actor turned photographer, and his wife, actress Dorothy McGuire. His first acting job at the playhouse was in a 1953 production of *The Postman Always Rings Twice* in which McGuire played the starring role. These years also marked the initiation of Hopper's relationship with Vincent Price, with whom Hopper shared the stage in another playhouse production. Price quickly became an artistic mentor, introducing Hopper to his own art collection which included paintings by Richard Diebenkorn, Emerson Woelffer, Franz Kline, and Jackson Pollock, influences that can be seen in Hopper's Abstract Expressionist paintings of this period. Pursuing broader acting roles, Hopper won a scholarship to the National Shakespeare Festival at Old Globe Theater to play the role of Lorenzo in *The Merchant of Venice,* a performance attended by Swope and McGuire.

1954

In November of 1954, Hopper, with a reference letter from Swope, headed
directly for Hollywood to visit Ruth Birch, head of casting at Hal Roach Studios.
She gave him a ten line part in the television series *Cavalcade of America*,
enabling him to obtain a Screen Actors Guild card and an agent. Thereafter,
Hopper was given a featured role as a boy with epilepsy in "Boy in a Storm," an
episode of the popular television series *The Medic*.

Dennis Hopper and Susan Kohner at La Jolla Playhouse, California, c. 1953

1955

When "Boy in a Storm" was aired on January 5, 1955, seven major studios contacted Hopper's agent, Bob Raison, to negotiate contracts. Accompanied by Raison, he first met with Harry Cohn, studio chief at Columbia Pictures, but the meeting ended in discord. They then visited Warner Brothers to meet with Nicholas Ray, who was preparing to direct *Rebel Without a Cause*.

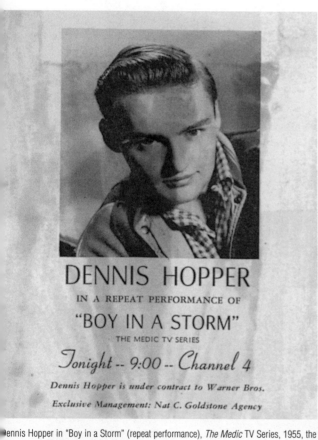

Dennis Hopper in "Boy in a Storm" (repeat performance), *The Medic* TV Series, 1955, the very first professional performance on TV

Portrait of Dennis Hopper, 1955 © Warner Brothers

Rebel Without a Cause, 1955, movie still (Dennis Hopper and others facing James Dean) © Warner Brothers

Rebel Without a Cause, 1955, movie still (Corey Allen, Natalie Wood, Dennis Hopper) © Warner Brothers

Hopper signed a standard seven-year contract with Warner Brothers, appearing in *I Died a Thousand Times* and then *Rebel Without a Cause,* playing Goon, an adversary of James Dean's character Jim. Dean became a mentor and close friend to Hopper during filming and encouraged Hopper's new interest in photography and directing film. It was Dean who first pointed toward what would become a compositional guideline for Hopper's photography: "I know you're going to direct some day, so learn to take photographs and don't crop them, use the still full-frame," Dean urged. Photography became an artistic endeavor as well as mental and visual training. Dean was also an influential figure in Hopper's training as an actor. Hopper relates: "He taught me the trick about the *imaginary line.* If you go to a movie set you'll notice that the people who are sitting around off camera are behaving one way, and the people who are on camera in another. In other words one is natural and the other is false. Dean knew how to bring that same tone of reality onto the set itself. And that's great acting, because then it isn't *acting* at all." This interpretation of realism has been a leading concept in Hopper's acting and film-making throughout his career.

Rebel Without a Cause, 1955, movie still © Warner Brothers

Rebel Without a Cause, 1955, movie still (Natalie Wood, Dennis Hopper, James Dean) Collection Takeshi Tanikawa

Rebel Without a Cause, 1955, Dennis Hopper reading the book *An Actor Prepares* by Constantin Stanislawski © Academy of Motion Picture Arts and Sciences

Rebel Without a Cause

October 1955, 111 min, Cinema Scope and Warner Color
Warner Brothers
Producer: David Weisbart
Director: Nicholas Ray
Screenplay: Stewart Stern (adaptation by Irving Shulman based on the story *The Blind Run* by Dr. Robert M. Lindner)
Director of photography: Ernest Haller
Music: Leonard Rosenman
Cast: James Dean (Jim); Natalie Wood (Judy); Sal Mineo (Plato); Corey Allen (Buzz); Dennis Hopper (Goon); Nick Adams (Moose)

Though Hopper's role is very small in this film, his merciless eyes and grin are the first indications of what will become the full-blown character of Frank Booth in David Lynch's *Blue Velvet.*

1956–1958

Following *Rebel Without a Cause,* both Dean and Hopper moved to Marfa, Texas to begin shooting *Giant,* a film directed by George Stevens and based on a best selling novel by Edna Ferber. Hopper's magnificent performance in the role of Jordy Jr. earned the high praise of both Stevens and Dean as well as many film critics, and Warner Brothers lobbied for Hopper's nomination for best supporting actor in the Oscar race. Dean's tragic sudden death occurred just eight days after he finished his final scene in Los Angeles. Hopper was devastated by the death of his close friend.

Giant, 1956, off set (Carol Baker, Dennis Hopper, Liz Taylor)

Giant

November 1956, 201 min, Cinema Scope and Warner Color
Warner Brothers
Producer: George Stevens and Henry Ginsberg
Director: George Stevens
Screenplay: Fred Guiol and Ivan Moffat (based on a novel by Edna Ferber)
Director of photography: William C. Mellor
Music: Dimitri Tiomkin
Cast: Elizabeth Taylor (Leslie Benedict); Rock Hudson (Bick Benedict); James Dean (Jett Rink); Carrol Baker (Luz Benedict II); Mercedes McCambridge (Luz Benedict); Sal Mineo (Angel Obregon III); Dennis Hopper (Jordan Benedict III)

In the first half of the film, Jett Rink, played by James Dean, monopolizes the audience's sympathy. When he suffers an emotional collapse in the second half of the film, Hopper's character, the sweetly sensitive and honest Jordan Benedict III, becomes the focus of the film.

Giant, 1956, movie still (Elsa Cardenas, Dennis Hopper) Collection Takeshi Tanikawa

256

In the summer of 1956, Elvis Presley – who had just signed his first movie contract with the producer Hal Wallis – visited Hopper in Hollywood. The two shared memories of Dean.

In October, Warner Brothers gave Hopper a principal role in *King's Row*, a drama for the studio's ABC-TV series. His co-star was Natalie Wood, who had developed a friendship with Hopper off-screen during the filming of *Rebel Without a Cause*.

Hopper played the part of Napoleon Bonaparte in *The Story of Mankind*. He also appeared in many television westerns including *Cheyenne*, *The Rifleman*, and *The Wagon Train*, and in the films *Gunfight at the OK Corral*, with Burt Lancaster and Kirk Douglas, and *The Young Land*, playing a villain opposite Pat Wayne. In 1958 Warner Brothers loaned Hopper to 20th Century Fox for another western, *From Hell to Texas*. A fatal clash of personalities between Hopper and the film's director, Henry Hathaway, resulted in loss of his Warner Brothers' contract and expulsion of Hopper from Hollywood.

"Please don't call me another Jimmy Dean …", from *Young Movie Lovers*, No. 1, 1957

The Young Land, 1959, movie still © Columbia Pictures

The Story of Mankind

November 1957, 100 min, Technicolor
Cambridge production
Producer: Irwin Allen
Associate producer: George E. Swink
Director: Irwin Allen
Screenplay: Irwin Allen and Charles Bennett (based on book by Henrick van Loon)
Director of photography: Nick Musuraca
Music: Paul Sawtell
Cast: Ronald Coleman (Spirit of Man); Vincent Price (Devil); Hedy LaMarr (Joan of Arc); Groucho Marx (Peter Minuit); Harpo Marx (Isaac Newton); Chico Marx (Monk); Virginia Mayo (Cleopatra); Agnes Moorehead (Queen Elizabeth); Peter Lorre (Nero); Charles Coburn (Hippocrates); Cedric Hardwicke (High Judge); Ceser Romero (Spanish Envoy); Dennis Hopper (Napoleon); Marie Wilson (Marie Antoinette)

In this all-star, surrealist epic that includes the Marx brothers and Vincent Price, Hopper plays Napoleon Bonaparte.

Gunfight at the O.K. Corral

May 1957, 122 min, Vista Vision and Technicolor Paramount
Producer: Hal B. Wallis
Director: John Sturges
Screenplay: Leon Uris
Director of photography: Charles Lang, Jr.
Music: Dimitri Tiomkin
Cast: Burt Lancaster (Wyatt Earp); Kirk Douglas (Doc Holliday); Rhonda Fleming (Laura Denbow); Jo Van Fleet (Kate Fisher); John Ireland (Ringo); Dennis Hopper (Billy Clanton); Lyle Bettger (Ike Clanton); Lee Van Cleef (Ed Bailey)

Hopper plays another sensitive character, Billy Clanton, the youngest son of a family at odds with Sheriff Wyatt Earp, played by Burt Lancaster. Recognizing Billy's innocence, Earp tries to protect the young man from becoming an innocent victim of this conflict.

The Young Land

May 1959, 89 min, Technicolor
C.V. Whitney production
Producer: Patrick Ford
Director: Ted Tetzzlaff
Screenplay: Norman Shannon Hall (based on the story *Frontier Frenzy* by John Reese)
Director of photography: Winton C. Hoch and Henry Sharp
Music: Dimitri Tiomkin
Cast: Pat Wayne (Jim Ellison); Yvonne Craig (Elena de la Madrid); Dennis Hopper (Hatfield Carnes); Dan O'Herlihy (Judge Isham)

Hopper plays his first villain, a gunman who challenges the sheriff, played by Patrick Wayne.

Hopper headed for New York to study with Lee Strasberg whose method acting was based on the notion that the brain and emotions are controlled by the senses: "… that's the way you get to have emotional memory. It's not remembering but going through your senses and seeing if the sense will bring back what happened when your mother slapped you. So the senses can then be used for emotional recall. To recall things is method acting."

In New York, Hopper also spent his time in galleries and museums, developing his artistic sense, as well as his art collection. Following the suggestion of Dean, Hopper began taking photographs for the purpose of learning composition. His first photographs were of people on the streets of New York, sort of "West Side Story" kind of photos. He continued to appear in numerous television series including *Zane Grey Theater, Pursuit, Barbara Stanwyck Theatre, Studio One, The Twilight Zone,* and *Naked City,* and in 1959 went back to Hollywood to play another villain in Phil Karlson's *Key Witness.*

The young punks and Ruby, their moll, meet in the hide-away after the killing.

M-G-M presents
An AVON Picture
"KEY WITNESS"
In CinemaScope

Key Witness, 1960, movie still (the young punks and Ruby, their moll, meet in the hide-away after the killing) © 1960 Loew's Incorporated

Key Witness, 1960, Dennis Hopper and Susan Harrison sign autographs f fans in Los Angeles Collection Takeshi Tanikawa

The Twilight Zone (He's Alive), 1963 © c

1961

In 1961 Hopper took part in an international photography competition in Australia with a contribution of five abstract photos, which he called *Pieces*. He won first place.

Hopper appeared on Broadway in *Mandingo*, a Lyceum Theater production with Franchot Tone and Brooke Hayward. The play, written by Jack Kirkland, was based on a novel by Kyle Onstott about life on a nineteenth century slave plantation. The production lasted only eight performances due to negative reviews. Soon thereafter, Hopper married Hayward, daughter of the film producer Leland Hayward whose credits include *The Sound of Music* and *South Pacific*. The wedding party of Hopper and Hayward was held in August at the apartment of actress Jane Fonda, a childhood friend of Hayward, who introduced Hopper to her younger brother Peter Fonda.

Their daughter Marin was born in 1961, and they moved to Bel Air, California. Soon afterward the famous Bel Air fire destroyed their home, including approximately three hundred Abstract Expressionist works and hundreds of pages of poetry that Hopper had begun in the mid-1950s.

Dennis Hopper teaches photography to his daughter Marin, 1963/64, Malibu, California © Robert Walker, Jr.

Dennis and Brooke Hopper's photographs at the Hopper House, 1964 © Dennis Hopper

Dennis Hopper at barber, 1964 © Dennis Hopper

Children's party at the Hopper House, 1964 © Dennis Hopper

Brooke Hopper at the Hopper House, 1964 © Dennis Hopper

Only his boxes of photographic negatives were saved, as they had been moved to Photo Lab/Gallery Barry Feinstein in preparation for his first exhibition. The burning of his early production had traumatic consequences. Hopper did not return to painting for nearly two decades: "And then I tried to start painting again, and I couldn't really do it. Walter Hopps has my last painting, when I said 'fuck painting,' and I took the frame, and I put it on a canvas, and I gold leafed it on a black velvet thing, and I glued and hammered the paintbrush onto the canvas, and said 'fuck it,' and threw it in a corner. Walter kept the painting, and there's one painting from 1955 that my father had taken for himself. So there's only those two works from anything before '61."

The Hoppers resettled in a Spanish-style home on North Crescent Heights Boulevard in West Hollywood, just north of Sunset Boulevard. The house was soon filled with Hopper's new collection of contemporary art which included works by Andy Warhol *(Campbell's Soup Can* and *Mona Lisa),* Edward Kienholz *(The Quickie* and *White on the Side),* Roy Lichtenstein *(Sunrise),* Edward Ruscha *(Standard Station),* Jasper Johns, Robert Rauschenberg, Frank Stella, Claes Oldenburg, Milton Avery, Martial Raysse, John Altoon, and Larry Poons. The notorious "Hopper House" was described as a "kaleidoscopically shifting assemblage of found objects and *objets d'art,*" which included, in addition to his Pop collection, a larger than life papier maché clown, Mexican paper flowers, an original Art Nouveau panel, billboards retrieved from the junkyard, a 750 pound fiber glass sedan, a carousel horse, and collages of old fruit can wrappers.

ew of the Hopper House, from *Vogue,* 1965 © Dennis Hopper

ennis and Brooke Hopper, 1964 © Robert Walker, Jr.

1961–1963

Hopper and his actor friends Dean Stockwell and Russ Tamblyn were close to many artists in California, especially assemblage artists Edward Kienholz, Wallace Berman, George Herms, and artist/filmmaker Bruce Conner. As Hopper was denied work in film, he turned increasingly to his artistic investigations. He started assembling objects with photographs (photo-assemblages) and questioning conceptually the relationship between "reality," "illusion," and "representation," sometimes working under the guidance of Kienholz. "I was

recording objects (in a photograph) and using the object the way it functioned, and then affixing the object itself to the record of the object, and using light and recreating the light of the real object, recreating the light in the gallery and having the record of it the way it looked using natural light and raw canvas." Hopper became a key figure in the L. A. art scene in the early 1960s, and his black and white photographs of artist friends were used occasionally for posters and announcements for the Ferus Gallery or for the covers of *Artforum*.

Double Standard, 1961 © Dennis Hopper

Biker Couple, 1961 © Dennis Hopper

Double Standard, 1961

The two Standard signs, the billboard, and the Route 66 signs, seen from the driver's perspective, make reference to the Southern California relationship with the automobile and the perceived mobility of the American west. Dennis Hopper's interest in these themes was shared with many of his contemporaries, Edward Ruscha among them. The "screen" of the windshield frames the photograph. The image has not been cropped, as is the case with most of Hopper's photographs. The artist's ability to frame the image in the camera lends a cinematic quality to his work. This conception of composition was to have a direct influence on Hopper's later work in film.

Biker Couple, 1961

In the post-war years, west coast biker culture offered a sharp critique of Atomic Age optimism. Intimately connected to the Second World War and its consequences, the first chapter of Hell's Angels was founded in 1947 by American GI's returning home, disillusioned and straining against the conformity of the new America. The introduction of the motorcycle, and of motorcycle culture, into the California landscape referenced the archetype of the outlaw in the west. The search for freedom, mobility, and a new tribalism was an interest shared by both the motorcycle and Beat scenes, often creating unlikely alliances, as outlaw biker met outlaw artist. Here Dennis Hopper beautifully captures a moment of intimacy in a culture that was to take on the aura of myth.

Arforum cover, Andy Warhol (with flower), photograph by Dennis Hopper, December 1964 © Artforum

Artforum cover, collage of black and white photographs by Dennis Hopper, September 1965 © Artforum

Night Tide, 1963, film poster © Curtis Harrington

In 1961 Hopper starred in Curtis Harrington's *Night Tide* (released in 1963), his first leading role in a feature film. One of the first American independent films, *Night Tide* was screened at the Festival of Two Worlds in Spoleto, Italy.

Night Tide

1963, 84 min, black and white
A Filmgroup Presentation
Producer: Aram Kantarian
Associate producer: H. Duane Weaver
Director: Curtis Harrington
Screenplay: Curtis Harrington
Director of photography: Vilis Lapenieks
Music: David Raksin
Cast: Dennis Hopper (Johnny); Linda Lawson (Mora);
Gavin Muir (Captain Murdock); Luana Anders (Ellen);
Marjorie Eaton (Madame Romanovitch)

Hopper's first leading role in a film, he plays a naïve young sailor who falls in love with a mysterious carnival mermaid.

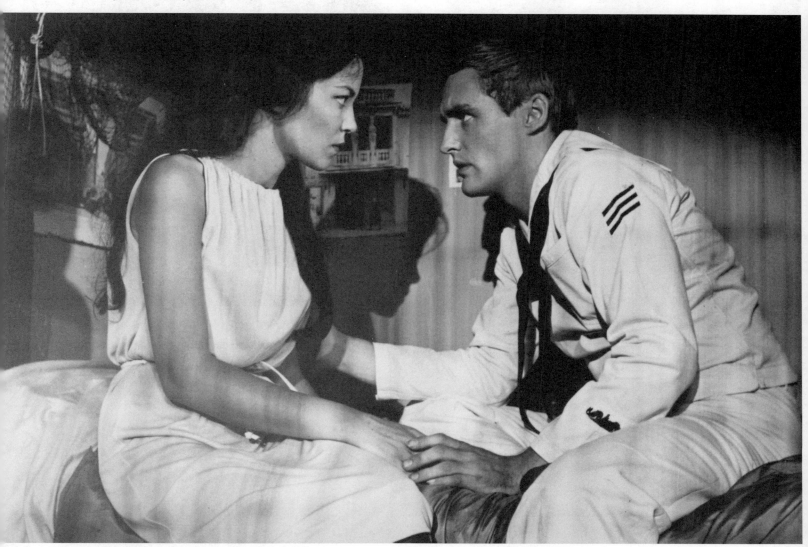

Night Tide, 1963, movie still (Dennis Hopper facing Linda Lawson) © Curtis Harrington

1963

In 1963 Henry Geldzahler, curator of twentieth century art at the Museum of Modern Art, introduced Hopper to Andy Warhol. Coincidentally, the meeting occurred on the very day Warhol introduced the young British artist David Hockney to Geldzahler, and all of them went to the sound stage on West 125th Street to watch Hopper work as guest star on the television series *The Defenders*. A few months later, Warhol mounted *An Exhibition by Andy Warhol* at Ferus Gallery in L. A., showing his silkscreen paintings of Elvis Presley and Liz Taylor. Hopper threw a party at which he introduced many actor friends to

Warhol. With a 16mm movie camera purchased before leaving New York, Warhol shot his first film, *Tarzan and Jane Regained ... Sort of,* while staying at the Beverly Hills Hotel. Hopper appeared in the film with Claes and Pat Oldenburg, Naomi Levine, Wallace Berman, and Taylor Mead. Under the influence of Warhol and the emerging Pop artists, Hopper was drawn to commercial images, billboards, silk screens, and "manufactured" art – to a "return to reality" which became a leitmotif during the 1960s.

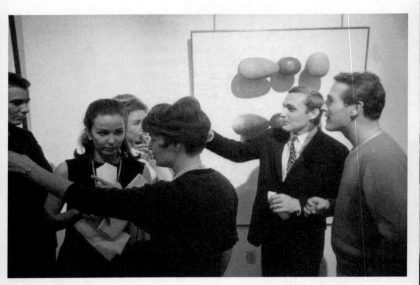

Dennis Hopper's solo exhibition of assemblage at Primus/David Stuart Gallery, Los Angeles, 1964 (Brooke Hopper, Joan Woodward, Dennis Hopper, and Paul Newman) © William Claxton

Dennis Hopper © William Claxton

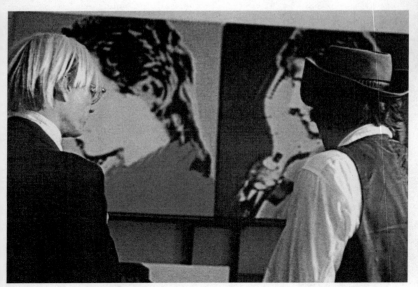

Andy Warhol and Dennis Hopper, 1963 © Jocelyn

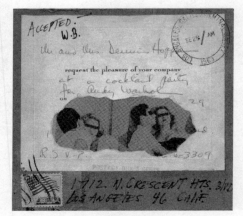

Brooke and Dennis Hopper's invitation to a cocktail party for Andy Warhol, 1963 © Alta Light

In October of 1963 Walter Hopps, curator at the Pasadena Art Museum, organized *by or of Marcel Duchamp or Rrose Selavy,* the first retrospective of Duchamp's work in the United States. This exhibition had an enormous impact on the entire L. A. art scene and on Hopper's work in particular. Hopper became increasingly interested in the idea of the readymade, shared authorship, and the artist as "finger pointer." During the exhibition, Hopper stole the sign of the Hotel Green, where Duchamp was staying, and had the artist sign the object with its image of a pointing finger. "I then went into a whole area of stealing things, of going out and stealing the Mobil flying red horse. I would make it into a piece of sculpture in front of a big car that Kienholz and I found, this big old Chevrolet. So then I'd steal all these road signs and road stuff: Quaker Oil, Mobil, and Shell Oil, and all these things that would sit in front of this big Chevy."

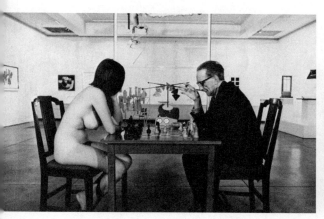

Marcel Duchamp playing chess with a nude woman at the Pasadena Art Museum, 1963
© 1963 Julian Wasser

Hotel Green (Entrance), 1963, Dennis Hopper with Marcel Duchamp, oil paint on wood panel © Alta Light

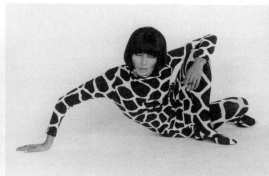

Gernreich Model (Giraffe Pattern), 1963 © Dennis Hopper

Original poster advertising Claes Oldenburg's *Autobodys* Happening, 1964

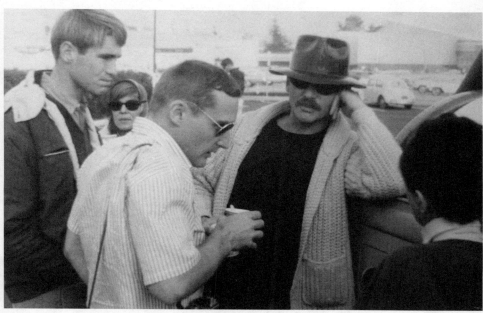

Claes Oldenburg, *Autobodys,* 1964 © Alta Light (Alan Shaffer Photography)

Robert Rauschenberg, *Pelican,* 1964 © Dennis Hopper

Allan Kaprow, *Fluids,* 1964 © Dennis Hopper

1964–1967

Hopper had his first solo exhibition of assemblages at Primus/David Stuart Gallery in L. A. in January 1964.

In 1965 Henry Hathaway hired Hopper for the production of *The Sons of Katie Elder,* starring John Wayne and Dean Martin and set in Durango, Mexico. In January 1966 Robert Fraser Gallery in London showed *Los Angeles Now,* an exhibition featuring Hopper's new *Foam Rubber* sculpture, which consisted of huge boulders and cacti constructed out of foam rubber. The exhibition also included works by Larry Bell, Wallace Berman, Jess Collins, Bruce Conner, Llyn Foulkes, Craig Kauffman, and Edward Ruscha.

1967 began a twenty-five year period of suspension of Hopper's photographic work, during which time he devoted his artistic energies mainly to film. His last artistic work was a replica of a World War II bomb-drop control switch constructed in plastic and stainless steel. "I started working in plastic, a big plastic *Bomb Drop*. And I found it out junking with Kienholz, this World War II bomb-drop. So I made it in a big plastic thing with lights inside and went through the primary colors – blue, yellow, red – and it would go to white and freeze there, and this big phallus with these big balls would go from arm to safe, arm to safe. And that was the last piece I did before I went, and I showed that at the Pasadena Art Museum" in February and March 1968.

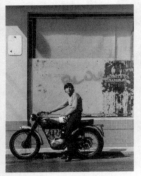

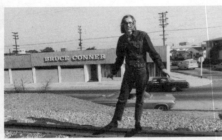

Bruce Conner at Physical Services, 1964 © Dennis Hopper

Edward Ruscha, 1964 © Dennis Hopper

Wallace Berman, 1964 © Dennis Hopper

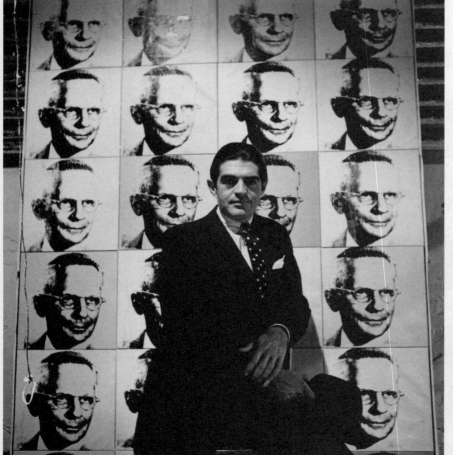

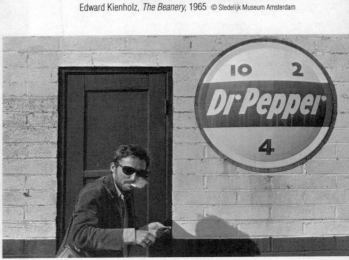

Edward Kienholz, *The Beanery*, 1965 © Stedelijk Museum Amsterdam

Irving Blum, 1964 © Dennis Hopper

Dennis Hopper in front of a Dr. Pepper sign, 1965 © Robert Walker, Jr.

The Sons of Katie Elder, 1962, John Wayne
and Dean Martin © Dennis Hopper

While editing *The Last Movie* in Taos,
New Mexico, Dennis Hopper visited Orson
Welles who was directing *The Other Side of
the Wind in Arizona.* The film's leading actor,
John Huston – director of one of Hopper's
favorite films, *Treasure of the Sierra Madre* –
and Hopper visited John Ford in the
hospital.

Dennis Hopper, John Ford, and John Huston,
1971, Palm Springs, California

© Skrebneski Photograph

Dennis Hopper at
Monterey Pop Festival, 1967

© Jim Marshall

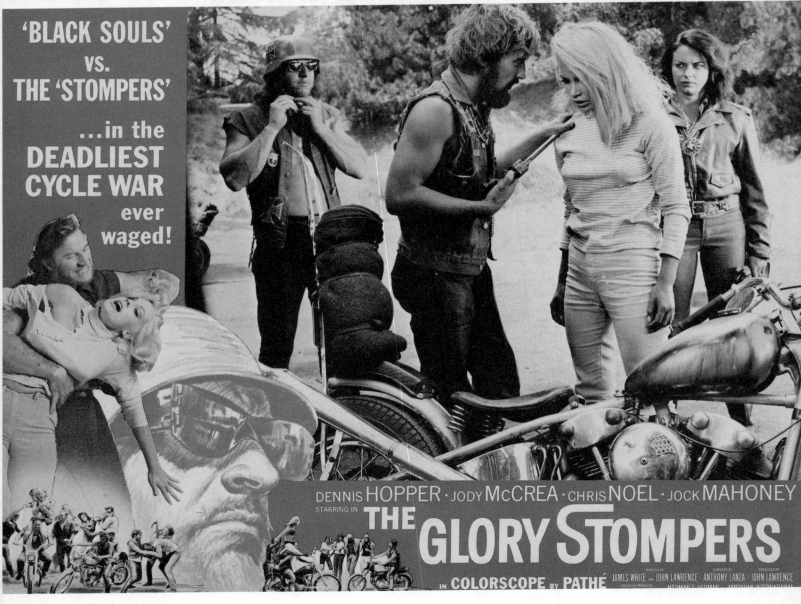

'BLACK SOULS'
VS.
THE 'STOMPERS'
...in the
DEADLIEST
CYCLE WAR
ever
waged!

DENNIS HOPPER · JODY McCREA · CHRIS NOEL · JOCK MAHONEY
STARRING IN

THE GLORY STOMPERS

IN COLORSCOPE BY PATHÉ JAMES WHITE and JOHN LAWRENCE · ANTHONY LANZA · JOHN LAWRENCE

The Glory Stompers, 1967, lobby card © The American International Pictures

During filming of *The Sons of Katie Elder,* Hopper began to conceptualize *The Last Movie,* which he wrote in collaboration with Stewart Stern, writer for *Rebel Without a Cause.* Struggling with financing, it became apparent that production of *The Last Movie* could not go forward, and Hopper took a small part in the psychedelic film *The Trip,* starring Peter Fonda, written by Jack Nicholson, and directed by Roger Corman, who gave Fonda and Hopper a chance to direct a scene in the film. *The Trip* earned a new audience among "anti-establishment viewers" and brought together the team that would later produce the 1969 breakthrough film *Easy Rider.* Hopper also directed part of *The Glory Stompers,* in which he played a villain once again. These two opportunities were good practice for Hopper's ongoing directorial activities.

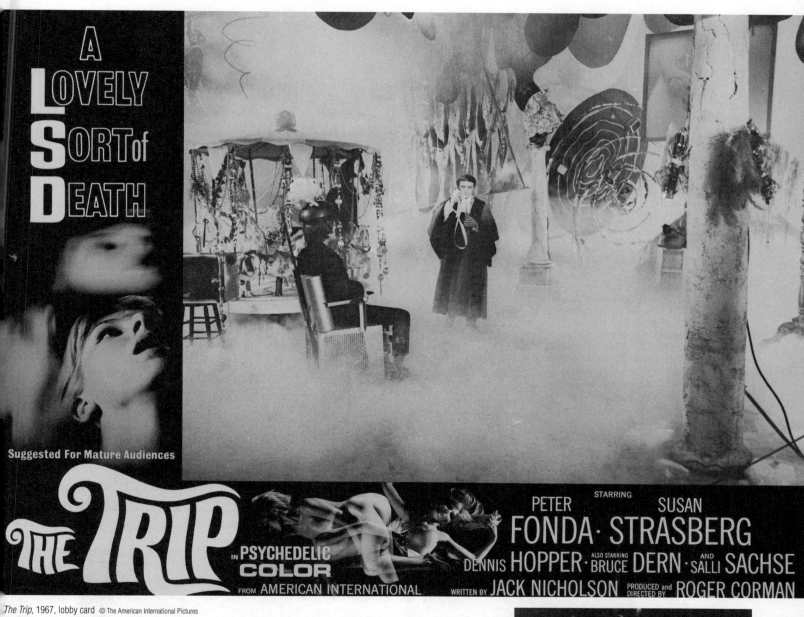

The Trip, 1967, lobby card © The American International Pictures

The Trip, 1967 © MGM

In 1968 Bert Schneider and Bob Rafelson agreed to finance the "biker film" *Easy Rider,* named and co-written by Terry Southern, Hopper and Fonda. Filming began immediately with a 16mm camera. Barry Feinstein, who had presented Hopper's first exhibition in 1961, served as the initial cinematographer for the project and was succeeded by Laszlo Kovacs after a series of difficulties shooting the film. The actor selected to play the role of George

Hanson, was Jack Nicholson. Interest in the film grew gradually, and it was eventually included, as the official entry of the United States, at the Cannes Film Festival, where it received an award for best new director. The film went on to break box office records throughout the world and was nominated for Academy Awards in two categories — best screenplay (Fonda, Southern, and Hopper) and best supporting actor (Nicholson).

Easy Rider

July 1969, 94 min, color
Pando Company in association with Raybert Productions
Executive producer: Bert Schneider
Producer: Peter Fonda
Associate producer: William Hayward
Director: Dennis Hopper
Screenplay: Peter Fonda, Dennis Hopper, and Terry Southern
Director of photography: Laszlo Kovacs
Cast: Peter Fonda (Wyatt); Dennis Hopper (Billy); Luke Askew (Stranger); Robert Walker (Jack); Jack Nicholson (George Hanson); Toni Basil (Mary); Karen Black (Karen).

Released in a moment of extreme sociological uncertainty generated by the Vietnam War, the success of *Easy Rider* was propelled by its raw sense of reality. Audiences, tired of up-beat Hollywood productions that glossed over the cultural upheavals and defeats of post-war America, readily embraced Hopper's anti-hero. In several scenes, Hopper cast non-actors, creating a live friction that blurred the lines between life and film set.

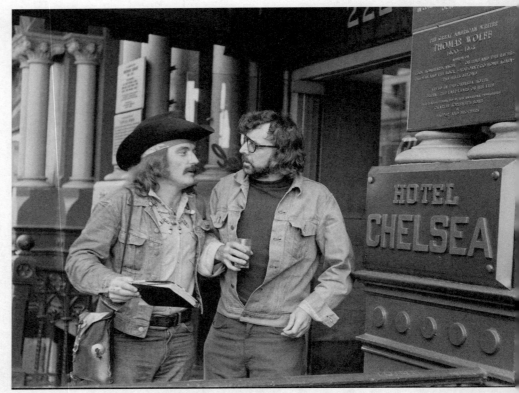

Dennis Hopper and Terry Southern in front of Hotel Chelsea, New York City, 1971 © Fred W. McDarrah

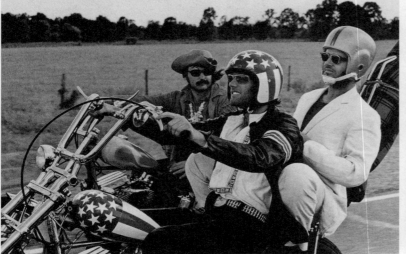

Easy Rider, 1969, movie still © Columbia Pictures

Easy Rider, 1969, lobby card © Columbia Pictures

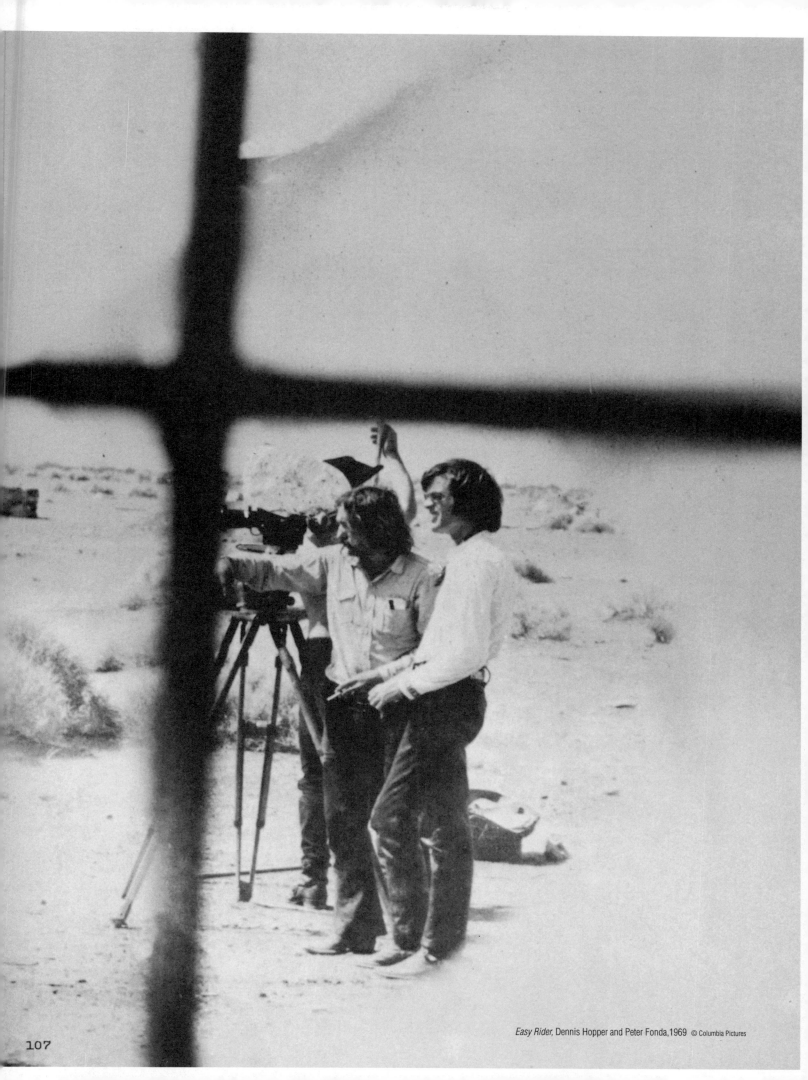

Easy Rider, Dennis Hopper and Peter Fonda,1969 © Columbia Pictures

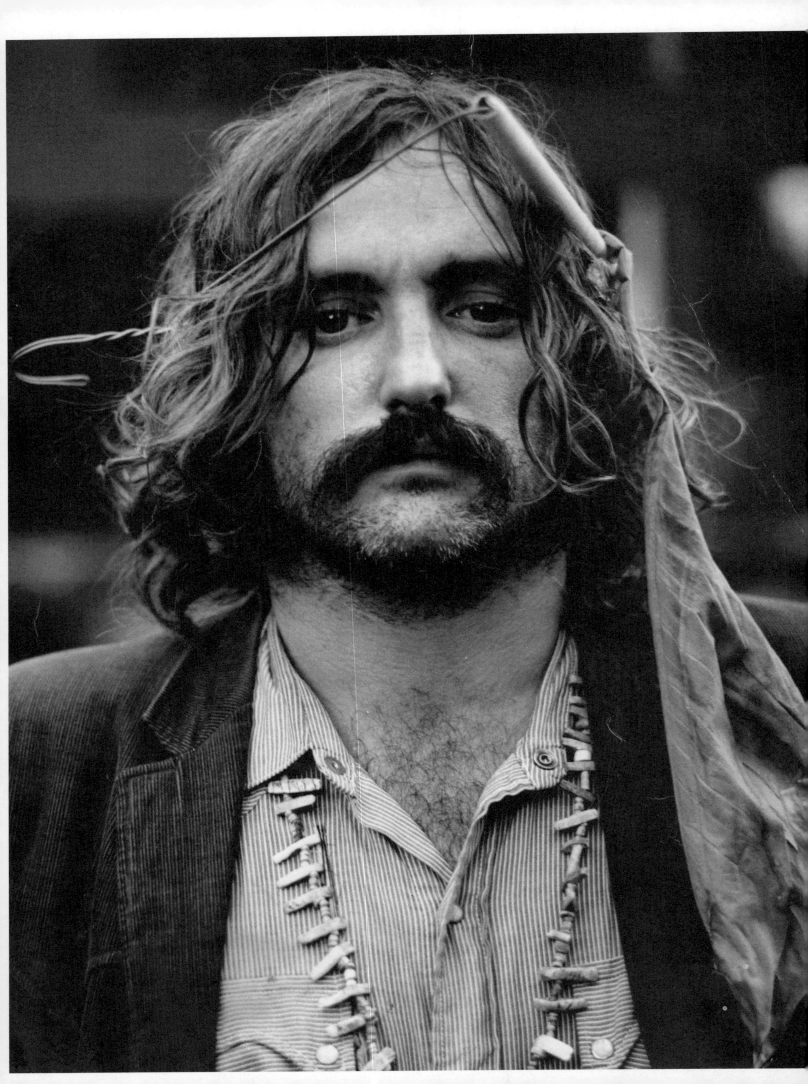

Kerry Brougher

EASY RIDING THROUGH THE UNDER-GROUND

Kerry Brougher, curator of film and art, currently Hirshhorn Museum, Washington D. C., speaks about the "fourth" type of cinema.

Generally, we are content to speak of three cinemas. The first two find their origins at the birth of the motion picture in the work of the brothers Lumiére and the magician Georges Méliès, whose pioneer films at the end of the nineteenth and beginning of the twentieth centuries launched respectively the documentary and fictional sides of the art form. Then there is the "other" cinema, the avant-garde or underground film. Any considerations of this lineage must take into account the history of the visual arts in the twentieth century with which it continually dovetails. Rejecting narrative and studio practices, avant-garde filmmakers considered themselves artists independent of the constraints of mainstream filmmaking and studio economics, and thus felt free to explore the poetic side of the medium. Independently financed, often shot with a crew of one or two, these filmmakers fully embraced the notion of the *auteur*, the vision of one individual over the collective group of talent. From the first blossoming of experimental films by artists such as Man Ray, Hans Richter, and Fernand Léger in the 1920s, through the mythical hallucinations of Maya Deren, Kenneth Anger, and Stan Brakhage in the 1940s and 1950s, and on to the rise of the self-reflexive, structuralist films of Peter Kubelka, Andy Warhol, and Michael Snow in the 1960s and 1970s, the avant-garde film rejected narrative structure, seamless editing strategies, and the classical composition of history painting, preferring instead to foreground film language, making the normally invisible aspects of filmmaking visible.

There is, however, one more type of cinema, an approach that has been used far less than these others but nevertheless contains some of the most provocative and beautiful films in the history of the medium. Neither fiction, documentary, nor avant-garde, these films find inspiration in cutting across classifications. Generally feature-length, these works utilize strategies of filmmaking normally found in documentary and experimental cinema, thereby blurring the line between prose and poetry. The lineage is rich in important, if rarely seen films: Robert Wiene's *Das Cabinett des Dr. Caligari* (1919), Dmitri Kirsanov's *Ménilmontant* (1924), Marcel L' Herbier's *L' Inhumaine* (1925), Sergei Eisenstein's *October* (1928), Jean Vigo's *À Propos de Nice* (1930), Tod Browning's *Freaks* (1932), Carl Dreyer's *Vampyr* (1932), William Dieterle's *A Midsummer Night's Dream* (1935), Albert Lewin's *Pandora and the Flying Dutchman* (1951), Jean-Luc Godard's *À Bout de Souffle* (1960), Jean Cocteau's *Le Testament d' Orphée* (1960), Alain Resnais' *L' Année dernière à Marienbad* (1962), Michelangelo Antonioni's *L' Eclisse* (1962), Chris Marker's *La Jetée* (1964), David Lynch's *Eraserhead* (1977), Atom Egoyan's *The Adjuster* (1991), and Alexandr Sokurov's *Mother and Son* (1997), to name a few. We could also include within this category the early animated films of Max Fleischer and Walt Disney, the montage sequences of Slavko Vorkapich, as well as occasional moments in the feature films of Josef von Sternberg, Alfred Hitchcock, Edgar G. Ulmer, Karl Freund, Stanley Kubrick, Federico Fellini, Dario Argento, Andrei Tarkovsky, Sam Raimi, Abbas Kiarostami, and the Coen brothers. Among this list of filmmakers we would also have to include Dennis Hopper, particularly in relation to his first two films as director, *Easy Rider* (1969) and *The Last Movie* (1971).

Hopper began his career in Hollywood as an actor, although he had a strong desire from the start to direct films as well.[1] His appearance in such mainstream classics as Nicholas Ray's *Rebel Without a Cause* (1955), George Stevens' *Giant* (1956), Henry Hathaway's *From Hell to*

Dennis Hopper (with coathanger on head), c. 1969 © Walter Chappell

Texas (1958), Hathaway's *The Sons of Katie Elder* (1965), and Stuart
Rosenberg's *Cool Hand Luke* (1967), belie the circle of acquaintances
Hopper was gathering around him. Hopper's crowd was not the
Hollywood élite but the L. A. underground. Hopper had arrived in Los
Angeles at a pivotal moment in the city's cultural history. Would-be
artists and musicians, such as Edward Ruscha, Mason Williams, and
Joe Goode, were in the process of arriving from the Midwest,
mimicking, like Hopper himself (he had come from Kansas), Jack
Kerouac's cross-country journeys.

In 1957, Walter Hopps and Edward Kienholz opened the influential
Ferus Gallery, launching a new, vital era in L. A. contemporary art,
while jazz clubs continued to flourish with names like Dexter Gordon
and Miles Davis on the bill. In the sunshine L. A. was the land of
housing tracts and freeways, movie premieres and billboards, but at
night a different, underground life thrived. Walter Hopps has suggested
that L. A.'s "poets (horn players, painters, et al) seemed then in the
shadows, or out of sight to the public world. In Southern California
then, in Orson Welles' failed land of a 'false dawn in the far west,' the
tract house builders went bananas. The real action was at night: dark
streets where little more than neonburn was possible, and darker
rooms."[2]

It was not within the fading glamour of Hollywood that Hopper
found his friends, but down Raymond Chandler's mean streets. If by
1960 Hopper found he had become stigmatized as the bad boy of
Hollywood, an actor who refused to cooperate on the set, he did not
seem to care much; he had found among the artists of L. A. a world that
was much better suited to his radical and rebellious instincts and his
desire to direct films that mattered. Among Hopper's acquaintances
were experimental filmmakers such as Bruce Conner, Kenneth Anger,
and Curtis Harrington; artists such as Wallace Berman, George Herms,
Billy Al Bengston, Llyn Foulkes, Robert Irwin, Edward Ruscha, and
Edward Kienholz; art dealers like Irving Blum, Walter Hopps, and
Virginia Dwan; and fellow actors on the fringes of the avant-garde
including Dean Stockwell, Peter Fonda, and Robert Walker, Jr. Through
Anger, Hopper's world even extended into occult hangouts populated by
Aleister Crowley "dead soul" types.

In the 1960s, Hopper's film roles began to reflect his rebellious
streak and his bohemian environment: in 1963, the actor starred in

Bruce Conner and Dennis Hopper at the reception for *The Dennis Hopper One Man Show* at the
James Willis Gallery, San Francisco, California, February 7, 1973 © Edmund Shea/Bruce Conner

Curtis Harrington's experimental feature *Night Tide;* in 1961, he
appeared in Andy Warhol's first film, *Tarzan and Jane Regained …
Sort of,* filmed in California; and in 1967, he had his first experience
behind the camera doing second unit work on Roger Corman's *The
Trip.* The close relationship of Hopper to the avant-garde is
demonstrated by Bruce Conner's appropriation of the actor's name for
his exhibition *The Dennis Hopper One Man Show* (1967/73) in order to
subvert the conventional artist-dealer relationship.[3] Much of this
underground scene, and the way it occasionally spilled over into the
daylight, was captured by Hopper in the photographs he took that later
became his book *Out of the Sixties* (1986); they were the "only creative
outlet" he had in the years before *Easy Rider.*[4]

Although *Easy Rider* comes out of the image of Marlon Brando in
The Wild One (1954) and Roger Corman's *The Wild Angels* (1966),
Hopper subverted the genre in a number of ways. First, the story, about
two bikers who, flush with money from a drug deal, set off for Mardi
Gras in New Orleans, moves from west to east, the opposite of
America's westward migration toward "paradise." It is a journey into hell
that, like Joseph Conrad's *Heart of Darkness,* grows darker the farther
down the road the protagonists travel, and despite its linear road movie
structure, the film seems aimless, mimicking the generation's loss of
direction. Second, Hopper does not hesitate to utilize the codes of
underground and documentary filmmaking. With its use of "flashing"
created by shooting directly into the sun, Laszlo Kovacs' anxious, hand-
held cinematography recalls the work of Stan Brakhage and various

practitioners of *cinéma vérité*.[5] Although Hopper's editing approach for *Easy Rider* was influenced by a wide range of experimental filmmakers such as Brakhage and Bruce Baillie, it was Bruce Conner who exerted the most direct inspiration, even acting as an informal consultant.[6] Conner's influence is particularly evident in the bad acid trip that takes place in a cemetery and in the rapid-fire back and forth cutting between scenes that recalls the artist's film about the Kennedy assassination, *Report* (1963–67). Although Hopper has down played any direct influence from Anger's *Scorpio Rising* (1963), in a broader sense the two biker films do share a desire to subvert the genre and to integrate popular culture into the cinematic experience, particularly in regards to their use of pop music.

This nod to popular culture is rejected by Hopper in his second film, *The Last Movie*. Rather, this is a film about moviemaking, a film that turns the cinema inside out. If *Easy Rider* managed to bring together the biker film and the underground cinema in order to capture the subversive if disjointed spirit of the times, *The Last Movie* brings to a culmination a string of postwar feature films meditating on the cinema itself. This lineage was launched with *Sunset Boulevard* (1950), in which Billy Wilder confused fiction and reality by casting an aging silent film star (Gloria Swanson) as the delirious Norma Desmond, removing the glossy veneer of Hollywood to see what was lurking beneath the surface. *Sunset Boulevard* was followed by Vincente Minnelli's *The Bad and the Beautiful* (1952), Robert Aldrich's *What Ever Happened to Baby Jane?* (1962), and Jean-Luc Godard's *Le Mépris* (1963), among others.

Ostensibly the story of a stuntman on location in Peru making a western, Hopper's work drifts between fiction and documentary, artifice and reality. Sam Fuller, the director of classic westerns, essentially

plays himself, a director in the process of making a new movie; after the film crew's departure, the local Chinchero Indians "remake" Fuller's film with equipment made from straw. The result is a brooding contemplation of real and imaginary sex, violence, and death as witnessed through the camera lens and through our cinematic eyes. Hopper's film is truly the last movie – it is as if the mainstream Hollywood cinema had been absorbed by the underground and regurgitated back out as a new type of art form, a Hollywood-financed production that ironically underscores the distance between art, industry, and reality – as both a debunking of the Hollywood dream machine and as a love letter to filmmaking, *The Last Movie* takes its place alongside such works as Weegee's *Naked Hollywood* (1953), Diane Arbus's photographs taken in darkened movie theaters, and Bruce Conner's film star assemblages.

Like those feature filmmakers who came before him and who also straddled the experimental, documentary, and mainstream film worlds, Dennis Hopper has struggled to produce meaningful art within a commercial industry. Although he has directed many significant films, including *Out of the Blue* (1980) and *Colors* (1988), after *The Last Movie,* Hopper's radical tendencies seemed to shift from filmmaking back into acting. His edgy, intense presence in films such as Wim Wender's *The American Friend* (1977), Francis Ford Coppola's *Apocalypse Now* (1979), and David Lynch's *Blue Velvet* (1986) continue to remind us of the young actor who left the Hollywood Hills and headed for the Hollywood underground.

1 Bill Landis, *Anger: The Unauthorized Biography of Kenneth Anger* (New York: Harper Collins, 1995): 71.
2 Walter Hopps, "L.A.c.1949: Dark Night-Jazz," in *Wallace Berman: Support the Revolution* (Amsterdam: ICA, 1992): 11.
3 Joan Rothfuss, "Escape Artist," in *2000 BC: The Bruce Conner Story,* Part II, exhibition catalog (Minneapolis: Walker Art Center, 1999): 163.
4 Dennis Hopper, foreword to *Dennis Hopper: Out of the Sixties* (Pasadena: Twelvetrees Press, 1986): unpaginated.
5 For a detailed discussion of *Easy Rider* and its relationship to underground film, see David James, *Allegories of Cinema: American Film in the Sixties* (Princeton: Princeton University Press, 1989): 12–18.
6 Dennis Hopper, foreword in *Bruce Conner: Assemblages, Paintings, Drawings, Engraving Collages: 1960–1990* (Santa Monica: Michael Kohn Gallery, 1990).

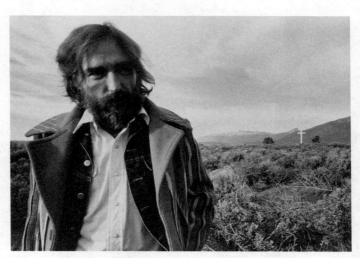

The American Dreamer, 1971, Dennis Hopper in Taos, New Mexico © Corda Productions

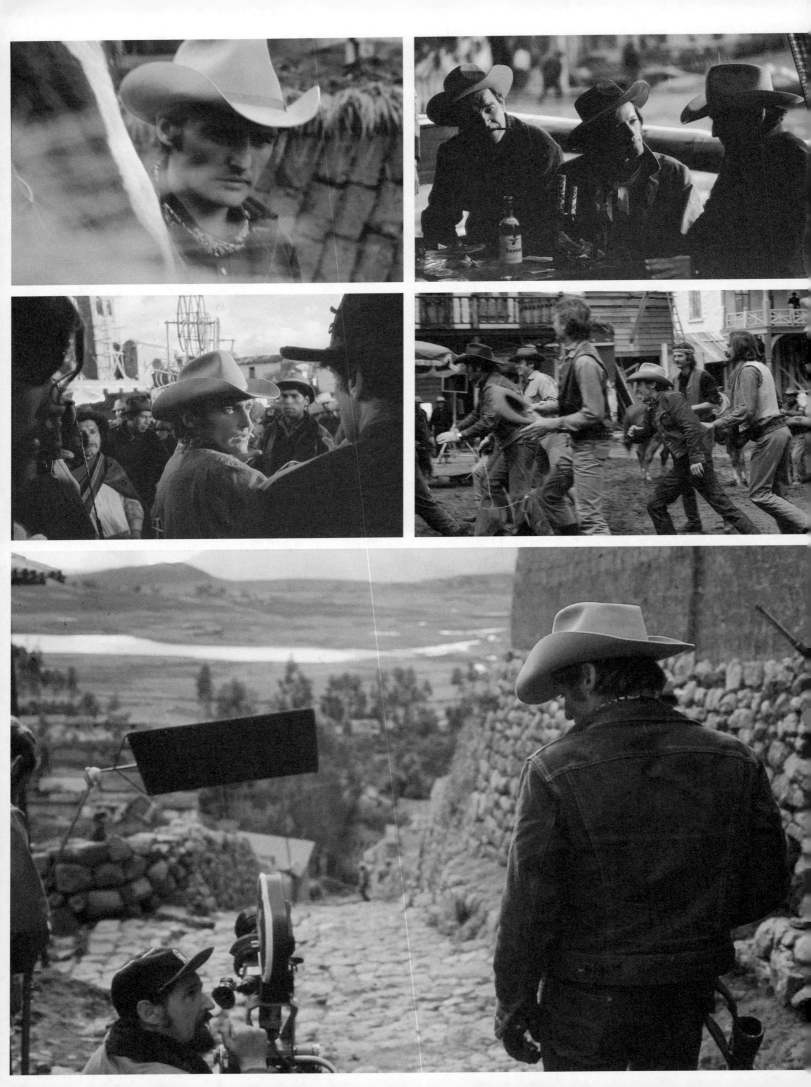

1971

The financial success of *Easy Rider* opened opportunities for young filmmakers. Universal Pictures hired five "young genius" directors, including Hopper, who, in 1970, revisited *The Last Movie* and began filming in Chinchero, Peru. The film would examine the process of Hollywood filmmaking and its affects on the natives of Peru as they observed the filmmaking process. The film was finished under budget and on schedule. Moving to Taos, New Mexico, Hopper purchased a house that had belonged to Mabel Dodge Luhan, caretaker of D. H. Lawrence. Here Hopper began editing *The Last Movie*.

During this period, Hopper married Michelle Phillips, who appeared in the film's thirty minute long pre-credit sequence (the longest in Hollywood film history) with many other young actors, including Dean Stockwell, Jim Mitchum, Russ Tamblyn, John Phillip Law, Kris Kristofferson, and Peter Fonda. The marriage lasted only eight days. During editing of *The Last Movie*, Lawrence Schiller and L. M. Kit Carson came to Taos to shoot a documentary film on Hopper, *The American Dreamer*, written by Schiller, Carson, and Hopper himself.

The Last Movie

September 1971, 108 min, Technicolor
Universal
Executive producer: Michael Gruskoff
Producer: Paul Lewis
Associate producer: David Hopper
Director: Dennis Hopper
Screenplay: Stewart Stern (story/concept by Stewart Stern and Dennis Hopper)
Director of photography: Laszlo Kovacs
Music: Kris Kristofferson, John Buck Wilkin, Chabuca Granda, Severn Darden, village musicians of Chinchero, Peru
Cast: Dennis Hopper (Kansas); Julie Adams (Mrs. Anderson); Don Gordon (Neville); Tomas Milian (Priest); Sam Fuller (Director); Dean Stockwell (Billy); Peter Fonda (Sheriff); Toni Basil (Rose); Henry Jaglom (Minister's Son); Kris Kristofferson (Minstrel Wrangler); John Phillip Law (Little Brother); Sylvia Miles (Script Girl); Jim Mitchum (Art); Michelle Phillips (Banker's Daughter); Russ Tamblyn (Member of Gang)

Influenced by Bruce Conner's experimental short films, Hopper composed *The Last Movie* as a series of montages disrupted by black frames. Presented at the Venice Film Festival, where it won the C.I.D.A.L.C. Award, the film was too experimental for its financial sponsor, Universal, and received only minimal distribution within the United States.

The Last Movie, 1971, movie stills
and off-screen shots
Universal Pictures

The Last Movie, 1971, Dennis Hopper as film director

1971–1973

In 1971 Hopper purchased El Cortez Movie Theater in Ranchos de Taos. The theater served as a screening room as well as a space for showing free cartoons to community children on the weekends. Hopper also opened a gallery, Dennis Hopper Works of Art, with the purpose of introducing various artists to the Taos community. One day Georgia O'Keeffe visited Hopper's house after hearing of the reputation of the man who had purchased the house of Mabel Dodge Luhan.

Though *The Last Movie* won the prestigious C.I.D.A.L.C. Award at the Venice Film Festival in 1971, the result was never announced, and Universal Pictures refused to distribute the film unless Hopper would agree to reedit it. Hopper declined, and the film was effectively shelved. Later, Hopper was able to arrange for a television release of the film under the title *Chinchero*.

Dennis Hopper holding the C.I.D.A.L.C. Award for *The Last Movie* at the Venice Film Festival, 1971
© Universal Pictures

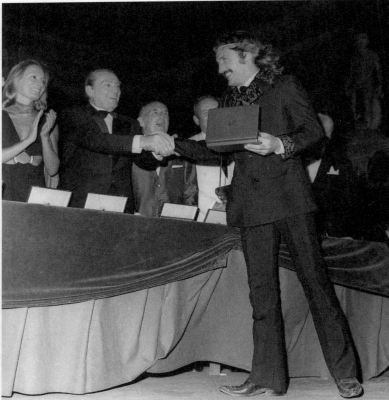

Dennis Hopper and Lucino Visconti at the Venice Film Festival, 1971

C.I.D.A.L.C. Award, 1971 © Alta Light

Hopper married Daria Halprin in 1972, and the couple returned to Taos, where Hopper's second daughter Ruthana was born the following year.

Although he had suspended his artistic activities outside of filmmaking, Hopper was represented in several exhibitions during the early-1970s: *Survey of the Sixties* (1970), an exhibition of two hundred photographs at the Festival of Two Worlds in Spoleto, Italy; *Dennis Hopper: Black and White Photographs* (1970), a solo exhibition organized by Henry T. Hopkins for the Fort Worth Art Center Museum in Fort Worth, Texas and the Denver Museum of Contemporary Art in Denver, Colorado, and *Dennis Hopper: Black and White Photographs from the 1960s* (1971), an exhibition of photographs at the Corcoran Gallery of Art in Washington, D.C. Following his Washington D.C. exhibition at the Corcoran Gallery, Hopper left thousands of negatives produced between 1961 and 1967 in the custody of Hopkins, who is responsible for ensuring their survival through the troublesome 1970s.

In the 1970s Hopper continued to collaborate with a number of significant artists. In 1971 Andy Warhol made a portrait of Dennis Hopper in *The Last Movie*. A year later Warhol and Hopper worked together on *MAO*, a silkscreen on paper, produced by Warhol. Hopper shot two bullets in the finished work.

In 1967 Conner had wanted to exhibit a series of collages at the James Willis Gallery, San Francisco as *The Dennis Hopper One Man Show*; due to differences between Conner and Willis the exhibition was not realized. Later, in 1973 Conner published a series of etchings based on the original collages and this show did take place at both the James Willis Gallery and the Texas Gallery in Houston under the title *The Dennis Hopper One Man Show*.

Andy Warhol,
Dennis Hopper, 1971,
silkscreen on canvas
© The Warhol Foundation

Andy Warhol with Dennis Hopper, *MAO*,
1972, silkscreen on paper © Alta Light

Bruce Conner, *Bruce Conner disguised as Dennis Hopper disguised as Bruce Conner*, 1973, etching © Alta Light

Bruce Conner, *Untitled*, 1973, etching © Alta Light (Alan Shaffer Photography)

279

1971–1977

Hopper acted in many films throughout the 1970s, including *Kid Blue* by James Frawley, *Tracks* by Henry Jaglom, *Mad Dog Morgan* by Philippe Mora, and *The American Friend* by Wim Wenders. One of his costars in *The American Friend* was his longtime friend, Nicholas Ray, who had cast Hopper in *Rebel Without a Cause* years earlier.

The American Friend
[Der amerikanische Freund]

September 1977, 127 min, color (German)
New Yorker Films
Producer: Wim Wenders, Road Movies, and
Les Films du Losange
Director: Wim Wenders
Screenplay: Wim Wenders (based on *Ripley's Game* by Patricia Highsmith)
Director of photography: Robbu Muller
Music: Jurgen Knieper
Cast: Bruno Ganz (Jonathan Zimmermann); Dennis Hopper (Tom Ripley); Lisa Kreuzer (Marianne Zimmermenn); Gerard Blain (Raoul Minot); Nicholas Ray (Derwatt); Samuel Fuller (The American); Daniel Schmid (Ingraham)

Hopper's character, Tom Ripley, appears seductively sensitive and innocent. Though it seems as if he desires only the friendship of Jonathan Zimmerman, a picture framer played by Bruno Ganz, he elusively draws Jonathan into his dark world.

Der amerikanische Freund, 1977, German film poster © Wim Wenders Production

The American Friend, 1977, (original title *Der amerikanische Freund*, Film directed by Wim Wenders)

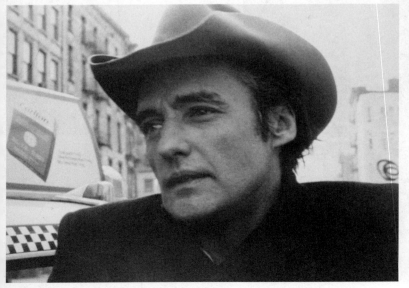

The American Friend, 1977 Collection Takeshi Tanikawa

Kid Blue

1971, 108 min, Panavision and Deluxe color
20th Century Fox
Producer: Marvin Schwartz
Director: James Frawley
Screenplay: Edwin Shrake
Director of photography: Billy Williams
Music: Tim McIntire
Cast: Dennis Hopper (Bickford Waner); Warren Oates
(Reese Ford); Peter Boyle (Preacher Bob); Ben Johnson
(Sheriff "Mean John" Simpson); Janice Rule (Janet
Conforto)

In this comedy western, Hopper plays a train
robber who decides to go straight.

Mad Dog Morgan [Mad Dog]

September 1976, 102 min, Panavision and Eastman color
Cinema Shares International
Producer: Jeremy Thomas
Associate producer: Richard Brennan
Director: Philippe Mora
Screenplay: Philippe Mora (based on the novel
Morgan: The Bold Bushranger by Margaret Carnegie)
Director of photography: Mike Molloy
Music: Patrick Flynn
Cast: Dennis Hopper (Daniel Morgan); David Gulpilil (Billy);
Frank Thring (Superintendent Cobham); Jack Thompson
(Detective Manwaring)

Hopper plays an anti-hero modeled after
Robin Hood and affects the perfect Irish
brogue required for the role.

Tracks

April 1977, 90 min, color
Rainbow Pictures
Producer: Howard Zuker, Irving Cohen, and Ted Shapiro
Director: Henry Jaglom
Screenplay: Henry Jaglom
Director of photography: Paul Glickman
Cast: Dennis Hopper (Sergent Jack Falen); Taryn Power
(Stephanie); Dean Stockwell (Mark); Topo Swope (Chloe)

Set within the confined space of a train,
Hopper plays a burnt-out Vietnam veteran
who is escorting the body of a fallen friend
to his burial ground. Hopper's initially
restrained acting gives way to increasingly
violent fantasies.

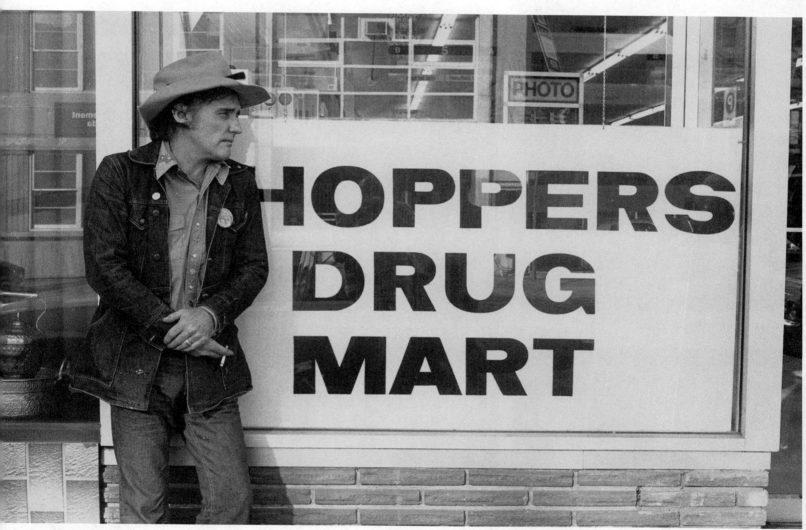

Dennis Hopper at Hoppers Drug Mart in Vancouver, Canada, 1979 © Chris McDougall Crown

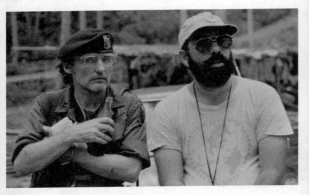

Dennis Hopper with Francis Coppola © Zoetrope

Dennis Hopper with Francis Coppola © Zoetrope

© Zoetrope

© Mary Ellen Mark

© Zoetrope

282 *Apocalypse Now*, 1979, movie stills and off-screen shots

1976–1979

In 1976, Hopper flew to Pagsanjan, Philippines, for the Francis Ford Coppola film *Apocalypse Now,* an opportunity to work with Marlon Brando. Hopper was widely praised for his performance as a photojournalist when the film was released in 1979 after three years in production.

Apocalypse Now

August 1979, 146 min, Technivision and Technicolor
Omni Zoetrope
Producer: Francis Coppola
Co-Producer: Fred Roos, Gray Frederickson,
and Ton Sternberg
Director: Francis Coppola
Screenplay: John Milius and Francis Coppola
Director of photography: Vittorio Storaro
Music: Carmine Coppola and Francis Coppola
Cast: Marlon Brando (Colonel Kurtz); Robert Duvall
(Lt. Colonel Kilgore); Martin Sheen (Captain Willard);
Frederic Forrest (Chef); Albert Hall (Chief); Sam Bottoms
(Lance); Larry Fishburne (Clean); Dennis Hopper (Photo
Journalist); Harrison Ford (Colonel Lucas)

Hopper plays the role of a photojournalist sent to retrieve Colonel Kurtz, played by Marlon Brando, from his self-created world of violent fantasy in the Cambodian jungle. Hopper's character serves as the narrator of the film, acting as a connection between the world outside the jungle and the terror of Kurtz' isolated psychological landscape. The film is based on Joseph Conrad's novel, *The Heart of Darkness.*

Apocalypse Now, 1979, movie still
© Zoetrope

1980–1982

In 1980 Hopper was invited to play the role of an alcoholic father in the Canadian film, *The Case of Cindy Barnes,* and later took over for Leonard Yakir, co-writer and original director of the film. Hopper rewrote the screenplay, renaming the film *Out of the Blue* after the song of his friend Neil Young.

During the early 1980s, Hopper appeared in *Rumble Fish* by Francis Ford Coppola, *The Human Highway* by Neil Young and Dean Stockwell, *The Osterman Weekend* by Sam Peckinpah, and *O.C. and Stiggs* by Robert Altman.

Out of the Blue

April 1982, 94 min, color
Robson Street production
Executive producer: Paul Lewis
Producer: Leonard Yakir
Director: Dennis Hopper
Screenplay: Leonard Yakir, Brenda Nielson, and Gary Jules Jouvenat
Director of photography: Marc Champion
Music: Tom Lavin
Cast: Linda Manz (Ce Be); Sharon Farrell (Kathy); Dennis Hopper (Don); Raymond Burr (Brean); Don Gordon (Charlie)

The original screenplay of this film focused on the relationship between a troubled girl and a psychologist who would attempt to rescue her from a destructive family environment. Mid-production, Hopper took over as director, changing the concept of the film completely by adding the crucial punk rock element and a shockingly dark ending inspired by the song of his friend Neil Young, from which the title of the film was taken.

Tracks, 1976, movie still

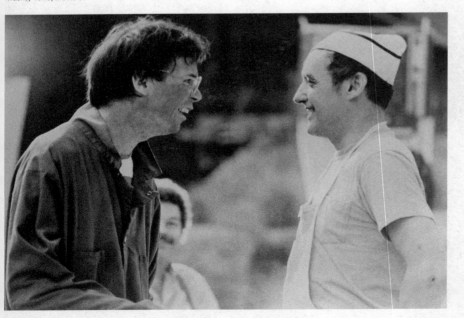

The Human Highway, 1982, movie still (Neil Young, Dennis Hopper) © Shakey Pictures Inc.

Out of the Blue, 1980, movie still (Linda Manz, Dennis Hopper) © Discovery Films

Out of the Blue, 1980, movie still (Dennis Hopper, Linda Manz, Sharon Farrell) © Discovery Films

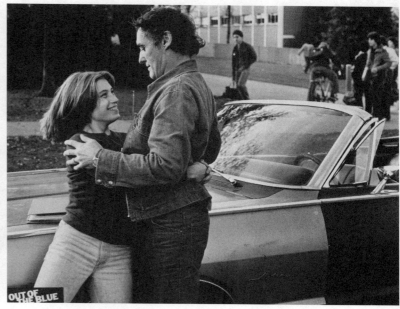

Out of the Blue, 1980, movie still (Linda Manz, Dennis Hopper) © Discovery Films

1982–1986

In 1982 the Film Center of the Art Institute Chicago presented *Dennis Hopper: Art on the Edge,* a cinematic retrospective and exhibit of a series of 1960s photographs, which traveled to Houston, Texas. Walter Hopps, director of the Rice Media Center, invited Hopper the following year to show *Shot on the Run,* a selection of one hundred photographs, an invitation that would trigger a new interest in painting. Hopper, still living in Taos, acquired some canvases from an Indian painter. As Hopper now describes the period: "I just go crazy for a couple of weeks using a lot of cocaine, and I do all these paintings, and I go down to Houston. Walter gets me a gallery to show 'em in, at the same time I'm showing my photographs at Rice University, the de Menils have a place there.

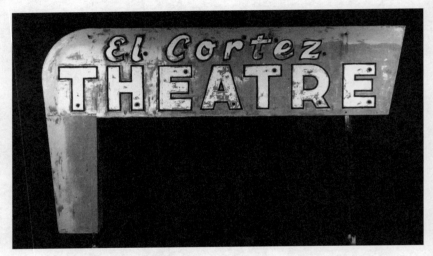

El Cortez Theatre sign from Taos, New Mexico © Dennis Hopper

Life After on Canvas, 1983–97, triptych of digitized ink prints, based on self-exposion performance © Dennis Hopper

Untitled (Cardboard, tin Indian), 1982 © Dennis Hopper

286

And then I blow myself up at the Big H Speedway. I put twenty sticks of dynamite around myself in this race car arena, and I blow myself up, and the dynamite won't blow in on itself, and I do this performance, and then I announce that I have now started painting again. So the last work I do is *Bomb Drop* in 1968, and then fifteen years later I blow myself up to announce my return to the art world and start painting again … Okay, and then from there I'm locked up, I'm incarcerated and I go through a bunch of shit and crap and so, and finally I get sober and I go through a year or so, whatever." The event referred to was a cataclysmic self-explosion with a "Russian Death Chair"

performance that would symbolize the end of an era of abuse and destruction and a return to painting and art. Within a few months, Hopper had created a series of *Indian Paintings,* using a combination of collage, abstract painting, and graffiti. The paintings reveal, in the words of Rudi Fuchs, an "obsessive hecticness and sloppiness, as if the artist was in a hurry. Once more, after all those years, he wanted to put into practice what he still knew from the old days: the movements of the hand and the controlling keenness of the eye." There is a "transitory" quality to the series, and Hopper, in fact, will take ten more years to accomplish the subsequent series *Colors* and *Morocco.*

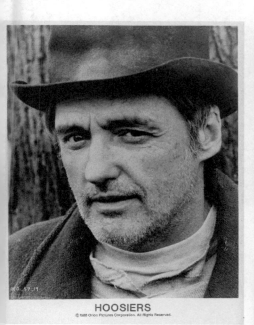

Hoosiers, 1986, movie still © Orion Pictures Corp.

over of *Vice,* 1986 © Orion Pictures Corp.

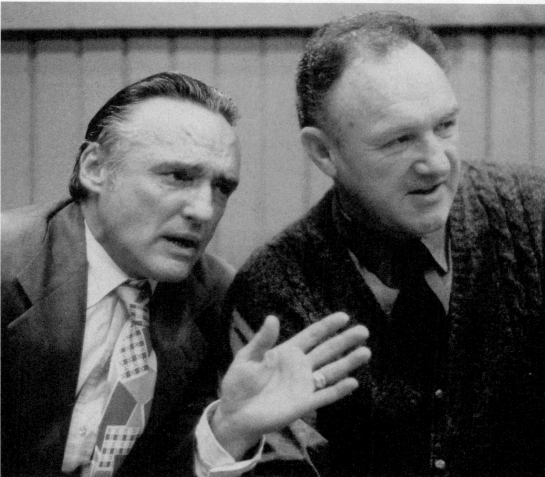

Hoosiers, 1986, movie still (Dennis Hopper, Gene Hackman)

Collection Takeshi Tanikawa

Hoosiers

October 1986, 114 min, CFI color
Orion
Executive producer: John Daly and Derek Gibson
Producer: Carter DeHaven and Angelo Pizzo
Associate producer: Graham Henderson
Director: David Anspaugh
Screenplay: Angelo Pizzo
Director of photography: Fred Murphy
Music: Jerry Goldsmith
Cast: Gene Hackman (Coach Norman Dale); Barbara Hershey (Myra Fleener); Dennis Hopper (Shooter Flagg); Sheb Wooley (Cletus); Fern Persons (Opal Fleener)

Hopper plays a town drunk in a small, rural Indiana community.

287

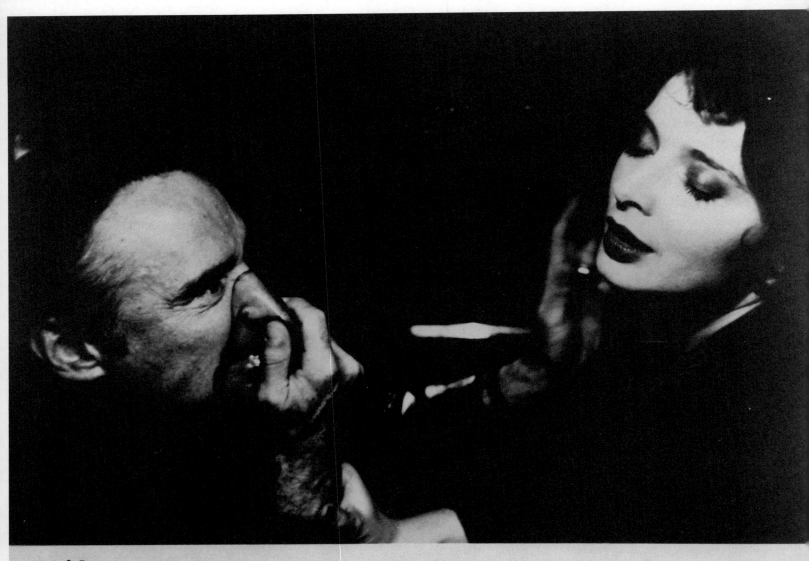

"BLUE VELVET"

Dennis Hopper portrays Isabella Rossellini's evil tormentor in the De Laurentiis Entertainment Group presentation of Dav
Lynch's sensual mystery thriller "BLUE VELVET."

Blue Velvet, 1986, movie still (Dennis Hopper, Isabella Rossellini)

Straight to Hell, 1986, Dennis Hopper and Grace Jones

Blue Velvet

September 1986, 120 min, color
De Laurentiis Entertainment Group
Executive producer: Richard Roth
Director: David Lynch
Screenplay: David Lynch
Director of photography: Frederick Elmes
Music: Angelo Badalamenti
Cast: Kyle MacLachlan (Jeffrey Beaumont); Isaballa
Rossellini (Dorothy Vallens); Dennis Hopper (Frank Booth);
Laura Dern (Sandy Williams); Hope Lange (Mrs. Williams);
Dean Stockwell (Ben)

Hopper plays a criminal sadist, Frank Booth,
one of his best performances and one of the
most memorable evil characters in the
history of film.

After struggling through a drug and alcohol rehabilitation program, Hopper returned to his acting career in 1985, appearing in David Lynch's *Blue Velvet,* and David Anspaugh's *Hoosiers,* for which he received an Academy Award nomination for best supporting actor. He won awards from the Los Angeles Film Critics Association and the National Society of Film Critics and was nominated for a Golden Globe Award for his roles in both films.

During the 1980s Hopper was also "rediscovered" as a photographer through two solo exhibitions in 1986, *Dennis Hopper Photographs* at Arts Lab in Birmingham, England and *Dennis Hopper: Out of the Sixties* at Tony Shafrazi Gallery in New York. Hopper decided to leave Taos and moved to Venice, California where he bought one of three studios built by Frank O. Gehry and Brian Murphy. Hopper's choice of Venice was influenced by his fond memories of attending beat poetry readings and cool jazz performances with James Dean in 1954.

Blue Velvet, 1986, Frank Booth's apartment

1987–1988

In 1987 Hopper started filming *Colors* with Sean Penn and Robert Duvall. When the film was released the following year, screenings were cancelled at fifteen theaters in California and New Jersey for fear of potential gang violence. Subsequent films included *Backtrack* with Jody Foster, Dean Stockwell, and Vincent Price; *The Hot Spot* with Don Johnson and Virginia Madsen; and *Chasers* with Tom Berenger, William McNamara, and Erika Eleniak.

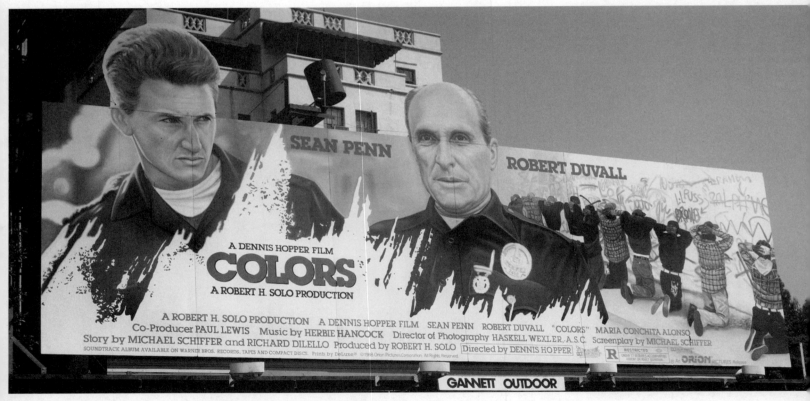

Colors, 1988, billboard advertisment
© Alta Light

Colors, 1988, Dennis Hopper and
Rapper Ice T, who created the
movie soundtrack © Peter C. Borsari

Colors

April 1988, 120 min, DeLuxe color
Orion
Producer: Robert H. Solo
Co-Producer: Paul Lewis
Director: Dennis Hopper
Screenplay: Michael Schiffer (story/concept by Michael Schiffer and Richard DiLello)
Director of photography: Haskell Wexler
Music: Herbie Hancock
Cast: Sean Penn (Danny McGavin); Robert Duvall (Bob Hodges); Maria Conchita Alonso (Louisa Gomez); Sy Richardson (Bailey); Seymour Cassel (Diaz)

Hopper was hired as director of *Colors* on the advice of Sean Penn. Making an immediate change in the storyline, Hopper opened the film to radical possibilities of direction that would reveal the brutal realities of Los Angeles street gangs. Real gang members were cast as extras in the film, and the predictable violence that erupted in several theaters during screenings led to protests and initial difficulties with distribution.

Colors, 1987, Dennis Hopper as film director © Orion Pictures Corp.

Colors, 1987, Dennis Hopper as film director Collection Takeshi Tanikawa

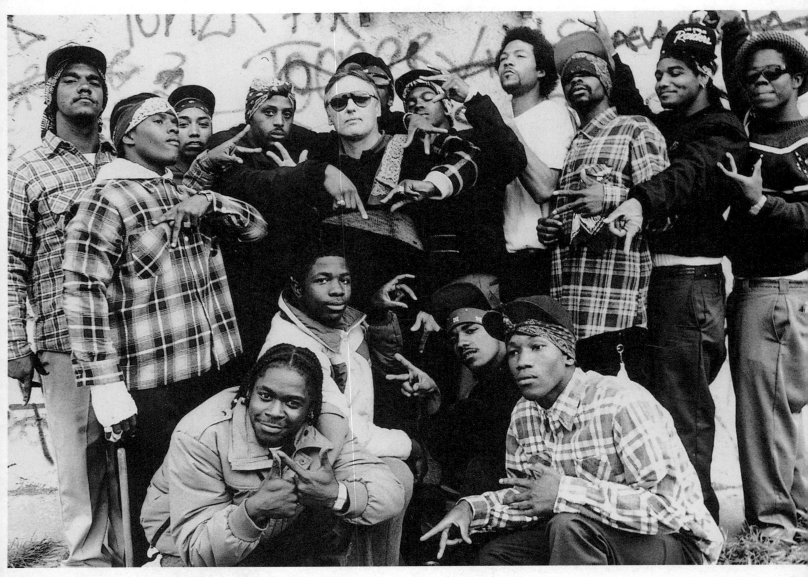

Colors, 1988, off set (Dennis Hopper surrounded by members of the "Crips") © Orion Pictures Corp.

Colors, 1988, movie still (Robert Duvall and Sean Penn), Photo by Merrick Morton

© Orion Pictures Corp.

Colors, 1988, off set (Sean Penn and director Dennis Hopper), Photo by Merrick Morton

© Orion Pictures Corp.

Colors, 1988, off set (Robert Duvall and Sean Penn), Photo by Merrick Morton

© Orion Pictures Corp.

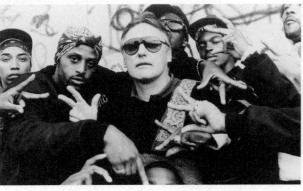

Colors, 1988, off set (Dennis Hopper surrounded by members of the "Crips")

© Orion Pictures Corp.

1987–1988

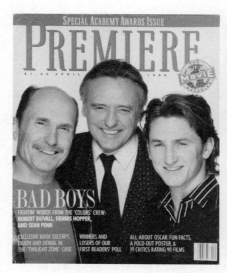

Cover of *Premiere*, 1988, Bad Boys (Robert Duval, Dennis Hopper, Sean Penn)

Cover of *Par Avion*, 1988, Bad Boys of 1980s

"RIVER'S EDGE"

ISLAND PICTURES

Dennis Hopper is Feck, an eccentric recluse who provides a provocative counterpoint to the teenagers' dilemma in director Tim Hunter's compelling and controversial film, "River's Edge."

RE 4

River's Edge, 1987, movie still © Island Pictures

The Texas Chainsaw Massacre Part 2, 1988, movie still

River's Edge

May 1987, 99 min, Metrocolor
Island Films
Executive producer: John Daly and Derek Gibson
Producer: Sarah Pillsbury and Midge Sanford
Co-Producer: David Streit
Director: Tim Hunter
Screenplay: Neal Jimenez
Director of photography: Frederick Elmes
Music: Jurgen Knieper
Cast: Crispin Glover (Layne); Keanu Reeves (Matt); Ione Skye Leitch (Clarissa); Daniel Roebuck (Samson); Dennis Hopper (Feck); Joshua John Miller (Tim)

Regarded as the *Rebel Without a Cause* of the 1980s, River's Edge charts the interactions of a group of teenagers following the rape and murder of their close friend. Hopper plays Feck, a pot dealer who lives with an inflatable sex doll, but who seems to have an intuitive understanding of a younger generation.

1987–1989

In late 1987 a solo exhibition and film retrospective, *Dennis Hopper: From Method to Madness,* was held at the Walker Art Center in Minneapolis, Minnesota. It traveled to New York, Boston, Cleveland, Houston, and Berkeley in 1988. His early assemblage and sculpture was featured in a group exhibition, *Forty Years of California Assemblage,* at Wight Art Gallery at University of California, L. A. in 1989. The exhibition traveled to San Jose, Fresno, and Omaha. Between October and November 1989, the first Dennis Hopper Festival, was held at Shibuya Parco in Tokyo and traveled to many cities in Japan throughout 1990. The festival included a film retrospective and photo exhibition, *Dennis Hopper: Photographs 1961–67.* During this period, Hopper

Riders of the Storm, 1988, movie still © Miramax

Backtrack (Catchfire), 1989, publicity photo (Dennis Hopper with saxhorn) Collection Takeshi Tanikawa

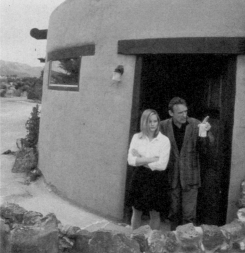

Backtrack (Catchfire), 1989, publicity photo (Jody Foster and Dennis Hopper in Taos, New Mexico) Collection Takeshi Tanikawa

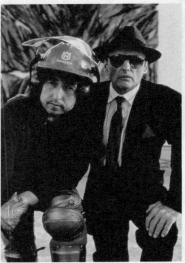

Backtrack (Catchfire), 1989, publicity photo (Bob Dylan and Dennis Hopper) Collection Takeshi Tanikawa

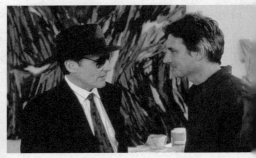

Backtrack (Catchfire), 1989, publicity photo (Dennis Hopper and Chuck Arnoldie) Collection Takeshi Tanikawa

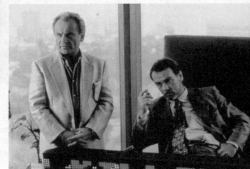

Backtrack (Catchfire), 1989, publicity photo (Joe Pesci and Dean Stockwell) Collection Takeshi Tanikawa

purchased a new Nikon 35Ti camera in Kyoto, and for the first time in nearly twenty-five years, began to work his way through thirty rolls of film. As with his photography of the 1960s, he worked with black-and-white film, believing that color obscures content, especially in abstract work. "In the States, I had them developed, looked at the proof sheets vaguely and put them away. Six months later I blew up twelve pictures to give to friends in Japan because they always give me presents. I was surprised how much I liked the pictures." The body of work consists of over three hundred photographs. Shortly after, Hopper began working in color for the first time.

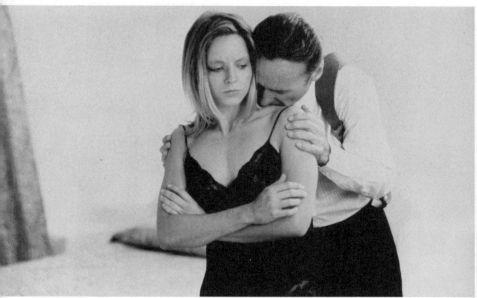

Backtrack (Catchfire), 1989, movie still (Jody Foster and Dennis Hopper) © Showtime

Chattahoochee, 1989, movie still (Dennis Hopper as Walker) © Hemdale Releasing Corp.

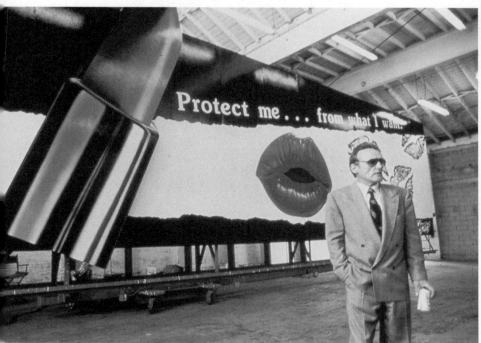

Backtrack (Catchfire), 1989, publicity photo (Dennis Hopper in front of billboard) Collection Takeshi Tanikawa

Backtrack

1989, 98 min, color
Vestron Pictures, Precision Films, Mack-Taylor Productions, Dick Clark Productions, and Backtrack Productions
Executive producer: Steve Reuther and Mitchell Cannold
Producer: Dick Clark and Dan Paulson
Director: Dennis Hopper
Screenplay: Rachel Kronstadt-Mann and Stephen L. Cotler
Director of photography: Edward Lachman
Music: Curt Sobel
Cast: Jodie Foster (Anne Benton); Dennis Hopper (Milo); Dean Stockwell (John Luponi); Vincent Price (Lino Avoca); John Turturro (Pinella); Joe Pesci (Leo Carelli); Fred Ward (Pauling); Julie Adams (Martha); Charlie Sheen (Bob)

Backtrack is an expression of Hopper's connection to art. Playing a hired assassin, Hopper stocks his victim, a conceptual artist, using his understanding of her work to follow her through changes of identity and location.

295

1991–1994

Around 1991 Hopper returned to his work on canvas, with a series of composite, multi-element paintings entitled *Colors*. Using computer enlarged prints of stills from his film *Colors* (1989), he created blurred images that he transferred onto canvas. The resulting imagery is difficult to identify. "And it's sort of like those Gerhard Richter kinds of images where you're not quite sure … It looks like something's violent, you're not quite sure what's happening. I took some of these images and I blew them up on canvas, committed them on canvas." On other panels, just as in the film, Hopper was obsessed with the iconography of L. A. gangs. Other paintings in the series are based on color Polaroid photographs of L. A. urban landscapes.

2nd Kyoto Dennis Hopper Film Festival, 1989, Film Festival Poster from Japan
Collection Takeshi Tanikawa

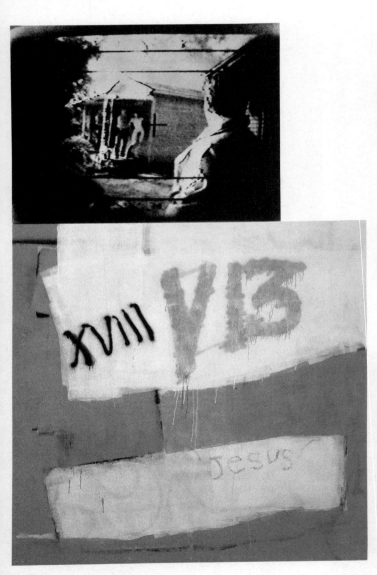

Cop, 1992, mixed media on canvas © Dennis Hopper

Flashback, 1989, movie stills © Paramount Pictures Corp.

1st Kyoto Dennis Hopper Film Festival, 1988 Collection Takeshi Tanikawa

Dennis Hopper Best Selection, 1993 Collection Takeshi Tanikawa

The 5 Hollywood Movies selected by Dennis Hopper, 1991 Collection Takeshi Tanikawa

The Hot Spot

October 1990, 129 min, DeLuxe color
Orion
Executive producer: Bill Gavin, Derek Power, and Stephen Ujlaki
Producer: Paul Lewis
Co-Producer: Deborah Capogrosso
Director: Dennis Hopper
Screenplay: Nona Tyson and Charles Williams (based on the novel Hell *Hath No Fury* by Charles Williams)
Director of photography: Ueli Steiger
Music: Jack Nitzsche
Cast: Don Johnson (Harry Madox); Virginia Madsen (Dolly Harshaw); Jennifer Connelly (Gloria Harper); Charles Martin Smith (Lon Gulik); Jack Nance (Julian Ward)

A languid, erotic thriller filmed in a small southern town, Hopper describes The *Hot Spot* as "Last Tango in Texas."

Chasers

April 1994, 101 min, Technicolor
A Morgan Creek Production
Executive producer: Gary Barber
Producer: James G. Robinson
Co-Producer: David Wisnievitz
Director: Dennis Hopper
Screenplay: Joe Batteer, John Rice, and Dan Gilroy
Director of photography: Ueli Steiger
Music: Dwight Yoakam and Pete Anderson
Cast: Tom Berenger (Rock Reilly); William McNamara (Eddie Devane); Erika Eleniak (Toni Johnson); Crispin Glover (Howard Finster); Dean Stockwell (Salesman Stig); Gary Busey (Sergeant Vince Banger); Seymour Cassel (Master Chief Bogg); Frederic Forrest (Duane)

Chasers is Hopper's first comedy film, featuring the country music of an especially brilliant Dwight Yoakam.

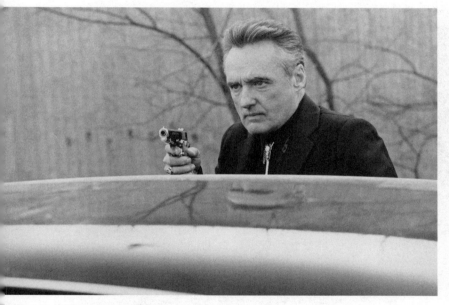

Red Rock West, 1993, movie still (Dennis Hopper as Lyle) © Rank Film Distributions Ltd.

The Indian Runner, 1991, movie stills (Dennis Hopper and Sean Penn as director), Photo Michael Tighe © Westmount Communications Film

Paris Trout, 1991, movie still (Dennis Hopper, Barbara Hershey, Ed Harris) © Showtime/Kelvin Jones

Nails, 1992, movie still © Medusa Pictures

1989–1995

Hopper married Katherine LaNasa in 1989 and their son, Henry Lee, was born in 1990. Hopper and LaNasa divorced in 1992.

Throughout the 1990s Hopper's work as an actor included such film and television productions as *Flashback, Chattahoochee, Paris Trout, Red Rock West, Doublecrossed, True Romance, Speed, Search & Destroy, Waterworld, Carried Away,* and *Ed TV.*

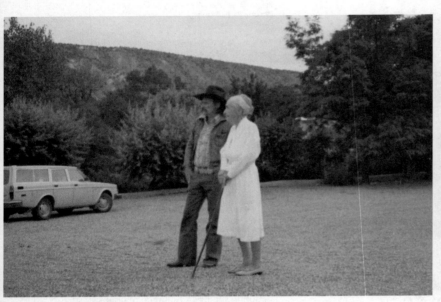

Dennis Hopper and Georgia O'Keeffe in Taos, New Mexico, early 1990s © Dean Stockwell

True Romance, 1993, movie still (Christian Slater and Dennis Hopper) © Warner Brothers

Speed, 1994, movie stills (Dennis Hopper with bomb; Dennis Hopper and Keanu Reeves) © Twentieth Century Fox

Speed, 1994, movie still © Twentieth Century Fox

Search & Destroy, 1995, movie still
© October Film

Paris Trout

April 1991, 99 min, color
Konigsberg-Sabitsky production
Executive producer: Diana Kerew
Producer: Frank Konigsberg and Larry Sanitsky
Associate producer: Jayne Beiber
Director: Stephen Gyllenhaal
Screenplay: Pete Dexter
Director of photography: Robert Elswit
Music: David Shire
Cast: Dennis Hopper (Paris Trout); Barbara Hershey (Hanna Trout); Ed Harris (Harry Sergraves); Ray McKinnon (Carl Bonner); Tina Lifford (Mary Sayers)

Paris Trout is set in a small town in Georgia in the early 1950s. Hopper plays a wealthy citizen whose life has been disrupted by the murder of a young black girl.

True Romance

September 1993, 118 min, Panavision and Foto-Kem color
A Morgan Creek production in association with Davis Film
Executive producer: James G. Robinson, Gary Barber, Bob Weinstein, Harvey Weinstein, and Stanley Margolis
Producer: Bill Unger, Steve Perry, and Samuel Hadida
Director: Tony Scott
Screenplay: Quentin Tarantino
Director of photography: Jeffrey L. Kimball
Music: Hans Zimmer
Cast: Christian Slater (Clarence Worley); Patricia Arquette (Alabama Whitman); Dennis Hopper (Clifford Worley); Val Kilmer (Mentor); Gary Oldman (Drexl Spivey); Brad Pitt (Floyd); Christopher Walken (Vincenzo Coccotti); Bronson Pinchot (Elliot Blitzer); Samuel L. Jackson (Big Don); Michael Rapaport (Dick Ritchie); Chris Penn (Bicky Dimes)

Hopper plays Clifford Worley, the rebellious and good-humored father of the troubled hero of the film.

Speed

June 1994, 115 min, Panavision and DeLuxe color
A Mark Gordon Production
Executive producer: Ian Bryce
Producer: Mark Gordon
Co-Producer: Allison Lyon
Director: Jan De Bont
Screenplay: Graham Yost
Director of photography: Andrzej Bartkowiak
Music: Mark Mancina
Cast: Keanu Reeves (Jack Traven); Dennis Hopper (Howard Payne); Sandra Bullock (Annie); Joe Morton (Captain McMahon); Jeff Daniels (Harry)

Hopper again plays a memorable villain, a former police officer turned bomber.

Waterworld

July 1995, 134 min, Eastman color
A Lawrence Gordon presentation with Davis Entertainment Company, Licht, and Mueller Film Corporation
Executive producer: Jeffrey Mueller, Andrew Licht, and Ilona Herzberg
Producer: Charles Gordon, John Davis, and Kevin Costner
Director: Kevin Reynolds
Screenplay: Peter Rader and David Twohy
Director of photography: Dean Semler
Music: James Newton Howard
Cast: Kevin Costner (Mariner); Dennis Hopper (Deacon); Jeanne Tripplehorn (Helen); Tina Majorino (Enola); Michael Jeter (Gregor)

Hopper plays a somewhat comical villain.

Waterworld, 1995, movie still © Universal Pictures

299

Dennis Hopper in high heels, 1993 © Firooz Zahedi

1994

In 1994, after a trip to Morocco, Hopper returned yet again to painting, creating a series reminiscent of Moroccan wall surfaces. "They make these big white grids that go all the way down on a wall and they had little squares underneath them and they'd put pictures in and writing in them and you'd see these white things everywhere." The flat surface also became the prevalent motif of his photographic work created between 1994 and 1998. Hopper's interest in the flatness of walls and objects without depth of field as analogous to the surface of a painting had already appeared in early photographs from the 1960s. During his travels, Hopper photographed these "abstract realties" and mounted them on metal, rather like small tablets, or enlarged them to human size. They are "pieces of walls, floors, man-made objects, with human surface scratchings – brief and temporary, like life itself, yet clear and precious." These works, including the earlier *Color* series, constitute a belated response to Abstract Expressionism turned into realism. "I was attacking like an action painter, but I was also using other things, references, and I was thinking of them as landscapes and not so much as abstract painting."

Dennis Hopper in Tokyo, 1994 © Takeshi Tanikawa

Japan (Girl running up stairs), 1991 © Dennis Hopper

In April 1996 Hopper and Victoria Duffy were married at the Old South Church in Boston.

Hopper has actively exhibited his photographs, paintings, and assemblages since the late-1980s and has held many solo exhibitions in Europe, Japan, and the United States. Recent solo exhibitions include *Dennis Hopper: The Sixties, The Eighties, and Now* at Fred Hoffman Fine Art in Santa Monica, California; *Dennis Hopper: Forms of Indifference* at Galerien Bittner & Dembinski in

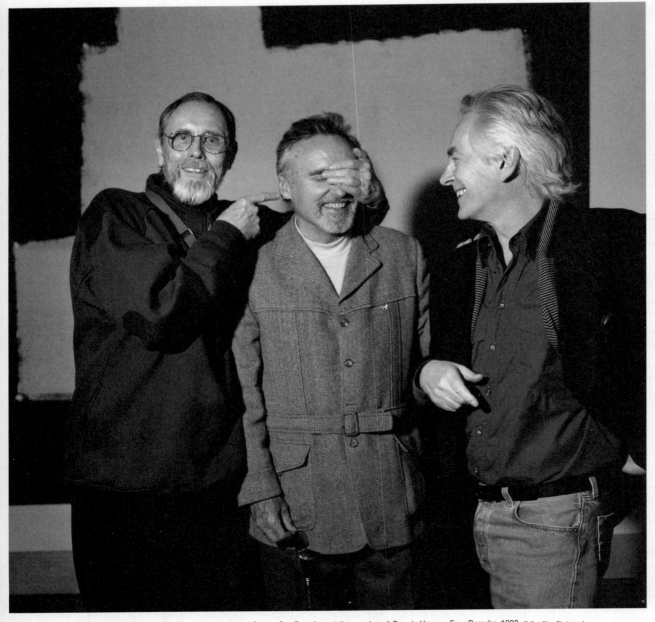

Bruce Conner, Dennis Hopper, and Michael McClure at Ansel Adams Center, San Francisco at the opening of *Dennis Hopper: Four Decades,* 1998 © Dan Dion Photography

Kassel, Germany; *Dennis Hopper: Italian Walls* at Palazzo Marino alla Scala in Milan, Italy; *Dennis Hopper: Four Decades* at Ansel Adams Center in San Francisco; *Dennis Hopper: Fotografias* at Metta Galeria in Madrid; *Abstract Reality* at Parco Gallery in Tokyo; *Reflections* at Galerie Hans Mayer in Berlin; and *American Pictures, 1961–1967: Photographs by Dennis Hopper* at the MAK Center for Art and Architecture in L. A.

Dennis Hopper and William Burroughs in New York City, 1996/97 © Caterine Milinaire

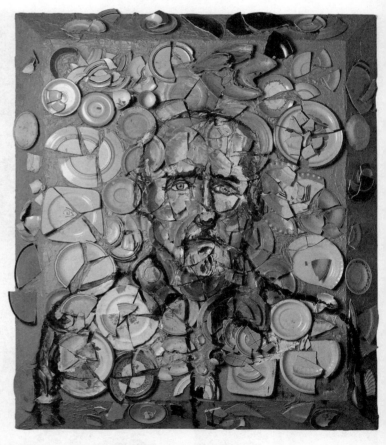

Julian Schnabel, *Portrait of Dennis Hopper,* 1999, mixed media © Julian Schnabel

Bruce Conner, Dennis Hopper, and Michael McClure at Ansel Adams Center, San Francisco at the opening of *Dennis Hopper: Four Decades,* 1998 © Dan Dion Photography

Covers of magazines (left to right):
The Face, 1987; *Brutus*, 1989; *03 Tokyo calling*, 1990; *Interview*, 1992
Cut, 1993; *GQ Japan*, 1994; *Esquire*, 1995; *Time Out*, 1995;
Doin; *Dennis Land*

In 1998 Hopper was given the George Eastman Award at the George Eastman House in Rochester, New York in honor of his achievements in film and art. For his retrospective exhibition at the Stedelijk Museum in Amsterdam and MAK Vienna in 2001, Hopper realized his latest series of Wall Assemblages, giant advertisement figures (*Mobil Man* and *Man from La Salsa*), and billboards, re-engaging his entire artistic repertoire from found objects, assemblage to wall images and billboards.

Dennis Hopper, manufacturer and Jan Hein Sassen, Curator at the Stedelijk Museum Amsterdam during the manufacturing of *Man from La Salsa* and *Mobil Man*, 2000 © Alta Light

Exhibition History

1961

Solo exhibition of photographs at photo lab/gallery of Barry Feinstein, Los Angeles

1964

January 7 – February 2, Solo exhibition of assemblages at Primus/Stuart Gallery, Los Angeles

December, *Artforum* cover (Andy Warhol with flower, repeated image)

1965

September, *Artforum* cover (photo montage of Abstract Expressionism)

1966

January 26 – February 19, Group exhibition (Larry Bell, Wallace Berman, Jess Collins, Bruce Conner, Llyn Foulkes, Dennis Hopper, Craig Kauffman, Edward Ruscha) *Los Angeles Now* at Robert Fraser Gallery, London

1968

February 24 – March 17, Exhibition of the installation *Bomb Drop* at the Pasadena Art Museum, Pasadena, California

1970

June – July, Exhibition of 200 documentary photographs, *Survey of the Sixties,* at the Spoleto Festival dei Due Mondi [Festival of Two Worlds] XIII, Spoleto, Italy

Solo exhibition *Dennis Hopper: Black and White Photographs* organized by Henry T. Hopkins at the Fort Worth Art Center Museum, Fort Worth, Texas

Exhibition at the Denver Museum of Contemporary Art, Denver

1971

Exhibition at the Corcoran Gallery of Art, Washington, D.C.

1982

Solo exhibition of photography at the Paton Gallery, England

November 1 – 21, Solo exhibition and film series *Dennis Hopper: Art on the Edge* at The Film Center, School of the Art Institute of Chicago, Chicago

1983

April 23 – May 23, Solo exhibition of 100 photographs and opening night self-explosion performance *Shot on the Run* at Rice Media Center, Rice University, Houston, Texas

May 21 – June 4, Solo exhibition *Paintings and Assemblages by Dennis Hopper* at Studio One Gallery, Houston, Texas

1984

May 12 – June 17, Group exhibition at Stables Art Center, Taos, New Mexico

May 19 – June 10, Solo exhibition *Dennis Hopper: New Paintings* (also included 1960s photography) at Return Gallery, Taos, New Mexico

Exhibition at Graham Parsons Gallery, London

1986

Solo exhibition *Dennis Hopper: Out of the Sixties* at Tony Shafrazi Gallery, New York

March 30 – April 24, Solo exhibition *Dennis Hopper Photographs* at Arts Lab, Birmingham, England

1987

April, Exhibition at Union County Gallery, Cranford, New Jersey

July 30 – August 30, Group exhibition *The New Who's Who* at Hoffman Borman Gallery, Santa Monica, California

October 9–23, Solo exhibition *Out of the Sixties: Photographs* at Sena Galleries West, Santa Fe, New Mexico

December 10–14, exhibited by Tony Shafrazi Gallery of New York at the international art fair Art/LA '87, Los Angeles

1987–8

December 6 – January 31, Solo exhibition and film retrospective *Dennis Hopper: From Method to Madness* at Walker Art Center, Minneapolis, Minnesota. Traveling to Film Forum, New York, February 1988; Institute of Contemporary Art, Boston, March 1988; Cleveland Institute of Art, Cleveland, Ohio, April 1988; Houston Museum of Fine Arts, Houston, Texas, May 1988; Pacific Film Archives, Berkeley, California, June 1988. (with catalog)

1988

March 11 – April 9, Solo exhibition and film retrospective *Out of the Sixties: Fotografie di Dennis Hopper* at Salone La Stampa, Torino, Italy

August 21 – October 23, Solo exhibition at Kunsthalle Basel, Basel, Switzerland. Traveling to Deutsch-Amerikanisches Institut, Tübingen, November 14 – December 22, 1988; Musée de l'Elysée, Lausanne, February 14 – April 2, 1989; 20èmes Rencontres Internationales de la Photographie, Arles, July 2 – August 15, 1989; Foto 89, Amsterdam, August 31 – September 22, 1989; Filmoteca Generalitat Valenciana 46, Sala Parpalló, Valencia, January 9 – February 10, 1990; Escuela de Artes Aplicadas y Oficios Artisticos de Almeria, Almeria, Spain, July 9–23, 1992. (with catalog)

August 23 – September 28, Exhibition at Galerie Thaddaeus Ropac, Salzburg, Austria

August 26 – September 23, Exhibition at Galerie Hans Mayer, Düsseldorf, Germany

1989

April 4 – May 21, Group exhibition *Forty Years of California Assemblage* at Wight Art Gallery, University of California, Los Angeles. Traveling to San Jose, California; Fresno, California; Omaha, Nebraska. (with catalog)

April 23 – May 20, Two-person exhibition of photographs with George Herms at L. A. Louver, Venice, California

September – November, Group exhibition *1964–1974* at G. Ray Hawkins Gallery, Los Angeles

November 10 – 23, Solo exhibition *Photographs 1961–67* at Shibuya Parco Gallery, Tokyo. Traveling to Sapporo Parco, Sapporo, December 9 – 25, 1989; Kumamoto Parco, Kumamoto, March 16 – 30; Kiyomizudera Temple, Joju-in, Kyoto, April 2 – 8; Osaka Shinsaibashi Parco, Osaka, mid-April.

1990

Exhibition at Boulakia Gallery, Paris

Exhibition of photographs at the Stockholm Film Festival, Stockholm, Sweden

1991

September 14 – October 18, Solo exhibition of silver and gold enamel silkscreens on aluminum at 72 Market Street Oyster Bar & Grill, Venice, California

1992

January 11 – February 1, Solo exhibition *New Work* at James Corcoran Gallery, Santa Monica, California

March 27 – 31, exhibited by Galerie Hans Mayer of Düsseldorf at the international art fair Art Frankfurt 1992, Frankfurt, Germany

April 25 – May 22, Two-person exhibition *Dennis Hopper/Ed Ruscha* at Tony Shafrazi Gallery, New York

June 5 – 27, Two-person exhibition *Dennis Hopper/William Burroughs* at Sena Galleries, Santa Fe, New Mexico

September 8 – December 8, Solo exhibition *Photographs and Paintings 1961–1992* at Galerie Thaddaeus Ropac, Paris

1992 – 93

October 31 – January 17, Group exhibition *Proof: Los Angeles Art and the Photograph 1960–1980* at the Laguna Art Museum, Laguna Beach, California. Traveling to Lincoln, Massachusetts; San Francisco; Montgomery, Alabama; Tampa, Florida; Des Moines, Iowa. (with catalog)

December 4 – January 8, Solo exhibition *Photographs and Paintings 1961–1993* at

Spielraum für Kunst, Fürth, Germany. Traveling to Württembergischer Kunstverein, Stuttgart; St. Ingbert-Saarland Museum, Saarbrücken, October 20 - November 21, 1992; Haus am Waldsee, Berlin; Lenbachhaus München, München; Kunsthalle Kiel, Kiel; Kunstsammlung Cottbus, Brandenburg; Sächsischer Kunstverein, Dresden; Schlossmuseum Beeskow, Beeskow; Kunstverein Göttingen, Göttingen.

1993

October 21 – November 15, Solo exhibition *Bad Heart: Fotografies i pintures 1961–1993* at Frontó Colom, Universitat Pompeu Fabra, Barcelona, Spain

1994

Exhibition in Andorra, Spain

February 26 – March 20, Solo exhibition at Photographic Resource Center at Boston University, Boston

June 11 – 19, Solo exhibition *Dennis Hopper: A Tourist* at Kiyomizudera Temple, Joju-in, Kyoto, Japan. Traveling to Kichijoji Parco Studio 0422, Tokyo, June – July; Sapporo Parco, Sapporo, August 5 – 23.

1995

March 3 – 30, Solo exhibition *Dennis Hopper: Fotografie 1961–1967* at Gallery Karolinum (Agentura Carolina), Prague.

1995 – 96

November 9 – February 4, Group exhibition *Beat Culture* and the New America 1950–65 at the Whitney Museum of American Art, New York. Traveling to Walker Art Center, Minneapolis, Minnesota, June 2 – September 15, 1996; M.H. de Young Memorial Museum, San Francisco, October 5 – December 29, 1996.

1996

January, Solo exhibition of color photography at Ochi Fine Art, Ketchum, Idaho.

February 15 – March 16, Solo exhibition *New Photographs* at Tony Shafrazi Gallery, New York

March 17 – July 28, Group exhibition *Hall of Mirrors: Art and Film Since 1945* at The Museum of Contemporary Art, Los Angeles. Traveling to the Wexner Center for the Arts, Columbus, Ohio, September 21, 1996 – January 5, 1997; Palazzo delle Esposizioni, Rome, May – September 1997; Museum of Contemporary Art, Chicago, October 11, 1997 – January 21, 1998. (with catalog)

July 6 – September 12, Group exhibition *Photographing the L. A. Art Scene 1955–77* at Craig Krull Gallery, Santa Monica, California

October 3 – November 9, Two-person exhibition with Bruce Conner at Gallery Paule Anglim, San Francisco

1996 – 97

November 17 – March 2, Solo exhibition and film series at the Museum of Contemporary Art, San Diego, California

1997

April 4 – June 8, Group exhibition *Photo Op: Tim Burton, Dennis Hopper, David Lynch, John Waters* at the Contemporary Arts Center, Cincinnati, Ohio

May 16 – September 7, *Sunshine & Noir: Art in Los Angeles, 1960–1997* Group exhibition at the Museum of Modern Art, Louisiana, Denmark (international traveling exhibition with catalog; final venue = Armand Hammer Museum/UCLA, November 1998)

May 31 – July 2, Solo exhibition, *Dennis Hopper: The Sixties, The Eighties, and Now* at Fred Hoffman Fine Art, Santa Monica, California

June 6 – 22, *1 Minute Scenario,* Printemps de Cahors Photography Festival, Cahors, France, curated by Jerome Sans, exhibit will be held at the Museum of Fine Arts, Cahors, France (international exhibition with catalog)

June 20 – August 3, Solo exhibition *Dennis Hopper: Forms of Indifference* at Galerien Bittner & Dembinski, Kassel, Germany

July 11 – September 26, Solo exhibition, *Dennis Hopper,* Center for Photographic Arts, Carmel, CA

July 19 – August 31, *1997, Countenance: Face, Head and Portrait in Contemporary Art,* at the Max Gandolph Bibliothek/Mozartplatz, Salzburg, Austria, organized by Thaddeaus Ropac Gallery, Salzburg, Austria

August 14 – September 19, Group exhibition: *Dennis Hopper, Bigas Lunas, Peter Greenaway, and Antonio Lopez,* Galeria Metropolitana de Barcelona, Spain

September 2 – October 26, Group exhibition *Collaboration/Transformation: Lithographs from the Hamilton Press,* Montgomery Gallery, Pomona College, CA

September 16 – October 31, *Group exhibition Face à Face,* Galerie Thaddaeus Ropac, Paris, France

November 8 – December 30, Group exhibition Director's Cut, Thomas Nordanstad Gallery, Stockholm, Sweden

1997–98

October 29, 1997 – February 1, 1998, Group exhibition *Heaven: Public View, Private View,* curated by Joshua Decter et al., PS1, Long Island City, New York

December 8, 1997 – January 18, 1998, Solo exhibition, *Dennis Hopper: Italian Walls* at il Palazzo Marino alla Scala, Milan, Italy

1998

January 14 – February 22, Solo exhibition *Dennis Hopper, Sundance,* Utah

April 7 – July 12, Solo exhibition, *Dennis Hopper: Four Decades,* Ansel Adams Center, San Francisco, California

April 21 – June 12, Group exhibition *Künstler-portraits,* Walter Storms Galerie, Munich, Germany

June 18 – July 20, Solo exhibition *Dennis Hopper: Fotografias,* Metta Galeria, Madrid, Spain

September 3 – 28, Solo exhibition *Abstract Reality,* Parco Gallery, Tokyo, Japan

September 25 – December 20, Group exhibition *American Playhouse: The Theatre of Self-Presentation,* The Power Plant, Toronto, Ontario, Canada

November 7 exhibited by Galerie Hans Mayer of Düsseldorf at the International Cologne Art Fair 1998, Cologne, Germany

November 20 – December, Solo exhibition *Dennis Hopper: Abstract Reality,* Galerie Hans Mayer, Düsseldorf, Germany

Distinguished Award: George Eastman Award, given by George Eastman House, Rochester, NY in honor of recipient's achievements in film and art

1999

February 7 – May 9, Group exhibition *Radical Past: Contemporary Art & Music in Pasadena, 1960 – 1974,* Norton Simon Museum of Art, Pasadena, California

March 27 – April, Solo exhibition *Reflections,* Galerie Hans Mayer, Berlin, Germany

March 25 – July 11, Group exhibition *So Far Away, So Close, Encore …* Bruxelles/Espace Meridian, Brussels, Belgium

April 16 – May 12, Group exhibition *Glass: Tocoma To Taos,* (also includes glass work by Dale Chihuly) Tony Abeyta Gallery, Taos, New Mexico

2000

March 25 – May 13, Group exhibition *Urban Hymns,* Harriet and Charles Luckman Fine Arts Gallery, Los Angeles

April 15 – May 20, Solo exhibition *Dennis Hopper Abstract Reality,* Craig Krull Gallery, Santa Monica, California

June 2 – September 17, Solo exhibition *American Pictures, 1961–1967: Pictures by Dennis Hopper* MAK Center, Los Angeles

August 28 – September 14, Solo exhibition *Dennis Hopper and Friends,* Galerie Thaddaeus Ropac, Salzburg, Austria

September 2000, Group exhibition *The New Frontier: Art and Television, 1960 – 1965,* Austin Museum of Art, Austin, Texas

2000 – 01 October 22, 2000 – February 25, 2001,

Group exhibition *Made In California: Art, Image and Identity, 1900 – 2000,* Los Angeles County Museum of Art, Los Angeles

2001

February 16 – April 29, Solo exhibition *Dennis Hopper: A Keen Eye,* Stedelijk Museum, Amsterdam, Holland (retrospective catalog with catalog)

May 30 – October 7, Solo exhibition *Dennis Hopper: A system of Moments,* MAK, Vienna, Austria (retrospective catalog with catalog)

Filmography

Director

Chasers, 1993 (US), Morgan Creek

The Hot Spot, 1990 (US), Orion

Backtrack [European title *Catchfire*], 1989 (US), Vestron/Showtime

Colors, 1988 (US), Orion

Out of the Blue, 1980 (Canada/US), Gary Jules Juvenat Productions/Discovery Films

The Last Movie, 1971 (US), Universal

Easy Rider, 1969 (US), Pando Company & Raybert Productions/Columbia Tri-Star Pictures

Actor

Choke, production June 2000 (US), John Sjogren

Ticker, production May 2000 (US), Nu Image Films/Artisan Entertainment

Knockaround Guys, post-production 1999–2000 (US), A.L.A. Productions/New Line Cinema

The 10 Commandments of Creativity, 2000 (Germany), Hermann Vaske, Emotional Network

Jason and the Argonauts, 2000 (US), Nick Willing, NBC Television

Jesus' Son, 2000 (US), Alison Maclean, Alliance/Lion's Gate

Held for Ransom, 2000 (US), Lee Stanley, Emmett/Furla Productions

The Spreading Ground, 2000 (US), James Burke, Tsunami Entertainment

Luck of the Draw, 2000, Luca Bercovici, Kandice King Productions

The Venice Project, 1999, Robert Dornhelm, Terra Films

The Prophet's Game, 1999, David Worth, Prophet Productions

Bad City Blues, release pending, Michael Stevens, Bad City Pictures

Straight Shooters, 1999 (Euro), Thomas Bohn, Perathon Film

Ed TV, 1999 (US), Ron Howard, Universal Pictures

Michaelangel, release pending, William Gove, Arama Entertainment

Tycus, release pending, John Putch, Phoenician Films

Lured Innocence, release pending, Kikuo Kawasaki, Dakota Sky Productions

Meet the Deedles, 1998 (US), Steve Boyum, Disney Pictures

Top of the World, 1998 (US), Barry Sampson, Phoenician Films

Road Ends, 1997, Rick King, PM Entertainment

The Last Days of Frankie the Fly, 1997, Peter Markle, Phoenician Films

Samson & Delilah, 1996, Nicholas Roeg, TNT Original

Space Truckers, 1996, Stuart Gordon, Universal Pictures

The Fine Art of Separating People From Their Money, 1996, directed by Hermann Vaske, Das Werk

Basquiat, 1996 (US), Julian Schnabel, Miramax

Carried Away, 1996 (US), Bruno Barreto, Cinetel/Fine Line

Search & Destroy, 1995 (US), David Salle, October Films

Waterworld, 1995 (US), Kevin Reynolds, Universal

Witch Hunt, 1995 (US), Paul Schrader, Pacific Western Productions/HBO

Speed, 1994 (US), Jan De Bont, Twentieth Century Fox

Boiling Point, 1993 (US/France), James Harris, Warner

Chasers, 1993 (US), Dennis Hopper, Morgan Creek

The Heart of Justice, 1993 (US), Bruno Barreto, Amblin Entertainment/TNT

Red Rock West, 1993 (US), John Dahl, Polygram Filmed Entertainment & Propaganda/Rank Films

Super Mario Bros., 1993 (US), Rocky Morton and Annabel Jankel, Cinergi/ Hollywood Pictures

True Romance, 1993 (US), Tony Scott, Morgan Creek/Warner

Sunset Heat, 1992 (US), John Nicolella, King Productions/New Line

Nails, 1992 (US), John Flynn, Viacom/Showtime

Crazy About the Movies (documentary), 1991 (US), Robert Guenette, Showtime

Doublecrossed, 1991 (US), Roger Young, Green and Epstein/HBO

Eyes of the Storm, 1991 (US), Yuri Zeltser, New Line

Hearts of Darkness: A Filmmaker's Apocalypse, 1991 (US), Fax Bahr and George Hickenlooper

Indian Runner, 1991 (US), Sean Penn, MGM

Paris Trout, 1991 (US), Stephen Gyllenhaal, Viacom/Showtime

Superstar: The Life and Times of Andy Warhol, 1991 (US)

Chattahoochee, 1990 (US), Mick Jackson, Hemdale

Backtrack [European title *Catchfire*], 1989 (US), Dennis Hopper, Vestron/Showtime

Flashback, 1989 (US), Franco Amurri, Paramount

A Hero of Our Time, 1988 (US), Michael Almereyda

Riders of the Storm, 1988 (US), Maurice Phillips, Miramax

The Texas Chainsaw Massacre Part 2, 1988 (US), Tobe Hooper, Cannon

Black Widow, 1987 (US), Bob Rafelson, Laurence Mark/Twentieth Century Fox

Blood Red, 1987 (US), Peter Masterson

O.C. and Stiggs, 1987 (US), Robert Altman

The Pick-Up Artist, 1987 (US), James Toback

River's Edge, 1987 (US), Tim Hunter, Hemdale

Blue Velvet, 1986 (US), David Lynch, DeLaurentiis/DEG Release

Hoosiers, 1986 (US), David Anspaugh, Hemdale/Orion

Straight to Hell, 1986 (US), Alex Cox

My Science Project, 1985 (US), Jonathan R. Betuel, Touchstone and Silver Screen Partners

Running Out of Luck, 1985, Julian Temple

Slaggskampen [The Inside Man], 1984 (Sweden/UK), Tom Klegg

The Osterman Weekend, 1983 (US), Sam Peckinpah, Davis-Panzer/Twentieth Century Fox

The Human Highway, 1982 (US), Bernard Shakey

King of the Mountain, 1981 (US), Noel Nossek

Renacida [Reborn], 1981 (Spain/US), Bigas Luna

Rumble Fish, 1981 (US), Francis Ford Coppola, Zoetrope Studios/Universal

White Star, 1981 (Germany), Roland Klick

Out of the Blue, 1980 (Canada/US), Dennis Hopper, Gary Jules Juvenat Prods/ Discovery Films

Apocalypse Now, 1979 (US), Francis Ford Coppola, Omni Zoetrope/UA

Couleur Chair, 1978 (Belgium), François Weyergans

L'ordre et la sécurité du monde, 1978 (France), Claude D'Anna

Les apprentis sorciers, 1977 (France), Edgardo Cozarinsky

Der amerikanische Freund [The American Friend], 1977 (Germany), Wim Wenders, New Yorker Films

Mad Dog Morgan, 1976 (Australia), Philippe Mora

Tracks, 1976 (US), Henry Jaglom, International Rainbow Pictures and Dumont/ Trio

Blood Bath (aka The Sky Is Falling), 1975

James Dean: The First American Teenager, 1975 (UK), Ray Connolly

Kid Blue, 1973 (US), James Frawley, Marvin Schwarz Productions/Twentieth Century Fox

The American Dreamer, 1971 (US), Lawrence Schiller & L. M. Kit Carson, Corda Prods/EYR

Crush Proof, 1971 (US), François de Ménil

The Last Movie, 1971 (US), Dennis Hopper, Universal

Easy Rider, 1969 (US), Dennis Hopper, Pando Company and Raybert Prods/ Columbia Pictures

True Grit, 1969 (US), Henry Hathaway, Hal B. Wallis/Paramount Pictures

Head, 1968 (US), Bob Rafelson, Columbia Pictures

Cool Hand Luke, 1967 (US), Stuart Rosenberg, Jalem/Warner Bros.

The Glory Stompers, 1967 (US), Anthony M. Lanza

Hang 'em High, 1967 (US), Ted Post, Malposo/United Artists

Luke, 1967 (US), Bruce Conner

Panic in the City, 1967 (US), Eddie Davis

The Trip, 1967 (US), Roger Corman, American International Pictures

Queen of Blood (aka Planet of Blood), 1966 (US), Curtis Harrington

The Sons of Katie Elder, 1965 (US), Henry Hathaway, Hal B. Wallis/Paramount Pictures

Night Tide, 1963 (US), Curtis Harrington, Virgo Films

Tarzan and Jane Regained … Sort of, 1963 (US), Andy Warhol

Key Witness, 1960 (US), Phil Karlson

The Young Land, 1959 (US), Ted Tetzlaff, Columbia Pictures

From Hell to Texas, 1958 (US), Henry Hathaway, Twentieth Century Fox

The Story of Mankind, 1957 (US), Irwin Allen, Cambridge/Warner Bros.

Giant, 1956 (US), George Stevens, Warner Bros.

Gunfight at the OK Corral, 1956 (US), John Sturges, Paramount Pictures

The Steel Jungle, 1956 (US), Walter Doniger

I Died a Thousand Times, 1955 (US), Stuart Heisler, Warner Bros.

Rebel Without a Cause, 1955 (US), Nicholas Ray, Warner Bros.

Selected Bibliography

Monographs

Darling, Michael. *Dennis Hopper: Italian Walls.* Milan, Italy: Pallazzo Marino Alla Scala Art Center, 1997. Sponsored by Fondazione Trussardi.

Hopper, Dennis. *Abstract Reality.* Tokyo, Japan: Korinsha Press, 1998.

Dennis Hopper: Bad Heart: Fotografies i pintures 1961–1993 [Photographs and Paintings 1961–1993]. Barcelona: Universitat Pompeu Fabra, 1993.

Hopper, Dennis and Michael McClure and Walter Hopps. *Dennis Hopper: Out of the Sixties.* Photos by Dennis Hopper. Pasadena, California: Twelvetrees Press, 1986.

Hopper, Dennis and Shintaro Katsu. *Dennis Hopper: A Tourist.* Kyoto: File, Inc., 1994.

Metzger, Rainer. *Countenance: Face, Head, and Portrait in Contemporary Art.* Thaddaeus Ropac Gallery, Salzburg/Paris: 1997.

Exhibition catalogs

Ammann, Jean-Christophe. *Dennis Hopper: Fotografien von 1961 bis 1967 [Photographs from 1961 to 1967].* Basel: Kunsthalle Basel, 1988.

Ayres, Anne. *Forty Years of California Assemblage.* Los Angeles: Wight Art Gallery, University of California at Los Angeles, 1989.

Ayres, Anne, et al. *L.A. Pop in the Sixties.* Newport Beach, California: Newport Harbor Art Museum, 1989.

Barbera, Alberto and Sara Cortellazzo and Davide Ferrario. *Dennis Hopper – il cinema.* Torino: Assessorato pe la Cultura, AIACE Torino, 1988.

Belloli, Jay et al. *Radical Past: Contemporary Art & Music in Pasadena, 1960 – 1974.* Pasadena

California: Armory Center for the Arts and Art Center College of Design, 1999.

Brougher, Kerry. *Art and Film Since 1945: Hall of Mirrors.* Los Angeles: Museum of Contemporary Art, 1996.

Collaboration/Transformation: Lithographs From The Hamilton Press. Group exhibition catalog, essays by Dave Hickey and Ed Hamilton. Montgomery Gallery, Pomona College (Traveled to Fred Jones Jr. Museum of Art, The University of Oklahoma).

Coplans, John. *Los Angeles Now.* London: Graphis Press Limited/Robert Fraser Gallery, 1966.

Desmarais, Charles. *Proof: Los Angeles Art and the Photograph 1960–1980.* Laguna Beach, California: Laguna Art Museum, 1992.

Hoberman, Jim. *Dennis Hopper: From Method to Madness.* Minneapolis, Minnesota: Walker Art Center, 1987.

Hopper, Dennis. "Into the Issue of the Good Old Time Movie Versus the Good Old Time." Introduction to *Easy Rider,* edited by Nancy Hardin and Marilyn Schlossberg, including the original screenplay by Peter Fonda, Dennis Hopper and Terry Southern. New York: Signet Books, The New American Library, Inc. 1969, pp 7–11.

Kohler, Michael. *Künstlerportraits.* Group exhibition catalog, Munich, Germany, Walter Storms Gallery, 1998.

Krull, Craig. *Photographing the L.A. Art Scene 1955–1975.* Santa Monica, California: Smart Art Press, 1996.

Monk, Philip. *American Playhouse: The Theatre of Self-Presentation.* Toronto, Ontario: The Power Plant, Contemporary Art Gallery at Harbourfront Centre, 1998.

Phillips, Lisa et al. *Beat Culture and the New America 1950–1965.* New York: The Whitney Museum of American Art, 1995.

Schulz, Berndt. *Dennis Hopper: Schauspieler/Regisseur/Fotograf.* West Germany: Gustav Lübbe Verlag, 1990.

Tanikawa, Takeshi. *Dennis Hopper: Legend of the Survivor.* Tokyo: 1995.

Tanikawa, Takeshi. *The Man Who Created Easy Rider.* Tokyo: 1996.

General books

Burke, Tom. "Dennis Hopper Saves the Movies." *Burke's Steerage.* New York: G.P. Putnam's Son, 1976, pp 115–134. (reprinted from *Esquire,* September 1970, pp 139–141.)

Cagin, Seth and Philip Dray. *Hollywood Films of the Seventies.* New York: Harper & Row, 1984, pp 41–74.

Crow, Thomas. *The Rise of the Sixties: American and European Art in the Era of Dissent.* New York: Harry N. Abrams, Inc., 1996, pp 78–81.

Gallagher, John Andrew. "Dennis Hopper." *Film Directors on Directing.* New York: Greenwood Press, 1989, pp 127–140.

Hickenlooper, George. "Dennis Hopper: Art, Acting and the Suicide Chair." *Reel Conversations: Interviews with Films Foremost Directors and Critics.* New York: Carol Publishing Group, 1991, pp 63–75.

Hopper, Dennis. Introduction to *Recent Forgeries: Viggo Mortensen,* edited by Pilar Perez. Santa Monica, California: Smart Art Press, 1998, p 5.

Hopper, Dennis. Introduction to *James Dean: Behind the Scene,* edited by Leith Adams and Keith Burns. New York: Carol Publishing Group, 1990, pp 8–12.

Pedersen, Martin (Ed.). *Graphis Photo 97.* Toppan, Hong Kong, 1997, pp 18–19.

Rudnick, Lois Palken. *Utopian Vistas: The Mabel Dodge Luhan House and the American Counterculture.* Albuquerque, New Mexico:

University of New Mexico Press, 1996, pp 185–284.

Siska, William Charles. "Formal Reflexivity in Dennis Hopper's The Last Movie." *Modernism in the Narrative Cinema: The Art Film as Genre.* Unpublished PhD dissertation, New York University, pp 80–100.

Articles/interviews

Algar, Nigel. "Hopper at Birmingham." *Sight and Sound,* vol 51, no 3 (Summer 1982), p 150.

The American Film Institute Harold Lloyd Master Seminar. Transcript of discussion with Dennis Hopper moderated by Ron Silverman, February 15, 1995.

Archibald, Lewis. "An Interview with Dennis Hopper: Is the Country Catching Up to Him?" *The Aquarian* (April 20, 1983), p 8.

Assayas, Oliver. "Dennis Hopper revient à Cannes." *Cahiers du Cinéma,* no 214 (June 1980), pp iii–iv.

Bruce, Bryan. "Rap/Punk/Hollywood: Beat Street and Out of the Blue." *CineAction!* (Spring 1985), pp 6–11.

Burke, Tom. "Dennis Hopper Saves the Movies." *Esquire* (September 1970), pp 139–141. (republished in Burke, Tom. "Dennis Hopper Saves the Movies." *Burke's Steerage.* New York: G.P. Putnam's Son, 1976, pp 115–134.)

Carcassonne, Philippe. "Rencontre avec Dennis Hopper." *Cinématographe,* no 68 (June 1981), p 77.

Chadwick, Susan. Exhibition review, Davis/McClain Gallery: "Photographer with a cause documents cultural era." *The Houston Post* (February 24, 1990).

Chaillet, Maurice. "Dennis Hopper: Out of the Sixties." *Première* (June 1987), pp 100–104.

Clothier, Peter. "Dennis Hopper at James Corcoran." *Art in America* (June 1992).

Combs, Richard. "The Last Movie." *Monthly Film Bulletin,* vol 49, no 585 (October 1982), pp 218–219.

Dalchow, Paula. "Der Fiesling und die Poesie." *Elle* (June 1996), pp 44–46.

Darrach, Brad. "The Easy Rider in the Andes Runs Wild." *Life* (June 19, 1970), pp 49–59.

Drohojowska, Hunter. "Ruscha Today." *LA Style* (June 1990). Portrait by Dennis Hopper.

Ebert, Roger. "Out of the Blue, an unforgettable poem." *Chicago Sun-Times* (November 17, 1982).

Enwezor, Okwui. "Basquiat," Frieze, issue 32 (January – February 1997), pp 82–83.

Factor, Donald. "Assemblage." *Artforum* (Summer 1964), illus. by Dennis Hopper.

Fischer, Jack. "Silent Pictures." *San Jose Mercury News* (July 18, 1997).

Goodwin, Michael. "In Peru with Dennis Hopper making The Last Movie." *Rolling Stone* (April 16, 1970), pp 26–32.

Green, Robin. "Confessions of a Lesbian Chick: A Penetrating Interview with Dennis Hopper." *Rolling Stone* (May 13, 1971), pp 34–36.

Hadenfield, Chris. "Citizen Hopper." *Film Comment,* vol 22, no 6 (November/ December 1986), pp 62–73.

Hainley, Bruce. "Dennis Hopper at Fred Hoffman Fine Art." Artforum (October 1997), pp 105–106.

Henschel, Regine C. "Dennis Rides Again." *Kultur News* (August 1997).

Hindry, Ann. "Cinema & Art: Dennis Hopper." *Galeries Magazine* [International Edition], no 51 (October/November 1992), pp 88–93.

Hopkins, Henry T. "Dennis Hopper's America." *Art in America* (May/June 1971), pp 80–91.

Hopper, Dennis. "Light Years from Home." *LA Style* (November 1989).

Hopper, Dennis. "Standard Bullshit." *Parkett,* no 18 (December 1988), pp 48–53, a series of photographs by Dennis Hopper selected for the Ed Ruscha issue.

Hopper, Dennis and Quentin Tarantino (interview). "Blood Lust Snicker Snicker in Wide Screen." *Grand Street 49,* vol 13, no 1 (Summer 1994), pp 10–22.

"Dennis Hopper with Tony Shafrazi," *Index Magazine,* (May/June 1999), pp 52–64.

James, David E. "Dennis Hopper's The Last Movie." *Journal of University Film and Television Association,* vol XXXV, no 2 (Spring 1983), pp 34–46.

James, David E. "Hall Of Mirrors: Art And Film Since 1945." *Art + Text,* no 54 (May 1996).

Kandel, Susan. "Troubling Flashbacks From Dennis Hopper," *Los Angeles Times* (June 13, 1997), Section F, p 12.

Kaprow, Allen. "The Happenings are Dead." *Artforum* (March 1966), photos by Dennis Hopper.

LaSalle, Mick. "Dennis Hopper's Artier Side." *San Francisco Chronicle* (September 29, 1996), Datebook section, pp 42–43.

Leider, Philip. "Regional Accent: California After the Figure." *Art in America,* vol 51, no 5 (October 1963).

McMillian, Elizabeth and Dennis Hopper. "Artist in Residence." *Southland* (Spring/Summer 1999), pp 57–65.

Petley, Julian. "Dennis Hopper." *Stockholm Film Festival 1991,* pp 148–175.

Penn, Sean and Robert Duvall and Dennis Hopper. "Colors." *City, Helsingin Kuukausilehti* (July 1988), pp 8–10.

Quinn, Joan Agajanian. "Road's Scholar: Dennis Hopper." *Interview* (December 1985), p 238.

Rugoff, Ralph. "Lost at the Mall. Searching for the intersection of art and film." *L.A. Weekly* (March 29 – April 4, 1996).

Schonholtz, Manuela. "Blick für das Gewöhnliche." *Feuilleton* (24 June 1997).

Schwefel, Heinz Peter. "Dennis Hopper: Ein Mann stellt die Bilder in Frage." *ART Das Kunstmagazin* (December 1997), pp 74–83.

Selwyn, Marc. "Dennis Hopper." *Flash Art International,* no 147 (Summer 1989), pp 118–121.

Sischy, Ingrid. "Dennis Hopper, Photographer." *Interview* (August 2000), p 102.

Southern, Terry. "The Loved House of the Dennis Hoppers." *Vogue* (August 1, 1965), pp 137–142.

Squire, Corinne. "Out of the Blue and Into the Black: A Psychoanalytic Reading." *Screen,* vol 23, no 3–4 (September – October 1982), pp 98–106.

Toshinori, Arai, photographs by Kazumi, Kurigami. "Director's Note," *Switch,* vol 15 no 5 (June 1997), pp 24–43, pp 60–65.

Uyeda Seiko. "Quest for Lost Image," *Seven Seas,* no 113 (January 1998), pp 171–175.

Wholden, R.G. "Assemblages at Primus/Stuart." *Artforum,* vol 1, no 10 (April 1963).

White, Garrett and Robert Dean. "Art of the Sixties: Another Side of Dennis Hopper." *Frank,* no 8/9 (Winter 1987/1988), pp 24–32.

White, Garrett and Michael Lassell. "Unconventional Perspectives." *LA Style* (June 1989).

White, Garrett and Robert Wilmington. "Citizen Rebel: Somewhere in the Middle with Dennis Hopper." *LA Style* (July 1989). Photographs by Herb Ritts.

Wilson, William. "More Than Meets the Eye." *Los Angeles Times* (January 14, 1992), Calendar section.

List of Illustrations

X-XEROX, 1982
Acrylic on canvas with verifax
72 x 48 x 1.5 inches
p. 198

KILLER PUSSY (Triptych), 1982–83
Acrylic on canvas
72 x 158 x 1.5 inches
p. 202/203

UNTITLED (Triptych), 1982–83
Acrylic on canvas
72 x 144 x 1.5 inches
p. 200/201

UNTITLED, 1991
Polaroids
16 x 16 x 1.5 inches
p. 167

BEAT, 1991
Photo emulsion, acrylic, rolotex, and spray paint on canvas
139 x 96 x 1.5 inches
p. 226/227

KING PART BUST TRAP, 1991–97
Photo emulsion, acrylic, rolotex, and spray paint on canvas
126 1/4 x 337 x 1.5 inches
p. 212/213

CITY, 1992
Photo emulsion, acrylic, rolotex, and spray paint
108 x 68 inches
p. 223

COP, 1992
Photo emulsion, acrylic, rolotex, and spray paint on canvas
107 3/8 x 68 1/4 x 1.5 inches
p. 222

CUFF, 1992
Photo emulsion, acrylic, rolotex, and spray paint on canvas
96 x 139 x 1.5 inches
p. 224/225

OFF, 1992
Photo emulsion, acrylic, rolotex, and spray paint
104 x 64 inches
p. 217

ONE OF FOUR JOINERS, 1992
Photo emulsion, rolotex, spray paint on canvas
80 x 53 x 1.5 inches
p. 218

ONE OF FOUR JOINERS, 1992
Photo emulsion, rolotex, spray paint on canvas
80 x 53 x 1.5 inches
p. 219

ONE OF FOUR JOINERS, 1992
Photo emulsion, rolotex, spray paint on canvas
80 x 53 x 1.5 inches
p. 220

TORERO (One of four joiners), 1992
Photo emulsion, rolotex, spray paint on canvas
80 x 53 x 1.5 inches
p. 221

VIA, 1992
Photo emulsion, acrylic, rolotex, and spray paint
110 x 70 inches
p. 216

MOROCCO I, 1994
Acrylic on canvas
70 x 70 x 1.5 inches
p. 208

MOROCCO II, 1994
Acrylic on canvas
96 x 96 x 1.5 inches
p. 209

MOROCCO (Brown grid), 1994
Acrylic on canvas
70 x 70 x 1.5 inches
p. 204

MOROCCO (Brown grid II), 1994
Acrylic on canvas
70 x 70 x 1.5 inches
p. 205

MOROCCO (Diptych), 1994
Acrylic on canvas
68 x 136 x 1.5 inches
p. 206/207

MOROCCO (Grid), 1994
Acrylic on canvas
40 x 53 x 1.5 inches
p. 210

MOROCCO (Grid II), 1994
Acrylic on canvas
40 x 53 x 1.5 inches
p. 211

UNTITLED (Morocco blue), 1994
Acrylic on canvas
40 x 40 x 1.5 inches
p. 215

UNTITLED (Morocco colors), 1994
Acrylic on canvas
40 x 53 x 1.5 inches
p. 214

BERLIN (Grey fluff), 1995
Color photograph
75 x 50 inches
p. 190

LONDON (Grey with white square), 1995
Color photograph
75 x 50 inches
p. 183

LONDON (Street with red spray), 1995
Color photograph
75 x 50 inches
p. 182

LOS ANGELES (Eye on fence), 1995
Color photograph
75 x 50 inches
p. 162

PRAGUE (Blue/grey graffiti), 1995
Color photograph
75 x 50 inches
p. 185

PRAGUE (Red horses), 1995
Color photograph
75 x 50 inches
p. 188

VENICE (Harpist's foot), 1995
Color photograph
75 x 50 inches
p. 187

VENICE (Sign "aperto"), 1995
Color photograph
75 x 50 inches
p. 184

FLORENCE (Grey wheel), 1996
Color photograph
75 x 50 inches
p. 189

FLORENCE (Muse), 1996
Color photograph
75 x 50 inches
p. 186

VENICE (The face), 1996
Color photograph
75 x 50 inches
p. 191

CEMETERY, 1997
Triptych of digitized videostills on canvas
from *Easy Rider,* 1969, ed. 1/3
32 x 132 x 1.5 inches
p. 228

WITHIN A MAN OF LIGHT, THERE IS ONLY LIGHT; WITHIN
A MAN OF DARKNESS, THERE IS ONLY DARKNESS
(Self Portrait), 1997
Digital ink jet print, transparency, and lightbox
p. 248

OSAKA (Black graffiti), 1997
Color photograph
75 x 50 inches
p. 179

THIS IS ART (Marcel's dilemma), 1997
Neon sign
3 x 20.5 inches
Collection Dallas Price, Los Angeles, California
p. 146

VENICE (Black circle with drip), 1997
Color photograph
75 x 50 inches
p. 181

VENICE (Man Ray), 1997
Color photograph
75 x 50 inches
p. 180

UNTITLED (Large color photograph diptych), 1998
Color photograph
80 x 120 inches (framed)
p. 192

UNTITLED (Large color photograph diptych), 1998
Color photograph
80 x 120 inches (framed)
p. 193

BILLBOARD FACTORY (Multi image of a woman's face),
2000
Billboard, water based primer, oil paint, matte varnish on vinyl
14 x 21.5 feet
p. 154/155

EFFACED DOUBLE POSTER, 2000
Billboard, water based primer, oil paint, matte varnish on vinyl
14 x 21.5 feet
p. 160/161

TORN POSTER (Girl), 2000
Billboard, water based primer, oil paint, matte varnish on vinyl
14 x 9.5 feet
p. 163

UNTITLED #2 (Two stucco walls with concrete columns),
2000
Wall assemblage, pine frames with Luan, columns made with MDF,
painted with walnut shell impregnated paint, steel frames and straps
and gutted AC unit
13 feet x 9 feet x 4.5 inches each
p. 164/165

UNTITLED #4 (Corrugated fence), 2000
Wall assemblage, channel steel welded to box steel with chain-link
fencing attached, with galvanized steel corrugated roofing, razor wire
approx 11 feet 4 inches x 24 feet x 5 inches
p. 168/169

UNTITLED #7 (Old plywood wall with graffiti), 2000
Wall assemblage, pine frames with 1/2 inch C.D.X., iron sulfate
16 feet x 8 feet x 4.5 inches
p. 166

UNTITLED #10 (Old metal wall), 2000
Wall assemblage, framing with tin covering, steel wire
9 feet 6 inches x 13 feet x 7 inches
p. 173

UNTITLED #11 (Representation of Man from La Salsa), 2000
Fiberglass with steel frame and paint
approx. 21 feet tall
p. 172

UNTITLED (Representation of Mobil Man), 2000
Fiberglass with steel frame and paint
approx. 21 feet tall
p. 170

Photo Credits

Academy of Motion Picture Arts and Sciences, 255

Alta Light (Alan Schaffer Photography), 265, 279

The American International Pictures, 268, 269

Artforum, 262

Peter C. Borsari, 290

CBS, 259

Walter Chappell, 272

William Claxton, 264

Collection Takeshi Tanikawa, 255, 256, 258, 280, 287, 291, 294, 295, 296, 297

Columbia Pictures, 257, 270, 271

Anton Corbijn, inside flaps

Corda Productions, 275

Alex Cox (Together Brothers), 288

De Laurentiis Entertainment Group, 288

Dan Dion Photography, 302, 303

Discovery Films, 285

Herbert Fidler, 13

Curtis Harrington, 263

Hemdale Releasing Corp., 295

Island Pictures, 293

Jocelyn, 264

Life, 30

Loew's Incorporated, 258

Mary Ellen Mark, 282

Jim Marshall, 268

Fred W. McDarrah, 270

Chris McDougall Crown, 281

Medusa Pictures, 297

MGM, 269

Caterine Milinaire, 303

Miramax, 294

Peter Noever, 11

October Film, 299

Orion Pictures Corp., 287, 291, 292

Paramount Pictures Corp., 296

Rank Film Distributions Ltd., 297

Julian Schnabel, 303

Shakey Pictures Inc., 284

Edmund Shea/Bruce Conner, 274

Showtime, 295

Showtime/Kelvin Jones, 297

Skrebneski Photograph, 267

Stedelijk Museum Amsterdam, 16, 266

Dean Stockwell, 298

Takeshi Tanikawa, 301

Manfred Trummer/MAK, 8

Twentieth Century Fox, 298

Universal Pictures, 276, 278, 299

Robert Walker, Jr., 260, 261, 266

The Warhol Foundation, 279

Warner Brothers, 253, 254, 255, 298

Julian Wasser, 41, 265

Wim Wenders Production, 280

Westmount Communications Film Joint Venture, L.P., 297

Joshua White, 12, 22, 23, 31

Firooz Zahedi, 300

Zoetrope, 282, 283

Gerald Zugmann, 14, 17, 18, 19, 20, 21

Many of the photographs in this publication are unidentified. All known photographers are mentioned with appropriate photo credits. All other photographs: Dennis Hopper/Alta Light.

Photos from *Vogue,* 1965, p. 119–122: courtesy of *Vogue.*

Text Credits

Walter Hopps, Out of the Sixties: courtesy of *Dennis Hopper: Out of the Sixties* (Passadena: Twelvetrees Press, 1986).

Andy Warhol, POPism: courtesy of Andy Warhol, Pat Hackett, *POPism, The Warhol Sixties* (San Diego/New York/London: Harcourt Brace & Company, First Harvest edition, 1990): p. 35–45.

Dennis Hopper, Edward Ruscha, The Pop Fathers: courtesy of *The Independent,* April 30, 2000.